中国出土壁画全集

徐光冀／主编

科学出版社

北京

版 权 声 明

图书在版编目（CIP）数据

中国出土壁画全集／徐光冀主编.—北京：科学出版社，2011
ISBN 978-7-03-030720-0

Ⅰ．①中... Ⅱ．①徐... Ⅲ．①墓室壁画-美术考古-中国-图集
Ⅳ．①K879.412

中国版本图书馆CIP数据核字（2011）第058079号

审图号：GS（2011）76号

责任编辑：闫向东／封面设计：黄华斌　陈　敬
责任印制：赵德静

科 学 出 版 社 出版
北京东黄城根北街16号
邮政编码：100717
http://www.sciencep.com

北京天时彩色印刷有限公司印刷
科学出版社发行　各地新华书店经销

*

2012年1月第 一 版　　开本：889×1194　1/16
2012年1月第一次印刷　印张：160
印数：1-2 000　　字数：1280 000

定价：3980.00元
（如有印装质量问题，我社负责调换）

THE COMPLETE COLLECTION OF MURALS UNEARTHED IN CHINA

Xu Guangji

Science Press

Beijing

Science Press

16 Donghuangchenggen North Street, Beijing,

P.R.China, 100717

Copyright 2011, Science Press and Beijing Institute of Jade Culture

ISBN 978–7–03–030720–0

《中国出土壁画全集》编委会

凡　例

1. 《中国出土壁画全集》为"中国出土文物大系"之组成部分。

2. 全书共10册。出土壁画资料丰富的省区单独成册，或为上、下册；其余省、自治区、直辖市根据地域相近或所收数量多寡，编为3册。

3. 本书所选资料，均由各省、自治区、直辖市的文博、考古机构提供。选入的资料兼顾了壁画所属时代、壁画内容及分布区域。所收资料截至2009年。

4. 全书设前言、中国出土壁画分布示意图、中国出土壁画分布地点及时代一览表。每册有概述。

5. 关于图像的编辑排序、定名、时代、尺寸、图像说明：

编辑排序：图像排序时，以朝代先后为序；同一朝代中纪年明确的资料置于前面，无纪年的资料置于后面。

定　　名：每幅图像除有明确榜题外，均根据内容定名。如是局部图像，则在原图名后加"（局部）"；如是同一图像的不同部分，则在图名后加"（一）（二）（三）……"；临摹图像均注明"摹本"。

时　　代：先写朝代名称，再写公元纪年。

尺　　寸：单位为厘米。大部分表述壁画尺寸，少数表述具体物像尺寸，个别资料缺失的标明"尺寸不详"。

图像说明：包括墓向、位置、内容描述。个别未介绍墓向、位置者，因原始资料缺乏。

6. 本全集按照《中华人民共和国行政区划简册·2008》的排序编排卷册。卷册顺序优先排列单独成册的，多省市区合卷的图像资料亦按照地图排序编排。编委会的排序也按照图像排序编定。

《中国出土壁画全集》编委会

中国出土壁画全集

— 4 —

| 山东 |
| SHANDONG |

主　编：郑同修
副主编：李　铭　刘善沂　李振光　杨　波
Edited by Zheng Tongxiu, Li Ming, Liu Shanyi, Li Zhenguang, Yang Bo

科学出版社
Science Press

山东卷编委会名单

参编人员（以姓氏笔画为序）

王予幻　王兴华　王书德　王惠民　孙　涛　刘善沂　衣同娟　李　铭　李振光
李曰训　何　利　邱玉鼎　杨　波　张光明　张瑞泉　郑同修　秦大树　魏成敏

山东卷参编单位

山东省文物考古研究所　　　　　济南市博物馆

山东博物馆　　　　　　　　　　临朐县博物馆

济南市考古研究所　　　　　　　博山区文物管理所

山东地区出土壁画概述

郑同修

20世纪50年代以来，山东地区发掘了大量的古代墓葬，其中部分汉代以来的墓葬中绘有精美的壁画，成为研究汉代及以后各时期古代文化最直观的珍贵资料。据统计，山东目前发现的壁画墓近50座，其中汉墓5座，北朝墓5座，隋墓2座，宋、金、元、明时期壁画墓数量较多，有30余座。从目前资料来看，这些出土壁画的墓葬中年代最早的为汉代，主要分布于济南、东平一带；北朝壁画墓主要分布于济南及临淄附近；隋代壁画墓仅见于嘉祥县一处；宋、金、元、明时期壁画墓主要分布于济南地区，聊城、淄博也有个别的金、元壁画墓葬。现按照时代顺序将山东出土古代壁画情况略予概述。

1.汉代墓葬壁画

目前发现山东省时代最早的壁画墓葬为东平县发现的3座。2007年秋，东平县物资局在进行楼房施工时，发现中小型汉墓18座，其中3座墓中绘有壁画，又以1号墓的壁画保存状况最好。该墓为一座中型石室墓，由墓道、前室、后室组成。壁画绘制于墓门门楣、前室墓壁和顶部。绘制壁画时，先在石壁上涂一薄层白粉为地，再在上面绘制画面。壁画内容较为丰富，墓顶绘制云气纹和金乌，其余部分以人物画像为主，间有鸡、狗等动物形象。具体有敬献、谒见、斗鸡、宴饮、舞蹈等场面，绘制各类人物形象多达48人。画面结构虽不复杂，但色彩艳丽，人物形态动作自如，衣纹简练流畅，生动逼真。绘制于门楣内侧的12个人物形象最具代表性，色彩艳丽，神态各异，写实逼真，反映出汉代画匠们的高超绘画技巧，极具艺术价值，为山东汉代壁画墓葬最重要之发现。墓葬早年被盗，残余随葬品极少，但从墓葬形制推断，应为王莽到东汉初，是山东地区目前发现时代最早的壁画资料。同时发掘的12、13号两座墓葬中也绘有壁画。其中12号墓的壁画绘于墓室门楣和墓门两侧，门楣上绘有青龙、白虎和神人，两侧画面漫漶不清。13号墓

的前室石壁上的壁画，只用墨线勾勒，保存有张弓射虎图等，线条粗犷有力[1]。从这两座墓葬的结构和出土器物判断，应属于新莽至东汉初年。

20世纪50年代初发现的梁山后银山（现属东平县）东汉壁画墓，是山东地区最早发现的壁画墓。该墓系一座砖石结构的前、后室墓葬，其前室顶部为覆斗式彩绘藻井，后室为砖券棺室。壁画绘于前室的四壁及墓顶，系先在墓壁上涂白粉地，然后以朱、墨两色勾绘。发现时壁画的颜色仍很鲜艳，内容丰富，所绘人物多有题记。墓室顶部中间绘有日、月，周围为云纹。从墓葬形制和壁画判断，该墓葬应属于东汉中期[2]。

济南青龙山壁画墓发现于1986年，是东汉晚期的墓葬。此墓发现壁画6幅，分布在墓门过洞两侧、前室南墙和西墙、中室南墙和西墙上。壁画以石墙为地，壁画的颜色有红、黑、绿等色。残存壁画内容有车马出行、人物等[3]。

已发现的汉代壁画墓葬资料，除青龙山壁画墓外，其余几座分布较为集中，梁山后银山壁画墓与东平壁画墓相毗邻。从壁画的制法上，都是在墓壁上涂刷白粉为地，然后作画。不同的是，砖室墓壁上作画前要先涂一层稍厚的泥土层和白灰层，而在石壁上作画则仅仅涂刷很薄的白粉地。从壁画的内容来看，并不复杂，除车马出行、建筑外，主要以人物形象为主。

2.北朝、隋代壁画

北朝时期的壁画墓以临朐崔芬墓、济南马家庄道贵墓、济南东八里洼北朝墓最为重要。另外，临淄北朝崔氏墓地、寿光北魏贾思伯墓中也发现有壁画。

崔芬墓位于临朐县冶源镇海浮山南坡，1986年4月发掘。墓葬由墓道、甬道和墓室组成，年代为北齐天保二年（551年）。壁画绘制于墓葬甬道两壁及墓室四壁和室顶，以白灰面为地，其上彩绘壁画。其中

甬道东、西两壁各绘一武士。墓室顶下部和四壁彩绘星象、四神、墓主夫妇出行及十七牒屏风，绘有"竹林七贤"和荣启期，以及舞蹈、备骑、马、树木、假山等图像。此墓的墓主人夫妇出行图中，男主人褒衣博带，高冠大履，双臂舒展，无论是人物形态，还是画面构图，都与传世的顾恺之《洛神赋图》王者出游行列极为相似。青龙、白虎、"竹林七贤"和荣启期壁画，其画像形态和构图，与南京附近的西善桥宫山、油坊村等南朝墓葬同类的拼镶砖画也类同[4]，从绘画风格和表现手法来看，显然受到了南朝绘画的影响。崔芬墓壁画是目前山东地区已发现同时期墓葬壁画中保存较为完好、绘画艺术水平较高的一处，为中国美术史的研究提供了珍贵的实物资料[5]。

1984年10月发掘的济南马家庄北齐道贵墓是一座石砌单室墓。壁画绘制于墓葬甬道、墓室四壁及墓顶。其中甬道门墙壁画画面以黑色勾绘猛兽，形似老虎，线条粗犷奔放有力。墓室四壁及穹隆顶上抹一层白灰，在白灰面上绘制壁画。人物形象部分以赭色起稿，部分是趁灰墙尚未干固之际用细棒勾出轮廓后再以黑色勾勒，涂以赭石、朱膘等色。墓顶绘北斗七星、南斗六星、太阳、月亮等星相图，墓室四壁绘车马人物。墓葬壁画保存较完整，反映了当时地方官吏的生活情景片断[6]。

济南市南郊东八里洼北朝壁画墓也是较为重要的一座。该墓发现于1986年，墓室东、西、北三面墓壁上绘有壁画。东、西壁画面已漫漶不清，隐约可辨有侍女形象。北壁壁画保存较完整，北壁及与东壁转角处，绘三足八扇赭石色屏风，屏风以上绘花草。中间四扇屏风各绘一人物，都是宽袍大袖，袒胸跣足坐于树下席上，身旁放置壶、盘、杯，正悠然自得，饮酒作乐。依据墓葬形制和出土器物分析，墓葬应属北齐时期[7]。

除以上3座墓葬外，临淄崔氏墓地中也有壁画。其中12号墓为北齐武平四年（573年）的墓葬，该墓墓门内两侧各彩绘武士一尊，与崔芬墓武士画像基本相同[8]。寿光北魏贾思伯墓中，墓室四壁及顶部也施有彩绘，惜已全部脱落[9]。

山东发现的北朝壁画墓，目前仅见于济南、临淄及附近的临朐、寿光一带。从壁画的手法和内容上，明显受到了南朝壁画的影响。发现的5座壁画墓中除一座属于北魏壁画脱落外，其余4座都属于北齐时期，为研究北齐的社会生活、风俗习惯、服饰制度、绘画艺术等，增添了宝贵的资料。

隋代壁画墓仅见于嘉祥满硐乡杨楼村英山1号墓和2号墓。其中1976年发掘的1号墓为隋开皇四年（584年）徐敏行夫妇合葬墓。该墓为砖筑单室墓，由墓道和墓室构成。墓顶、墓室四壁及门洞内、外壁上有彩绘壁画。墓顶上绘天象图，按东、西、南、北四个方位分别绘出星辰、太阳、月亮、桂树和捣药的玉兔等；墓室四壁绘宴饮行乐、出行图。该墓壁画人物画占比例较大，以铁线描勾勒，重彩为主，兼施淡彩，继承了魏晋以来的传统勾线涂彩方法。绘画内容也继承了山东北朝墓葬壁画的一些特点，如墓门、门洞所绘武士、门吏，墓顶的天象图以及墓室正壁所绘屏风画等；但在细节上较北朝壁画又有所发展，如墓门、门洞上除绘武士、门吏外，又增加了司阍，出行图的细部也更为详尽。英山2号墓为徐敏行之父徐之范的墓葬，也有壁画的痕迹，但不完整[10]。

3.宋、金、元、明时期壁画

宋代壁画墓目前只有3座，都发现于济南地区。以1986年在山东工业大学（现山东大学千佛山校区）院内发掘的一座北宋建隆元年（960年）砖雕壁画墓较为重要。该墓平面呈圆形，穹隆顶。墓室周壁绘有花卉、立柱、斗拱、门窗、桌椅及染布的工具等，生活气息浓郁[11]，是山东地区最重要的有明确纪年的宋代壁画墓葬。

1988年发掘的洪家楼宋墓也是砖雕壁画墓，墓室内除顶部外，均涂一层白灰面，壁画多已脱落，残存有花卉图案及朱笔题记。从墓葬形制和出土器物分析，时代为北宋[12]。

章丘女郎山75号墓时代约为北宋晚期到金代初年。墓门及墓室均遍涂白灰，其上有笔墨勾勒图案，白灰层极薄又斑驳脱落，画面内容多漫漶不清，可辨有斗拱、花卉、雄鸡等图案[13]。

金代壁画墓壁画保存较好的有高唐虞寅墓、博山神头金墓和济南历城区港沟镇中日合资昭和塑料（济南）有限公司厂区、章丘宝岛街两座金墓。另外，章丘女郎山金墓中也残存有壁画的痕迹。

高唐虞寅墓发现于1979年。该墓为仿木构建筑的圆形单室砖墓，砖壁上涂抹一层很薄的白灰，然后作画。墓室内有6根砖砌倚柱，把墓室分成7间，墓壁上分别饰有砖砌灯檠、彩绘假门、花窗及盛开的牡丹等；甬道两侧绘车马出行图。墓室内的绘画内容以人物为主，多数人物旁都题有表明身份的墨书，如"家奴"、"家乐"等。每个画面独立成幅，又相互衔接，构成完整的场景。画面结构严谨，构图自然，富有浓厚的生活气息。据出土墓志铭记载，墓主人为女真人虞寅，金承安二年（1197年）下葬[15]。

博山神头金墓发现于1990年，为砖筑单室墓葬，由墓门、甬道、墓室构成，穹隆顶。壁画绘制于墓室四壁及墓顶。墓顶主要以朱彩绘制缠枝牡丹、莲花等吉祥图案。墓室四壁绘画以人物为主，内容有墓主人夫妇对坐、男仆、婢女、妇人启门、牵马及衣架图等。壁画人物主要以墨线勾画，以朱彩和墨线绘制衣纹，人物造型准确生动，色彩绚丽，技法娴熟。据墓内墨书题记知该墓为金代大安二年（1210年）的墓葬[14]。

章丘市宝岛街金代墓发现于2002年，壁画绘于甬道和前室墓壁，原有13幅，部分脱落，有些已漫漶不清。墓壁多绘生活场景，墓顶绘人物图和孝行故事图。

另外，章丘女郎山也发现这一时期的壁画墓，但壁画已斑驳脱落，残存有墨笔勾勒的斑猫一只[17]。

山东元代壁画墓葬材料最为丰富，已发掘的有临淄大武[18]，济南柴油机厂[19]、港沟乡大官庄[20]、邢村[21]、埠东村[22]、章丘市刁镇茄庄[23]、旭升乡西鸠坞村[24]、女郎山[25]、济南市郭店[26]、齐鲁宾馆、司里街、华荣路、章丘龙山镇、三涧村、西沟头、小康村[27]等近20座，除临淄大武一座外，其余都散布在济南市及所辖县区。

这些元代壁画墓葬，具有共同的特点：①墓葬大部分为砖筑仿木结构，个别也用石砌；②绝大部分为单室墓，平面圆形或方形，穹隆顶，一般由墓道、墓门或门楼、甬道、墓室构成；③墓葬壁画的绘制都是先在砖壁上涂抹一层白灰面，然后构图作画；④壁画题材除与砖雕相配的楼阁、斗拱、门楼等建筑彩画及各类花卉、鸟兽图案外，更多的是与世俗生活直接相关的内容，如夫妇对坐、宴饮的场景，妇人启门的画面，这类壁画题材宋金时期即已出现，至元代成为壁画墓中的固定内容。此外，这一时期墓葬壁画的另一个特点是孝行故事十分丰富，如郭巨埋儿、孟宗哭竹、王祥卧冰等为墓中常见题材。⑤多数壁画系用墨线勾画轮廓，再以红、赭、绿等重彩填涂，画面色彩浓艳厚重，装饰效果极强。尤其是建筑类壁画，大量使用鲜艳的红彩，并以白粉为地，墨线勾勒画框，将图案衬托得分外醒目，艳丽明快。

1988年发掘的济南柴油机厂壁画墓为仿木结构单室砖墓，由墓道、墓门、甬道、墓室构成。墓门、甬道、墓室四壁及墓顶都绘有壁画，出土时色彩艳丽清晰，保存较好。壁画先在砖壁上涂抹一层白灰，以墨线勾画轮廓，再以红、黄、赭、绿等色平涂填色。内容大致可分为建筑彩绘、装饰图案、生活场景和历史故事四大类。其中仿木建筑砖雕上全部施以彩绘，依照砖雕建筑的部件形状以墨线勾框，红、绿、黄等色填充。装饰图案类主要用红、绿、黄彩绘制缠枝牡丹、缠枝莲花等各类花草，有的花草插于瓶中，花草、彩云间又穿插蝴蝶、鸳鸯、仙鹤等。社会生活题材类有牵马图、男仆、女侍形象。历史故事类有郭巨埋儿、舜耕历山、王祥卧冰、孟母断机、打虎救父、舍子救侄、孟宗哭竹等孝行故事，内容丰富。

邢村砖雕壁画墓与埠东村石雕壁画墓的壁画均以墓主夫妇日常家居生活及装饰图案为主。邢村砖雕壁画构图充分体现了汉民族文化的特点：画中男女主人作汉族人装扮，妇人启门也以汉族妇女形象出现，壁画装饰以汉民族特点的木构建筑为主。埠东村石雕壁画墓的男主人及男仆人衣冠服饰则具有北方游牧民族的特点。常见的妇人启门画面，在此墓变成了头戴笠帽的男仆。虽然在东、北、西三壁砌有歇山顶仿木构

屋顶石雕，但在各画面的衬地上绘有交叉的网纹，与蒙古包的壁栏相似，突出了游牧民族的特点。

明代壁画墓以章丘女郎山1990年发掘的5座为代表，时代为明代初年。墓葬均为仿木结构的砖筑墓葬。壁画的绘制也是先涂刷白灰为地，再以墨线勾边，最后以朱、赭、绿色填充绘画，显然是继承了元代壁画的做法。尽管壁画画面装饰华丽，但内容却相对简单。如60号墓，该墓自墓门到墓室遍绘壁画，建筑构件均以墨线勾勒椽道，再分别填以赭、绿、朱色；立颊绘金银锭、仰莲、流云和金元宝；甬道门楣上绘莲花图案；前室顶部绘大朵赭色团花，四壁主要绘制花卉、帷帐、绶带等装饰；后室四壁与前室相同，以帷幔、绶带为装饰。其他墓葬如14、15号墓的结构和壁画形式与60号墓基本一致，显示出这一组墓葬的同一性。

综上所述，山东出土壁画墓葬资料不算太丰富，时代上尚存在缺环，但除魏晋和唐代以外，汉代以来各历史时期的壁画墓都有发现。在分布地域上也极不平衡，不同时期的壁画墓各局限于某一个小的范围之内，如汉代壁画墓目前只见于济南和东平湖周围，北朝壁画墓仅发现于济南及临淄一带，元代壁画墓主要分布于济南及附近地区。但在这些数量有限的壁画墓中，各时期都不乏精美之作，绘画的精美程度和内容之丰富，都堪与其他地区同期壁画相媲美。在绘画技巧上，山东地区发现的各时期壁画前后衔接紧密，早期壁画特别是北朝时期的壁画在内容和绘画技法上多受南方的影响，而隋代以后的壁画，后一时期都是前期的传承和发展，这种现象在宋代以来的壁画墓中表现尤甚。随着田野考古工作的不断开展，山东地区将会有更多的古代壁画墓葬被发现、发掘，对古代壁画的研究也将不断深入。

注　释

[1]　山东省文物考古研究所发掘资料。

[2]　杨子范：《山东梁山县后银山村发现带彩绘的古墓》，《文物》1954年第3期；《华东文物工作队勘察清理山东梁山县的彩绘汉墓》，《文物》1954年第10期；关天相、冀刚：《梁山汉墓》，《文物参考资料》1955年第5期。

[3]　济南市文化局文物处：《山东济南青龙山画像石壁画墓》，《考古》1989年第11期。

[4]　南京博物院、南京市文物保管委员会：《南京西善桥南朝墓及其砖刻壁画》，《文物》1960年第8、9期合刊；罗宗真：《南京西善桥油坊村南朝大墓的发掘》，《考古》1963年第6期。

[5]　山东省文物考古研究所、临朐县博物馆：《山东临朐北齐崔芬壁画墓》，《文物》2002年第4期。

[6]　济南市博物馆：《济南市马家庄北齐墓》，《文物》1985年第10期。

[7]　山东省文物考古研究所：《济南市东八里洼北朝壁画墓》，《文物》1989年第4期。

[8]　山东省文物考古研究所：《临淄北朝崔氏墓》，《考古学报》1984年第2期。

[9]　寿光县博物馆：《山东寿光北魏贾思伯墓》，《文物》1992年第8期。

[10]　山东省博物馆：《山东嘉祥英山一号隋墓清理简报——隋代墓室壁画的首次发现》，《文物》1981年第4期；嘉祥县文物管理所：《山东嘉祥英山二号隋墓清理简报》，《文物》1987年第11期。

[11]　济南市博物馆、济南市考古所：《济南市宋金砖雕壁画墓》，《文物》2008年第8期。

[12][21][22]　刘善沂、王惠明：《济南市历城区宋元壁画墓》，《文物》2005年第11期。

[13][17][25]　济青公路文物考古队绣惠分队：《章丘女郎山宋金元明壁画墓的发掘》，《济青高级公路章丘工段考古发掘报告集》，齐鲁书社，1993年。

[14]　山东省淄博市博山区发掘资料，墓葬现存博山区文管所。

[15]　聊城地区博物馆：《山东高唐金代虞寅墓发掘简报》，《文物》1982年第1期。

[16][27]　济南市考古研究所发掘资料。

[18]　山东省文物考古研究所、北京大学中国考古学研究中心：《山东临淄大武村元墓发掘简报》，《文物》2005年第11期。

[19]　济南市文化局文物处：《济南柴油机厂元代砖雕壁画墓》，《文物》1992年第2期。

[20][23][24][26]　济南市文化局、章丘县博物馆：《济南近年发现的元代砖雕壁画墓》，《文物》1992年第2期。

Mural Unearthed From Shandong

By Zheng Tongxiu

Starting from 1950s, many ancient tombs including some exquisite mural tombs since the Han dynasty were excavated in Shandong Province. These discoveries are the important visual materials for the study on the dynastic cultures after the Han dynasty. According to the statistics, there are nearly 50 mural tombs excavated in Shandong including 5 Han tombs, 5 Northern dynasties tombs, 2 Sui tombs, and more than 30 tombs between the Song and Ming dynasty. Han mural tombs, the earliest group, were mainly distributed in Jinan and Dongping area. Northern dynasties mural tombs were mainly distributed in Jinan and Linzi area. Sui mural tombs were only found in Jiaxiang. Mural tombs of the Song, Yuan, and Ming dynasty were mainly distributed in Jinan area. A few Jin and Yuan mural tombs were found in Liaocheng and Zibo area. This article will give a brief description on these discoveries on dynastic order.

1. Han mural tombs

The earliest mural tombs in Shandong found at present are three tombs from Dongping. In the autumn of 2007, 18 middle and small sized Han tombs, including three mural tombs, were excavated during the construction of the Dongping county Goods and Materials Bureau. Tomb M1, a well preserved middle-sized stone construction, is composed of the passageway, front chamber, and rear chamber. Its murals, which were painted on a layer of plaster, were distributed on the lintel of the door, walls and ceiling of the front chamber. Pictures on the ceiling are clouds and golden crow. Other walls were painted human portraits and animals such as chickens and dogs. The theme of painting include the scene of offering, visiting, cockfighting, feasting, and dancing etc. The total amounts of human portraits are 48. With simple composition and bright colors, the pictures depict lively bodies motion and smooth clothing lines. The 12 vivid portraits, which were painted in the inner side of the lintel, are the great example of skilled painting by the Han artisans, which is undoubtedly the most important discovery of the Han mural tombs in Shandong. Looted earlier with only few burial objects left, the burial date of tomb M1 is about between Wang Mang and the early Eastern Han dynasty. It made tomb M1 the earliest mural tomb found in Shandong province. Tombs M12 and M13, which were unearthed at the same site, were also decorated with murals. Murals of tomb M12 were distributed on the lintel and both sides of the door. The paintings on the lintel are Green Dragon, White Tiger, and spiritual humans. The paintings on both sides of the door were damaged. In tomb M13, a tiger shooting scene, only drawn by bold ink lines, was painted on the walls of the front chamber[1]. Based on the burial objects and the constructions type, the two tombs were dated to the Xin to early Eastern Han dynasty.

The Houyinshan Eastern Han mural tomb, which was excavated in 1950s at Liangshan (present Dongping), is the first mural tomb excavated in Shandong Province. Constructed by bricks and stones, the tomb was composed of the front chamber and rear chamber. The painted ceiling in the front chamber is a chamfered shape; the roof in the rear coffin chamber is a vault shape. Its murals, which were distributed on the walls and the ceiling of the front chamber, were painted on a layer of plaster. The bright color pictures depict various subjects accompanied with inscriptions for most portraits. The ceiling was painted Moon and Sun in the center and clouds in the surrounding area. Based on the construction type and the murals style, this tomb was dated to the middle period of the Eastern Han dynasty[2].

Qinglongshan mural tomb, which was excavated in 1986 at Jinan City, is a late Han dynasty tomb. Its murals were distributed on both sides of the doorway, southern and western wall in the front chamber, and southern and western wall in the rear chamber. Painted directly on the stone walls, the colors used are red, black and green. The subjects of the murals could be identified are the procession scene and human portraits[3].

Most of these Han mural tombs including Houyinshan mural tomb and Dongping mural tombs were distributed in an adjoining area. The murals are all painted on the white undercoating of the walls. Tombs made of bricks were applied an additional layer of plaster before paint on the white undercoating. The subjects of murals include procession scene,

architectures, and human portraits.

2. Murals of Northern dynasties and Sui

The most important Northern dynasties mural tombs include Cui Fen's tomb at Linqu, Daogui's tomb at Majiazhuang in Jinan, and the Northern dynasty tomb at Dongbaliwa of Jinan. Besides these, there are also murals found from the Northern dynasties Cui family tombs at Linzi and Jia Sibo's tomb of Northern Wei at Shouguang.

Cui Fen's tomb was excavated in the southern slope of the Haifushan mountain at Yeyuanzhen township in Linqu, on April in 1986. Buried at the 2nd year of the Tianbao Era in the Northern Qi dynasty (551CE), this tomb is composed of the passageway, entryway, and tomb chamber. Its murals, painted on a layer of plaster, were distributed on the walls of the entryway and tomb chamber. A warrior was painted on each side of the entryway. Paintings in the tomb chamber includes stars, the Four Supernatural Beings, procession scene of tomb occupant couple, and 17 screens which include "Seven sages of the bamboo grove" and Rong Qiqi, and the scene of dancing, horse preparing, horse, trees, and rockeries. On the procession scene of the occupant couple, the male occupant, who wears a loose grown with wide girdles, high hat and heavy shoes, is stretching his arms out. It is very similar to the king's portrait of the procession scene in the painting Nymph of the Luo River, which was made by Gu Kaizhi. The composition and images of the Green Dragon, White Tiger, "Seven sages of the bamboo grove" and Rong Qiqi, are also similar to the brick mounted paintings which were excavated from the Southern dynasties tombs at Gongshan of Xishanqiao, and Youfangcun in Nanjing area[4]. It is obviously that the painting of Cui Fen's tomb was influenced by the Southern dynasties in both painting style and skill. As a well perseveved Northern dynasties mural tomb, Cui Fen's tomb provides important materials for the study on Chinese art history[5].

Daogui's tomb of the Northern Qi dynasty, which was excavated at Majiazhuang in Jinan, on October in 1984, is a stone single chamber tomb. Its murals were distributed on the walls of the entryway, tomb chamber, and roof. A lively tiger like animal face was painted on the screen wall above the entryway. A layer of white plaster was applied on the walls of the tomb chamber and dome roof before painting. Some of the portraits were drafted with reddish brown, while as others were drafted with stick before the plaster fully dried; then drawn by black lines and added reddish brown and red color. Subjects painted on the roof include the Plow, Southern Dipper, Sun, and Moon. On the walls it is painted carts, horses, and attendants. The well preserved murals depict the scene of a local official's daily life[6].

The Dongbaliwa Northern dynasties tomb, which was excavated in the Southern suburb of Jinan, in 1986, is another important mural tomb of this period. Its murals, painted on the eastern, western, and northern wall, were mostly damaged with only the painting on the northern wall well preserved. An eight panels reddish brown screen with triple legs was painted on this wall. Above the screen are flowers and plants. The central four screens were painted a seated person for each. Exposing their necks and feet, they all wear loose robe with wide sleeves. With drinking utensils including pots, plates and wine cups on the side, they are drinking and enjoying themselves. Based on the tomb structure and the burial objects, this tomb was dated to the Northern Qi dynasty[7].

Besides the three tombs mentioned above, murals were also found in the Cui family cemetery at Linzi. Tomb M12, which was buried at the 4th year of the Wuping Era (573CE) in the northern Qi dynasty, has two warriors on both sides of the doorway, same to the discovery from Cui Fen's tomb[8]. The tomb of Jia Sibo at Shouguang was also found seriously damaged paintings on the walls and roof of tomb chamber[9].

The northern dynasties mural tombs in Shandong were only distributed in Jinan, Linzi and adjacent Linqu and Shouguang area. Its paintings were influenced by the Southern dynasties on the technique and themes. Of all five discoveries, four tombs belong to the Northern Qi dynasty except for the damaged Northern Wei tomb. It provides important materials for the study on the social life, customs and traditions, dressing system, and painting art of this period.

Only two Sui mural tombs were discovered in Shandong, the Yingshan tomb M1 and M2 at Yangloucun in Mantongxiang of Jiaxiang. The Yingshan tomb M1, which was excavated in 1976, is the joint burial tomb of Xu Minxing and his wife. This brick single chamber tomb has a passageway in the front. Its murals were distributed on the ceiling, walls of tomb

chamber, and doorway. The stars, Sun, Moon, and Bay Tree with Jade Hare were painted on the eastern, western, southern, and northern section of the ceiling. The walls of the tomb chamber depict the feasting and procession scene. Continuing to use the drawing method of outlining combined with coloring, which is the tradition since the Wei and Jin dynasty, the portraits of this tomb were drawn by iron-wire stroke and added rich colors combining with light colors. Its subjects are also carried forward some features of the Northern dynasties, such as the warriors and door guards on tomb's doors and doorway, the stars on the roof and the screen painting on the main wall. However, some new details were added in this tomb, such as the doorman (Sihun). The procession scene is much detailed. The occupant of Yingshan tomb M2 is Xu Zhifan, father of Xu Minxing. Its murals were damaged[10] .

3. Murals of the Song, Jin, Yuan, and Ming dynasty

Only three Song mural tombs were found in Shandong. The most important one, which is also the only dated Song tomb in Shandong province, buried at the 1st year of the Jianlong Era (960CE), was excavated in the campus of Shandong Polytechnical University (present southern campus of Shandong University), in 1986. Its brick carving tomb chamber has a round plan and a domed roof. The surrounding wall was painted flowers, pillars, bracket sets, doors and windows, tables, chairs, stools, and dye-work tools. All these subjects reflect the rich smack of everyday life[11].

The Hongjialou Song tomb, which was excavated in 1987, is also a brick carving mural tomb. A layer of plaster was applied on the walls except for the ceiling. The murals were mostly damaged with a few flower patterns and red inscriptions left. Based on the construction type and the burial objects, this tomb was dated to the Northern Song dynasty[12].

The burial date of Nülangshan tomb M75 at Zhangqiu is between the late Northern Song dynasty and early Jin dynasty. A layer of white plaster was applied on the wall of tomb chamber and the doors. The painting, mostly damaged, could be identified to include bracket sets, flowers, and rooster[13].

Jin tombs which have well preserved murals include the Yu Yin's tomb at Gaotang, Shentou Jin tomb at Boshan, Jin tomb from the (Jinan) factory of Sino-Japanese Zhaohe Plastic Limited Company at Ganggouzhen in Licheng district, and Baodaojie Jin tomb at Zhangqiu. Beside these, the Nülangshan Jin tombs at Zhangqiu were also found mural traces.

The Yu Yin's tomb, which was excavated at Gaotang in 1979, is a brick tomb with the imitation wooden structure in its single chamber. Six brick columns divide the tomb chamber into seven bays. A layer of white plaster was applied on the brick wall before painting. The wall was decorated with brick lamp stands, colored phony doors, flower windows, and blossom peonies. Procession scenes were painted on both side of the entryway. Murals in tomb chamber mainly depict human portraits accompanying with inscriptions such as "family servant", and "family musician". Separate pictures connect each other properly to form a complete scene. According to the epitaph, the occupant Yu Yin is a Jurchen. He was buried at the 2nd year of the Chengan Era (1197)[14].

The Shentou Jin tomb, which was found in 1990 at Boshan, is a brick single chamber tomb. The tomb is composed of the passageway, entry way, and tomb chamber with a domed roof. Its murals were painted on the walls and ceiling of the tomb chamber. The ceiling was decorated with red auspicious patterns such as peony and lotus. The murals on the walls mainly depict human portraits such as the tomb occupant couple seated face to face, male servants, maids, woman opening a door ajar, the scene of leading a horse, and the racks for clothes. The human portraits were drawn by skilled black lines; their clothes were depicted with red or black lines. The ink inscription shows the date of this tomb: the 2nd year of the Daan Era (1210)[15].

The Baodaojie Jin tomb, which was excavated at Zhangqiu in 2002, has 13 murals in its entryway and front chamber. The murals, partially damaged, mainly depict the scene of daily life. The roof of tomb chamber was decorated with human portraits and filial piety stories[16].

Besides these, murals were also found in Jin tombs at Nülangshan. Most of its murals were damaged with only an ink tiger left[17].

Yuan mural tombs have the most abundant discoveries in Shandong province. Nearly 20 tombs were excavated including

the tomb at Dawu of Linzi[18], Diesel Engine factory in Jinan[19], Daguanzhuang in Ganggou town of Licheng district of Jinan[20], Xingcun[21], Budongcun in Licheng district[22], Qiezhuang in Diaozhen[23], Xijiuwucun in Xushengxiang[24], Nülangshan[25] of Zhangqiu, Guodian[26], Qilu Hotel, Silijie Street, Huaronglu Road in Jinan, Longshanzhen in Zhangqiu, Sanjiancun in Zhangqiu, Xigoutou in Zhangqiu, and Xiaokangcun in Zhangqiu[27] etc. Most of these tombs were distributed in Greater Jinan except for the one found at Dawucun in Linzi.

The common features of these Yuan tombs are: first, most tombs are brick chambers with imitation wooden structure except for a few stone chamber tombs. Second, most tombs are single chamber tomb with round or square plan. Normally a tomb composed of the passageway, door or gatehouse, entryway, and tomb chamber. Third, a layer of white plaster was applied on the brick wall before painting. Fourth, a few subjects of the murals are architectural patterns combined with carved bricks such as towers, bracket sets, gatehouses, and decoration patterns such as flowers, birds, and animals. Most subjects related to people's everyday life, such as the scene of occupant couple seated face to face, feasting, and woman opening a door. These subjects, originated from the Song and Jin dynasty, became the essential subjects of Yuan mural tombs. Another feature of these Yuan tombs is abundant pictures of filial piety stories such as Guo Ju burying his own son, Meng Zong weeping the bamboo, and Wang Xiang lying on ice. Fifth, most murals were drawn by ink lines first; then colored with red, reddish brown, and green. The pictures depict strong decorative effect by the bright colors. The architectural pattern for example, red was used a lot on the white base. Ink lines were used to draw the frame, which made the patterns extremely shining.

The mural tomb at the Diesel Engine factory in Jinan, which was excavated in 1988, is a brick single chamber tomb with imitation wooden structure. Composed of the passageway, door, entryway, and tomb chamber, its well preserved murals were distributed on most walls except for the passageway. A layer of white plaster was applied to the wall before drawing the ink lines. The colors added to the picture include red, yellow, reddish brown, and green. The subjects of murals could be divided into four sections, the architectural patterns, decorative patterns, scenes of everyday life, and historical stories. The imitation wooden structures were all added red, yellow, and green color inside the ink outlines. The decorative patterns mainly include branch peonies and lotus which were painted in red, yellow, and green color. Some flowers were stick into vases. Butterflies, mandarin ducks, and cranes scatter among the flowers, grass, and clouds. The scenes of social life include horse leading, portraits of male servants and maids. The historical stories include many filial pieties such as Guo Ju burying his own son, (Shun's) filial piety moving Heaven, Wang Xiang lying on the ice in search of carp, Mother Meng breaking the loom, Strangling a tiger to save father, Sacrificing son to save nephew, and Meng Zong weeping till the bamboo sprouted.

Both murals of Xingcun brick carving mural tomb and Budongcun stone carving mural tomb depict the daily life of the tomb occupant couple accompanied with decorative patterns. Due to the difference of ethnic customs, the composition styles and decoration patterns of two tombs are different. The murals of Xingcun tomb reflect the features of Han culture: the occupant couple wear Han style dressing, the woman who is opening a door is Han woman. The decoration pattern mainly uses Han style imitation wooden structures. On the Budongcun's side, the dressing of the male occupant and his male servant are nomadic style, which is clearly different from Han style. Instead of a woman opening a door, the person was replaced with a male servant who wears a round wide brim hat. Even the stone carved gablet roof, which was decorated on the eastern, northern, and western wall, was also painted with net pattern background, which is similar to the wall fence of modern yurt. It indicates that the tomb occupant might be a Mongolian.

Five early Ming mural tombs, which were excavated at Nülangshan in Zhangqiu, in 1990, are the representatives of Ming mural tombs in Shandong. These tombs are all brick made with imitation wooden architectural structure. The process of the mural making also inherited the method of the Yuan dynasty: applying a layer of plaster on the wall at first; then drawing the outlines; adding red, reddish brown, and green color at last. The composition of the pictures is simple compared to the gorgeous looking. Tomb M60 for example, it was thoroughly decorated from door to tomb chamber. Architecture components were outlined by ink and colored reddish brown, green, and red. Door's sides were decorated with gold and silver ores, inverted lotus, clouds, and gold ingots. The lintel of the entryway was painted lotus patterns. The roof of the

front chamber was painted large round flower. The walls of the front and rear chambers were decorated with flowers, tent, and silk ribbons. Other tombs such as tomb M14 and M15 have the similar decoration with tomb M60, which reflect the identity of the same tomb group.

To conclude, Shandong has not rich discoveries on mural tombs. The missing link in the Wei, Jin, and Tang dynasty still needs to make up. On the other hand, the distribution of mural tombs is also unequal. Mural tombs of a specific dynasty usually confined in a small area. For example, Han mural tombs were only seen in Jinan and Lake Dongping surrounding area; Northern dynasties mural tombs were only found in Jinan and Linzi area; Yuan mural tombs were mainly distributed in Jinan and surrounding area. However, there are masterpieces in these limited discoveries for each period. The exquisite painting and its rich subjects can compete with the counterparts in other areas. As for the painting skill, the early discoveries in Shandong, especially those of the Northern dynasties, were strongly influenced by the south. Since the Sui dynasty, especially after the Song dynasty, the dynastic inheritance and development is very clear and obvious. Along with the development of the fieldworks of archaeology, more ancient mural tombs are expected to be found, which will help the study of this field in depth.

References

[1] Excavated materials by the Institute of Cultural Relics and Archaeology in Shandong Province.

[2] Yang Zifan. 1954. Ancient painting tomb was found at Houyinshancun in Liangshan of Shandong. Wenwu (Cultural Relics), 3; 1954. Huadong Cultural Relics Work Team made survey and excavation on the painting Han tomb at Liangshan in Shandong. Wenwu, 10; Guan Tianxiang, Ji Gang. 1955. Liangshan Han tomb. Cultural Relics Reference Material 5.

[3] Cultural Relics Department of the Cultural Bureau in Jinan. 1989. the painting tomb with curved stone at Qinglongshan in Jinan of Shandong. kaogu (Archaeology) 11.

[4] Nanjing Museum. 1960. Southern dynasties tomb at Xishanqiao in Nanjing and its brick carved murals.Wenwu, (8,9 joint issue); Luo Zongzhen. 1963. Excavation of the Southern dynasties tomb at Youfangcun in Xishanqiao of Nanjing. kaogu 6.

[5] Institute of Cultural Relics and Archaeology in Shandong Province, Linqu Museum. 2002. Northern Qi Cui Fen's mural tomb at Linqu in Shandong. Wenwu 4.

[6] Jinan Museum. 1985. the Northern Qi tomb at Majiazhuang in Jinan. Cultural Relics 10.

[7] Institute of Cultural Relics and Archaeology in Shandong Province. 1989. Northern dynasty mural tomb at Dongbaliwa in Jinan. Wenwu 4.

[8] Institute of Cultural Relics and Archaeology in Shandong Province. 1984. Cui family tombs of the Northern dynasties at Linzi. Acta Archaeologica Sinica 2.

[9] Shouguang Museum. 1992. Jia Sibo's tomb of the Northern Wei dynasty at Shouguang in Shandong. Wenwu 8.

[10] Shandong Museum. 1981. Brief excavation report of the Sui tomb M1 at Yingshan in Jiaxiang of Shandong: the first discovery of the Sui tomb mural. Wenwu 4; Management Institute of Cultural Relics in Jiaxiang. 1987. Brief report on the excavation of the Sui tomb M2 at Yingshan in Jiaxiang of Shandong. Wenwu 11.

[11] Jinan Museum. 2008. Institute of Archaeology in Jinan, Brick carved mural tombs of the Song and Jin dynasty at Jinan. Cultural Relics 8.

[12][21][22] Liu Shanyi. 2005.Wang Huiming, Song and Yuan mural tombs at Lichengqu in Jinan. Wenwu 11.

[13][17][25] Xiuhui Archaeological Branch Team on Ji-Qing Highway Construction. 1993. the excavation of the Song, Jin, Yuan, and Ming mural tombs at Nülangshan in Zhangqiu. Collection of Archaeological Report on Zhangqiu Section of the Ji-Qing Highway Construction. Jinan: Qilu Press.

[14] Liaocheng Regional Museum. 1982. Brief excavation report on Yu Yin's tomb of the Jin dynasty at Gaotang in

Shandong. Wenwu 1.

[15] Archaeological excavation materials at Boshan district in Zibo, Shandong. Preserved in the Management Institute of Cultural Relics in Boshan District.

[16][27] Archaeological excavation material of the Institute of Archaeology in Jinan.

[18] Institute of Archaeology in Shandong Province, Chinese Archaeology Study Center of Peking University. 2005. Brife excavation report of the Yuan tomb at Dawucun in Linzi of Shandong. Wenwu 11.

[19] Cultural Relics Department of Cultural Bureau in Jinan. 1992. Brick curved mural tomb at the Diesel Engine factory of Jinan. Wenwu 2.

[20][23][24][26] Cultural Bureau in Jinan. The Zhangqiu Museum. 1992. Brick Curved mural tombs found in recent years in Jinan. Wenwu 2.

目 录 CONTENTS

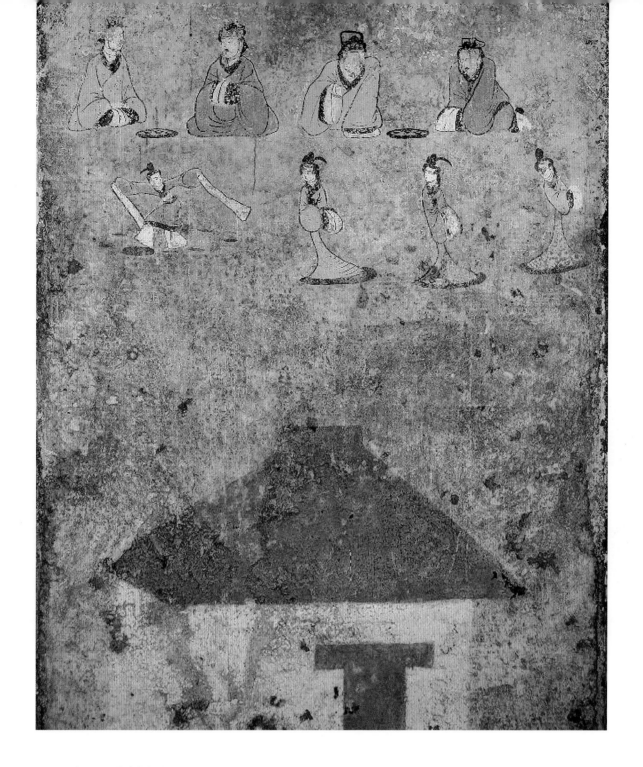

1.观舞、建筑图

新—东汉初（9~88年）

高150、宽99厘米

2007年山东省东平县物资局1号墓出土。现存于山东博物馆。

墓向270°。位于前室南壁上部。画面分上、下层。上层绘观舞图，四人盘腿而坐观赏舞蹈，四人正表演舞蹈。下层绘一建筑。建筑呈方形，四面坡顶，房门在正中，仅绘出轮廓。

（撰文：李振光　摄影：张瑞泉）

Dance Watching, Architecture

Xin to Early Eastern Han (9-88 CE)

Height 150 cm; Width 99 cm

Unearthed from tomb M1 at the construction site of Goods and Materials Bureau in Dongpingxian, Shandong, in 2007. Preserved in the Shandong Museum.

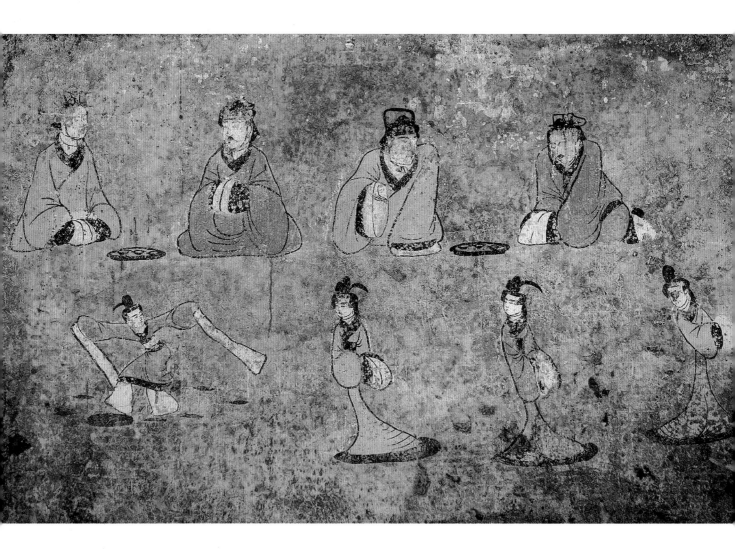

2.观舞图

新—东汉初（9～88年）

高60、宽99厘米

2007年山东省东平县物资局1号墓出土。现存于山东博物馆。

墓向270°。位于前室南壁上部。画面人物分上下两排，上排四人盘腿而坐，正观赏舞蹈，人物前面地面上左右各置一盘，盘内置放耳杯。下排四人作舞蹈状，左侧一女子长袖起舞，右侧三女身着曳地长裙，作细步曼舞状。

（撰文、摄影：李振光）

Dance Watching

Xin to Early Eastern Han (9-88 CE)

Height 60 cm; Width 99 cm

Unearthed from tomb M1 at the construction site of Goods and Materials Bureau in Dongpingxian, Shandong, in 2007. Preserved in the Shandong Museum.

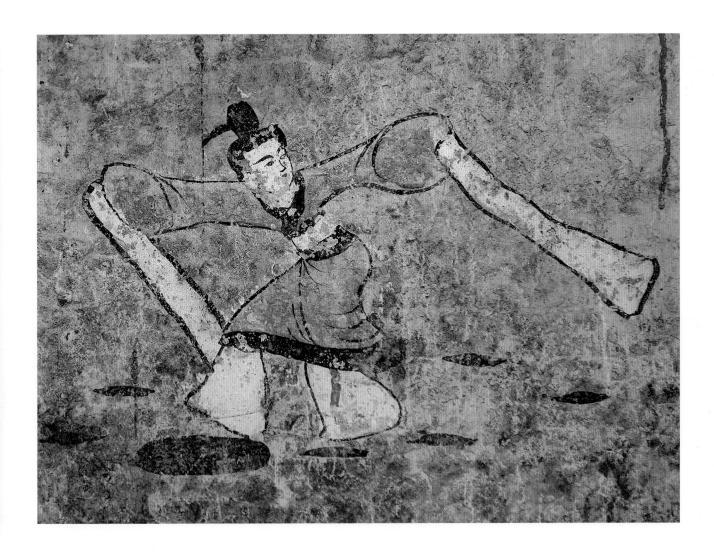

3. 观舞图（局部）

新—东汉初（9～88年）

高20、宽28厘米。

2007年山东省东平县物资局1号墓出土。现存于山东博物馆。

墓向270°。位于前室南壁上层，为舞蹈画面的局部。舞伎头梳高髻，面色清秀，双臂挥舞，长袖飘逸，回首顾盼，婀娜多姿。

（撰文：李振光　摄影：张瑞泉）

Dance Watching (Detail)

Xin to Early Eastern Han (9-88 CE)

Height 20 cm; Width 28 cm

Unearthed from tomb M1 at the construction site of Goods and Materials Bureau in Dongpingxian, Shandong, in 2007. Preserved in the Shandong Museum.

4. 人物图（一）

新—东汉初（9～88年）

高37.5、宽155厘米

2007年山东省东平县物资局1号墓出土。现存于山东博物馆。

墓向270°。位于前室南侧门楣上。画面以白粉为地，彩绘六个人物，神态各异，栩栩如生。

（撰文：李振光　摄影：张瑞泉）

Figures (1)

Xin to Early Eastern Han (9-88 CE)

Height 37.5 cm; Width 155 cm

Unearthed from tomb M1 at the construction site of Goods and Materials Bureau in Dongpingxian, Shandong, in 2007. Preserved in the Shandong Museum.

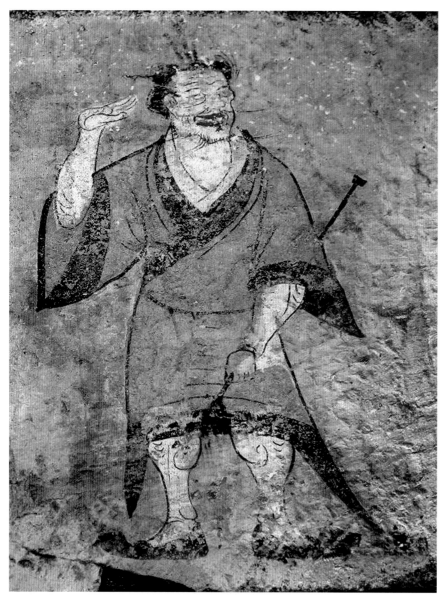

5. 人物图（一）
（局部一）

新—东汉初（9～88年）

高37.5、宽28.5厘米

2007年山东省东平县物资局1号墓出土。现存于山东博物馆。

墓向270°。位于前室南侧门楣上。为画面六人中的右起第二人。人物头梳发髻，黑发较乱，满脸皱纹，络腮胡须，嘴唇涂成鲜红色。身着宽袖长袍，左手下垂，执一长杆状物，右手高举，掌心向上。赤臂露膊，两腿分开，赤足蹬黑履。

（撰文：李振光　摄影：张瑞泉）

Figures (1) (Detail 1)

Xin to Early Eastern Han (9-88 CE)

Height 37.5 cm; Width 28.5 cm

Unearthed from tomb M1 at the construction site of Goods and Materials Bureau in Dongpingxian, Shandong, in 2007. Preserved in the Shandong Museum.

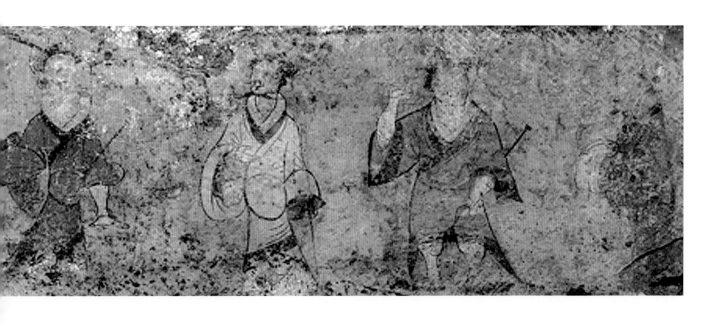

6.人物图（一）（局部二）

新—东汉初（9～88年）

高37.5、宽21.9厘米

2007年山东省东平县物资局1号墓出土。现存于山东博物馆。

墓向270°。位于前室南侧门楣上。为画面六人中的右起第三人。画中人物头梳发髻，黑发上翘，胡须横飘，身着宽袖长袍，左手下垂，执一长杆，右手端于胸前，侧目右视，神情昂然。

（撰文：李振光　摄影：张瑞泉）

Figures (1) (Detail 2)

Xin to Early Eastern Han (9-88 CE)

Height 37.5 cm; Width 21.9 cm

Unearthed from tomb M1 at the construction site of Goods and Materials Bureau in Dongpingxian, Shandong, in 2007. Preserved in the Shandong Museum.

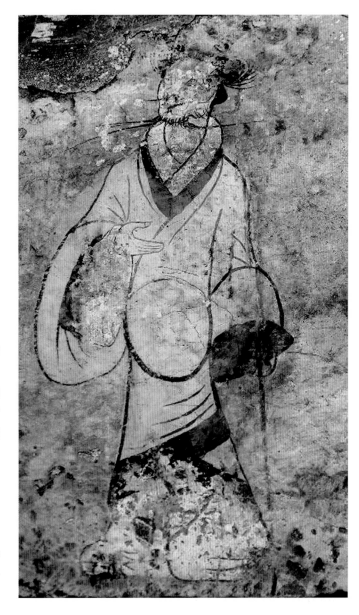

7. 人物图（二）

新—东汉初（9～88年）

高37.5、宽155厘米

2007年山东省东平县物资局1号墓出土。现存于山东博物馆。墓向270°。位于前室北侧门楣上。画面以白粉为地，彩绘六个人物，或跪或立，神态各异，形象逼真。

（撰文：李振光　摄影：张瑞泉）

Figures (2)

Xin to Early Eastern Han (9-88 CE)

Height 37.5 cm; Width 155 cm

Unearthed from tomb M1 at the construction site of Goods and Materials Bureau in Dongpingxian, Shandong, in 2007. Preserved in the Shandong Museum.

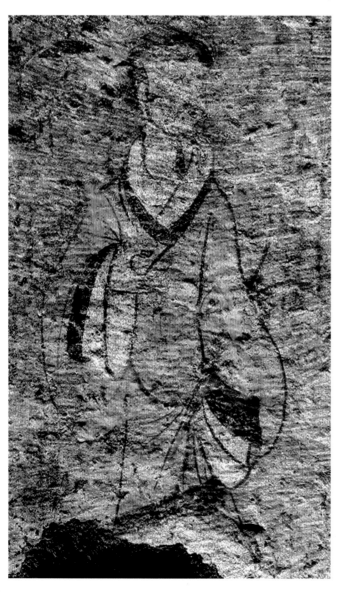

8. 人物图（二）（局部一）

新—东汉初（9～88年）

高37.5、宽22.2厘米

2007年山东省东平县物资局1号墓出土。现存于山东博物馆。

墓向270°。位于前室北侧门楣上，为画面六人中的左起第一人。人物呈站立状，头发后飘，身着绿色宽袖长袍，右手平端于胸前，左手下垂，执一长杆状物，轻提衣角，侧面左视。

（撰文：李振光　摄影：张瑞泉）

Figures (2) (Detail 1)

Xin to Early Eastern Han (9-88 CE)

Height 37.5 cm; Width 22.2 cm

Unearthed from tomb M1 at the construction site of Goods and Materials Bureau in Dongpingxian, Shandong, in 2007. Preserved in the Shandong Museum.

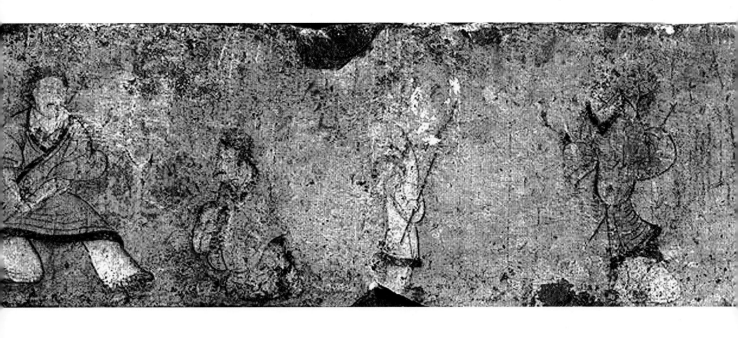

9.人物图（二）
（局部二）

新—东汉初（9～88年）

高37.5、宽30厘米

2007年山东省东平县物资局1号墓
出土。现存于山东博物馆。

墓向270°。位于前室北侧门楣
上，为画面六人中的左起第三人。
人物头发凌乱，面部漫漶不清，嘴
唇涂朱。上身着绿色宽袖长袍，下
穿白色长裤，双手交于胸前，背插
双杆状物，右腿侧蹲，侧面左视。

（撰文：李振光　摄影：张瑞泉）

Figures (2) (Detail 2)

Xin to Early Eastern Han (9-88 CE)

Height 37.5 cm; Width 30 cm

Unearthed from tomb M1 at the
construction site of Goods and
Materials Bureau in Dongpingxian,
Shandong, in 2007. Preserved in the
Shandong Museum.

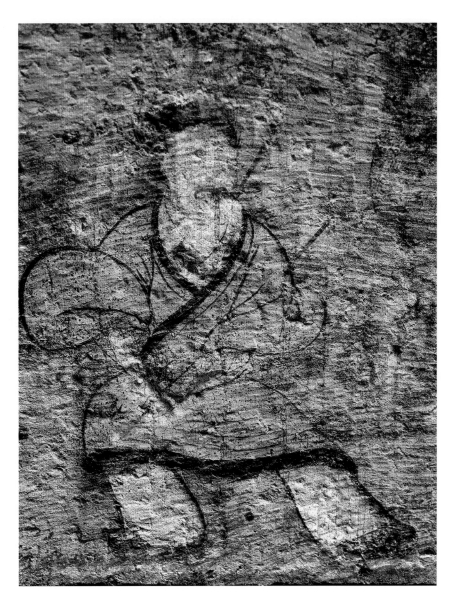

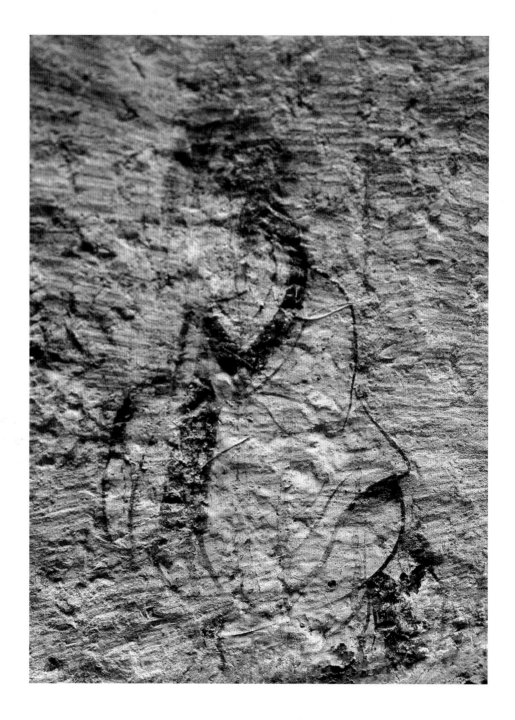

10. 人物图（二）（局部三）

新—东汉初（9～88年）

高37.5、宽30厘米

2007年山东省东平县物资局1号墓出土。现存于山东博物馆。

墓向270°。位于前室北侧门楣上，为画面六人中的左起第四人。人物头戴高冠，身着宽袖灰袍，面部神情自然，八字胡须，嘴唇涂朱。双腿跪地，两手抄于胸前，低头作禀告状。

（撰文：李振光　摄影：张瑞泉）

Figures (2) (Detail 3)

Xin to Early Eastern Han (9-88 CE)

Height 37.5 cm; Width 30 cm

Unearthed from tomb M1 at the construction site of Goods and Materials Bureau in Dongpingxian, Shandong, in 2007. Preserved in the Shandong Museum.

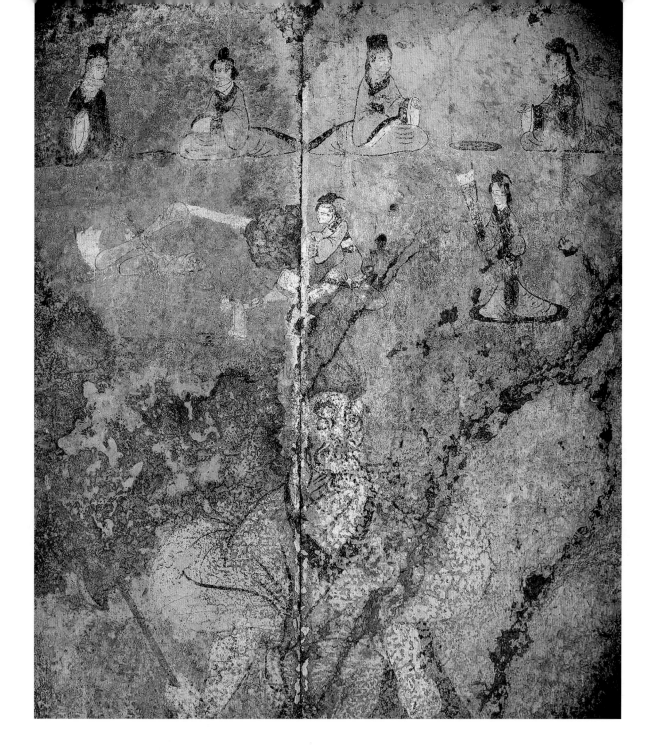

11.人物图（三）

新—东汉初（9～88年）

高150、宽77厘米

2007年山东省东平县物资局1号墓出土。现存于山东博物馆。

墓向270°。位于前室西壁南侧。画面分上下二层，上层绘四个人物两两对坐，正观赏三人舞蹈；下层绘一面目凶恶、手中执斧的神人。

（撰文：李振光 摄影：张瑞泉）

Figures (3)

Xin to Early Eastern Han (9-88 CE)

Height 150 cm; Width 77 cm

Unearthed from tomb M1 at the construction site of Goods and Materials Bureau in Dongpingxian, Shandong, in 2007. Preserved in the Shandong Museum.

12. 人物图（三）（局部一）

新—东汉初（9~88年）

高19、宽77厘米

2007年山东省东平县物资局1号墓出土。现存于山东博物馆。

墓向270°。位于前室西壁南侧上层，为观舞的两对人物。四人两两对坐，对坐的两人为一男一女，各着宽袖长袍，长袍颜色各不相同。男者戴冠，女人头梳高髻，中间各放置一盘，上置耳杯。

（撰文：李振光　摄影：张瑞泉）

Figures (3) (Detail 1)

Xin to Early Eastern Han (9-88 CE)

Height 19 cm; Width 77 cm

Unearthed from tomb M1 at the construction site of Goods and Materials Bureau in Dongpingxian, Shandong, in 2007. Preserved in the Shandong Museum.

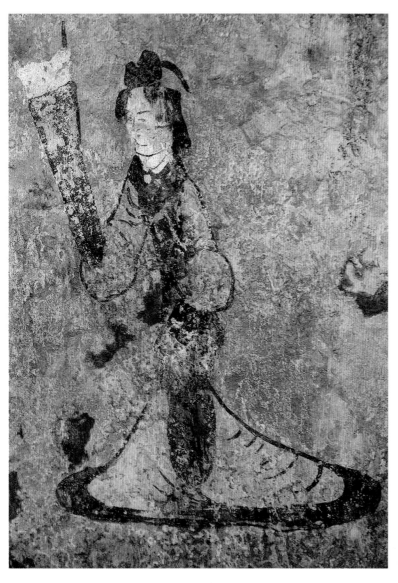

13. 人物图（三）（局部二）

新—东汉初（9~88年）

高30、宽23.6厘米

2007年山东省东平县物资局1号墓出土。现存于山东博物馆。

墓向270°。位于墓葬前室西壁南侧上层右侧，为三名舞伎中的右起第一人。舞女头梳高髻，身着蓝色长裙，长袖挥舞，裙摆曳地，舞姿翩翩。

（撰文：李振光　摄影：张瑞泉）

Figures (3) (Detail 2)

Xin to Early Eastern Han (9-88 CE)

Height 30 cm; Width 23.6 cm

Unearthed from tomb M1 at the construction site of Goods and Materials Bureau in Dongpingxian, Shandong, in 2007. Preserved in the Shandong Museum.

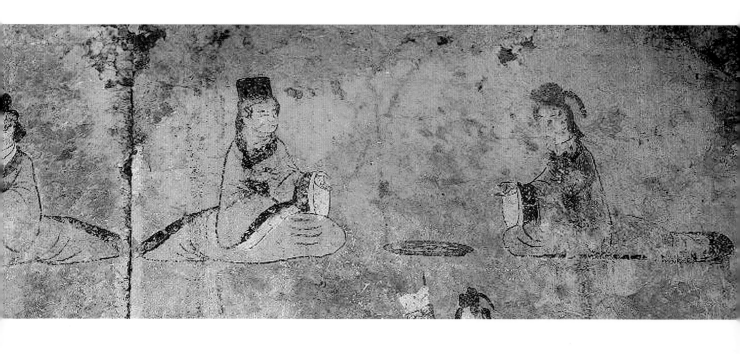

14. 人物图（三）
（局部三）

新—东汉初（9～88年）

高60、宽65厘米

2007年山东省东平县物资局1号墓出土。现存于山东博物馆。

墓向270°。位于前室西壁南侧下层。神人，面目凶恶，须发飞扬，双目圆睁，上身穿绿衣，下着黑裤，右手执一利斧。

（撰文：李振光 摄影：张瑞泉）

Figures (3) (Detail 3)

Xin to Early Eastern Han (9-88 CE)

Height 60 cm; Width 65 cm

Unearthed from tomb M1 at the construction site of Goods and Materials Bureau in Dongpingxian, Shandong, in 2007. Preserved in the Shandong Museum.

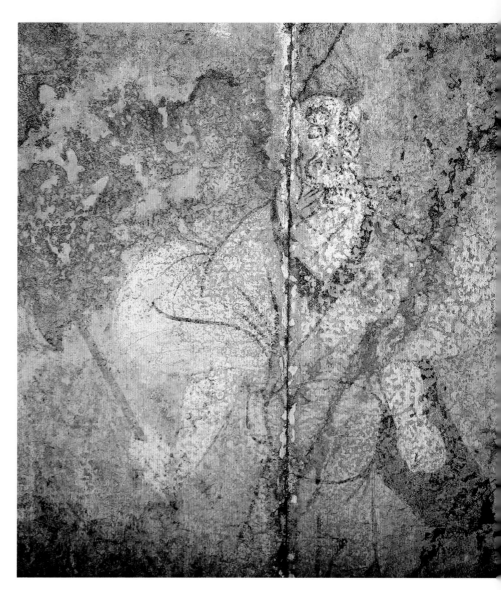

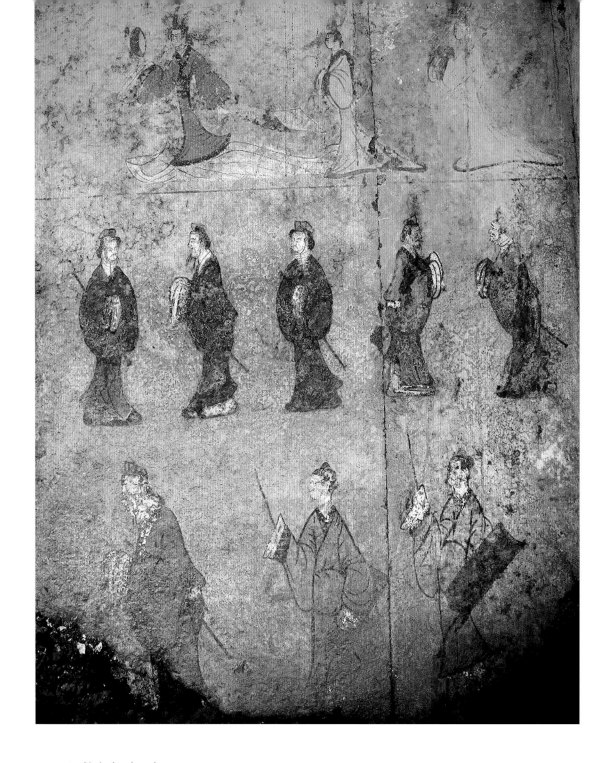

15. 人物图（四）

新—东汉初（9～88年）

高115、宽88厘米

2007年山东省东平县物资局1号墓出土。现存于山东博物馆。

墓向270°。位于前室西壁北侧。人物，分上、中、下三层。上、下层各绘三人，中层绘五人。

<div align="right">（撰文：李振光　摄影：张瑞泉）</div>

Figures (4)

Xin to Early Eastern Han (9-88 CE)

Height 115 cm; Width 88 cm

Unearthed from tomb M1 at the construction site of Goods and Materials Bureau in Dongpingxian, Shandong, in 2007. Preserved in the Shandong Museum.

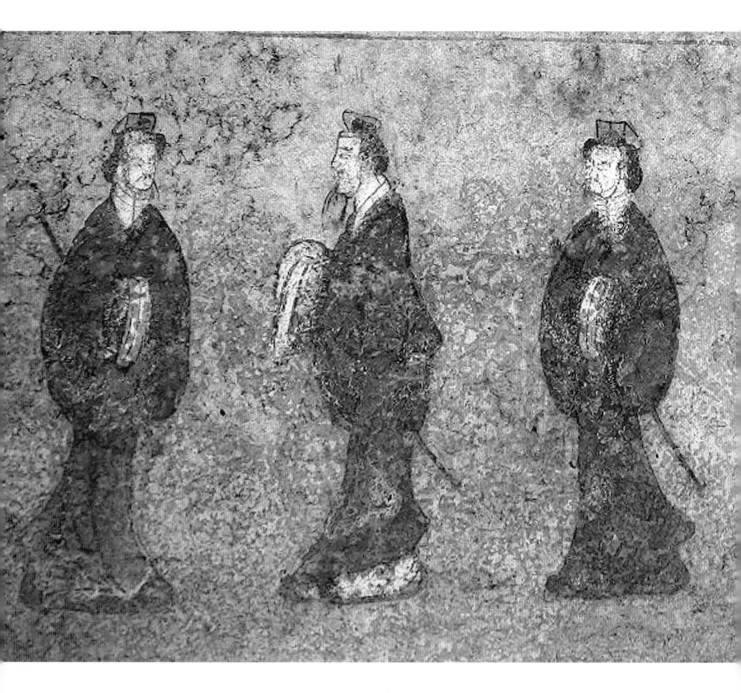

16. 人物图（四）（局部一）

新—东汉初（9～88年）

高40、宽51厘米。

2007年山东省东平县物资局1号墓出土。现存于山东博物馆。

墓向270°。位于前室西壁北侧中层，画面为左侧局部。彩绘站立男子三人，皆身穿灰色长袍，头戴高冠。左侧一人身微侧，双手抄于腹部，怀中抱一物，背后背一长剑；中间一人双手拱于前，斜挎长剑，拜见前者；右侧一人面左而立，双手抄于腹部，斜挎长剑。

（撰文：李振光　摄影：张瑞泉）

Figures (4) (Detail 1)

Xin to Early Eastern Han (9-88 CE)

Height 40 cm; Width 51 cm

Unearthed from tomb M1 at the construction site of Goods and Materials Bureau in Dongpingxian, Shandong, in 2007. Preserved in the Shandong Museum.

17.人物图（四）（局部二）

新—东汉初（9~88年）

高33、宽79厘米

2007年山东省东平县物资局1号墓出土。现存于山东博物馆。

墓向270°。位于前室西壁北侧上层。彩绘人物三人。左侧绘一妇女，头梳高髻，身穿蓝色长裙，长袖飘逸；右手持一镜状物，似对镜照面；中间一人穿灰衣，长袍曳地，双手抄于前，肩后背一包袱；右侧一人穿绿色长袍，作拱手相送状。

（撰文：李振光　摄影：张瑞泉）

Figures (4) (Detail 2)

Xin to Early Eastern Han (9-88 CE)

Height 33 cm; Width 79 cm

Unearthed from tomb M1 at the construction site of Goods and Materials Bureau in Dongpingxian, Shandong, in 2007. Preserved in the Shandong Museum.

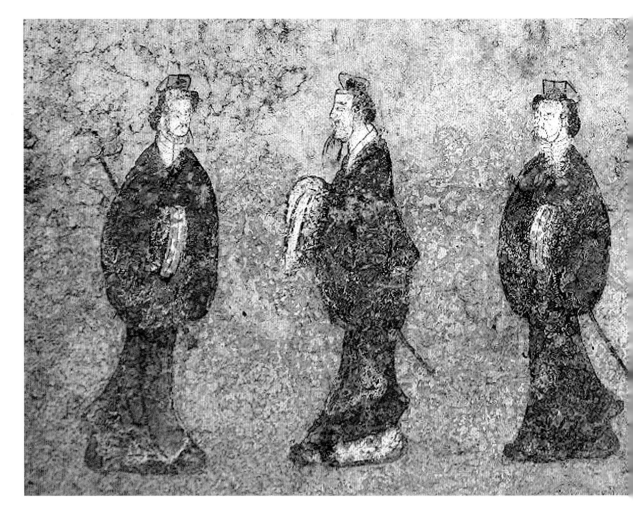

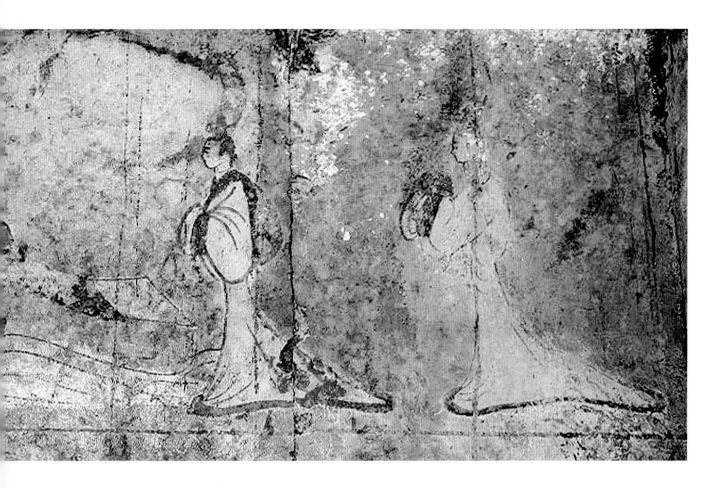

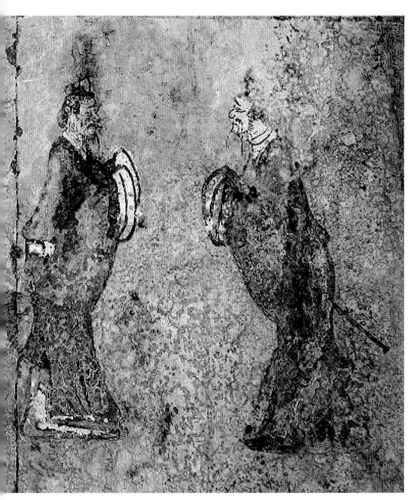

18. 人物图（四）（局部三）

新—东汉初（9～88年）

高40、宽88厘米

2007年山东省东平县物资局1号墓出土。现存于山东博物馆。

墓向270°。位于前室西壁北侧中层。彩绘男子五人，皆身穿灰色长袍，头戴高冠。中间一人双手抄于前，斜挎长剑，侧面而视；左侧两人，一人正面而立，双手抄于胸前，后倒佩长剑，一人侧面而立，拜见前者；右侧二人对面而立，作对揖状。

（撰文：李振光　摄影：张瑞泉）

Figures (4) (Detail 3)

Xin to Early Eastern Han (9-88 CE)

Height 40 cm, Width 88 cm

Unearthed from tomb M1 at the construction site of Goods and Materials Bureau in Dongpingxian, Shandong, in 2007. Preserved in the Shandong Museum.

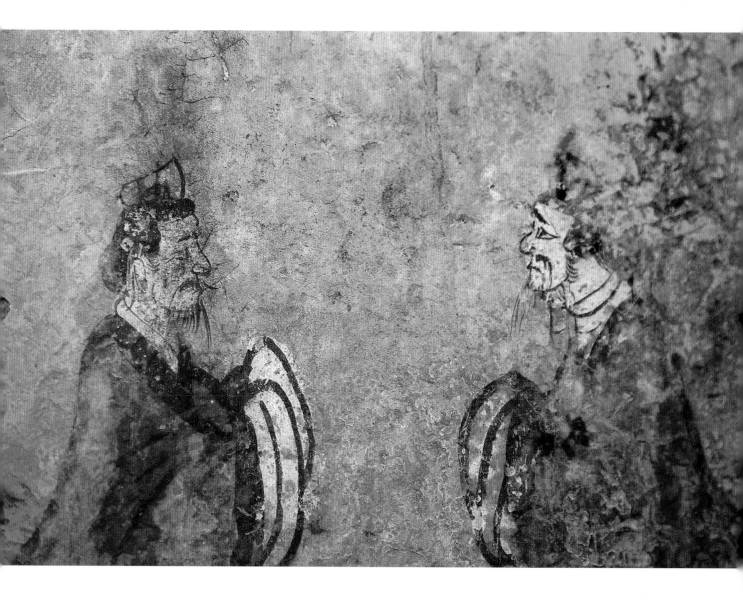

19．人物图（四）（局部四）

新—东汉初（9～88年）

高约18、宽约30厘米

2007年山东省东平县物资局1号墓出土。现存于山东博物馆。

墓向270°。位于前室西壁北侧中层，画面为右侧人物像局部。彩绘男子二人，对面拱手而立，躬身作对拜状。人物面部眉须清晰，神态栩栩如生。

（撰文：李振光　摄影：张瑞泉）

Figures (4) (Detail 4)

Xin to Early Eastern Han (9-88 CE)

Height ca. 18 cm; Width ca. 30 cm

Unearthed from tomb M1 at the construction site of Goods and Materials Bureau in Dongpingxian, Shandong, in 2007. Preserved in the Shandong Museum.

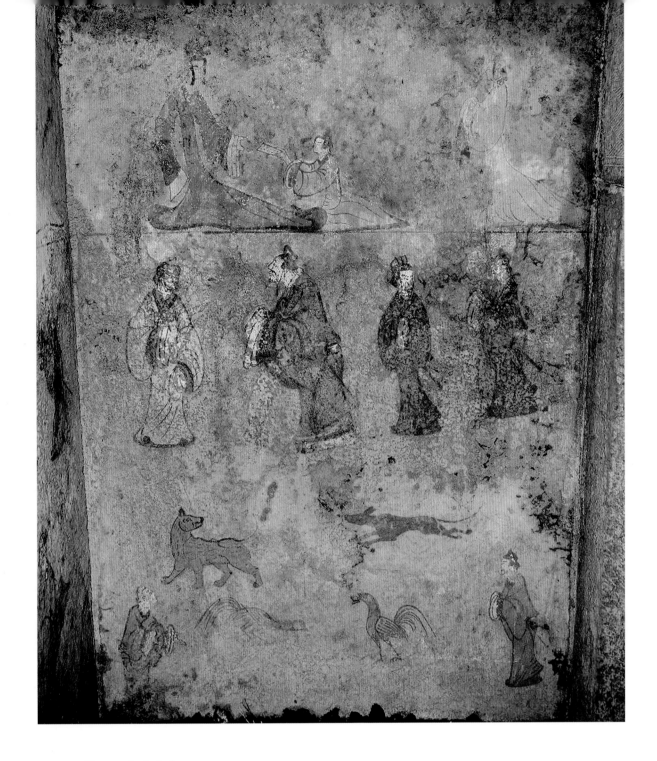

20.人物、鸡犬图

新—东汉初（9～88年）

高150、宽105厘米

2007年山东省东平县物资局1号墓出土。现存于山东博物馆。

墓向270°。位于前室北壁。画面在白粉地上又施以红彩为地，画面分四层。自上而下，第一层绘人物三人；第二层绘人物四人；第三层绘狗两只；第四层绘斗鸡一对，左侧绘一老妪，左手前伸作喂食状，右侧立一男子观赏。

<div align="right">（撰文：李振光　摄影：张瑞泉）</div>

People, Chickens and Dogs

Xin to Early Eastern Han (9-88 CE)

Height 150 cm; Width 105 cm

Unearthed from tomb M1 at the construction site of Goods and Materials Bureau in Dongpingxian, Shandong, in 2007. Preserved in the Shandong Museum.

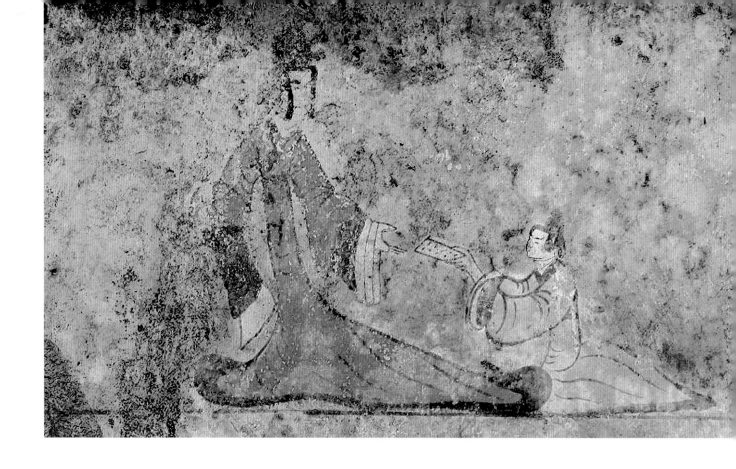

▲ 21. 人物、鸡犬图（局部一）

新—东汉初（9~88年）

高42、宽101厘米

2007年山东省东平县物资局1号墓出土。现存于山东博物馆。

墓向270°。位于前室北壁上层。画面绘人物三人，左侧绘一妇人，头梳高髻，长发垂于脸旁，身穿蓝色长裙，右手掩于长袖内，左手接物；中间绘一着灰衣人物，双膝跪地面向左侧妇人，双手呈物作恭献状；右侧站立一女子，身穿绿色长裙，拱手面左而立。

（撰文：李振光　摄影：张瑞泉）

Humans, Chickens, and Dogs (Detail 1)

Xin to Early Eastern Han (9-88 CE)

Height 42 cm; Width 101 cm

Unearthed from tomb M1 at the construction site of Goods and Materials Bureau in Dongpingxian, Shandong, in 2007. Preserved in the Shandong Museum.

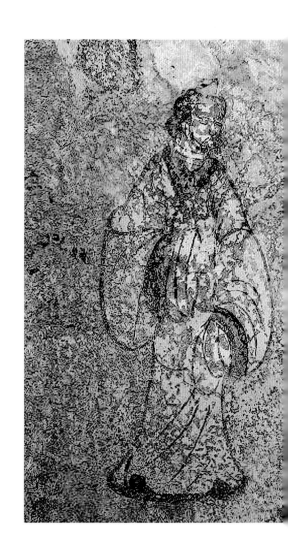

▼22.人物、鸡犬图（局部二）

新—东汉初（9～88年）

高48、宽104厘米

2007年山东省东平县物资局1号墓出土。现存于山东博物馆。

墓向270°。位于前室北壁上部，为第二层画面。画面绘人物四人，左侧一人着绿袍，右手横于胸前，左手下垂；其右侧绘一穿灰袍男子，拱手于胸前作拜谒状；右侧二人身材较矮小，亦作拱手拜谒状。

（撰文：李振光　摄影：张瑞泉）

Humans, Chickens and Dogs (Detail 2)

Xin to Early Eastern Han (9-88 CE)

Height 48 cm; Width 104 cm

Unearthed from tomb M1 at the construction site of Goods and Materials Bureau in Dongpingxian, Shandong, in 2007. Preserved in the Shandong Museum.

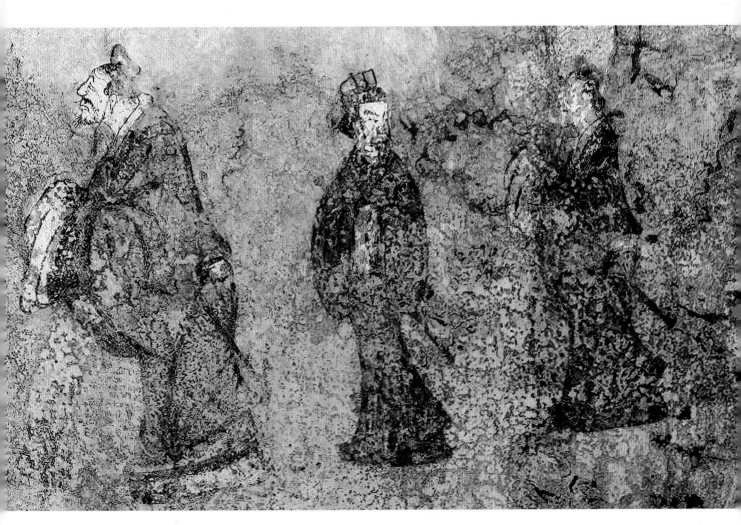

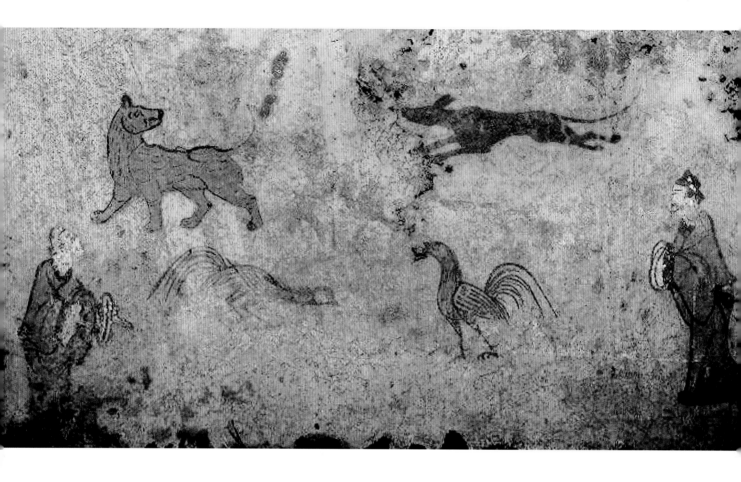

23. 人物、鸡犬图（局部三）

新—东汉初（9~88年）

高55、宽105厘米

2007年山东省东平县物资局1号墓出土。现存于山东博物馆。

墓向270°。位于前室北壁下部，为第三层、第四层画面。第三层绘狗两只，左侧一只回首观望，右侧一只奔跑追逐。第四层左侧绘一老妪，左手前伸作喂食状；右侧绘一男子高冠灰袍，面左侧立作观赏状；中间绘斗鸡两只，一只双腿蜷曲，头颈平伸作欲搏状，另一只昂首挺立，警惕注视对方。

（撰文：李振光　摄影：张瑞泉）

People, Chickens and Dogs (Detail 3)

Xin to Early Eastern Han (9-88 CE)

Height 55 cm; Width 105 cm

Unearthed from tomb M1 at the construction site of Goods and Materials Bureau in Dongpingxian, Shandong, in 2007. Preserved in the Shandong Museum.

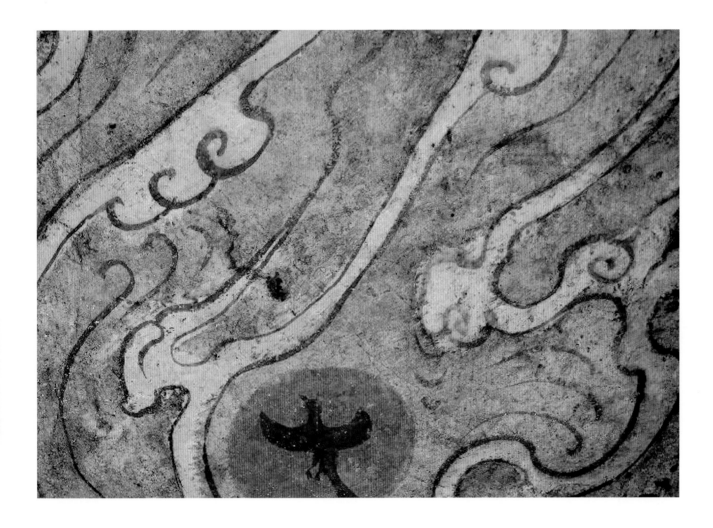

24.金乌图

新—东汉初（9～88年）

直径约21厘米

2007年山东省东平县物资局1号墓出土。现存于山东博物馆。

墓向270°。位于前室顶部壁画局部，以朱色绘一太阳，内以黑色绘金乌一只，周围为云气纹。

（撰文：李振光　摄影：张瑞泉）

Golden Crow

Xin to Early Eastern Han (9-88 CE)

Diameter ca. 21 cm

Unearthed from tomb M1 at the construction site of Goods and Materials Bureau in Dongpingxian, Shandong, in 2007. Preserved in the Shandong Museum.

25.人物、白虎图

新—东汉初（9~88年）

高40、宽95厘米

2007年山东省东平县物资局13号墓出土。现存于山东博物馆。
墓向270°。位于北侧回廊前门楣上。画面在白粉地上用墨线勾勒人物、白虎。人物在左侧，盘腿而坐，左手按于腿部，右手横举；右侧为人骑白虎，白虎匍匐于地，昂头张嘴，尾巴后翘，上骑一人漫漶不清，似双臂上举，作挥舞状。

（撰文：李振光　摄影：李振光、王泽冰）

Human Portrait, White Tiger

Xin to Early Eastern Han (9-88 CE)

Height 40 cm; Width 95 cm

Unearthed from tomb M13 at the construction site of Goods and Materials Bureau in Dongpingxian, Shandong, in 2007. Preserved in the Shandong Museum.

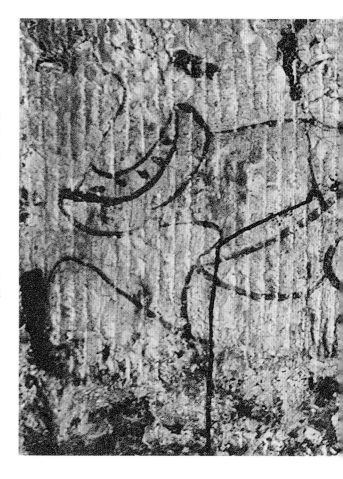

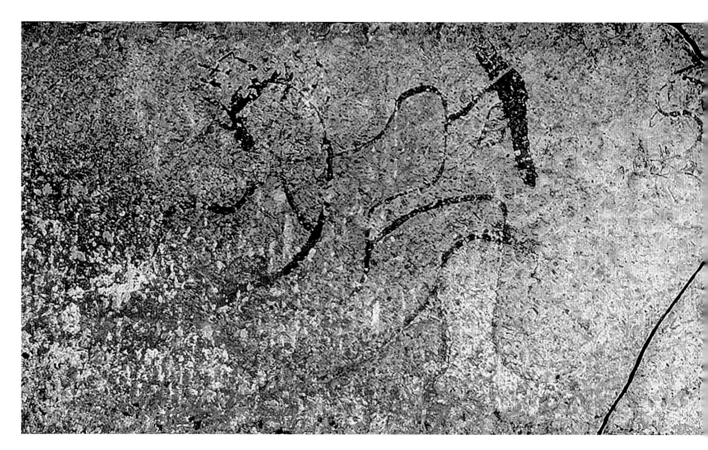

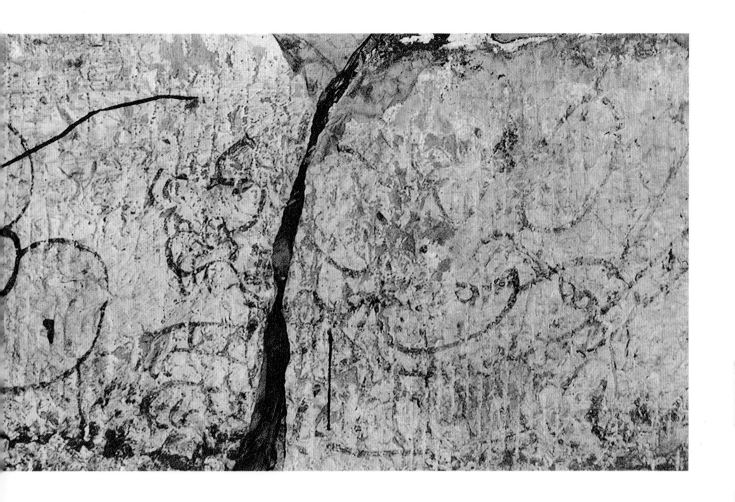

26. 斗虎图

新—东汉初（9～88年）

高40、宽134厘米

2007年山东省东平县物资局13号墓出土。现存于山东博物馆。

墓向270°。位于北侧墓室门楣上。画面在白粉地上用墨线勾勒斗虎图像。左侧绘一人，头梳发髻，左手执钩镶，右手持剑，左腿弓，右腿斜蹬，作与虎格斗状；右侧绘一虎，虎头高昂，虎嘴大张，对人咆哮。

（撰文、摄影：李振光）

Tiger Fighting Scene

Xin to Early Eastern Han (9-88 CE)

Height 40 cm; Width 134 cm

Unearthed from tomb M13 at the construction site of Goods and Materials Bureau in Dongpingxian, Shandong, in 2007. Preserved in the Shandong Museum.

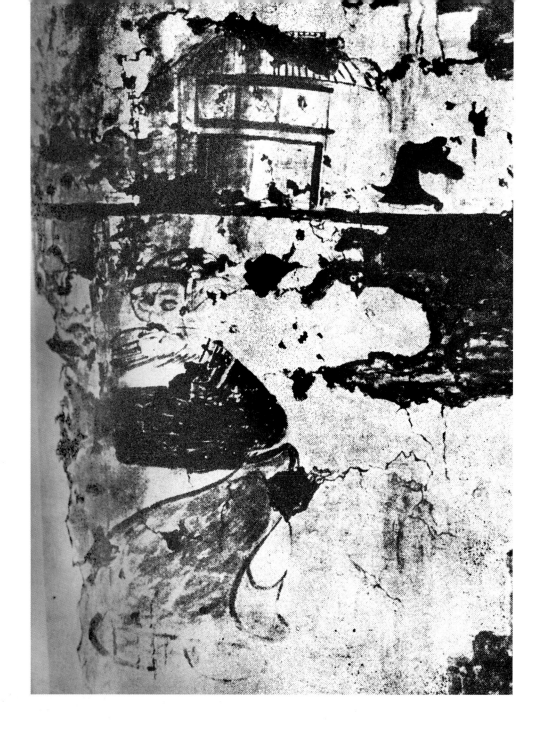

27. 都亭人物图（摹本）

东汉（25～220年）

1953年山东省梁山县后银山东汉墓出土。原址保存。

墓向南。位于墓室南壁，上部绘一座题"都亭"的两层楼房，上层三间，每间坐着一个穿白衣有胡须的人。下层是以着红帽作开门状的人。楼房右侧是一着黑服、捧红色盾作打躬状的人。左旁为题有"曲成侯驿"的人，在这人的帽上系有一绳，被题有"□所□"的人牵着。下部绘一老人，题名"士"，老人是壁画人物像中最大的一个，高约1米。其余人物像高10～20厘米。

<div align="right">（撰文：引自《文物参考资料》1955年第5期　摄影：不详）</div>

Capital Pavilion and Figure (Replica)

Eastern Han (25-220 CE)

Unearthed from Houyinshan Eastern Han tomb at Liangshanxian, Shandong, in 1953. Preserved on the original site.

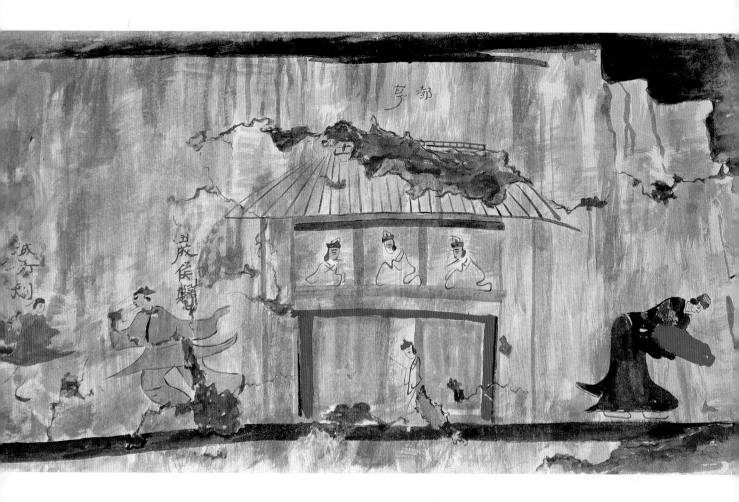

28.都亭人物图（局部一）（摹本）

东汉（25～220年）

高43、宽89厘米

1953年山东省梁山县后银山东汉墓出土。原址保存。

墓向南。位于前室南壁西侧上层。图像正中绘一两层楼阁，楼阁顶部题名"都亭"，楼上有三个穿白衣的人物，楼下绘一头戴红帽的守门人物。楼阁左侧绘着红衣的人物两人，分别题名"曲成侯驿"、"□所□"；楼阁右侧绘一着黑衣、捧盾作打躬状的人物。

（临摹：山东博物馆提供，临摹者不详　撰文、摄影：郑同修）

Capital Pavilion and Humans Portrait (Detail 1) (Replica)

Eastern Han (25-220 CE)

Height 43 cm; Width 89 cm

Unearthed from Houyinshan Eastern Han tomb at Liangshanxian, Shandong, in 1953. Preserved on the original site.

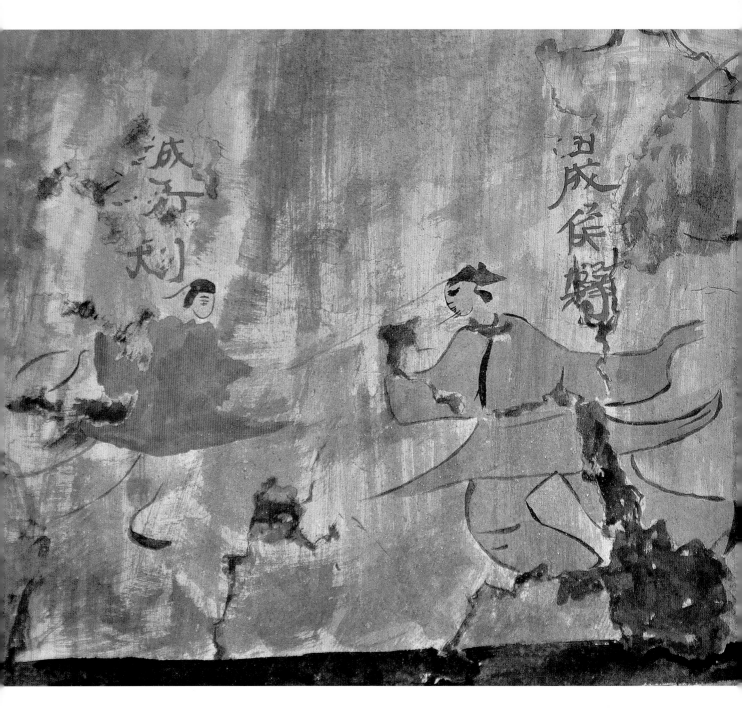

29.都亭人物图（局部二）（摹本）

东汉（25～220年）

高20、宽31厘米

1953年山东省梁山县后银山东汉墓出土。原址保存。

墓向南。位于墓前室南壁西侧上层。所绘人物二人皆着红衣，面相对，分别题名"曲成侯驿"、"□所□"。人物衣袂飘逸，似作舞蹈状。

<div align="right">（临摹：山东博物馆提供，临摹者不详　撰文、摄影：郑同修）</div>

Capital Pavilion and Humans Portrait (Detail 2) (Replica)

Eastern Han (25-220 CE)

Height 20 cm; Width 31 cm

Unearthed from Houyinshan Eastern Han tomb at Liangshanxian, Shandong, in 1953. Preserved on the original site.

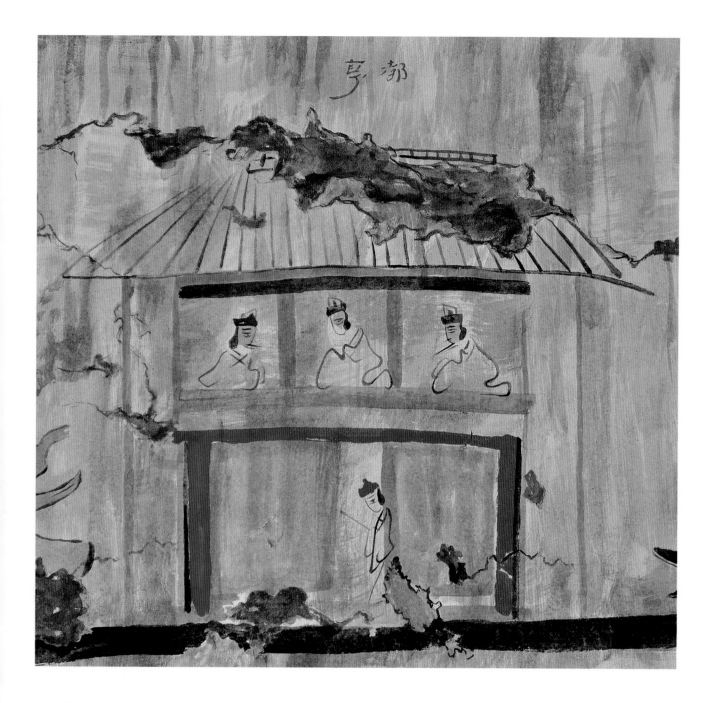

30. 都亭人物图（局部三）（摹本）

东汉（25～220年）

高37、宽31厘米

1953年山东省梁山县后银山东汉墓出土。原址保存。

墓向南。位于墓前室南壁西侧上层。画面为一两层楼阁，楼阁上部题名"都亭"。楼上绘三个穿白衣的人物，其中左侧一人端坐，右侧二人皆面向左侧人物作跪拜状。楼下绘一头戴红帽、身穿白衣的人物，站立开着的门侧，作守门状。整个画面线条简练。

（临摹：山东博物馆提供，临摹者不详　撰文、摄影：郑同修）

Capital Pavilion and Humans Portrait (Detail 3) (Replica)

Eastern Han (25-220 CE)

Height 37 cm; Width 31 cm

Unearthed from Houyinshan Eastern Han tomb at Liangshanxian, Shandong, in 1953. Preserved on the original site.

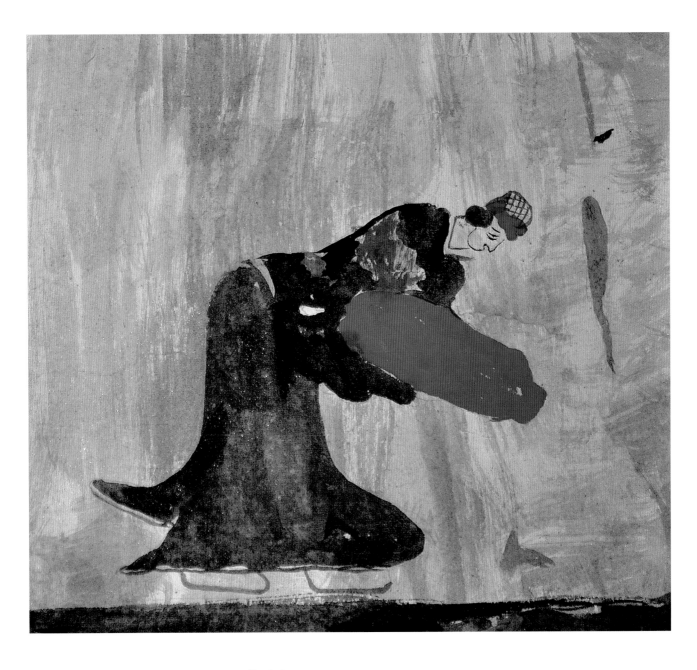

31. 都亭人物图（局部四）（摹本）

东汉（25 ~ 220年）

高13.5、宽15厘米

1953年山东省梁山县后银山东汉墓出土。原址保存。

墓向南。位于墓前室南壁西侧的都亭右侧。画面绘一人物，身穿黑衣，头戴网状纱冠，着履，手捧盾，躬身向右作打躬状。

（临摹：山东博物馆提供，临摹者不详　撰文、摄影：郑同修）

Capital Pavilion and Human Portrait (Detail 4) (Replica)

Eastern Han (25-220 CE)

Height 13.5 cm; Width 15 cm

Unearthed from Houyinshan Eastern Han tomb at Liangshanxian, Shandong, in 1953. Preserved on the original site.

32.都亭人物图（局部五）（摹本）

东汉（25～220年）

高85、宽40厘米

1953年山东省梁山县后银山东汉墓出土。原址保存。

墓向南。位于墓前室南壁西侧下层。画面绘一老人，题名"怒（？）士"，为该墓壁画人物像中最大的一个。老人须发飘逸，身穿红衣，面左作打躬状。

（临摹：山东博物馆提供，临摹者不详　撰文、摄影：郑同修）

Capital Pavilion and Human Portrait (Detail 5) (Replica)

Eastern Han (25-220 CE)

Height 85 cm; Width 40 cm

Unearthed from Houyinshan Eastern Han tomb at Liangshanxian, Shandong, in 1953. Preserved on the original site.

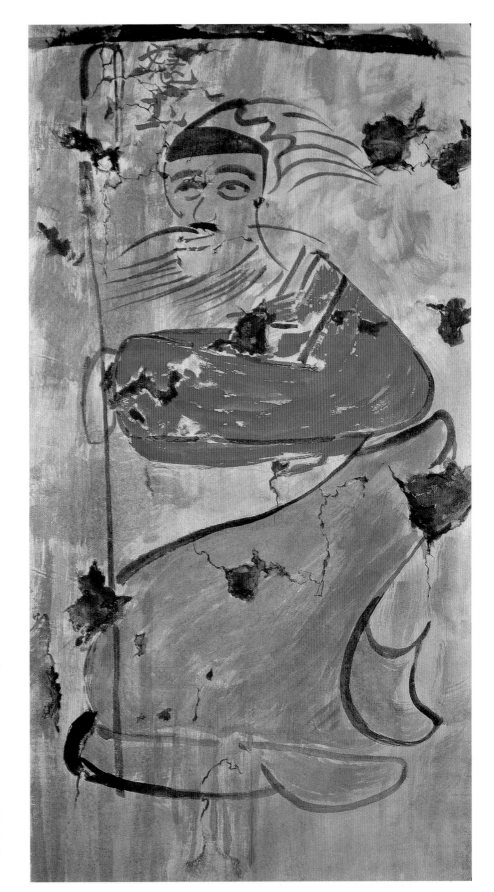

33.建筑图（摹本）

东汉（25～220年）

高49、宽107厘米

1953年山东省梁山县后银山东汉墓出土。原址保存。

墓向南。位于前室南壁东侧。画面为一房屋建筑，分为三间，各绘有人物。其中左屋内绘一人，前面置放一儿；中屋可看出一人，从画面布局应为两人；右屋内绘两人。因有土附着或漫漶，画面不甚清晰。

（临摹：山东博物馆提供，临摹者不详　撰文、摄影：郑同修）

Architecture (Replica)

Eastern Han (25-220 CE)

Height 49 cm; Width 107 cm

Unearthed from Houyinshan Eastern Han tomb at Liangshanxian, Shandong, in 1953. Preserved on the original site.

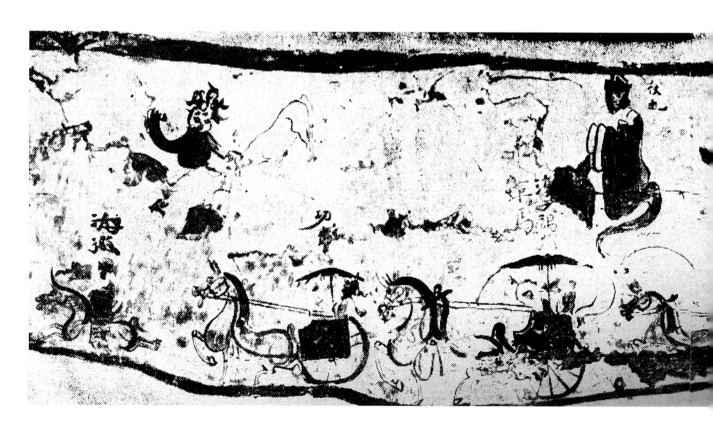

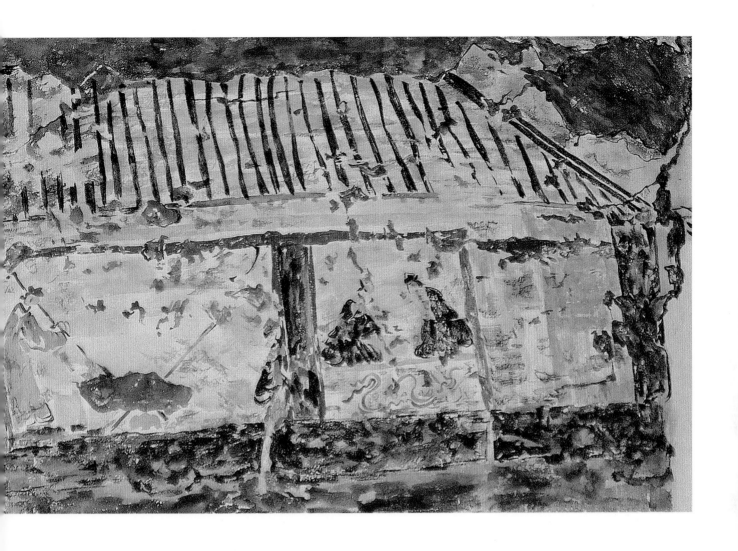

34.出行图（摹本）

东汉（25～220年）

宽约215厘米

1953年山东省梁山县后银山东汉墓出土。原址保存。

墓向南。位于前室西壁。画面左侧绘一人骑马，题名"游徼"，其后分别绘三辆车，前面一车，题名"功曹"；中间一车，题名"淳于鵲卿车马"；后面一车题名"主簿"。车后为骑吏和一送行属吏，均无题名。其中"游徼"的马，马足前后直伸作飞奔的样子。在车马出行行列的上方，有神怪、伏羲和朱雀图像。

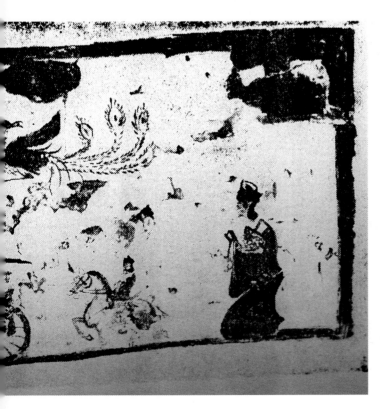

（临摹：山东博物馆提供，临摹者不详

撰文、摄影：郑同修）

Procession Scene (Replica)

Eastern Han (25-220 CE)

Width ca. 215 cm

Unearthed from Houyinshan Eastern Han tomb at Liangshanxian, Shandong, in 1953. Preserved on the original site.

35.穿环龙纹图案（摹本）

东汉（25～220年）

高60、宽214厘米

1953年山东省梁山县后银山东汉墓出土。原址保存。

墓向南。位于前室北壁。画面分上、下两层，上、下层之间以锯齿纹隔开。上层绘云纹；下层分列四根立柱，将下层画面分成三部分，其左侧绘串环纹图案；中间似为一龙纹；右侧画面不清。顶部以朱彩绘垂帐纹。画面下部也绘锯齿纹。

<div align="right">

（临摹：山东博物馆提供，临摹者不详

撰文、摄影：郑同修）

</div>

Rings String and Dragon Pattern (Replice)

Eastern Han (25-220 CE)

Height 60 cm; Width 214 cm

Unearthed from Houyinshan Eastern Han tomb at Liangshanxian, Shandong, in 1953. Preserved on the original site.

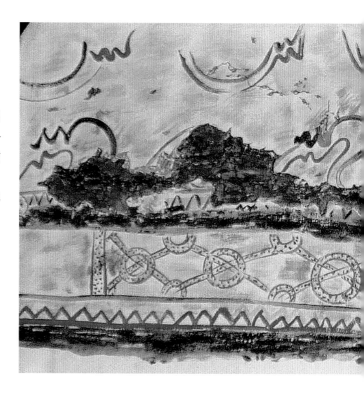

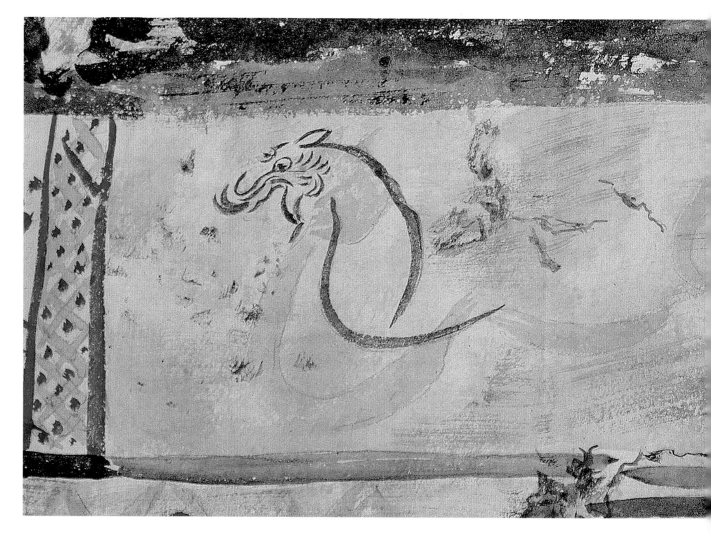

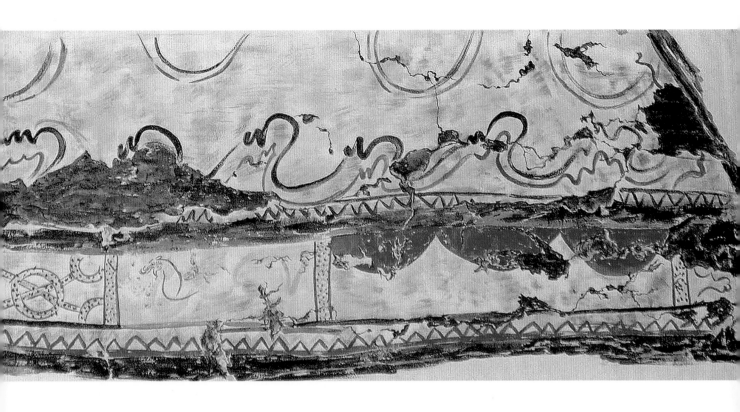

36.龙纹图（摹本）

东汉（25～220年）

高12、宽33厘米

1953年山东省梁山县后银山东汉墓出土。原址保存。墓向南。位于墓前室北壁下层中部。图像两侧为立柱，其间以浅墨色绘制一龙形动物形象，龙头向左作腾飞状，龙身漫漶不清。

（临摹：山东博物馆提供，临摹者不详

撰文、摄影：郑同修）

Dragon Pattern (Replica)

Eastern Han (25-220 CE)

Height 12 cm; Width 33 cm

Unearthed from Houyinshan Eastern Han tomb at Liangshanxian, Shandong, in 1953. Preserved on the original site.

37. 人物图（摹本）

东汉（25～220年）

高50、宽124厘米

1953年山东省梁山县后银山东汉墓出土。原址保存。

墓向南。位于墓前室东壁南侧。画面绘人物九个。自左至右，人物渐次矮小，左侧五人较清晰，后面四人因有土附着不甚清晰。九个人物各有榜题，分别为"子元"、"子礼"、"子（任？）"、"子仁"、"子（衬？）"、"子喜"等九人。

（临摹：山东博物馆提供，临摹者不详　撰文、摄影：郑同修）

Figures (Replica)

Eastern Han (25-220 CE)

Height 50 cm; Width 124 cm

Unearthed from Houyinshan Eastern Han tomb at Liangshanxian, Shandong, in 1953. Preserved on the original site.

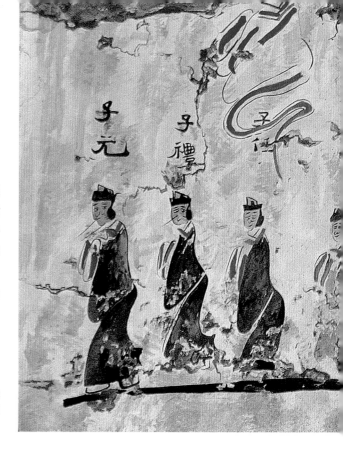

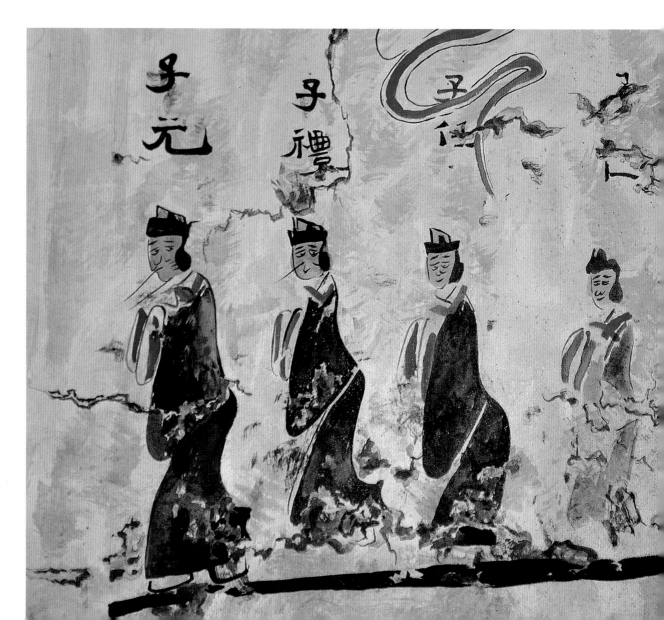

38.人物图（局部）（摹本）

东汉（25～220年）

高23、宽42厘米

1953年山东省梁山县后银山东汉墓出土。原址保存。

墓向南。位于墓前室东壁南侧。画面为九个人物中的左面五位，自左至右渐次矮小，皆戴冠，身着黑衣。人物各有榜题，分别为"子元"、"子礼"、"子（任？）""子仁"、"子（衬？）"。

（临摹：山东博物馆提供，临摹者不详　撰文、摄影：郑同修）

Figures (Detail) (Replica)

Eastern Han (25-220 CE)

Height 23 cm; Width 42 cm

Unearthed from Houyinshan Eastern Han tomb at Liangshanxian, Shandon, in 1953. Preserved on the original site.

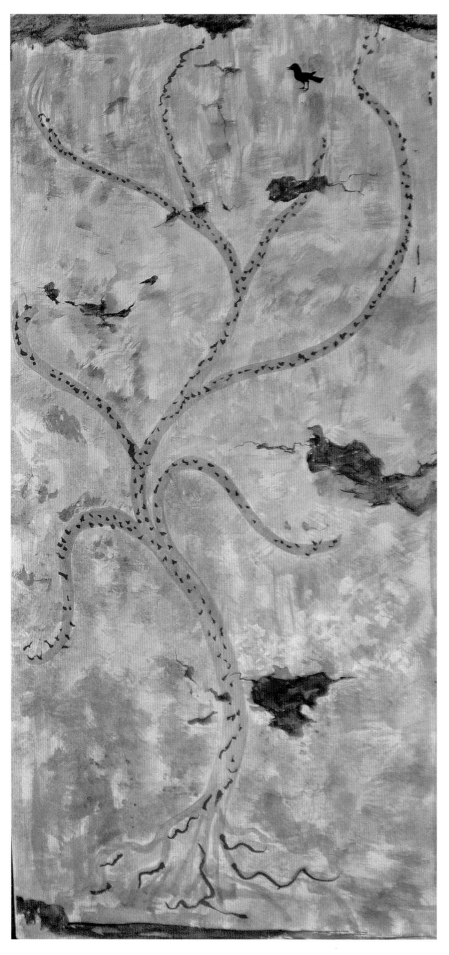

39.扶桑树（摹本）

东汉（25~220年）

高127、宽86厘米

1953年山东省梁山县后银山东汉墓出土。原址保存。

墓向南。位于墓前室东壁北侧。图像绘一大树，树干青灰色，以红点点缀，应为扶桑树。树枝摇曳，顶部站立一乌鸦。

（临摹：山东博物馆提供，临摹者不详

撰文、摄影：郑同修）

Huge Mulberry Tree (Replica)

Eastern Han (25-220 CE)

Height 127 cm; Width 86 cm

Unearthed from Houyinshan Eastern Han tomb at Liangshanxian, Shandong, in 1953. Preserved on the original site.

40. 金乌图（摹本）

东汉（25～220年）

高145、宽44厘米；太阳直径23～24厘米

1953年山东省梁山县后银山东汉墓出土。原址保存。

墓向南。位于墓葬前室顶部。图像以朱彩绘一圆轮以象征太阳，太阳内以墨色绘一金乌。太阳周围为云纹。

<div align="right">

（临摹：山东博物馆提供，临摹者不详　撰文、

摄影：郑同修）

</div>

Golden Crow (Replica)

Eastern Han (25-220 CE)

Height 143 cm; Width 44 cm; Diameter of sun: 23-24 cm

Unearthed from Houyinshan Eastern Han tomb at Liangshanxian, Shandong, in 1953. Preserved on the original site.

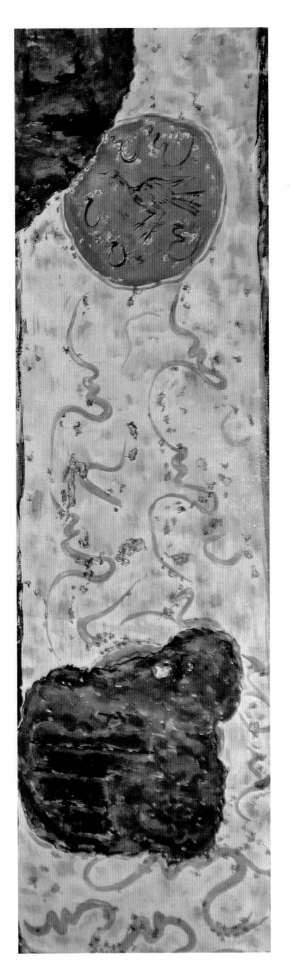

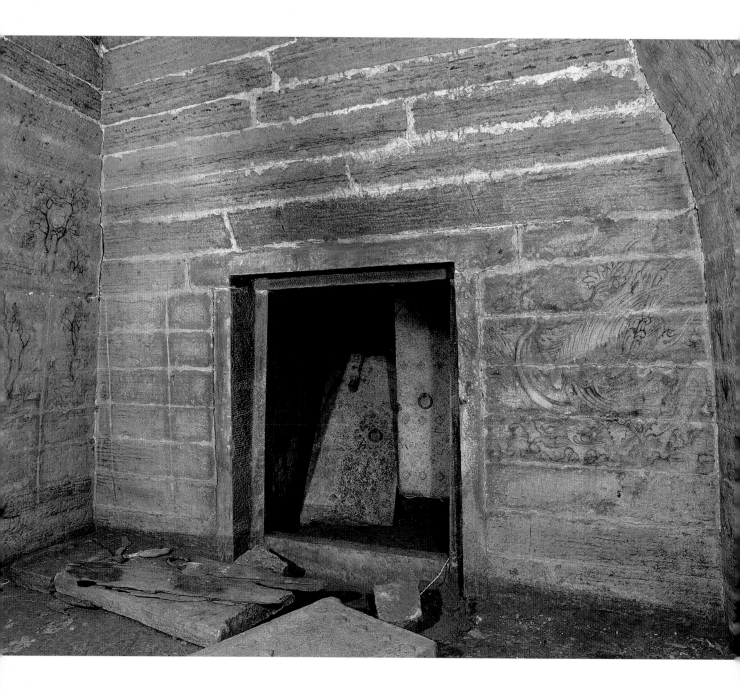

41. 墓室南壁壁画

北齐天保二年（551年）

高260、宽360厘米

1986年山东省临朐县冶源镇海浮山崔芬墓出土。原址保存。

墓向150°。南壁墓顶底部有几个不太清楚的黑点，可能原有星宿图，但因浸蚀脱落严重，现在漫漶不清，也可能是未完成部分。墓门西侧绘有朱雀图，东侧勾画出两个屏风边框，但未绘画。

（撰文：郑同修　摄影：刘小放）

Mural on the South Wall of the Tomb Chamber

2nd Year of Tianbao Era, Northern Qi (551 CE)

Height 260 cm; Width 360 cm

Unearthed from the tomb of Cui Fen at Haifushan in Yeyuanzhen of Linquxian, Shandong, in 1986. Preserved on the original site.

42.墓室西壁壁画

北齐天保二年（551年）

高260、宽360厘米

1986年山东省临朐县冶源镇海浮山崔芬墓出土。原址保存。

墓向150°。西壁壁画可分为上、中、下三栏。上栏为墓壁上端覆斗状墓顶底部，绘星象图，以墨点表示星宿，或组成星座，浸蚀脱落较多重，星宿组合不太完整。中栏为仙人驭虎及月象图，下栏可分两部分，壁龛额之上绘墓主人夫妇出行图，壁龛两侧各绘屏风式壁画两幅，内容或为人物或为树石。

（撰文：郑同修 摄影：刘小放）

Mural on the West Wall of the Tomb Chamber

2nd Year of Tianbao Era, Northern Qi (551 CE)

Height 260 cm; Width 360 cm

Unearthed from the tomb of Cui Fen at Haifushan in Yeyuanzhen of Linquxian, Shandong, in 1986. Preserved on the original site.

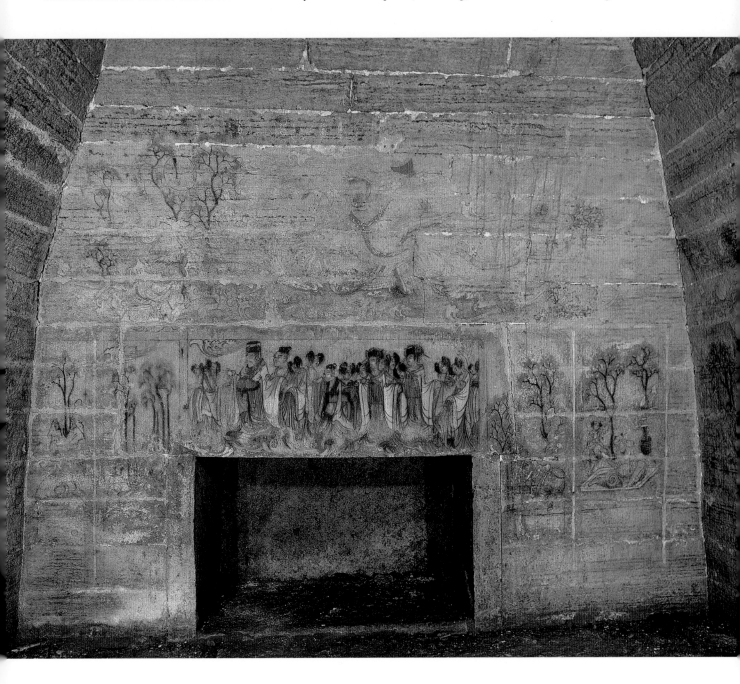

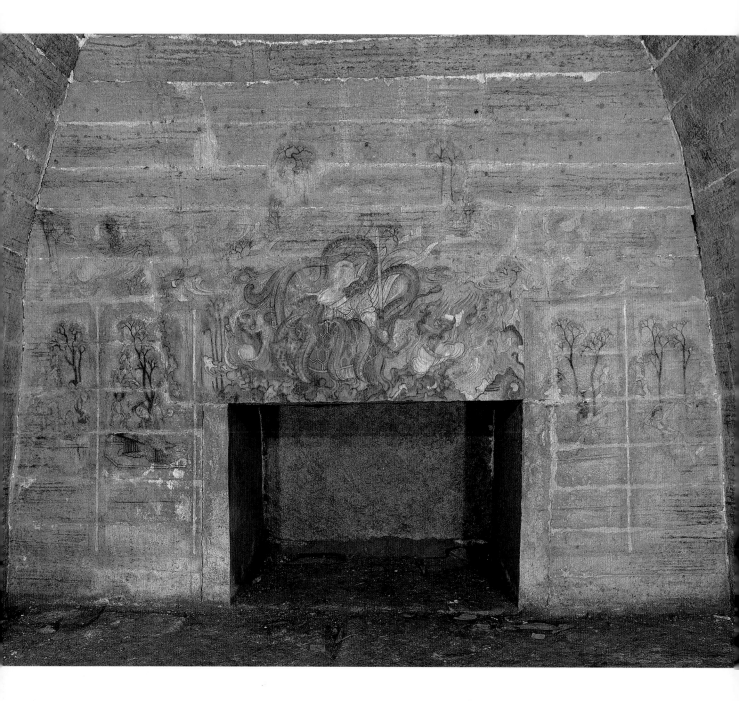

43.墓室北壁壁画

北齐天保二年（551年）

高260、宽360厘米

1986年山东省临朐县冶源镇海浮山崔芬墓出土。原址保存。

墓向150°。北壁壁画可分为上、中、下三栏。上栏绘星宿图，其中"斗、牛、女、虚、危、室、壁"七星宿清晰可辨，其他因浸蚀而不明显。中栏绘西向驱驰玄武图，是四神图中保存最好的一幅。下栏位于壁龛两侧，左右各绘屏风或壁画两幅，内容或为人物或为树石。

（撰文：郑同修　摄影：刘小放）

Mural on the North Wall of the Tomb Chamber

2nd Year of Tianbao Era, Northern Qi (551 CE)

Height 260 cm; Width 360 cm

Unearthed from the tomb of Cui Fen at Haifushan in Yeyuanzhen of Linquxian, Shandong, in 1986. Preserved on the original site.

44. 墓室东壁壁画

北齐天保二年（551年）

高260、宽360厘米

1986年山东省临朐县冶源镇海浮山崔芬墓出土。原址保存。

墓向150°。东壁壁画可分为上、中、下三栏。上栏绘星宿图，其中"角、亢、氐、房、心、尾、箕"七星宿清晰可辨，群星之中有一斜下直杠，似为流星或慧星。中栏绘仙人乘龙及日象图，下栏绘屏风人物树石图七幅。

（撰文：郑同修　摄影：刘小放）

Mural on the East Wall of the Tomb Chamber

2nd Year of Tianbao Era, Northern Qi (551 CE)

Height 260 cm; Width 360 cm

Unearthed from the tomb of Cui Fen at Haifushan in Yeyuanzhen of Linquxian, Shandong, in 1986. Preserved on the original site.

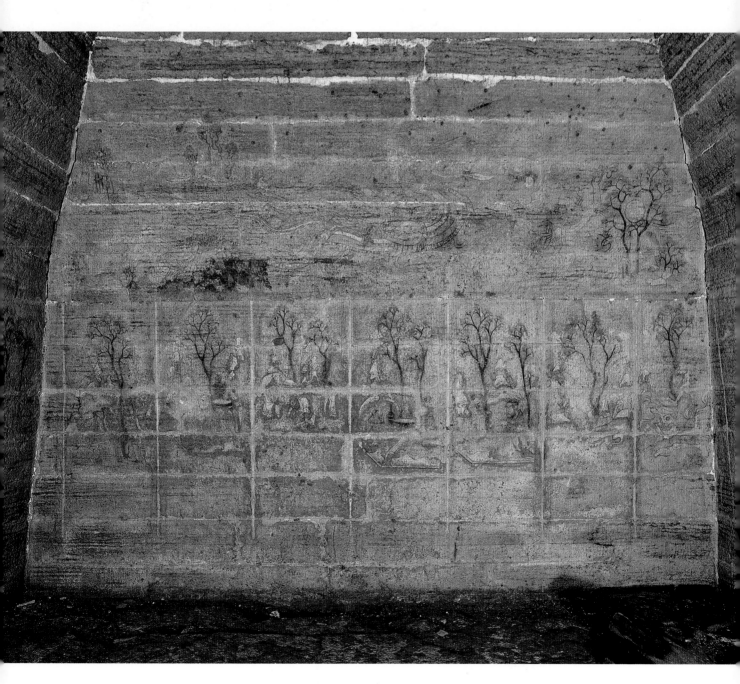

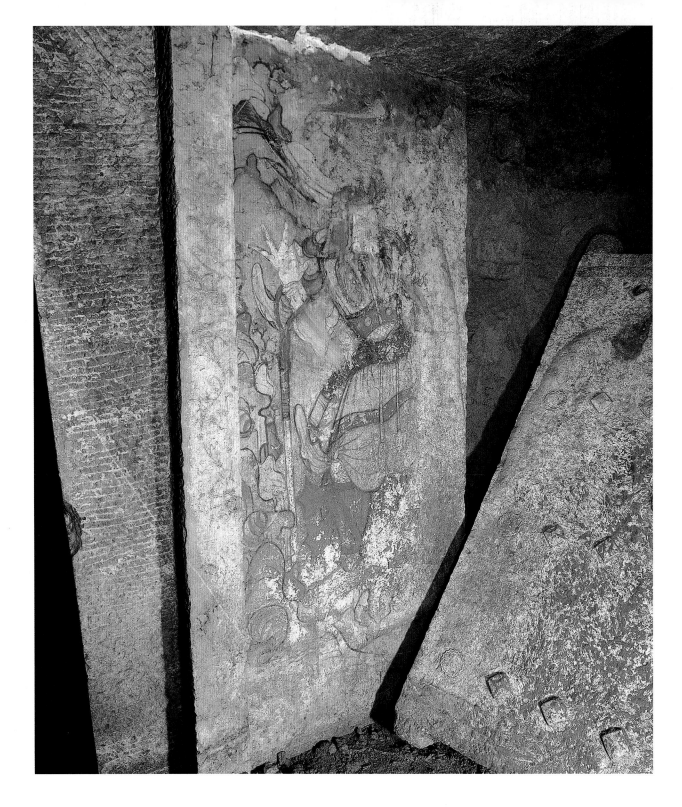

45.武士图（一）

北齐天保二年（551年）

高154、宽64厘米

1986年山东省临朐县冶源镇海浮山崔芬墓出土。原址保存。

墓向150°。位于墓甬道东壁。绘一面部狰狞，赤足着铠的武士。武士头着盔，插鹖尾，身着护胸铠甲、甲裙及裤，腰束革带，上臂隐于衣中。一手置盾牌之上，另一手手掌伸开，手腕下悬剑。身后背景有树木、山峦、云朵等。

（撰文：郑同修　摄影：刘小放）

Warrior (1)

2nd Year of Tianbao Era, Northern Qi (551 CE)

Height 154 cm; Width 64 cm

Unearthed from the tomb of Cui Fen at Haifushan in Yeyuanzhen of Linquxian, Shandong, in 1986. Preserved on the original site.

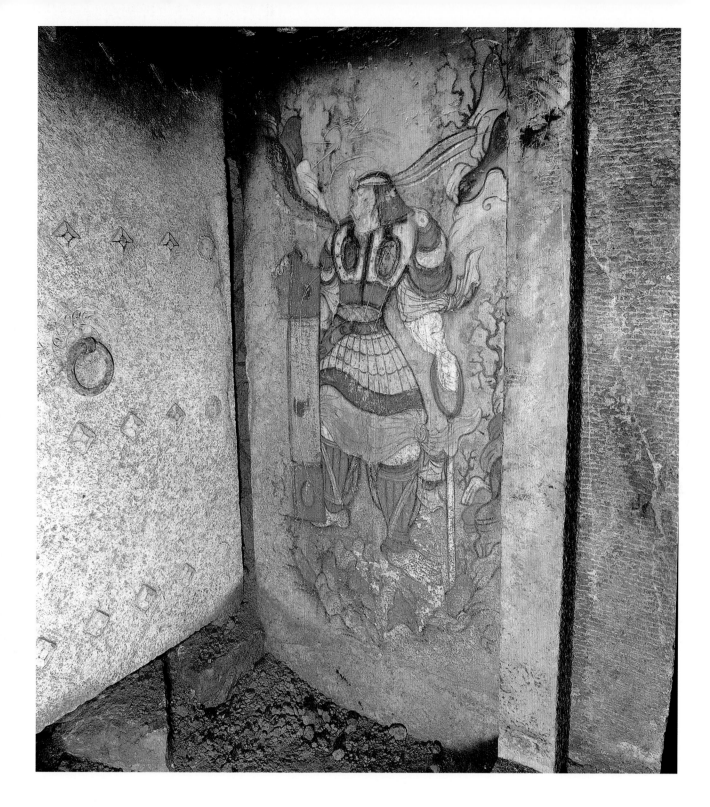

46.武士图（二）

北齐天保二年（551年）

高154、宽64厘米

1986年山东省临朐县冶源镇海浮山崔芬墓出土。原址保存。墓向150°。位于墓甬道西壁。绘一面部狰狞，赤足着铠的武士。武士头着盔，插鹖尾，身着护胸铠甲、甲裙及裤，腰束革带，上臂隐于衣中。一手置盾牌之上，另一手握手成拳，手腕下悬剑。身后背景有树木、山峦、云朵等。

（撰文：郑同修　摄影：刘小放）

Warrior (2)

2nd Year of Tianbao Era, Northern Qi (551 CE)

Height 154 cm; Width 64 cm

Unearthed from the tomb of Cui Fen at Haifushan in Yeyuanzhen of Linquxian, Shandong, in 1986. Preserved on the original site.

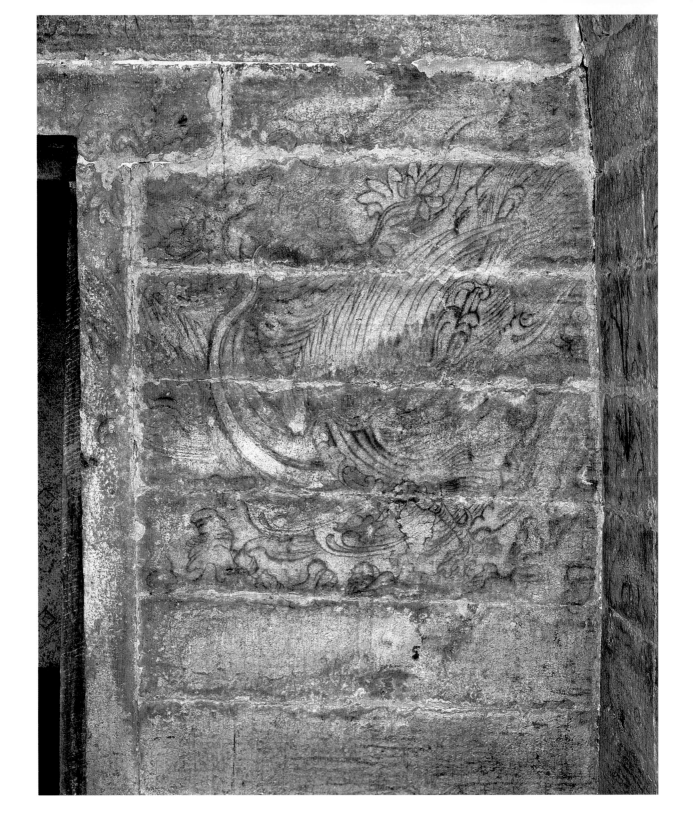

47. 朱雀图

北齐天保二年（551年）

高95、宽110厘米

1986年山东省临朐县冶源镇海浮山崔芬墓出土。原址保存。墓向150°。位于南壁墓门西侧，甬道西壁。朱雀呈东向，两翅展开，引颈回顾，作欲腾飞状。朱雀喙衔一枝莲花状仙草，头部右上方绘仙草一株，两腿间绘祥云两朵，神态矫健有力。

（撰文：郑同修　摄影：刘小放）

Scarlet Bird

2nd Year of Tianbao Era, Northern Qi (551 CE)

Height 95 cm; Width 110 cm

Unearthed from the tomb of Cui Fen at Haifushan in Yeyuanzhen of Linquxian, Shandong, in 1986. Preserved on the original site.

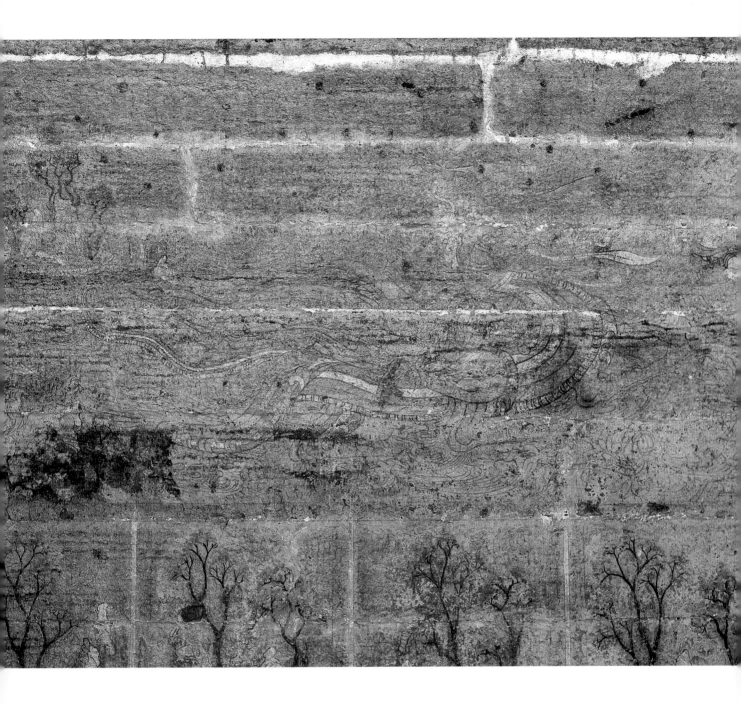

48.仙人乘龙图

北齐天保二年（551年）

高82、宽180厘米

1986年山东省临朐县冶源镇海浮山崔芬墓出土。原址保存。

墓向150°。位于墓室东壁。青龙南向作腾云飞奔状，昂首翘尾，两眼凸出，口吐长舌，胸前右爪下绘有莲花状仙草，腰部前端绘有展开的宽大翅膀，一女相神人头戴花冠，衣带漂浮，乘于青龙之背。驱鬼逐疫的方相氏作奔跑状紧随青龙之后，青龙之前有手执仙草引逗的两羽人。

（撰文：郑同修　摄影：刘小放）

Immortal Riding Dragon

2nd Year of Tianbao Era, Northern Qi (551 CE)

Height 82 cm; Width 180 cm

Unearthed from the tomb of Cui Fen at Haifushan in Yeyuanzhen of Linquxian, Shandong, in 1986. Preserved on the original site.

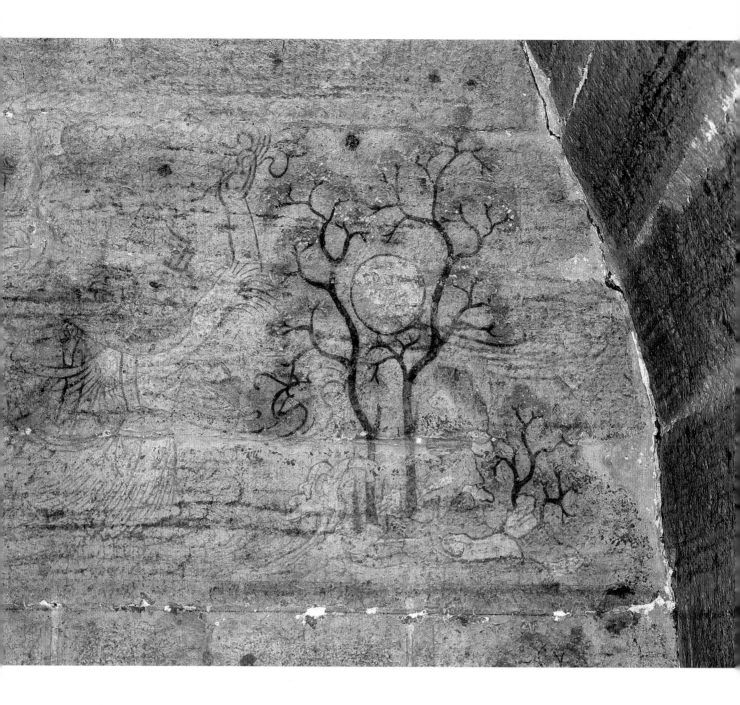

49.日象图

北齐天保二年（551年）

高70、宽75厘米

1986年山东省临朐县冶源镇海浮山崔芬墓出土。原址保存。

墓向150°。位于墓室东壁仙人乘龙图右侧，羽人前面两株树枝间绘日象，日象内绘展翅欲飞的三足金乌。两树的上部还绘有并排两行日轮，每行四个，下一行的四个小太阳已开始由北向南逐一下落，似示轮流值班。画中的远处绘以山峦树木。

（撰文：郑同修　摄影：刘小放）

Solar Phenomena

2nd Year of Tianbao Era, Northern Qi (551 CE)

Height 70 cm; Width 75 cm

Unearthed from the tomb of Cui Fen at Haifushan in Yeyuanzhen of Linquxian, Shandong, in 1986. Preserved on the original site.

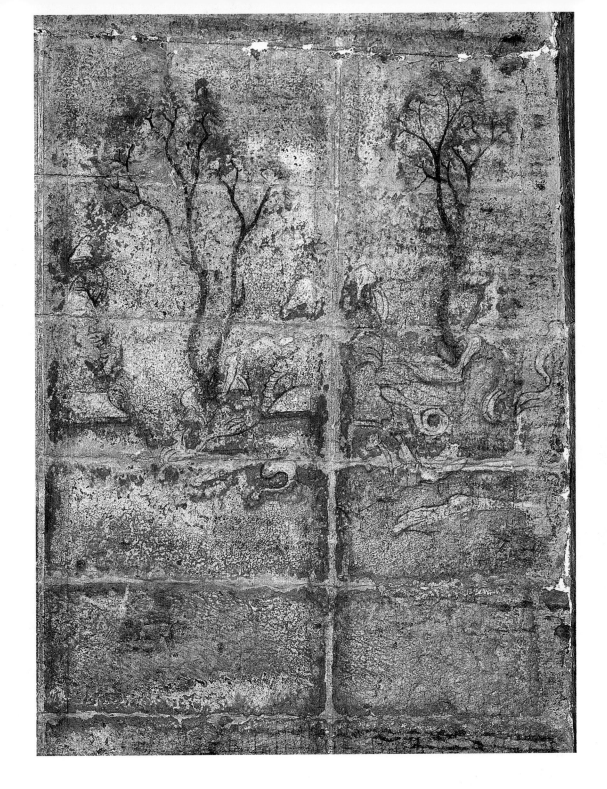

50.屏风人物图（一）

北齐天保二年（551年）

左右图：高120、宽40厘米

1986年山东省临朐县冶源镇海浮山崔芬墓出土。原址保存。墓向150°。位于墓室东壁青龙图的下方。为由右向左起第一幅、第二幅。右图画面绘树木山石。中间绘大树一棵，树前有怪石，左侧有叠起的怪石数块。大树躯干粗壮，枝繁叶茂。中图为由南向北起第二幅。画面绘树木山石。中间绘两株大树，树的左侧有叠起的怪石。

（撰文：郑同修　摄影：刘小放）

Screen Humans Portrait (1)

2nd Year of Tianbao Era, Northern Qi (551 CE)

Left and Right: Height 120 cm; Width 40 cm Unearthed from the tomb of Cui Fen at Haifushan in Yeyuanzhen of Linquxian, Shandong, in 1986. Preserved on the original site.

◄**51. 屏风人物图（二）**

北齐天保二年（551年）

高121、宽48厘米

1986年山东省临朐县冶源镇海浮山崔芬墓出土。原址保存。墓向150°。位于墓室东壁青龙图的下方。由右向左起第三幅。画面绘人物盆景图。画中一老者留有短须，跪坐于方形茵席之上，头戴双耳巾帻，身着宽袖肥袍，腰间束带，袒胸露臂，其左手托一盆小巧玲珑的奇石盆景，似观看欣赏，神态安详。前面一侍女，发梳双丫髻，专心侍立。人物身后以近树远山作衬托，体现出主人的闲情逸致。

（撰文：郑同修　摄影：刘小放）

Screen Humans Portrait (2)

2nd Year of Tianbao Era, Northern Qi (551 CE)

Height 121 cm; Width 48 cm

Unearthed from the tomb of Cui Fen at Haifushan in Yeyuanzhen of Linquxian, Shandong, in 1986. Preserved on the original site.

52. 屏风人物图（三）▶

北齐天保二年（551年）

左图：高124、宽49厘米；右图：高121、宽49厘米

1986年山东省临朐县冶源镇海浮山崔芬墓出土。原址保存。墓向150°。位于墓室东壁由右向左起第四幅、第五幅。右图画中主人有短须，头发分成两股束于头顶，侧身，左臂靠枕，半卧于方形茵席上，斜倚隐囊，着宽袖的宽松长袍，腰间束一丝绳，面向一女婢，面前放置黑色大瓶、大盘各一个。侍者头梳双丫髻，左向站在大盘前面，主人似在饮酒作乐，且已半醉，呈放浪形骸状。画面背景衬以高大绿树两棵，树一侧绘假山怪石。左图画面主人左腿屈起盘于身下，坐在方形茵席之上，此人有短须，头发用丝绦束起，身着一短袖紧身衫，下裤宽松，右手轻抚其颊，左手靠在右腿上，头微低，一幅醉态。两侧有男女仆婢各一人。左侧是一男仆，身着广袖衫，双臂抬起，服侍主人；右侧为一女婢，发梳双丫髻，立于其侧。背景为两棵绿树，树间配以怪石。

（撰文：郑同修　摄影：刘小放）

Screen Humans Portrait (3)

2nd Year of Tianbao Era, Northern Qi (551 CE)

Left: Height 124 cm, Width 49 cm; Right: Height 121 cm, Width 49 cm

Unearthed from the tomb of Cui Fen at Haifushan in Yeyuanzhen of Linquxian, Shandong, in 1986. Preserved on the original site.

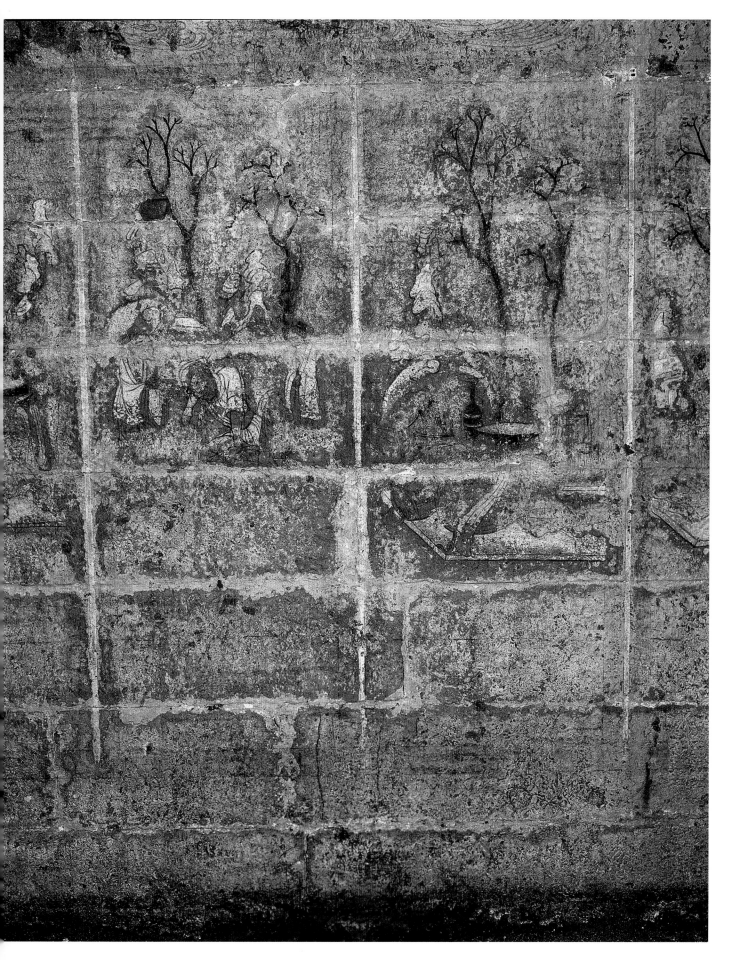

53.屏风人物图（四）

北齐天保二年（551年）

左图：高约124、宽约48厘米；右图：高124、宽48厘米

1986年山东省临朐县冶源镇海浮山崔芬墓出土。原址保存。

墓向150°。位于墓室东壁由右向左起第六幅、第七幅。右图画面主人盘腿端坐于方形茵席之上，其发用巾帻束成高髻，身着宽袖的宽松长袍，袒露其胸，右手轻抚长须，神色专注陶然，在其左侧有一女婢，发梳双丫髻，面左侍立，婢女身旁放置圆口细颈大腹的花瓶，瓶口绘有黑色花纹。背景为一株绿树和两组点缀性的山峦怪石。左图为一身着窄袖衫，腰系带，腿穿马裤，头裹巾的马夫，一手执缰绳，一手扬起驯马工具牵马欲行。马背着马鞍，前右腿前伸，后腿屈起，头颈部转向主人牵动方向，呈走动状。后为绿树一棵，树侧衬山峦怪石。

（撰文：郑同修　摄影：刘小放）

Screen Humans Portrait (4)

2nd Year of Tianbao Era, Northern Qi (551 CE)

Left: Height ca. 124 cm, Width ca. 48 cm;
Right: Height 124 cm, Width 48 cm
Unearthed from the tomb of Cui Fen at Haifushan in Yeyuanzhen of Linquxian, Shandong, in 1986. Preserved on the original site.

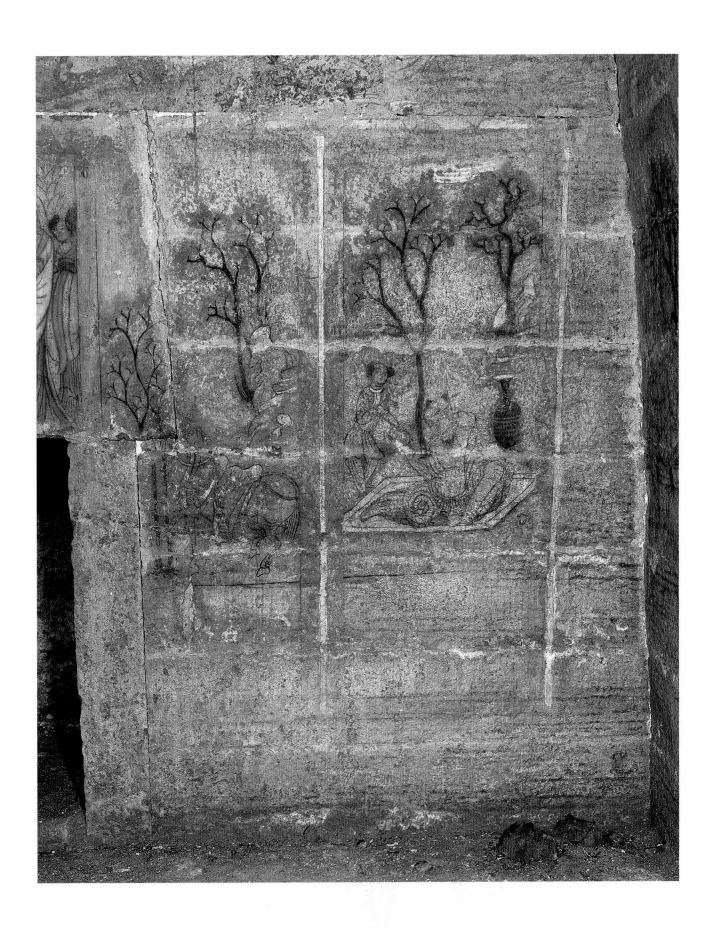

◀54. 屏风人物图（五）

北齐天保二年（551年）

左图：高124、宽50厘米；右图：高125、宽51厘米

1986年山东省临朐县冶源镇海浮山崔芬墓出土。原址保存。

墓向150°。位于墓室西壁壁龛北侧。右图主人坐于方形茵席之上，袒胸露腹，身体肥胖，发结作两个双丫形角髻，身着广袖宽松长袍，腰间束带，神情悠闲安逸。左手斜撑，右手伸开轻举，似向身侧婢女示意。婢女身着紧身合体的窄袖长裙，发绾作双丫髻，手举一物，匆忙向主人身边走来。远景为两株大树和山峦怪石。树下怪石旁置一着彩的花瓶。左图画面为山脚下一树上栓一匹白马，左前腿前伸，右后腿抬起，头胸部转向右侧，似作嘶鸣状。马体肥硕，背置马鞍，头部色彩漫漶，头略显瘦小，颈部长鬃斜披。山脚稍上方还有绿树两棵，并有怪石在树旁。

（撰文：郑同修　摄影：刘小放）

Screen Humans Portrait (5)

2nd Year of Tianbao Era, Northern Qi (551 CE)

Left: Height 124 cm, Width 50 cm; Right: Height 125 cm, Width 51 cm

Unearthed from the tomb of Cui Fen at Haifushan in Yeyuanzhen of Linquxian, Shandong, in 1986. Preserved on the original site.

55. 屏风人物图（五）（局部）▶

北齐天保二年（551年）

高125、宽51厘米

1986年山东省临朐县冶源镇海浮山崔芬墓出土。原址保存。

墓向150°。位于墓室西壁壁龛北侧。右图主人坐于方形茵席之上，袒胸露腹，身体肥胖，发结作两个双丫形角髻，身着广袖宽松长袍，腰间束带，神情悠闲安逸。左手斜撑，右手伸开轻举，似向身侧婢女示意。婢女身着紧身合体的窄袖长裙，发绾作双丫髻，手举一物，匆忙向主人身边走来。远景为两株大树和山峦怪石。树下怪石旁置一着彩的花瓶。左图画面为山脚下一树上栓一匹白马，左前腿前伸，右后腿抬起，头胸部转向右侧，似作嘶鸣状。马体肥硕，背置马鞍，头部色彩漫漶，头略显瘦小，颈部长鬃斜披。山脚稍上方还有绿树两棵，并有怪石在树旁。

（撰文：郑同修　摄影：刘小放）

Screen Humans Portrait (5) (Detail)

2nd Year of Tianbao Era, Northern Qi (551 CE)

Height 125 cm; Width 51 cm

Unearthed from the tomb of Cui Fen at Haifushan in Yeyuanzhen of Linquxian, Shandong, in 1986. Preserved on the original site.

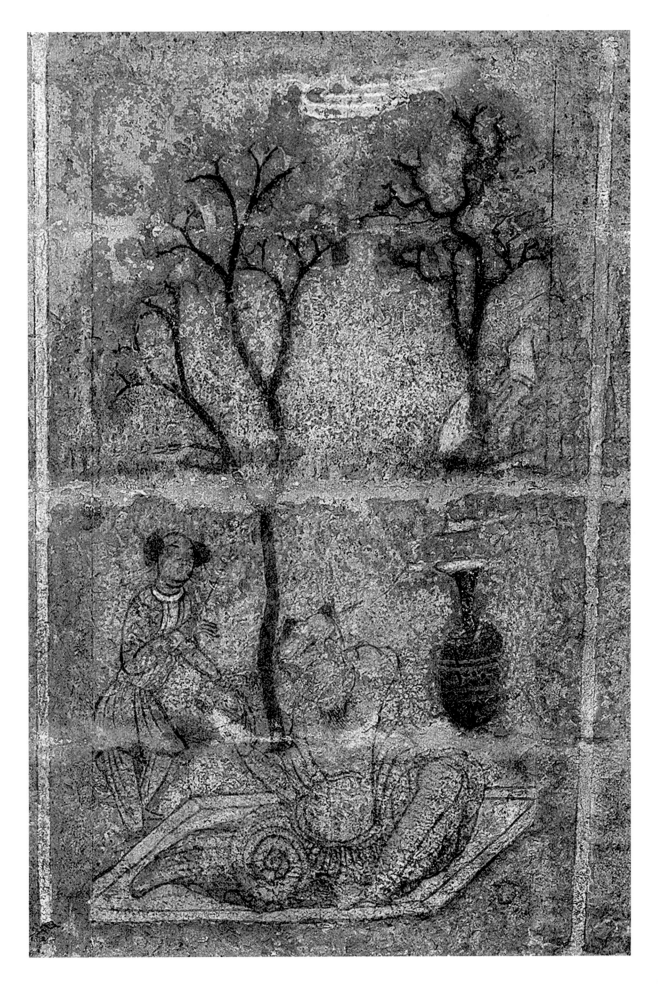

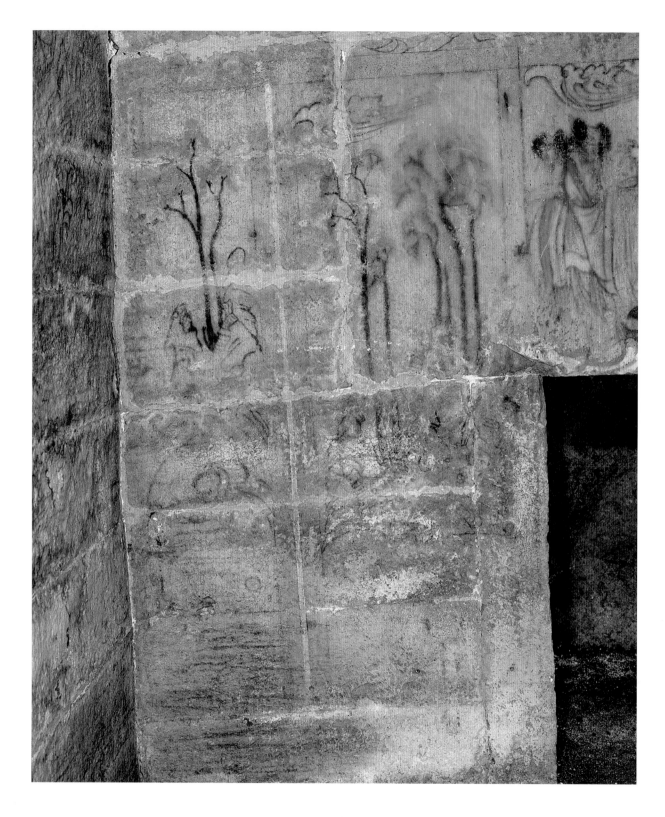

56.屏风人物图（六）

北齐天保二年（551年）

两幅画面面积约0.82平方米

1986年山东省临朐县冶源镇海浮山崔芬墓出土。原址保存。墓向150°。位于墓室西壁壁龛南侧。画面主体为绿树，树下绘山峦怪石，树上方绘流云一朵。这两幅壁画恰好绘在墓主人夫妇出行图的前方，与出行图的画面较为协调。

（撰文：郑同修　摄影：刘小放）

Screen Humans Portrait (6)

2nd Year of Tianbao Era, Northern Qi (551 CE)

Square measure of two paintings: ca. 0.82 square meters

Unearthed from the tomb of Cui Fen at Haifushan in Yeyuanzhen of Linquxian, Shandong, in 1986. Preserved on the Original site.

57.屏风人物图（七）

北齐天保二年（551年）

左图：高125、宽52厘米；右图：高122、上宽38、下宽47厘米

1986年山东省临朐县冶源镇海浮山崔芬墓出土。原址保存。

墓向150°。位于墓室北壁壁龛东侧。右图为胡旋舞图。内容为两人舞蹈的场面，两舞女头发盘成高髻，身着紧身合体的窄袖舞裙，腰系带，下着瘦长裤，跣足。两人扭腰，一手同对方相牵，并高高抬起，另一手各抬于各自头上，一腿屈起，舞姿优美。两人对舞的背后衬以树木山石，树木两棵居中，两侧为层层叠起的怪石。左图主人斜倚隐囊坐于方形茵席之上。此人留短须，头戴笠，身着宽松宽袖长袍，袒胸露腹，右小腿亦袒露，轻抬靠于左膝，神情闲逸。背景为树木两棵，树两侧点缀山峦怪石，两树间置一黑色大瓶。

（撰文：郑同修 摄影：刘小放）

Screen Humans Portrait (7)

2nd Year of Tianbao Era, Northern Qi (551 CE)

Left: Height 125 cm, Width 52 cm; Right: Height 122 cm, Width (top) 38 cm, (buttom) 47 cm

Unearthed from the tomb of Cui Fen at Haifushan in Yeyuanzhen of Linquxian, Shandong, in 1986. Preserved on the original site.

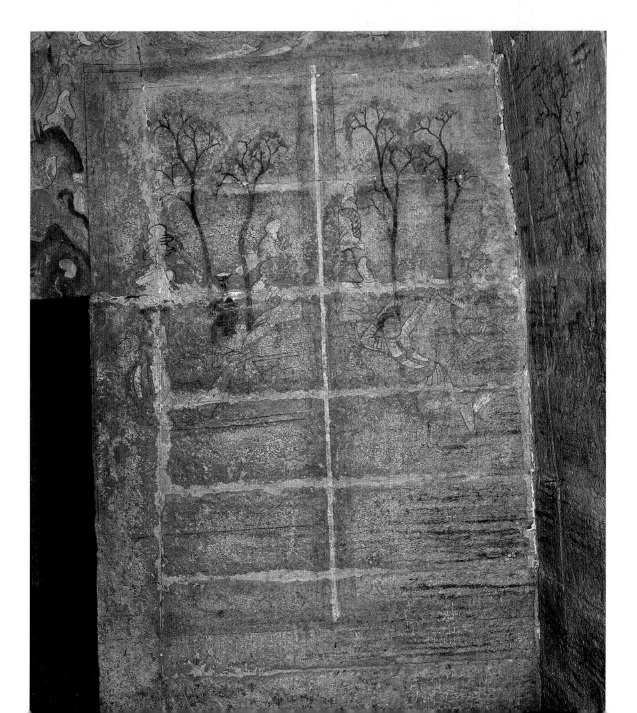

58. 屏风人物图（八）▶

北齐天保二年（551年）

左图：高122、宽46厘米；右图：高122、宽51厘米

1986年山东省临朐县冶源镇海浮山崔芬墓出土。原址保存。

墓向150°。位于墓室北壁壁龛西侧。右图画中主人跪坐于方形茵席之上，身子右斜，留长须，发分束为双丫形角髻，身着长袍，腰间束带。其身前为矮几案，上置纸、石砚及笔架。此人一手握笔作书画状，身前倾，似以其臂压纸，神情专注。主人左侧有一侍女，发梳双丫髻，手执台灯站在一边，为主人照明。背景为一株枝繁叶茂的大树，树两侧衬有山峦怪石。

左图画中主人呈醉态，斜坐于方形茵席之上，留短须，头发结成两丫形角髻，身着窄袖长袍，右腿盘屈，左腿轻抬，双手皆撑于席上，似不胜酒力。身后一侍女弯腰弓背奔走状，忙来侍候，两手张开，似给主人按摩背部。侍女发束双丫髻，身着紧袖衫。人物背后远景处衬以树木怪石。

（撰文：郑同修　摄影：刘小放）

Screen Humans Portrait (8)

2nd Year of Tianbao Era, Northern Qi (551 CE)

Left: Height 122 cm, Width 46 cm; Right: Height 122 cm, Width 51 cm

Unearthed from the tomb of Cui Fen at Haifushan in Yeyuanzhen of Linquxian, Shandong, in 1986. Preserved on the original site.

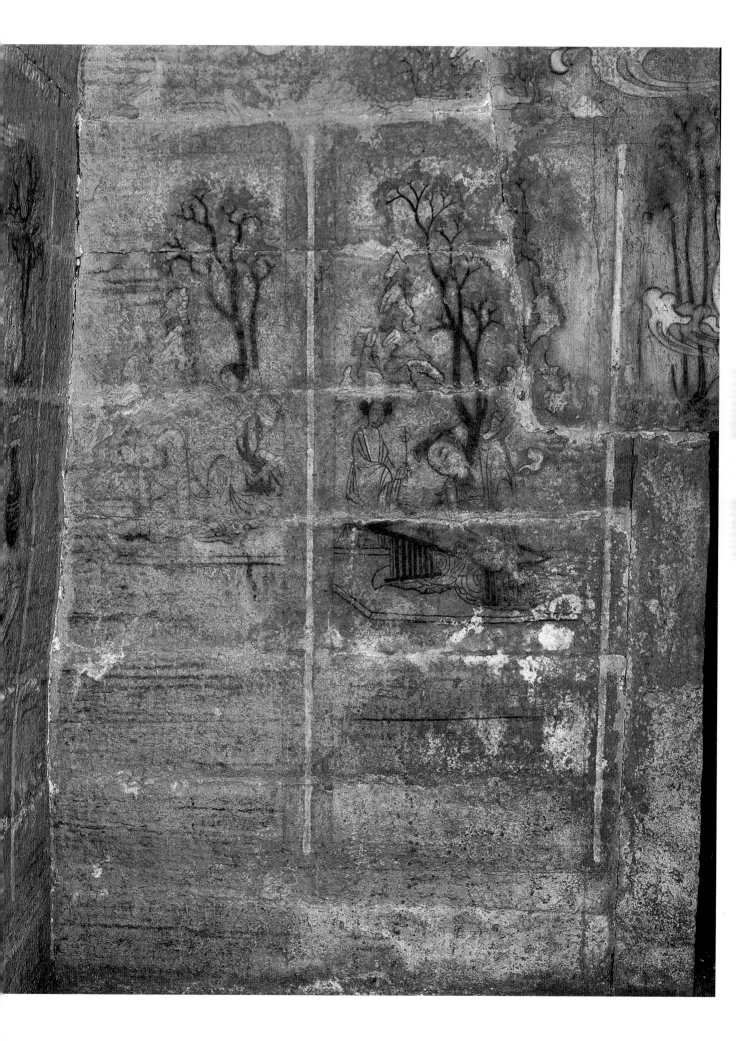

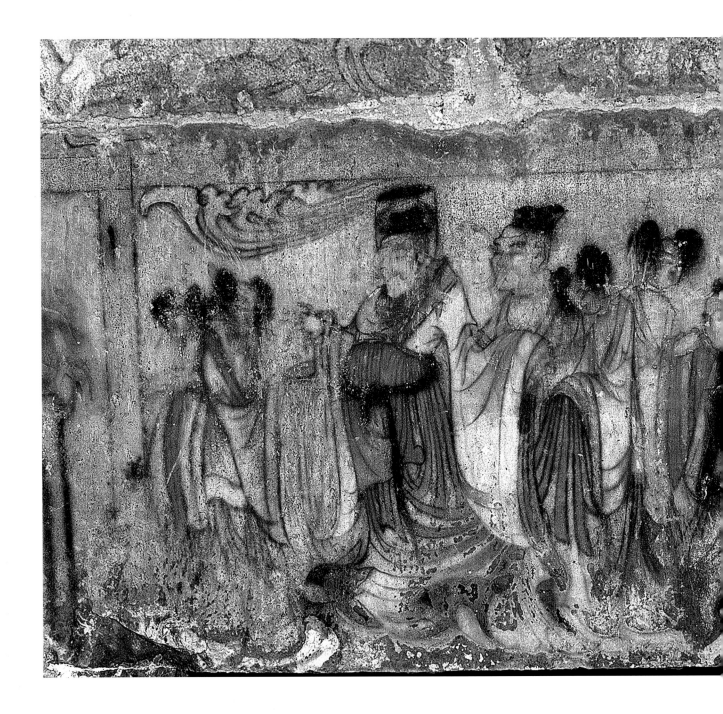

59. 出行图

北齐天保二年（551年）

高57、宽147厘米

1986年山东省临朐县冶源镇海浮山崔芬墓出土。原址保存。

墓向150°。位于墓室西壁龛额以上部位。绘制内容当为墓主人夫妇出行的场面。画面横向展开，由十六个人物组成，绘有三男十三女，正南向行进（向左）。画面中最突出的形象为左起第三人，此人为一中年男子形象，神态威严，周围婢仆簇拥。画面左上角有祥云一朵，其上部绘仙草一株，使画面充实而疏密有致，主从分明。构图繁而不乱，人物顾盼多姿，线条流畅，着色艳丽，体现出作者深厚的绘画功力，是不可多得的北齐人物画杰作。

（撰文：郑同修　摄影：刘小放）

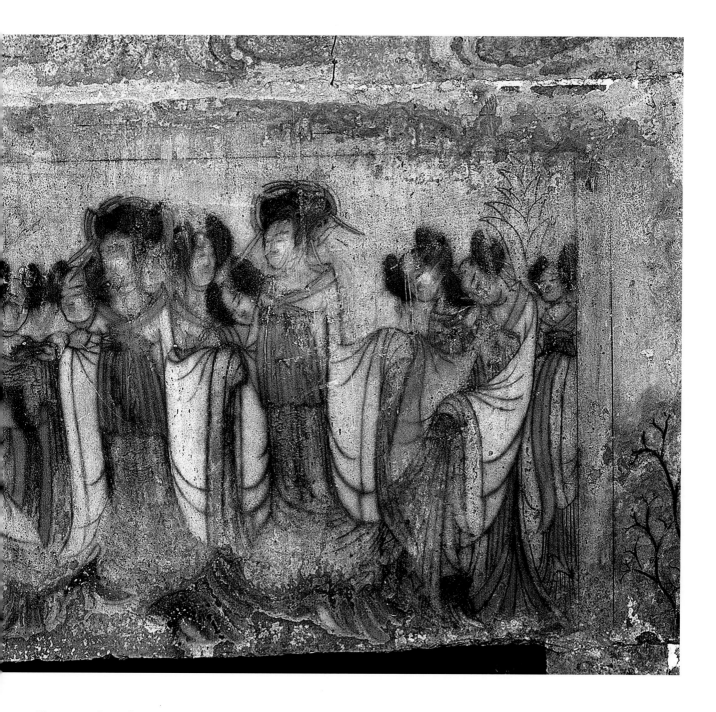

Procession Scene

2nd Year of Tianbao Era, Northern Qi (551 CE)

Height 57 cm; Width 147 cm

Unearthed from the tomb of Cui Fen at Haifushan in Yeyuanzhen of Linquxian, Shandong, in 1986. Preserved on the original site.

60.月象图

北齐天保二年（551年）

高90、宽100厘米

1986年山东省临朐县冶源镇海浮山崔芬墓出土。原址保存。

墓向150°。位于墓室西壁白虎图左侧，白虎左上方绘有两株高大的树木，一轮圆月绘在两树中间，月象内绘有玉兔捣药，旁有蟾蜍。再前方衬有绿树四株。

（撰文：郑同修　摄影：刘小放）

Lunar Phenomena

2nd Year of Tianbao Era, Northern Qi (551 CE)

Height 90 cm; Width 100 cm

Unearthed from the tomb of Cui Fen at Haifushan in Yeyuanzhen of Linquxian, Shandong, in 1986. Preserved on the original site.

61.仙人驭虎图

北齐天保二年（551年）

高90、宽330厘米

1986年山东省临朐县冶源镇海浮山崔芬墓出土。原址保存。

墓向150°。位于墓室西壁出行图上方。白虎有翼，南向作奔驰状，虎尾平伸，四爪张开，脚踩云气，昂首吐长舌，双目圆睁凸出，神态威猛。虎头上部饰祥云两朵，虎背上骑乘一头戴花冠的女相驭虎神人。神人腮部施胭脂，唇涂朱红，身上红色衣带随风飘起。虎前后方各绘一作急驰状驰鬼逐疫的方相氏。

（撰文：郑同修　摄影：刘小放）

Immortal Riding Tiger

2nd Year of Tianbao Era, Northern Qi (551 CE)

Height 90 cm; Width 330 cm

Unearthed from the tomb of Cui Fen at Haifushan in Yeyuanzhen of Linquxian, Shandong, in 1986. Preserved on the original site.

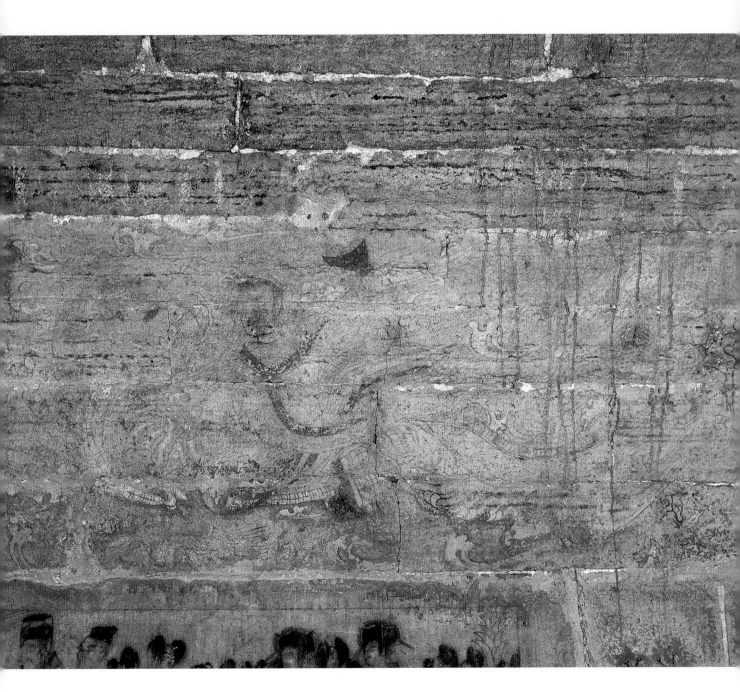

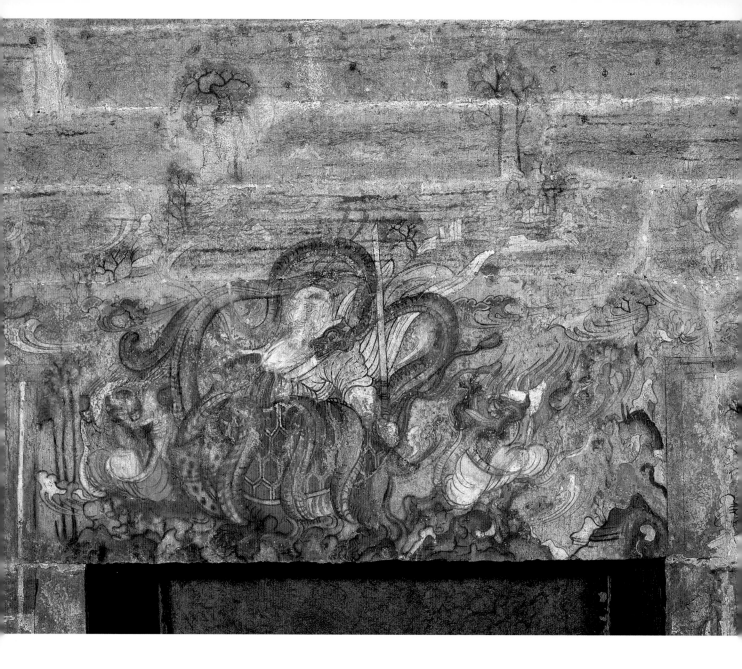

62.玄武图

北齐天保二年（551年）

高120、长330厘米

1986年山东省临朐县冶源镇海浮山崔芬墓出土。原址保存。

墓向150°。位于墓室北壁中部延伸至室顶下部、龛额上部，绘西向驱驰玄武。玄武绘有中心部位，为龟蛇缠绕的龟蛇合体。玄武下面有云气承托，龟背上骑乘仗剑神人，龟头引颈后望至神人胸前，蛇体缠绕龟体数周后，蛇头绕至神人左肩上部与龟首相对，蛇口喷白雾，蛇尾半卷，飘在神人头部前方。神人头部前后有祥云数朵。神人束发戴小方冠，红色束带高高飘起，胡须短而翘起，怒目圆睁，面部神态威严凶狠。左手所执长刀几近垂直，且恰处在墓壁的中间。龟体前后画有驱鬼逐疫的方相氏。前面的方相氏作回首状，其前还绘有祥云一朵，绿树两株。后面的方向氏口吐长舌，面目狰狞，紧相跟随，其后为祥云、树木、山峦、莲花状仙草等。画面远处，神人前方还有一方相氏作回返奔跑状，画面最后端也有一方相氏作追赶状。图的右侧远景有六组绿树两两对应。整组画面构图疏密相间，气势恢弘。保存情况相对较好，是四神图中保存最好的一幅。

（撰文：郑同修　摄影：刘小放）

Sombre Warrior

2nd Year of Tianbao Era, Northern Qi (551 CE)

Height 120 cm; Width 330 cm

Unearthed from the tomb of Cui Fen at Haifushan in Yeyuanzhen of Linquxian, Shandong, in 1986. Preserved on the original site.

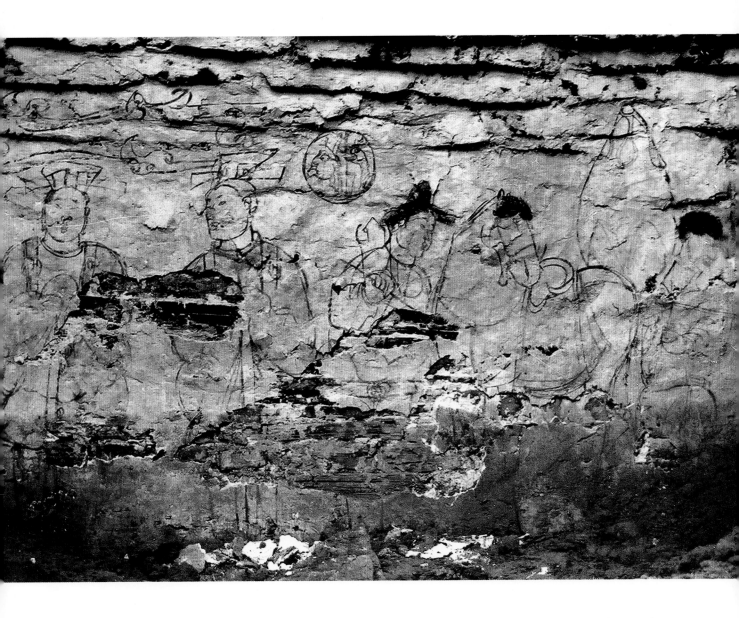

63.墓主人出行图

北齐武平二年（570年）

高约150、宽约340厘米

1984年山东省济南市文化东路冶金宾馆院内北齐墓出土。原址保存。

墓向190°。位于墓室东壁，系在白灰面上绘制壁画。画面北端绘持仪仗卫两人，皆戴贯穿骨笄的小冠，着圆领窄袖裲裆衫，两手拱于胸前，挂板杖。南端绘一回首嘶鸣的鞍马，马前一驭吏，手持鞭，马尾绘一驭役深目高鼻。

（撰文：李铭　摄影：济南市博物馆）

Procession Scene of Tomb Occupant

2nd Year of Wuping Era, Northern Qi (570 CE)

Height ca. 150 cm; Width ca. 340 cm

Unearthed from the Northern Qi tomb at the courtyard of Yejin Hotel in East Wenhua Road of Jinan, Shandong, in 1984. Preserved on the original site.

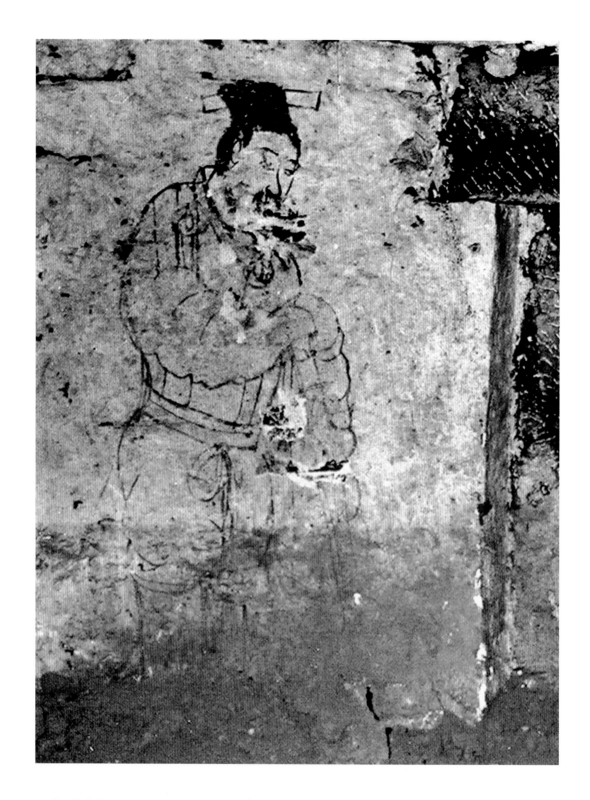

64.门吏图（一）

北齐武平二年（570年）

高约150、宽约100厘米

1984年山东省济南市文化东路冶金宾馆院内北齐墓出土。原址保存。

墓向190°。位于墓室南壁墓门的东侧，门卫身着长袍，黑胡须，双手拱于胸前，拄斑剑，神态肃穆。

（撰文：李铭　摄影：济南市博物馆）

Door Guard (1)

2nd Year of Wuping Era, Northern Qi (570 CE)
Height ca. 150 cm; Width ca. 100 cm
Unearthed from the Northern Qi tomb at the courtyard of Yejin Hotel in East Wenhua Road of Jinan, Shandong, in 1984. Preserved on the original site.

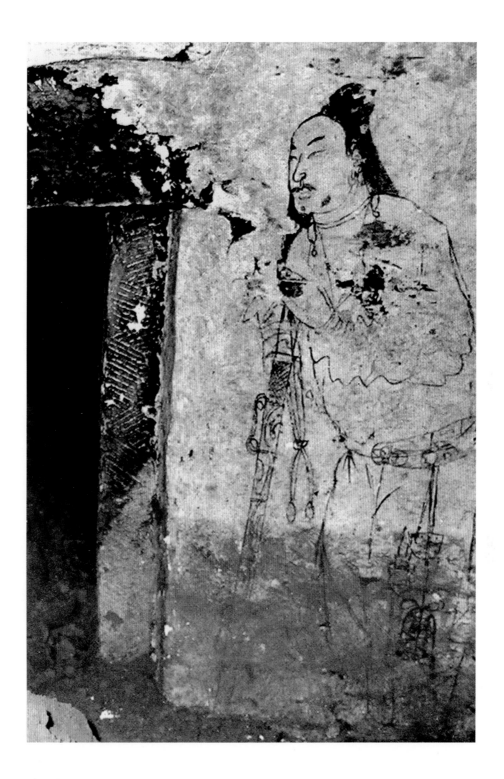

65.门吏图（二）

北齐武平二年（570年）

高约150、宽约100厘米

1984年山东省济南市文化东路冶金宾馆院内北齐墓出土。
原址保存。

墓向190°。位于墓室南壁墓门的西侧，门卫头戴黑弁
帽，身着紧身翻领袖长衫，腰束带，黑胡须，双手拱于胸
前，拄斑剑，神态肃穆。

（撰稿：李铭　摄影：济南市博物馆提供）

Door Guard (2)

2nd Year of Wuping Era, Northern Qi
(570 CE)

Height ca. 150 cm; Width ca. 100 cm
Unearthed from the Northern Qi tomb
at the courtyard of Yejin Hotel in East
Wenhua Road of Jinan, Shandong,
in1984. Preserved on the original site.

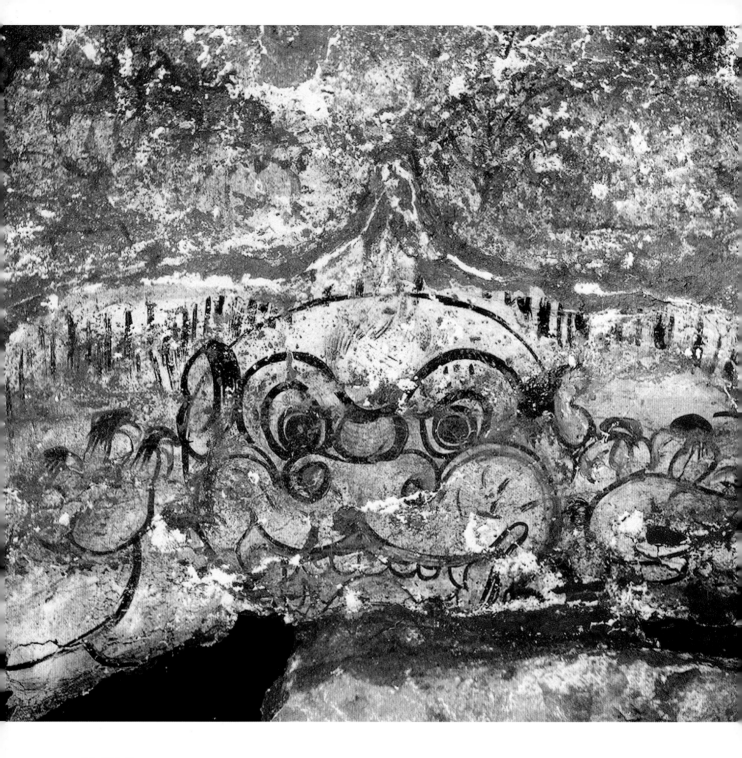

66.怪兽图

北齐武平二年（570年）

高约40、宽约80厘米

1984年山东省济南市文化东路冶金宾馆院内北齐墓出土。原址保存。

墓向190°。位于墓门门楣，以墨线勾绘猛兽，怒目圆睁，张牙舞爪，爪各三趾，注视前方。形象似为老虎，线条粗犷奔放有力。应属白虎形象。

（撰文：李铭　摄影：济南市博物馆）

Mythical Animal

2nd Year of Wuping Era, Northern Qi (570 CE)

Height ca. 40 cm; Width ca. 80 cm

Unearthed from the Northern Qi tomb at the courtyard of Yejin Hotel in East Wenhua Road of Jinan, Shandong, in 1984. Preserved on the original site.

67.墓主夫人出行图

北齐武平二年（570年）

高约150、宽约340厘米

1984年山东省济南市文化东路冶金宾馆院内北齐墓出土。原址保存。

墓向190°。位于墓室西壁，墓主夫人在中间，左右各站一侍女，一辆精致马车停在墓主夫人的右侧，与东壁组成夫妇出行的画面。

<div align="right">（撰文：李铭　摄影：济南市博物馆）</div>

Procession Scene of Tomb Occupant's Wife

2nd Year of Wuping Era, Northern Qi (570 CE)

Height ca. 150 cm; Width ca. 340 cm

Unearthed from the Northern Qi tomb at the courtyard of Yejin Hotel in East Wenhua Road of Jinan, Shandong, in 1984. Preserved on the original site.

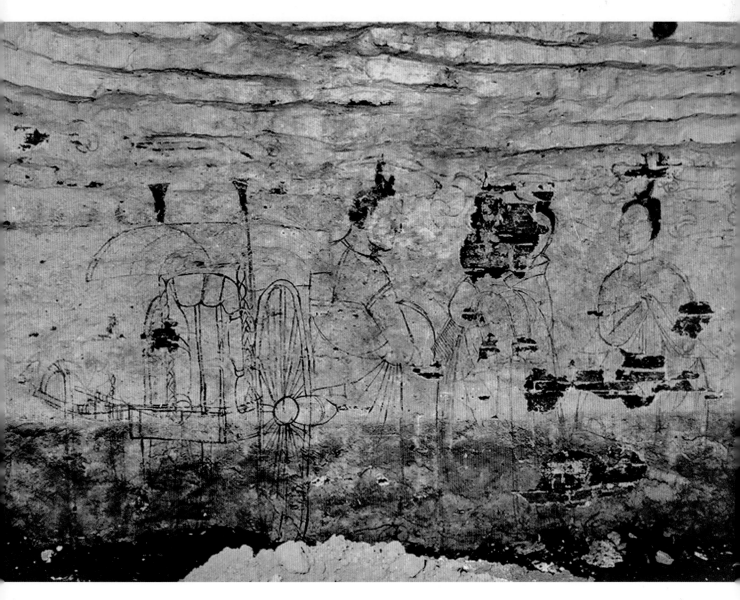

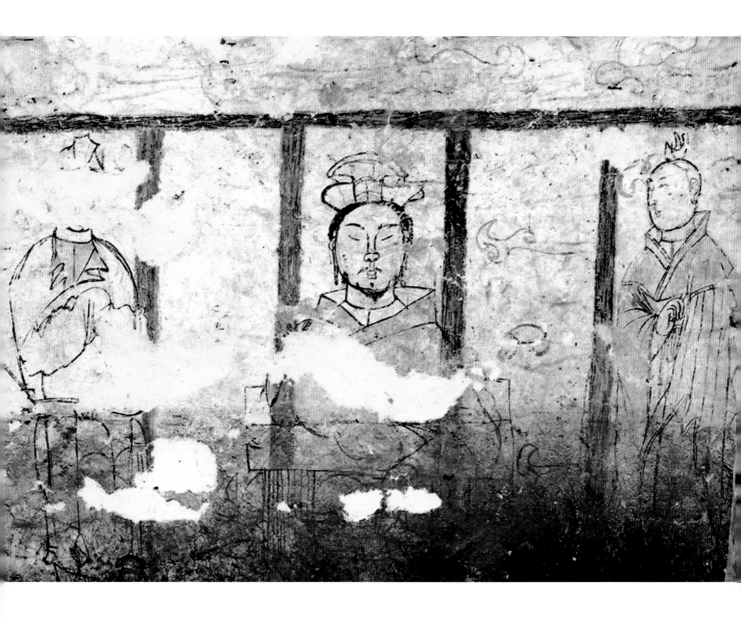

68.墓主人图

北齐武平二年（570年）

高约150、宽约250厘米

1984年山东省济南市文化东路冶金宾馆院内北齐墓出土。原址保存。

墓向190°。位于墓室北壁中部（局部），墓主人端坐中央，左右各站一侍从，后有九扇屏。

（撰文：李铭 摄影：济南市博物馆）

Portrait of Tomb Occupant

2nd Year of Wuping Era, Northern Qi (570 CE)

Height ca. 150 cm; Width ca. 250 cm

Unearthed from the Northern Qi tomb at the courtyard of Yejin Hotel in East Wenhua Road of Jinan, Shandong, in 1984. Preserved on the original site.

69.徐敏行夫人出行图

隋开皇四年（584年）

高91、宽121厘米

1976年山东省嘉祥县英山徐敏行墓出土。现存于山东博物馆。

墓向南略偏西。位于墓室东壁。最前列是一帷屏牛车，应是女主人乘坐的安车，由四侍从护卫前行；车后为四个女侍，捧巾等器物；最后为饲犬人与双犬。所画人物都用铁线描，平涂颜色，用笔简练。

<div align="right">（撰文：杨波　摄影：王书德）</div>

Procession Scene of Xu Minxing's wife

4th Year of Kaihuang Era, Sui (584 CE)

Height 91 cm; Width 121 cm

Unearthed from the tomb of Xu Minxing at Yingshan in Jiaxiang, Shandong, in 1976. Preserved in the Shandong Museum.

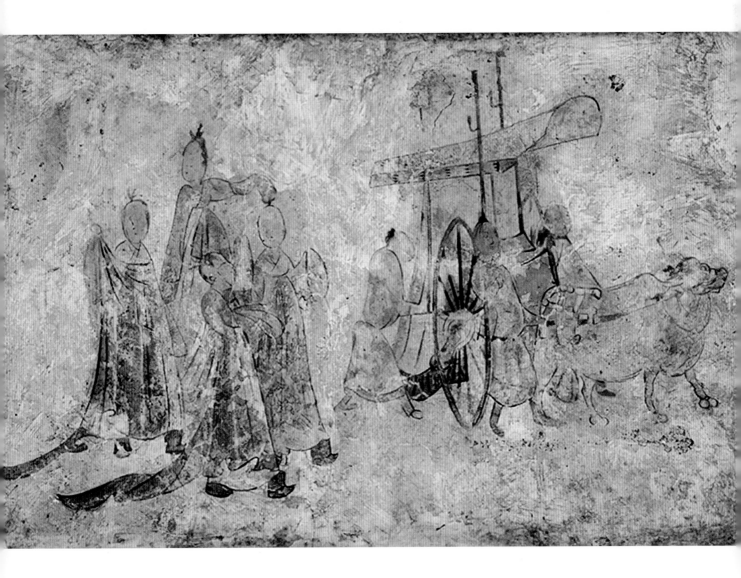

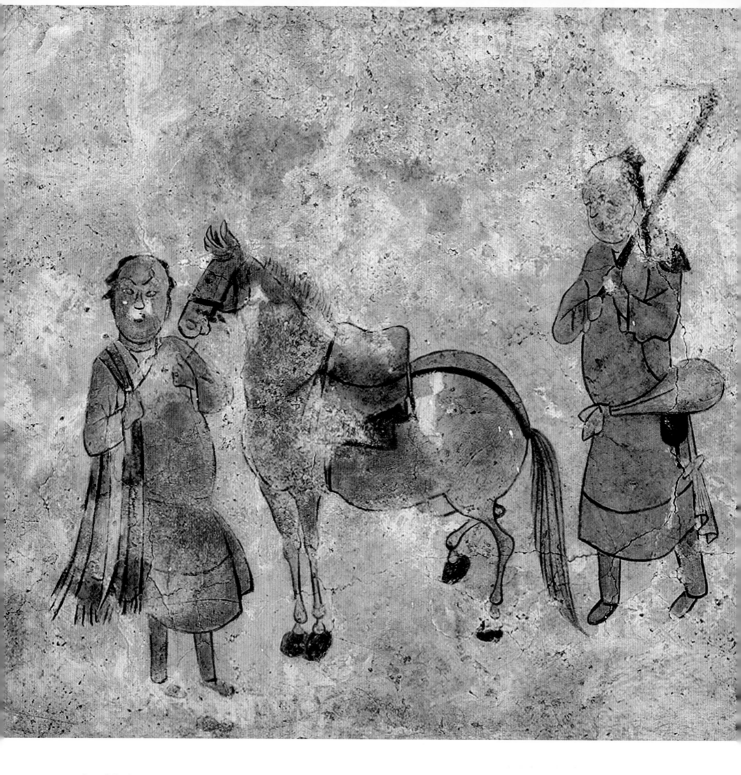

70. 备骑图

隋开皇四年（584年）

高63、宽68.5厘米

1976年山东省嘉祥县英山徐敏行墓出土。现存于山东博物馆。

墓向南略偏西。位于墓室西壁，共有三组、两组画人和马，一组为仪仗队，似为准备男主人出行场面。三组之间浑然一体，彼此呼应，此幅图所画二人一马，其中一人执缰，一人携乐器立马后，表现了备马的生动场景。

（撰文：杨波　摄影：王书德）

Horse Preparing Scene

4th Year of Kaihuang Era, Sui (584 CE)

Height 63 cm; Width 68.5 cm

Unearthed from the tomb of Xu Minxing at Yingshan in Jiaxiang, Shandong, in 1976. Preserved in the Shandong Museum.

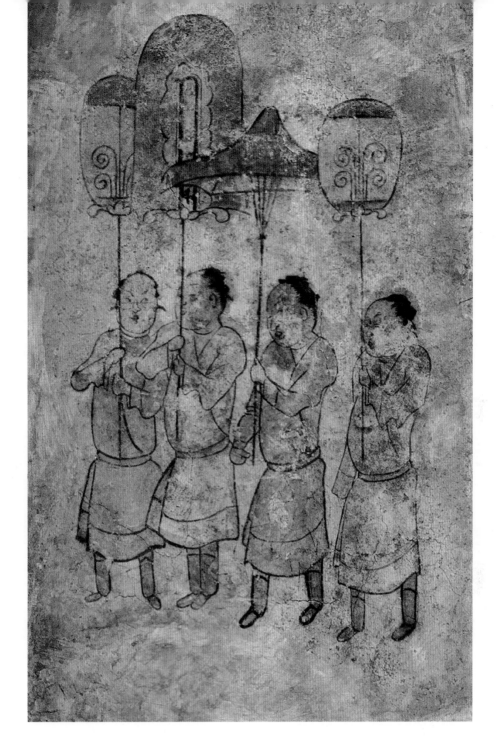

71.侍从图

隋开皇四年（584年）

高90、宽60厘米

1976年山东省嘉祥县英山徐敏行墓出土。现存于山东博物馆。

墓向南略偏西。位于墓室西壁中部，画面上四人身着贺领或翻领衫袍，并肩而立，二人执灯，一人执伞，一人执扇。虽然四人并肩站立，但看起来毫无呆滞之感。

（撰文：杨波　摄影：王书德）

Attendants

4th Year of Kaihuang Era, Sui (584 CE)

Height 90 cm; Width 60 cm

Unearthed from the tomb of Xu Minxing in Yingshan in Jiaxiang, Shandong, in 1976.
Preserved in the Shandong Museum.

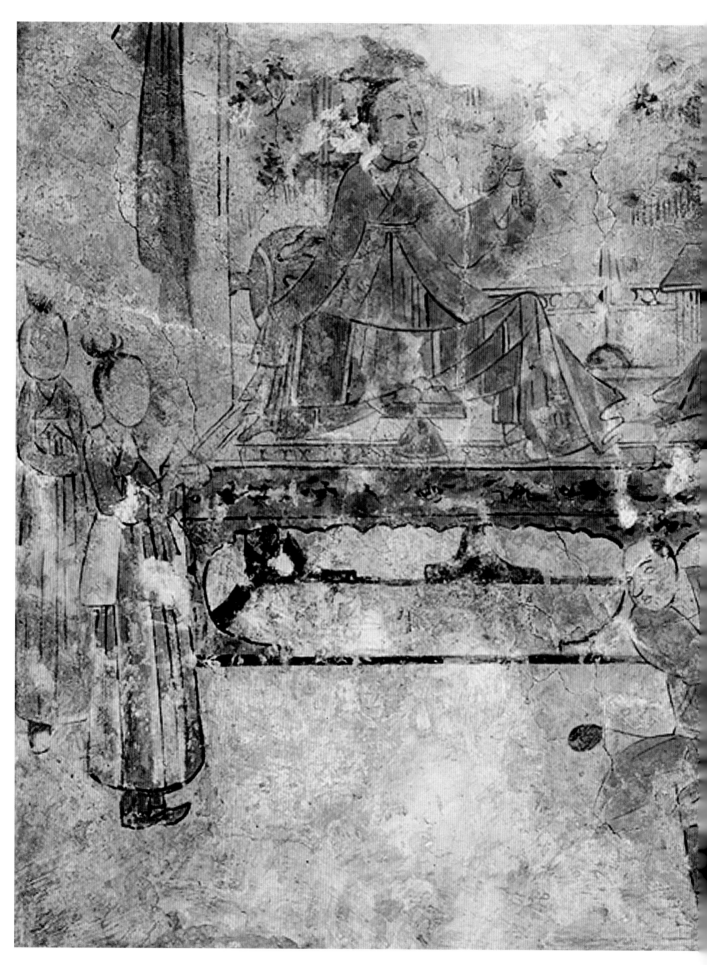

72.宴享行乐图

隋开皇四年（584年）

高74、宽93厘米

1976年山东省嘉祥县英山徐敏行墓出土。现存于山东博物馆。

墓向南略偏西。位于墓室北壁，描写了墓主人徐敏行夫妇生前宴饮场景：画上绛帐开启，悬垂于榻两旁，徐敏行夫妇正襟端坐木榻上，手中各执一高足透明杯，面前摆满果蔬食品，背后设一山水屏风。木榻两边各站两个侍女，榻前一人腰束皮带，带上系一球状物，圆球跃起，飘然欲动，似为早期的蹴鞠之戏。

（撰文：杨波　摄影：王书德）

Feasting and Amusement

4th Year of Kaihuang Era, Sui (584 CE)

Height 74 cm; Width 93 cm

Unearthed from the tomb of Xu Minxing at Yingshan in Jiaxiang, Shandong, in 1976. Preserved in the Shandong Museum.

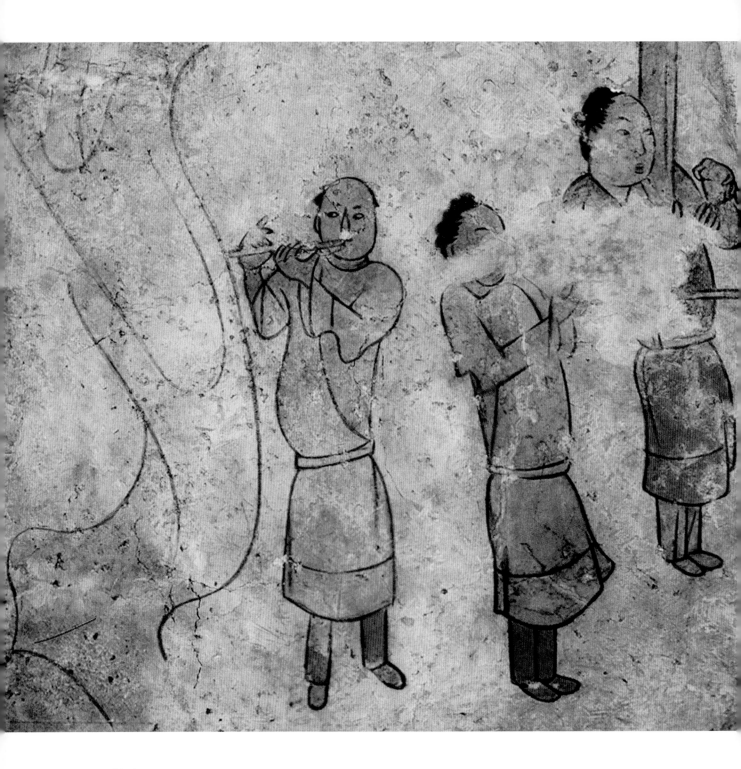

73.伎乐图

隋开皇四年（584年）

高62、宽64.5厘米

1976年山东省嘉祥县英山徐敏行墓出土。现存于山东博物馆。

墓向南略偏西。位于墓室北壁徐敏行夫妇木榻左边，有三人于树下奏乐，持横笛等乐器，人物造型比例合度，神姿栩栩如生。

（撰文：杨波　摄影：王书德）

Music Band Playing

4th Year of Kaihuang Era, Sui (584 CE)

Height 62 cm; Width 64.5 cm

Unearthed from the tomb of Xu Minxing at Yingshan in Jiaxiang, Shandong, in 1976. Preserved in the Shandong Museum.

74.桌椅图

北宋建隆元年（960年）

高120、宽140厘米

1986年山东省济南市经十路山东大学千佛山校区北宋墓出土。已残毁。

墓向175°。位于墓室东壁，两柱之间绘有一桌二椅，方桌为鹤膝桌，足部做出马蹄，上置注壶和台盏，桌两侧各绘一椅，特意画得变形，使椅面向前，椅面上绘方框，四隅为圆弧，中心为四瓣花卉。

（撰文：刘善沂　摄影：济南市博物馆）

Table and Chairs

1st Year of Jianlong Era, Northern Song (960 CE)

Height 120 cm; Width 140 cm

Unearthed from the Northern Song tomb at Qianfoshan campus of Shandong University in Jingshi Road of Jinan, Shandong, in 1986. Not preserved.

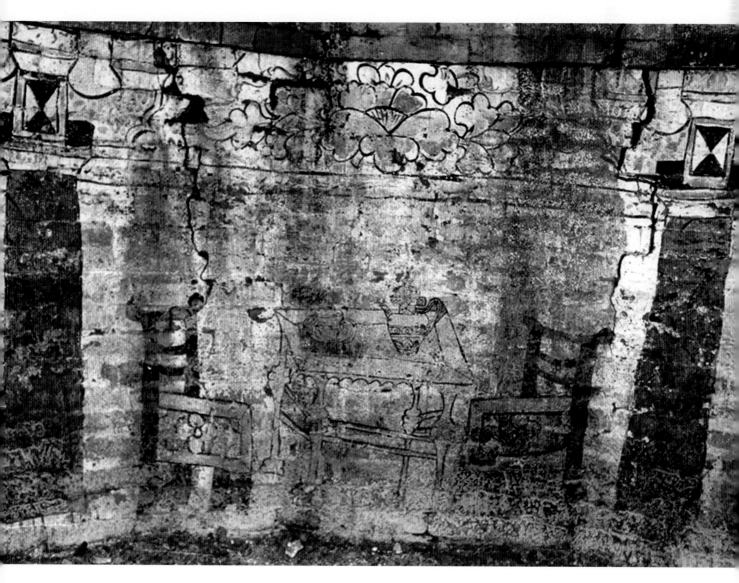

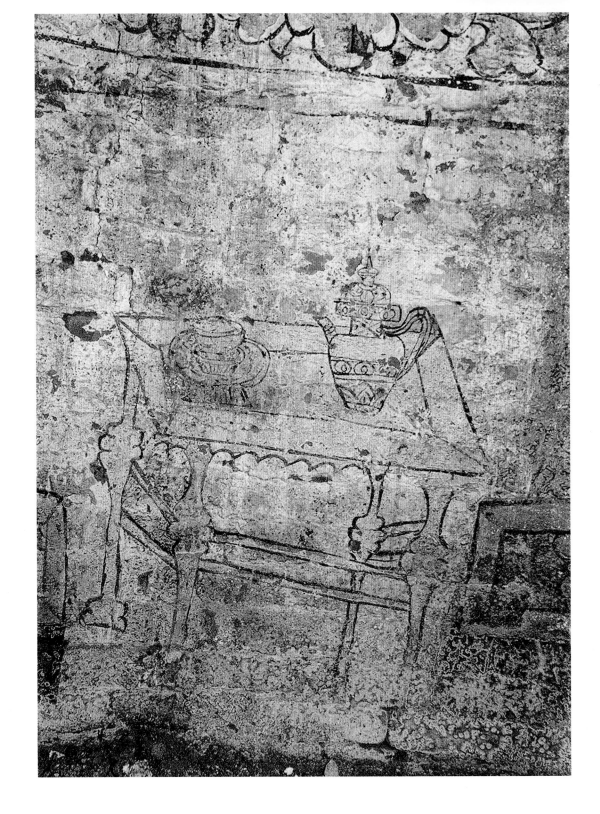

75.桌椅图（局部）

北宋建隆元年（960年）

高60、宽55厘米

1986年山东省济南市经十路山东大学千佛山校区北宋墓出土。
已残毁。

墓向175°。位于墓室东壁中段，正中为一鹤膝桌，上置一把
注壶和一套台盏，桌面下部有二横撑，桌面与横撑之间作壶门
样式，桌腿下部翻作马蹄状。

（撰文：刘善沂　摄影：济南市博物馆）

Table and Chairs (Detail)

1st Year of Jianlong Era, Northern Song
(960 CE)

Height 60 cm; Width 55 cm

Unearthed from the Northern Song tomb
at Qianfoshan campus of Shandong
University in Jingshi Road of Jinan,
Shandong, in 1986. Not preserved.

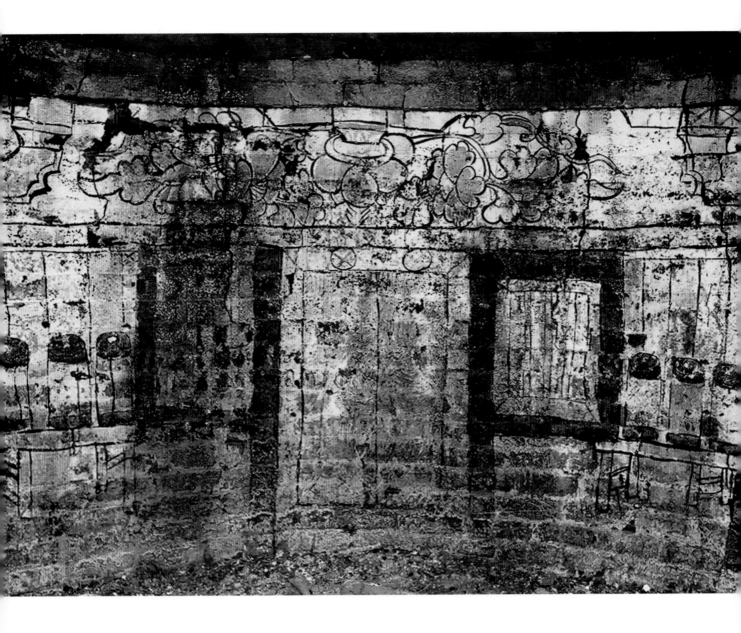

76.门窗图

北宋建隆元年（960年）

高约100、宽约200厘米

1986年山东省济南市经十路山东大学千佛山校区北宋墓出土。已残毁。

墓向175°。位于墓室北壁，中间为板门，门框上有两枚圆形门簪，门两侧为直棂窗，两窗旁有架，上挂有蓝、黄等色布匹，架前各放一条长案，上置三卷布匹。

（撰文、摄影：李铭）

Door and Windows

1st Year of Jianlong Era, Northern Song (960 CE)

Height ca. 100 cm; Width ca. 200 cm

Unearthed from the Northern Song tomb at Qianfoshan campus of Shandong University in Jingshi Road of Jinan, Shandong, in 1986. Not preserved.

77.箱和灯檠图

北宋建隆元年（960年）

高约100、宽约100厘米

1986年山东省济南市经十路山东大学千佛山校区北宋墓出土。已残毁。

墓向175°。位于墓室东南壁，画面南侧为安放有"品"字形灯盏的灯檠，北侧矮柜上放置一箱。

（撰文、摄影：李铭）

Case and Lamp Stand

1st Year of Jianlong Era, Northern Song (960 CE)

Height ca. 100 cm; Width ca. 100 cm

Unearthed from the Northern Song tomb at Qianfoshan campus of Shandong University in Jingshi Road of Jinan, Shandong, 1986. Not preserved.

78.衣架图

北宋建隆元年（960年）

高约100、宽约150厘米

1986年山东省济南市经十路山东大学千佛山校区北宋墓出土。已残毁。

墓向175°。位于墓室西壁，在两倚柱之间放一衣架，上挂有布帛，下方有两个大罐和熨斗；右侧有一立柜，柜上放一大盖盒，似为漆盒。

（撰文、摄影：李铭）

Clothes Stand

1st Year of Jianlong Era, Northern Song (960 CE)

Height ca. 100 cm; Width ca. 150 cm

Unearthed from the Northern Song tomb at Qianfoshan campus of Shandong University in Jingshi Road of Jinan, Shandong, in 1986. Not preserved.

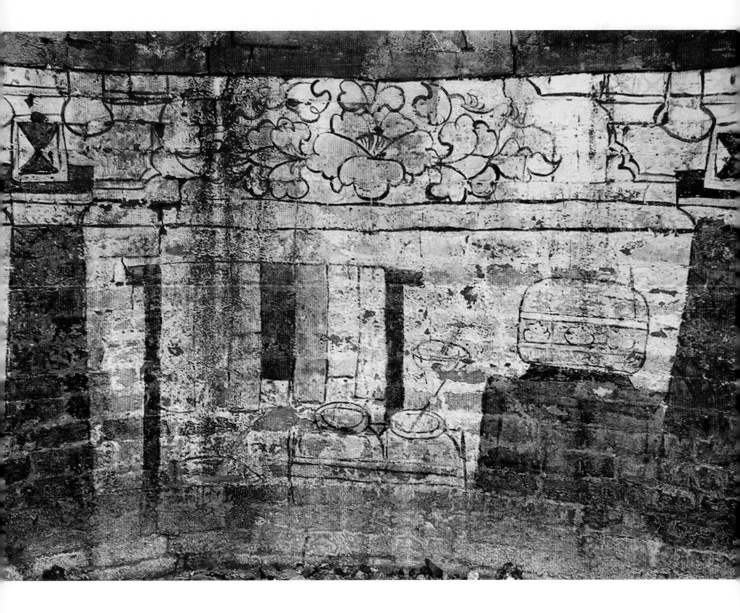

79.谷物处理图

北宋建隆元年（960年）

高约100、宽约100厘米

1986年山东省济南市经十路山东大学千佛山校区北宋墓出土。已残毁。

墓向175°。位于墓室西南壁，画面为两组木架，左侧架中部有一栏杆，下部有一大臼，为春米架，右侧木架中有一斜置的筛子，为筛米工具。

（撰文、摄影：李铭）

Grain Processing

1st Year of Jianlong Era, Northern Song (960 CE)

Height ca. 100 cm, Width ca. 100 cm

Unearthed from the Northern Song tomb at Qianfoshan campus of Shandong University in Jingshi Road of Jinan, Shandong, in 1986. Not preserved..

80. 拱眼壁牡丹花卉图（局部）

北宋建隆元年（960年）

高约30、宽约88厘米

1986年山东省济南市经十路山东大学千佛山校区北宋墓出土。已残毁。

墓向175°。位于墓室北壁正上方，为两柱斗拱之间拱眼壁上绘缠枝牡丹花卉。

（撰文、摄影：济南市博物馆）

Peony between Bracket Sets (Detail)

1st Year of Jianlong Era. Northern Song (960 CE)

Height ca. 30 cm; Width ca. 88 cm

Unearthed from the Northern Song tomb at Qianfoshan campus of Shandong University in Jingshi Road of Jinan, Shandong, in 1986. Not preserved.

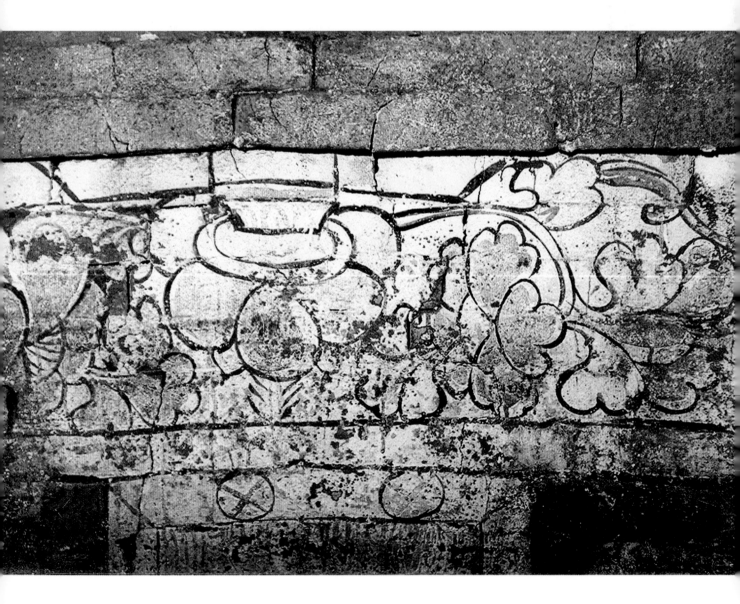

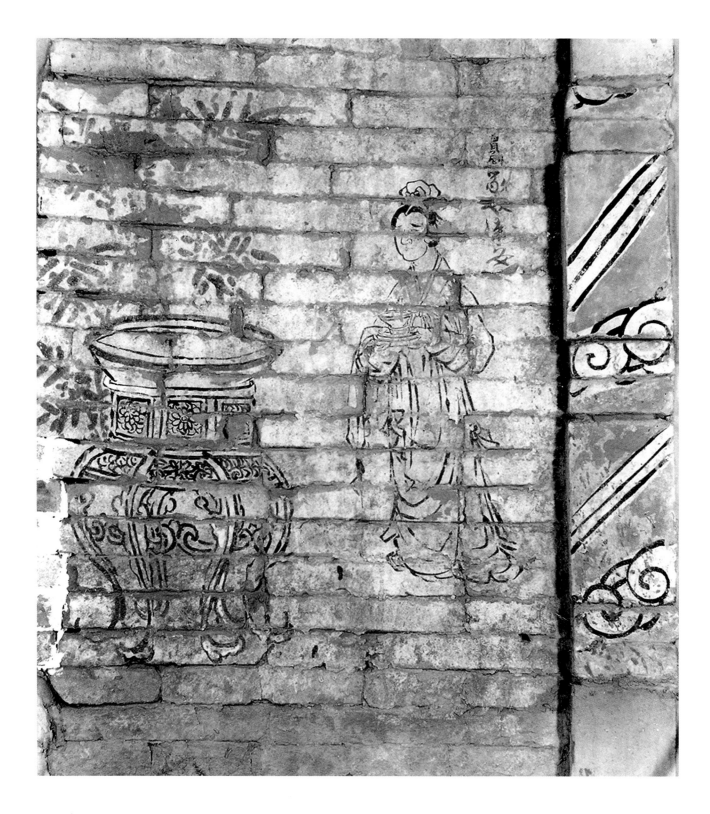

81.家婢图

金承安二年（1197年）

高100、宽74厘米

1979年山东省高唐县寒寨乡谷官屯村虞寅墓出土。现存于聊城市博物馆。墓向189°。位于墓室的东壁，画面左侧有一直领五蹄足盆架，上置盆。右侧为一女侍，着交领窄袖长衫，双手持酒台子作趋步前行状。女侍右上墨书题记"买到家婢□安"，表明这个形象的身份是墓主家婢女。

（撰文、摄影：刘善沂）

Maid

2nd Year of Cheng'an Era, Jin (1197 CE)

Height 100 cm; Width 74 cm

Unearthed from Yu Yin's tomb at Guguantun in Hanzhai of Gaotang, Shandong, in 1979. Preserved in the Liaocheng Museum.

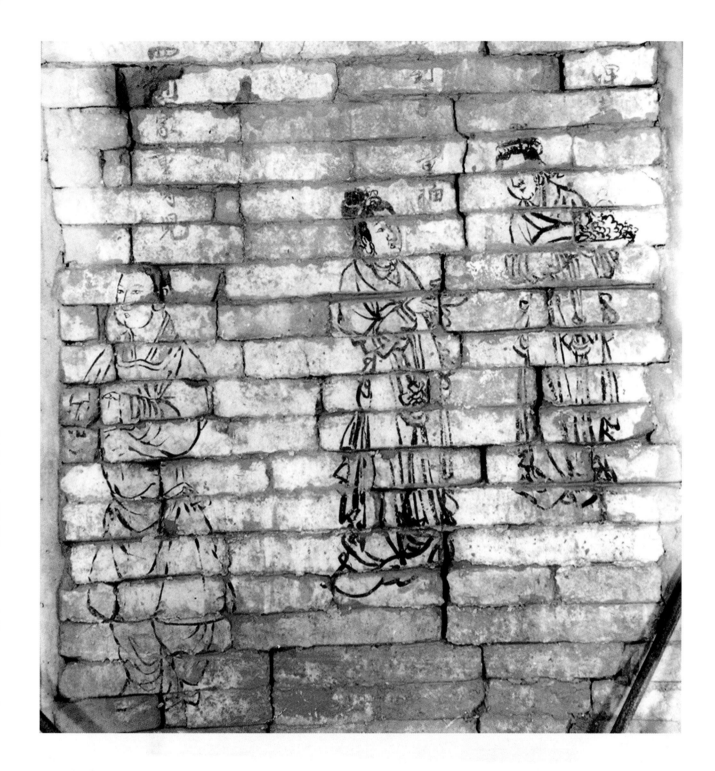

82.家童家婢图

金承安二年（1197年）

高108、宽86厘米

1979年山东省高唐县寒寨乡谷官屯村虞寅墓出土。现存于聊城市博物馆。
墓向189°。位于墓室北壁仿木楼阁建筑东侧，画面左侧为家童，鬈发，着方领窄袖长袍，腰束带，拱手侍立，上方题记"买到家童寿儿"，右侧二人为家婢，左一人梳高髻垂带，着交领窄袖长衫（大袂子），束带于胸部，双手持盘盏，上方题记"买到□□董福"；右一人双手持食盘，着交领窄袖长衫，束带于胸部，从胸前垂下绦环，扭身回望，上方题记"买到家婢□□"。作趋步前行状。

（撰文、摄影：刘善沂）

Child Servant and Maids

2nd Year of Cheng'an Era, Jin (1197 CE)
Height 108 cm; Width 86 cm
Unearthed from Yu Yin's tomb at Guguantun in Hanzhai of Gaotang, Shandong, in 1979. Preserved in the Liaocheng Museum.

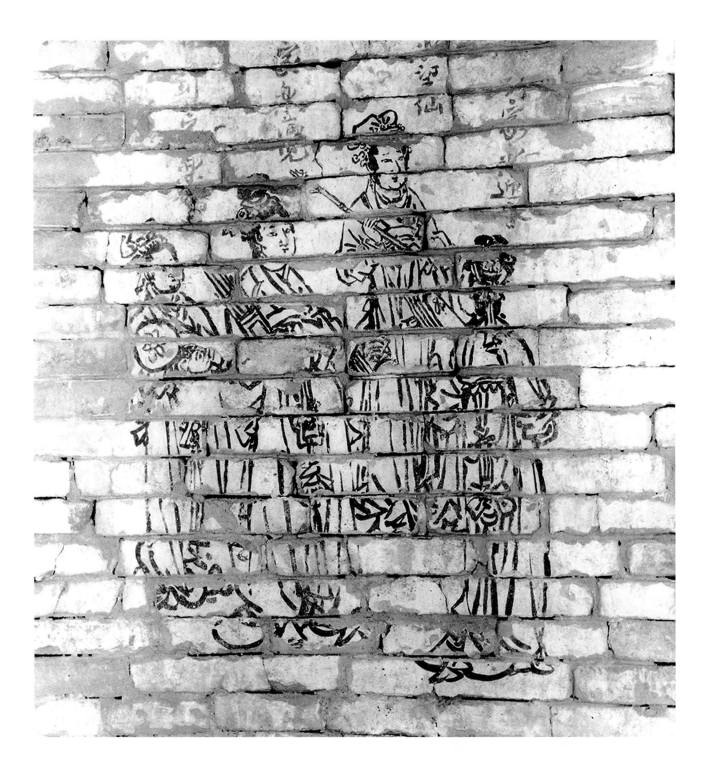

83.伎乐图

金承安二年（1197年）

高100、宽57厘米

1979年山东省高唐县寒寨乡谷官屯村虞寅墓出土。现存于聊城市博物馆。
墓向189°。位于墓室西壁，画面为四个乐伎，梳高髻垂带或包髻，着交领窄
袖长衫，身前后均垂下绦带，分别手持笙、笛、腰鼓、拍板等乐器。四人上方
均有墨书题记，分别标明此四人的身份及姓名，从右至左分别为"买到家乐迎
咏"、"家乐望仙"、"家乐□儿"、"买到家乐娇□"。

（撰文、摄影：刘善沂）

Music Band Playing

2nd Year of Cheng'an Era, Jin (1197 CE)
Height 100 cm; Width 57 cm
Unearthed from Yu Yin's tomb at Guguantun
in Hanzhai of Gaotang, Shandong, in 1979.
Preserved in the Liaocheng Museum.

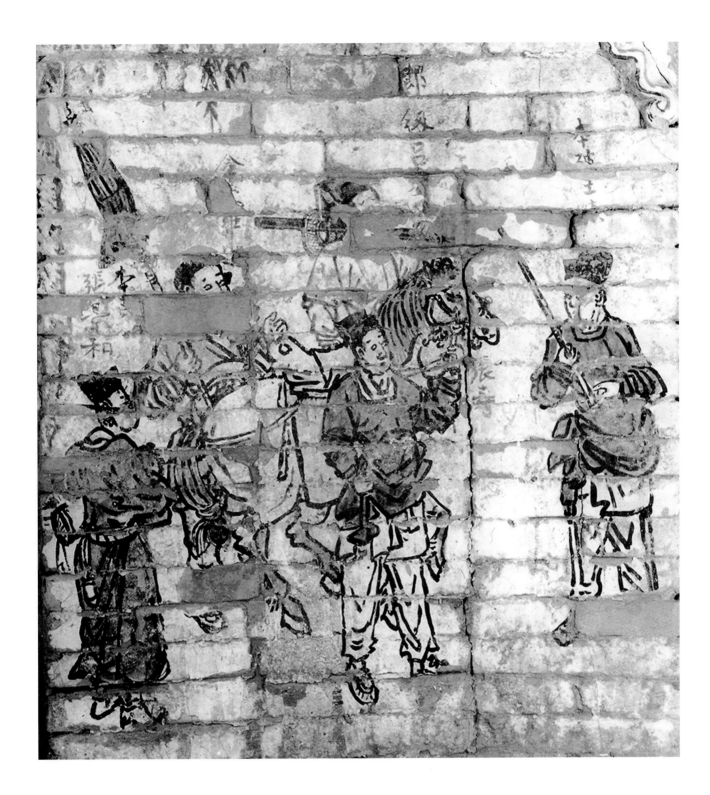

84.出行图

金承安二年（1197年）

高110、宽78厘米

1979年山东省高唐县寒寨乡谷官屯村虞寅墓出土。现存于聊城市博物馆。墓向189°。位于墓室东壁，画面中心为一马，马前一人头戴幞头，短衫着裤持骨朵扛于肩上。马夫持缰立于马前侧。马左侧二人，前者左腋下夹一筒状物，头上有"张景和"题记；后者右肩扛一伞盖，旁侧有"李□"题记。马后立一人，肩扛一物，头上有"郎级吕□"题记。

（撰文、摄影：刘善沂）

Procession Scene

2nd Year of Cheng'an Era, Jin (1197 CE)

Height 110 cm; Width 78 cm

Unearthed from Yu Yin's tomb at Guguantun in Hanzhai of Gaotang, Shandong, in 1979. Preserved in the Liaocheng Museum.

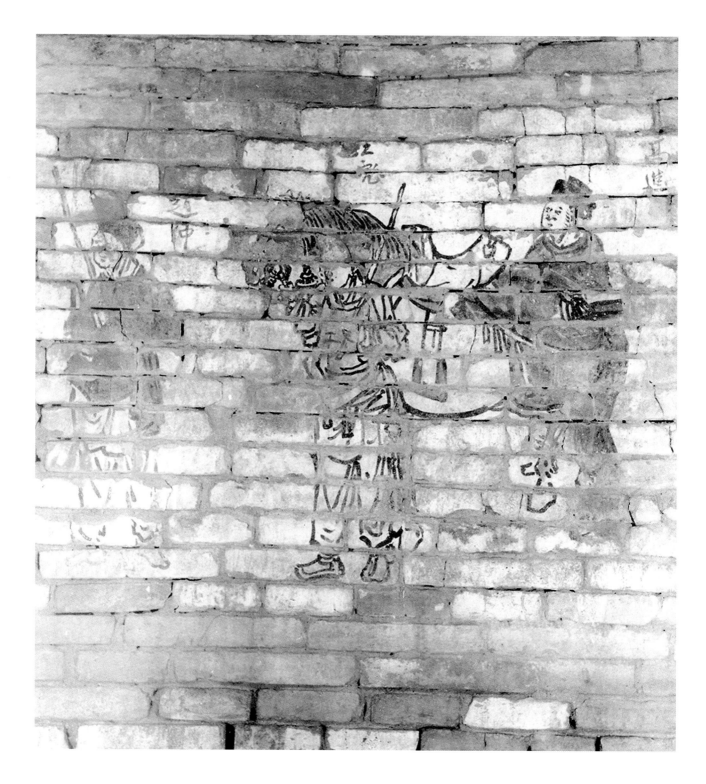

85.牵马图

金承安二年（1197年）

残高100、宽90厘米

1979年山东省高唐县寒寨乡谷官屯村虞寅墓出土。现存于聊城市博物馆。墓向189°。位于墓室西南壁，为三人牵马图，前一人头戴幞头，着盘领窄袖袍，双手持骨朵，中间一鞍马，控马者着盘领窄袖袍，肩扛杖（鞭），立于马左前侧，马右后侧立一人，袖手相随。头裹巾，短衫着裤。三人上方分别有墨书题记，从右到左可辨有"高进"、"□旺儿"、"赵仲"。

（撰文、摄影：刘善沂）

Horse Leading Scene

2nd Year of Cheng'an Era, Jin (1197 CE)

Height of remain 100 cm; Width 90 cm

Unearthed from Yu Yin's tomb at Guguantun in Hanzhai of Gaotang, Shandong, in 1979. Preserved in the Liaocheng Museum.

86. 假门图

金承安二年（1197年）

高85、宽85厘米

1979年山东省高唐县寒寨乡谷官屯村虞寅墓出土。现存于聊城市博物馆。墓向189°。位于墓室北壁。立柣、门框绘缠枝花卉及卷云纹，门半启，左右门板绘门钉，门额绘门簪二枚及连弧纹；拱眼壁内绘穿花凤鸟。

（撰文、摄影：刘善沂）

Phony Door

2nd Year of Cheng'an Era, Jin (1197 CE)

Height 85 cm; Width 85 cm

Unearthed from Yu Yin's tomb at Guguantun in Hanzhai of Gaotang, Shandong, in 1979. Preserved in the Liaocheng Museum.

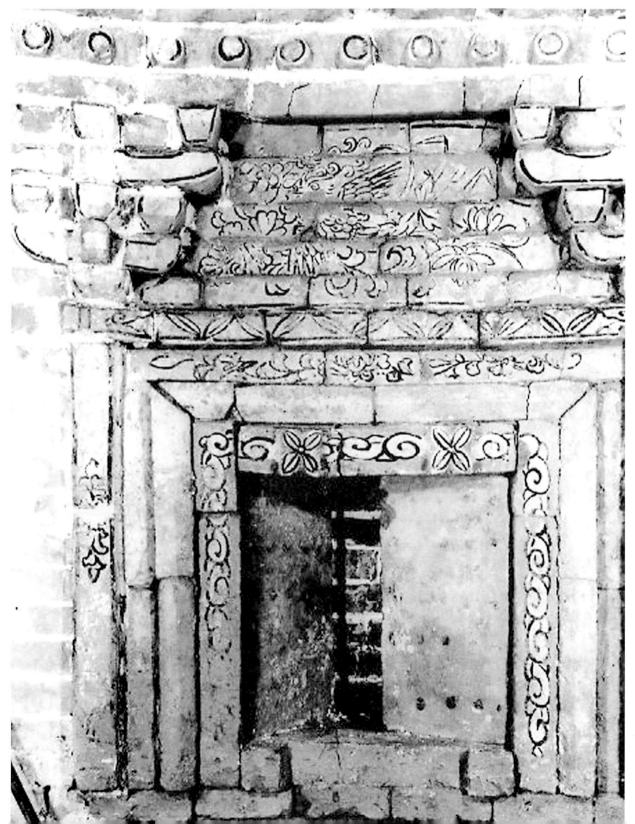

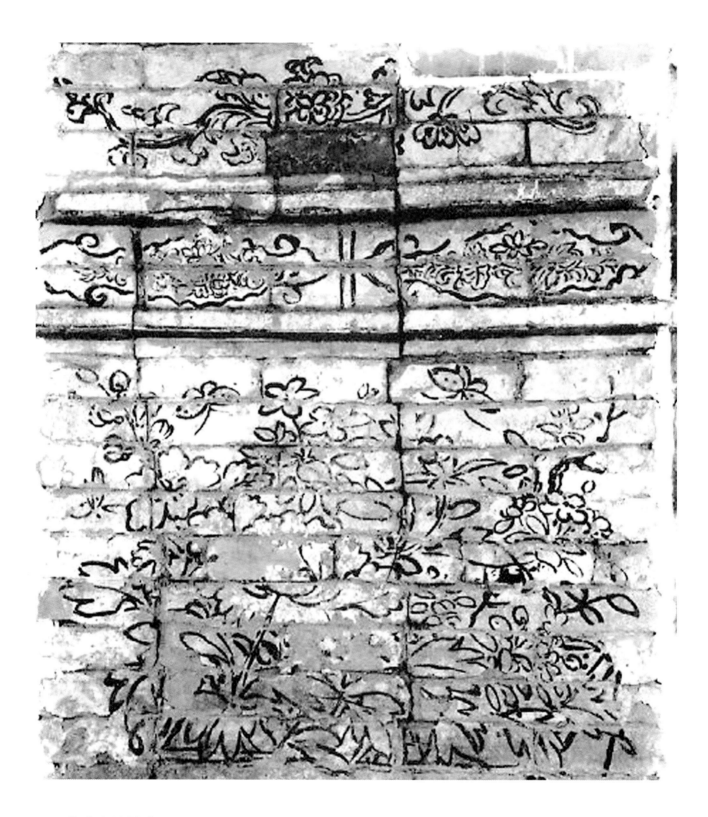

87.花卉屏风图

金承安二年（1197年）

残高90、宽69厘米

1979年山东省高唐县寒寨乡谷官屯村虞寅墓出土。现存于聊城市博物馆。墓向189°。位于墓室东南壁。残存三层画面，上层缠枝花卉，中层表现阑额长的籣头，内绘花卉，下层绘栽牡丹花卉的盆花。

（撰文、摄影：刘善沂）

Flowers Screen

2nd Year of Cheng'an Era, Jin (1197 CE)

Height of remain 90 cm; Width 69 cm

Unearthed from Yu Yin's tomb at Guguantun in Hanzhai of Gaotang, Shandong, in 1979. Preserved in the Liaocheng Museum.

88.仿木建筑楼阁图

金泰和元年（1201年）

高171、宽123厘米

1999年山东省济南市历城区港沟镇中日合资昭和塑料（济南）有限公司厂区1号墓出土。原址保存。

墓向193°。砖雕图像位于墓室北壁，为山花向前式的二层仿木建筑楼阁。上层中间绘妇人启门图，两侧绘带裙板和卷帘的假门；下层立柱间绘三幅婴戏图。建筑两侧绘湖石墨竹。

（撰文、摄影：刘善沂）

Imitation Wooden Tower

1st Year of Taihe Era, Jin (1201 CE)

Height 171 cm; Width 123 cm

Unearthed from tomb M1 at the (Jinan) factory of Sino-Japanese Zhaohe Plastic Limited Company in Ganggouzhen of Licheng district, Jinan, Shandong, in 1999. Preserved on the original site.

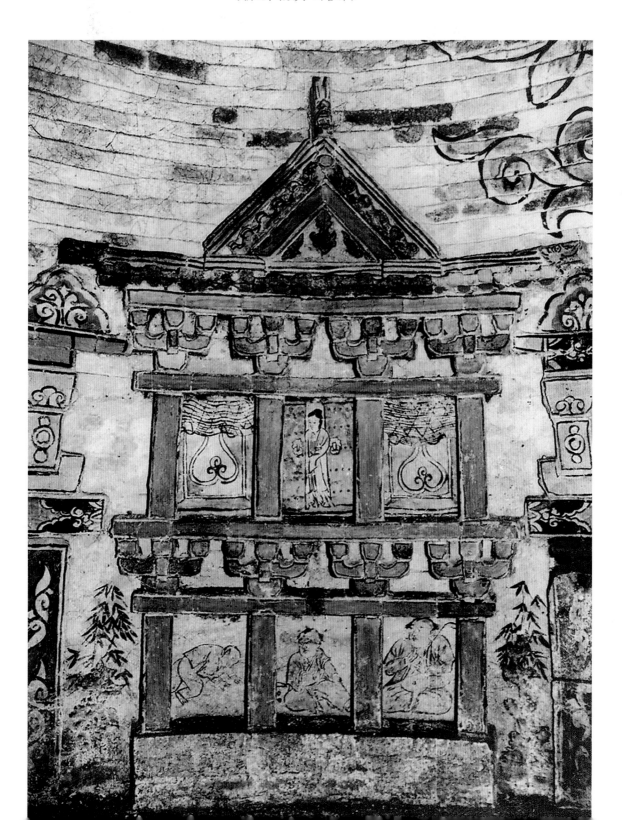

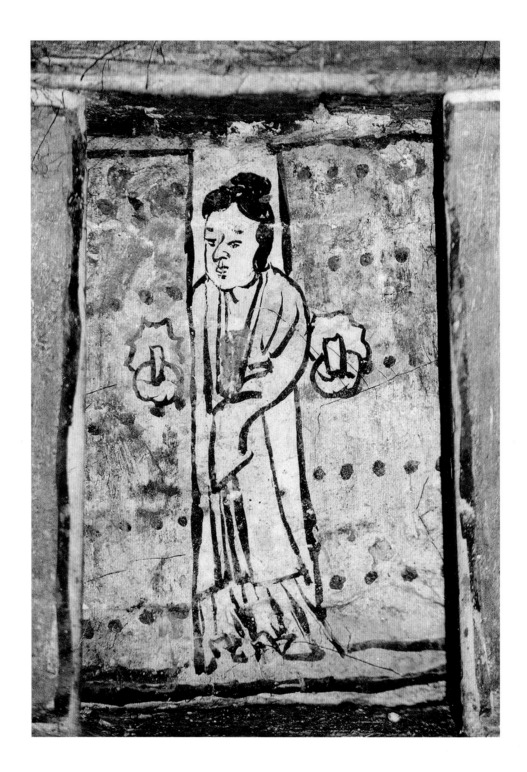

89.妇人启门图

金泰和元年（1201年）

高28、宽20厘米

1999年山东省济南市历城区港沟镇中日合资昭和塑料（济南）有限公司厂区1号墓出土。原址保存。

墓向193°。位于墓室北壁仿木二层楼阁建筑第二层当心之间。二扇门扉半启，门板绘有门钉及铺首衔环，妇人梳高髻，着窄袖绰子，下着裙，立于二门扉之间。

（撰文、摄影：刘善沂）

Lady Opening the Door Ajar

1st Year of Taihe Era, Jin (1201 CE)

Height 28 cm; Width 20 cm

Unearthed from tomb M1 at the (Jinan) factory of Sino-Japanese Zhaohe Plastic Limited Company in Ganggouzhen of Licheng district, Jinan, Shandong, in 1999. Preserved on the original site.

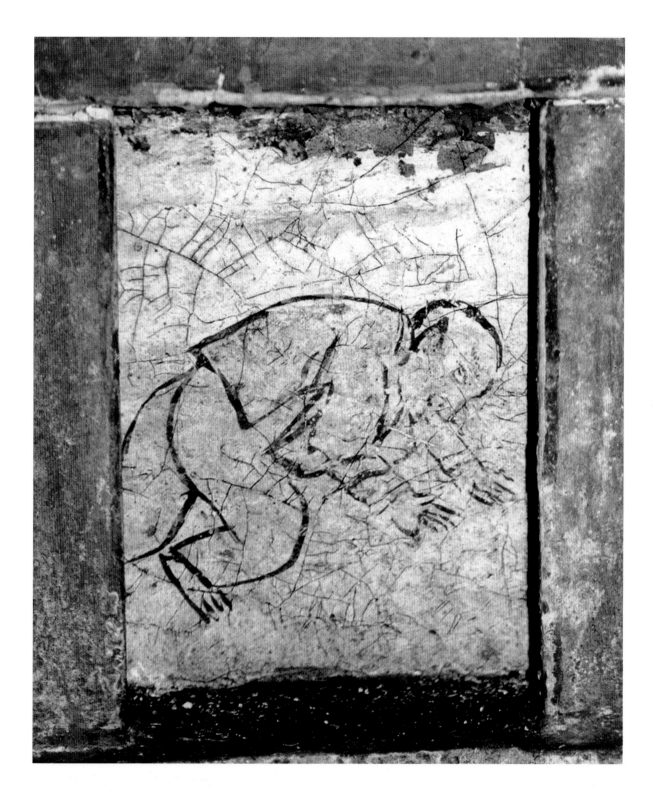

90.嬰戏图（一）

金泰和元年（1201年）

高25、宽18厘米

1999年山东省济南市历城区港沟镇中日合资昭和塑料（济南）有限公司厂区1号墓出土。原址保存。

墓向193°。位于墓室北壁仿木门楼下部左侧。绘一儿童，鬅发，短袄着裤匍匐作爬行状。

（撰文、摄影：刘善沂）

Child Playing (1)

1st Year of Taihe Era, Jin (1201 CE)

Height 25 cm; Width 18 cm

Unearthed from tomb M1 at the (Jinan) factory of Sino-Japanese Zhaohe Plastic Limited Company in Ganggouzhen of Licheng district, Jinan, Shandong, in 1999. Preserved on the original site.

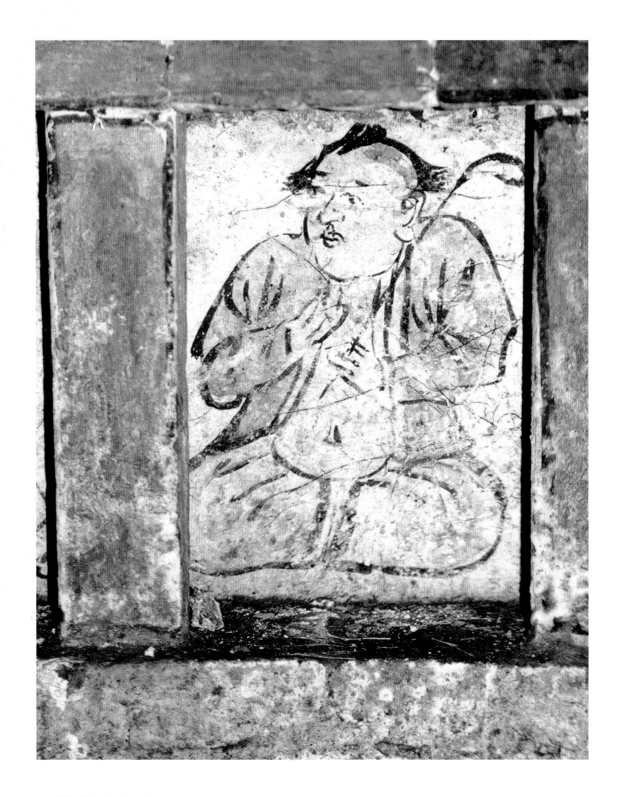

91. 婴戏图（二）

金泰和元年（1201年）

高25、宽20厘米

1999年山东省济南市历城区港沟镇中日合资昭和塑料（济南）有限公司厂区1号墓出土。原址保存。

墓向193°。位于墓室北壁仿木门楼下部中间。绘一儿童盘坐，头部留发做"三搭头式"，短衫着裤，手持捶丸棒。

（撰文、摄影：刘善沂）

Child Playing (2)

1st Year of Taihe Era, Jin (1201 CE)

Height 25 cm; Width 20 cm

Unearthed from tomb M1 at the (Jinan) factory of Sino-Japanese Zhaohe Plastic Limited Company in Ganggouzhen of Licheng district, Jinan, Shandong, in 1999. Preserved on the original site.

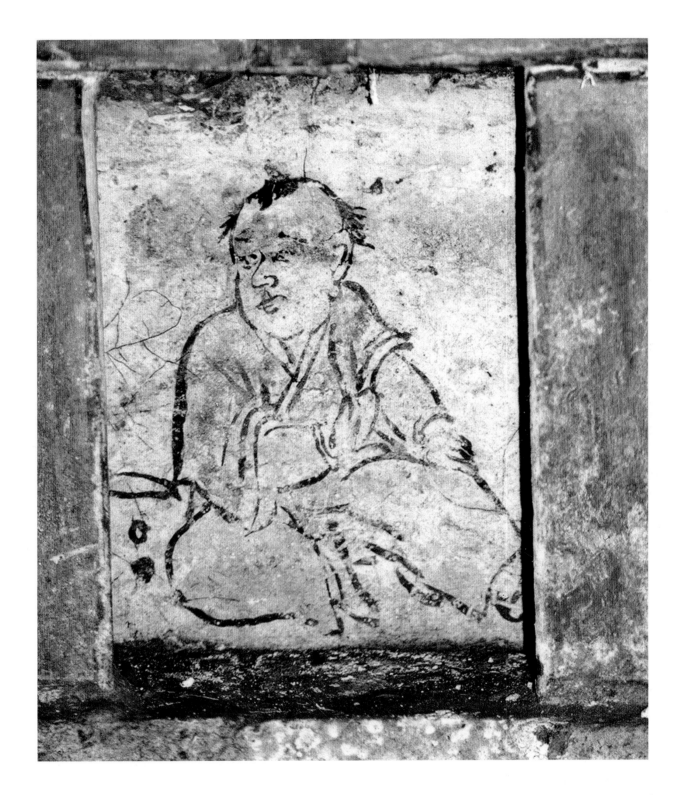

92.婴戏图（三）

金泰和元年（1201年）

高25、宽17厘米

1999年山东省济南市历城区港沟镇中日合资昭和塑料（济南）有限公司厂区1号墓出土。原址保存。

墓向193°。位于墓室北壁仿木门楼下部左侧。绘一儿童盘坐玩耍。"三搭头"式发式，着半臂，下着裤。

（撰文、摄影：刘善沂）

Child Playing (3)

1st Year of Taihe Era, Jin (1201 CE)

Height 25 cm; Width 17 cm

Unearthed from tomb M1 at the (Jinan) factory of Sino-Japanese Zhaohe Plastic Limited Company in Ganggouzhen of Licheng district, Jinan, Shandong, in 1999. Preserved on the original site.

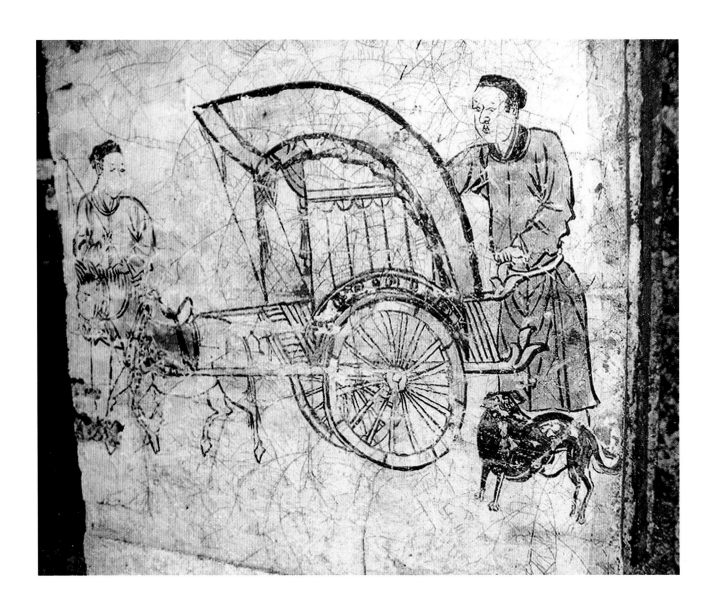

93.马车图

金泰和元年（1201年）

高66、宽83厘米

1999年山东省济南市历城区港沟镇中日合资昭和塑料（济南）有限公司厂区1号墓出土。原址保存。

墓向193°。位于墓室甬道东壁。画面为一驾篷车左行，车夫位于篷车的左侧，头戴巾，着盘领窄袖袍，左手控缰，右手执鞭。车后跟一人，头戴巾，着盘领窄袖长袍，脚下随一黑犬。

（撰文、摄影：刘善沂）

Horse Cart

1st Year of Taihe Era, Jin (1201 CE)

Height 66 cm; Width 83 cm

Unearthed from tomb M1 at the (Jinan) factory of Sino-Japanese Zhaohe Plastic Limited Company in Ganggouzhen of Licheng district, Jinan, Shandong, in 1999. Preserved on the original site.

94.侍女图

金泰和元年（1201年）

高62、宽90厘米

1999年山东省济南市历城区港沟镇中日合资昭和塑料（济南）有限公司厂区1号墓出土。原址保存。

墓向193°。位于墓室东壁。画面中为砖雕灯檠，右侧一侍女左手提壶油，右臂向左伸，向灯台内添灯油。左侧二侍女，均梳高髻，着窄袖绰子，下着裙，前者手捧盘盏，后者手捧食盘。

（撰文、摄影：刘善沂）

Maids

1st Year of Taihe Era, Jin (1201 CE)

Height 62 cm; Width 90 cm

Unearthed from tomb M1 at the (Jinan) factory of Sino-Japanese Zhaohe Plastic Limited Company in Ganggouzhen of Licheng district, Jinan, Shandong, in 1999. Preserved on the original site.

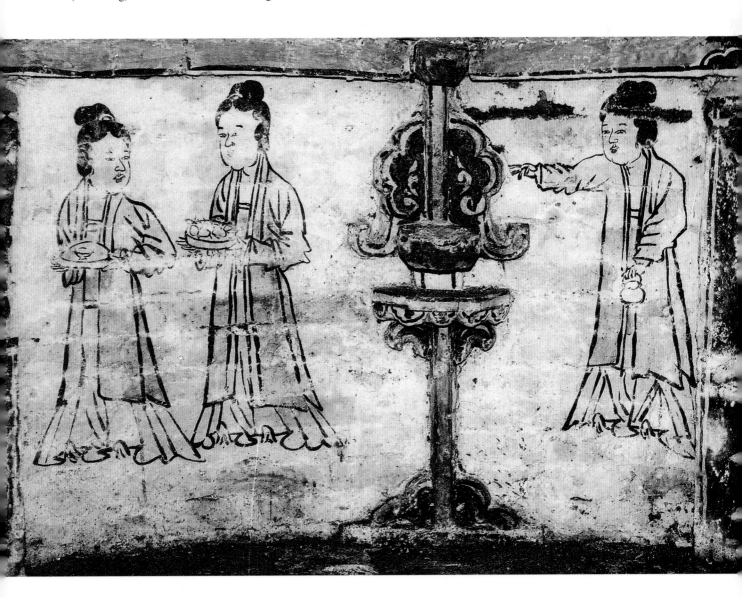

95.彩绘砖雕方亭

金泰和元年（1201年）

高99、宽55厘米

1999年山东省济南市历城区港沟镇中日合资昭和塑料（济南）有限公司厂区金1号出土。原址保存。

墓向193°。位于墓室南壁，墓门的东侧。砖雕亭子由红、黄、蓝色分别涂抹，斗拱瓦顶，墨线勾轮廓，似为表现"西库"；二柱间绘库内杂宝。亭右侧立一人，头戴巾，着交领窄袖长袍，手捧杂宝盘。左侧有不可辨之题记。

（撰文、摄影：刘善沂）

Colored Brick Carving Square Pavilion

1st Year of Taihe Era, Jin (1201 CE)

Height 99 cm; Width 55 cm

Unearthed from tomb M1 at the (Jinan) factory of Sino-Japanese Zhaohe Plastic Limited Company in Ganggouzhen of Licheng district, Jinan, Shandong, in 1999. Preserved on the original site.

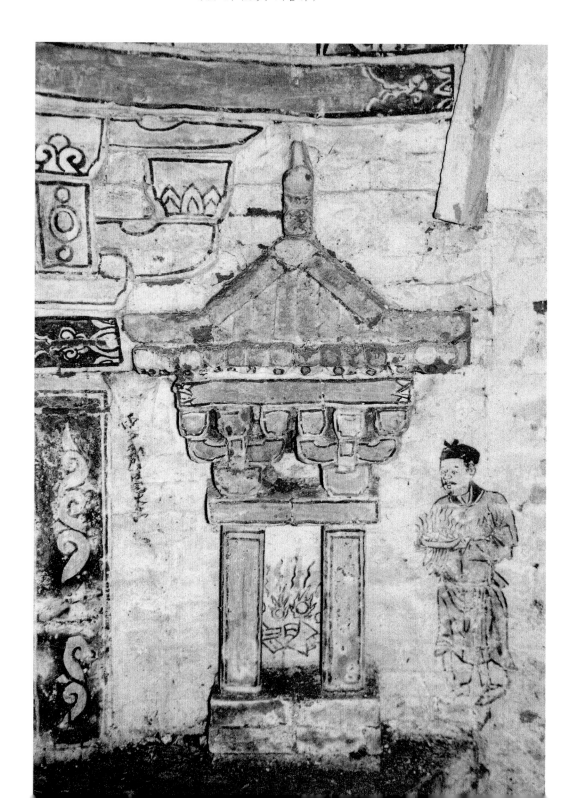

96.杂宝图

金泰和元年（1201年）

高26、宽24厘米

1999年山东省济南市历城区港沟镇中日合资昭和塑料（济南）有限公司厂区1号墓出土。原址保存。

墓向193°。位于南侧墓门东侧的砖雕方亭内，亭中下部有方圣、银铤、摩尼宝珠等杂宝，宝光四射。

（撰文、摄影：刘善沂）

Various Treasures

1st Year of Taihe Era, Jin (1201 CE)

Height 26 cm; Width 24 cm

Unearthed from tomb M1 at the (Jinan) factory of Sino-Japanese Zhaohe Plastic Limited Company in Ganggouzhen of Licheng district, Jinan, Shandong, in 1999. Preserved on the original site.

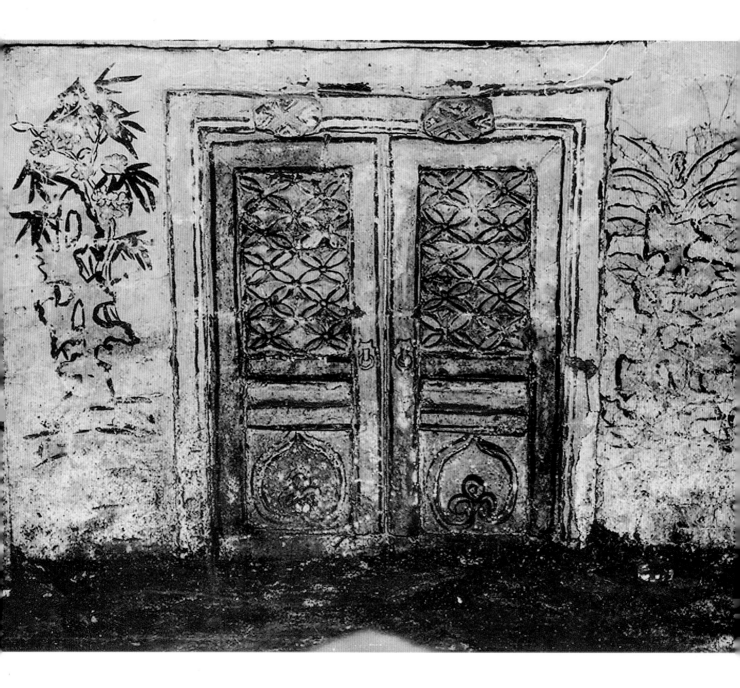

97. 假门图

金泰和元年（1201年）

高62、宽96厘米

1999年山东省济南市历城区港沟镇中日合资昭和塑料（济南）有限公司厂区1号墓出土。原址保存。

墓向193°。位于墓室西北壁。砖雕隔扇门，涂朱彩，墨线勾框上方有门簪两枚，门两侧为石竹及石蕉图像。

（撰文、摄影：刘善沂）

Phony Door

1st Year of Taihe Era, Jin (1201 CE)

Height 62 cm; Width 96 cm

Unearthed from Tomb M1 at the (Jinan) factory of Sino-Japanese Zhaohe Plastic Limited Company in Ganggouzhen of Licheng district, Jinan, Shandong, in 1999. Preserved on the original site.

98. 竹石图

金泰和元年（1201年）

高62、宽20米

1999年山东省济南市历城区港沟镇中日合资昭和塑料（济
南）有限公司厂区1号墓出土。原址保存。

墓向193°。位于墓室西南壁。绘太湖石及翠竹。

<div align="right">（撰文、摄影：刘善沂）</div>

Bamboos and Stone

1st Year of Taihe Era, Jin (1201 CE)

Height 62 cm; Width 20 cm

Unearthed from tomb M1 at the (Jinan)
factory of Sino-Japanese Zhaohe Plastic Li-
mited Company in Ganggouzhen of Licheng
district, Jinan, Shandong, in 1999. Preserved
on the original site.

99. 束莲图

金泰和元年（1201年）

高18、宽84厘米

1999年山东省济南市历城区港沟镇中日合资昭和塑料（济南）有限公司厂区1号墓出土。原址保存。

墓向193°。位于墓室西壁两柱头斗拱间拱眼壁上，绘荷花、荷叶、莲蓬，下部束为一把，寓意"一品清廉"。

<div align="right">（撰文、摄影：刘善沂）</div>

Cluster of Lotus

1st Year of Taihe Era, Jin (1201 CE)

Height 18 cm; Width 84 cm

Unearthed from tomb M1 at the (Jinan) factory of Sino-Japanese Zhaohe Plastic Limited Company in Ganggouzhen of Licheng district, Jinan, Shandong, in 1999. Preserved on the original site.

100.彩绘砖雕斗拱

金泰和元年（1201年）

高60、宽52厘米

1999年山东省济南市历城区港沟镇中日合资昭和塑料（济南）有限公司厂区1号墓出土。原址保存。

墓向193°。位于墓门仿木建筑楼阁上的斗拱。为双下昂重拱斗拱，上绘建筑彩画。

（撰文、摄影：刘善沂）

Colored Brick Carving Bracket Set

1st Year of Taihe Era, Jin (1201 CE)

Height 60 cm; Width 52 cm

Unearthed from tomb M1 at the (Jinan) factory of Sino-Japanese Zhaohe Plastic Limited Company in Ganggouzhen of Licheng district, Jinan, Shandong, in 1999. Preserved on the original site.

101.折枝莲花、牡丹图

金泰和元年（1201年）

高134、宽266厘米

1999年山东省济南市历城区港沟镇中日合资昭和塑料（济南）有限公司厂区1号墓出土。原址保存。

墓向193°。位于墓室穹隆顶东北壁上。用墨线勾绘大幅折枝莲花、牡丹各一枝。

<div align="right">（撰文、摄影：刘善沂）</div>

Lotus and Peony Branches

1st Year of Taihe Era, Jin (1201 CE)

Height 134 cm; Width 266 cm

Unearthed from tomb M1 at the (Jinan) factory of Sino-Japanese Zhaohe Plastic Limited Company in Ganggouzhen of Licheng district, Jinan, Shandong, in 1999. Preserved on the original site.

102.花卉图

金泰和元年（1201年）

高100、宽106厘米

1999年山东省济南市历城区港沟镇中日合资昭和塑料（济南）有限公司厂区1号墓出土。原址保存。

墓向193°。位于墓室穹隆顶西北壁上，用墨线勾绘折枝芍药花卉一枝。

（撰文、摄影：刘善沂）

Flowers

1st Year of Taihe Era, Jin (1201 CE)

Height 100 cm; Width 106 cm

Unearthed from tomb M1 at the (Jinan) factory of Sino-Japanese Zhaohe Plastic Limited Company in Ganggouzhen of Licheng district, Jinan, Shandong, in 1999. Preserved on the original site.

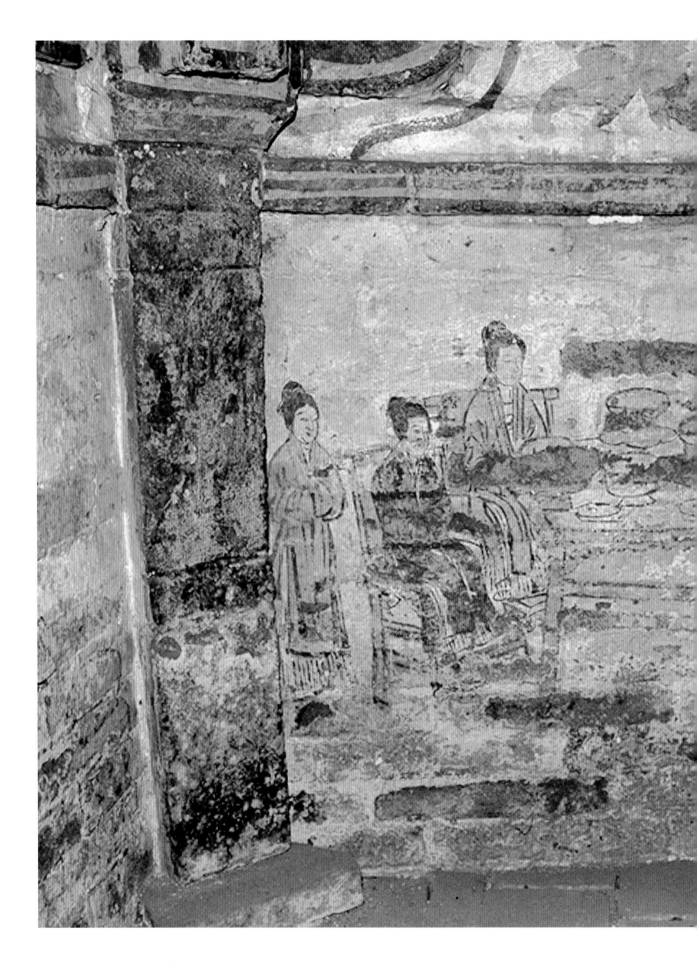

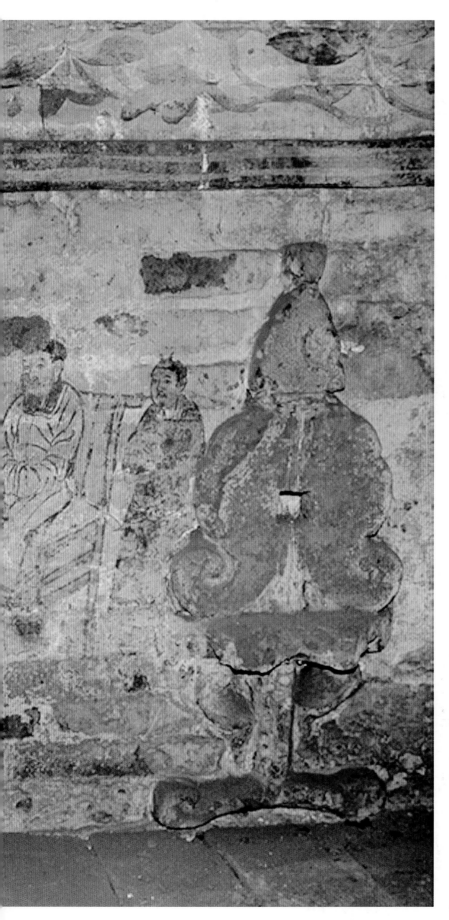

103.夫妇对坐图

金大安二年（1210年）

高68、宽74厘米

1990年山东省淄博市博山区神头金墓出
土。现存于博山区文物管理所。

墓向180°。位于墓室东壁北部。画面中
间绘一方桌，桌上放置杯盘、碗盏等食
具、饮具，男女主人三人分别坐在桌子
两侧的高背椅子上，脚踏足承。女主人
为两人，均梳高髻，着窄袖绰子，二人
身后立一女侍。男主人坐在桌子右侧，
头戴巾子，着方领窄袖长袍，身后立一
男侍。

（撰文、摄影：郑同修）

Tomb Occupant Couple Seated Beside the Table

2nd Year of Da'an Era, Jin (1210 CE)

Height 68 cm; Width 74 cm

Unearthed from the Shentou Jin tomb at
Boshan District in Zibo, Shandong, in
1990. Preserved in the Committee for
Preservation of Ancient Monuments in
Boshan District.

104.衣架图

金大安二年（1210年）

高69、宽46厘米

1990年山东省淄博市博山区神头金墓出土。现存于博山区文物管理所。

墓向180°。位于墓室东壁南部。画面绘一衣架，衣架上挂满衣物。

（撰文、摄影：郑同修）

Clothes Stand

2nd Year of Da'an Era, Jin (1210 CE)

Height 69 cm; Width 46 cm

Unearthed from the Shentou Jin tomb at Boshan District in Zibo, Shandong, in 1990. Preserved in the Committee for Preservation of Ancient Monuments in Boshan District.

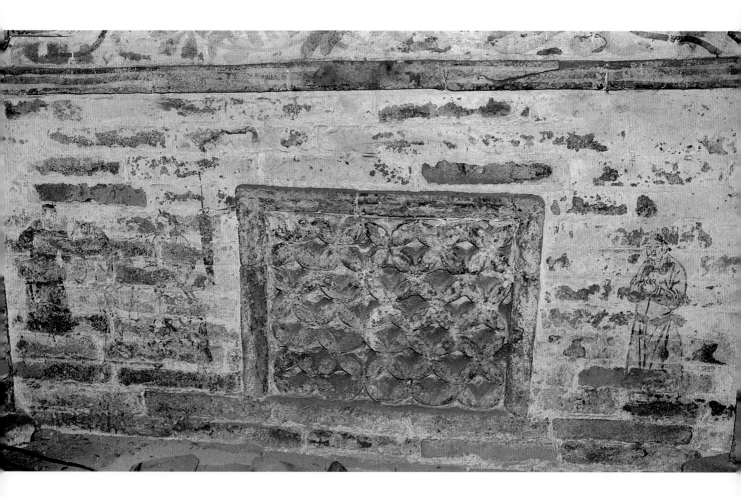

105.墓室西壁壁画

金大安二年（1210年）

高约69、宽约160厘米

1990年山东省淄博市博山区神头金墓出土。现存于博山区文物管理所。

墓向180°。位于墓室西壁下部，中间为砖雕钱纹棂花窗，表面涂赭彩，周匝以赭色勾框。棂花窗左侧绘牵马图，为二人一马，左侧一人牵马，右侧一人立于马后侧，肩扛长杆，后挑一伞。棂花窗右侧绘一立人物，图像为一人站立，着方领窄袖长袍，行叉手礼，以墨线勾绘。画面局部剥落。

（撰文、摄影：郑同修）

Mural on the Western Wall

2nd Year of Da'an Era, Jin (1210 CE)

Height ca. 69 cm; Width ca. 160 cm

Unearthed from the Shentou Jin tomb at Boshan District in Zibo, Shandong, in 1990. Preserved in the Committee for Preservation of Ancient Monuments in Boshan District.

106. 牵马图（一）

金大安二年（1210年）

高68、宽39厘米

1990年山东省淄博市博山区神头金墓出土。现存于博山区文物管理所。

墓向180°。位于墓室南壁墓门东侧。画面绘一人牵马，头戴巾子，着方领窄袖长袍，手牵缰绳，马上有全套的鞍鞯。

（撰文、摄影：郑同修）

Leading a Horse (1)

2nd Year of Da'an Era, Jin (1210 CE)

Height 68 cm; Width 39 cm

Unearthed from the Shentou Jin tomb at Boshan District in Zibo, Shandong, in 1990. Preserved in the Committee for Preservation of Ancient Monuments in Boshan District.

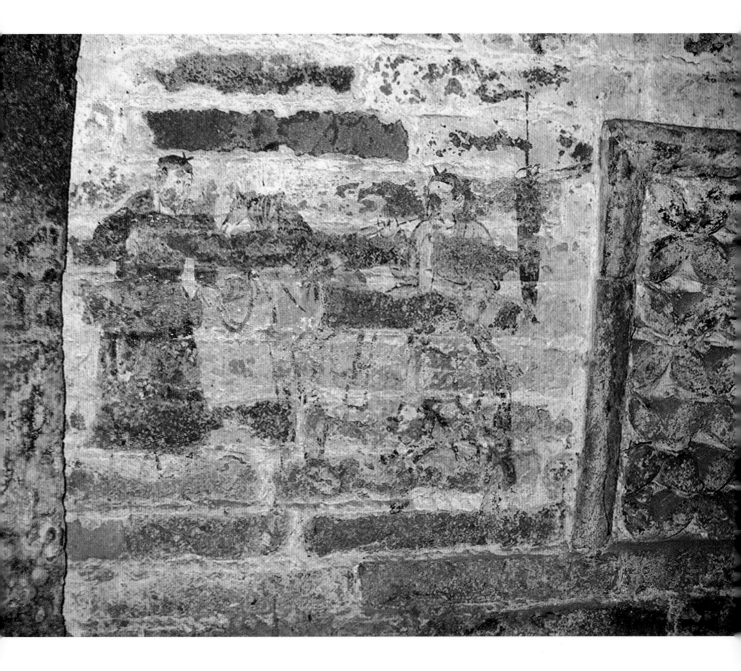

107.牵马图（二）

金大安二年（1210年）

高69、宽51厘米

1990年山东省淄博市博山区神头金墓出土。现存于博山区文物管理所。

墓向180°。位于墓室西壁南部。为二人一马，左侧一人牵马前行，头戴巾子，着方领窄袖长袍，右侧一人立于马后侧，肩荷一长杆，后挑一伞。画面局部剥落。

（撰文、摄影：郑同修）

Leading a Horse (2)

2nd Year of Da'an Era, Jin (1210 CE)

Height 69 cm, Width 51 cm

Unearthed from the Shentou Jin tomb at Boshan District in Zibo, Shandong, in 1990. Preserved in the Committee for Preservation of Ancient Monuments in Boshan District.

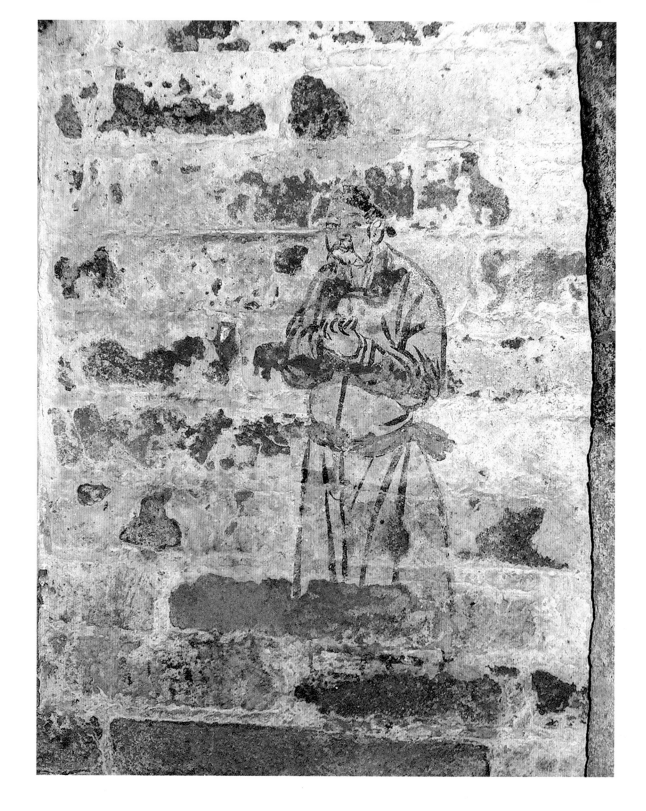

108. 人物图

金大安二年（1210年）

高69、宽36厘米

1990年山东省淄博市博山区神头金墓出土。现存于博山区文物管理所。

墓向180°。位于墓室西壁北部。图像为一人站立，头戴巾子，着方领窄袖长袍，行叉手礼，以墨线勾绘。画面局部剥落。

（撰文、摄影：郑同修）

Attendant

2nd Year of Da'an Era, Jin (1210 CE)

Height 69 cm, Width 36 cm

Unearthed from the Shentou Jin tomb at Boshan District in Zibo, Shandong, in 1990. Preserved in the Committee for Preservation of Ancient Monuments in Boshan District.

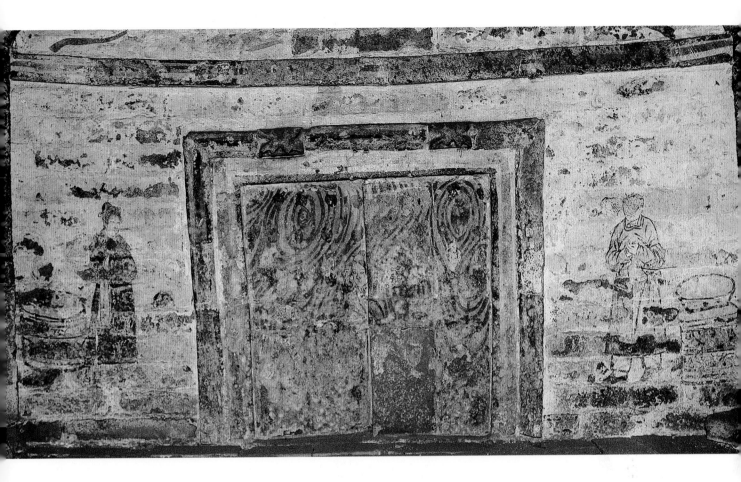

109. 墓室北壁壁画

金大安二年（1210年）

高约54、宽104厘米

1990年山东省淄博市博山区神头金墓出土。现存于博山区文物管理所。

墓向180°。图像中部为假门图像，周匝以墨线、赭色勾框。画面绘二扇板门，绘有门钉和云气纹，一妇人半身探出二门扉之间。左侧为侍女图，绘一女子袖手持巾，面向右而立。右侧为男仆图，以墨线勾绘一男仆叉手面左而立，其身后地面上一盆架，架上有一盆，人物面部剥落不清。

（撰文、摄影：郑同修）

Mural on the North Wall of the Tomb Chamber

2nd Year of Da'an Era, Jin (1210 CE)

Height ca. 54 cm; Width 104 cm

Unearthed from the Shentou Jin tomb at Boshan District in Zibo, Shandong, in 1990. Preserved in the Committee for Preservation of Ancient Monuments in Boshan District.

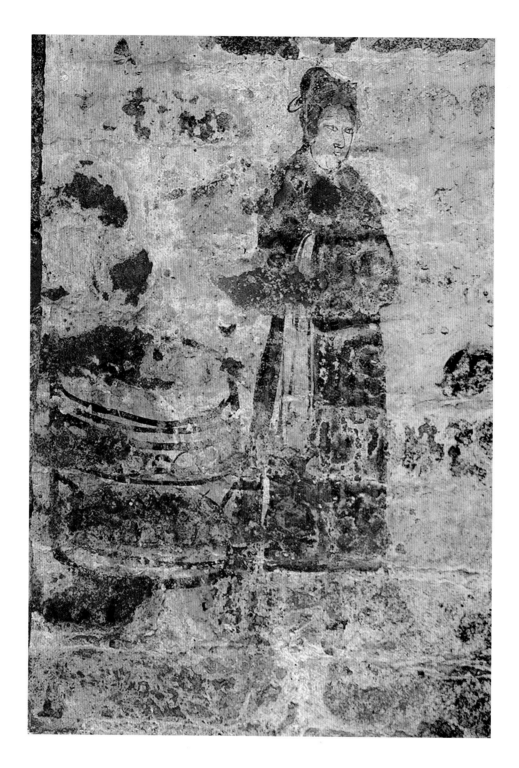

110. 侍女图

金大安二年（1210年）

高68、宽35厘米

1990年山东省淄博市博山区神头金墓出土。现存于博山区文物管理所。

墓向180°。位于墓室北壁西部。图像为一女侍，梳高髻，袖手持巾面向右而立，面部以墨线勾绘，身着紫红色交领长袍，衣饰以朱彩勾绘。身后地面上有一圆形笼状物，似为盛放衣物的箧笥。

（撰文、摄影：郑同修）

Maid

2nd Year of Da'an Era, Jin (1210 CE)

Height 68 cm; Width 35 cm

Unearthed from the Shentou Jin tomb at Boshan District in Zibo, Shandong, in 1990. Preserved in the Committee for Preservation of Ancient Monuments in Boshan District.

111.妇人启门图

金大安二年（1210年）

高47、宽50厘米

1990年山东省淄博市博山区神头金墓出土。现存于博山区文物管理所。

墓向180°。位于墓室北壁中部。二扇板门微开启，门板上有门钉和涡状云气，妇人梳包髻，着交领长衫，半身探出微开启的板门之间。

（撰文、摄影：郑同修）

Lady Opening the Door Ajar

2nd Year of Da'an Era, Jin (1210 CE)

Height 47 cm; Width 50 cm

Unearthed from the Shentou Jin tomb at Boshan District in Zibo, Shandong, in 1990. Preserved in the Committee for Preservation of Ancient Monuments in Boshan District.

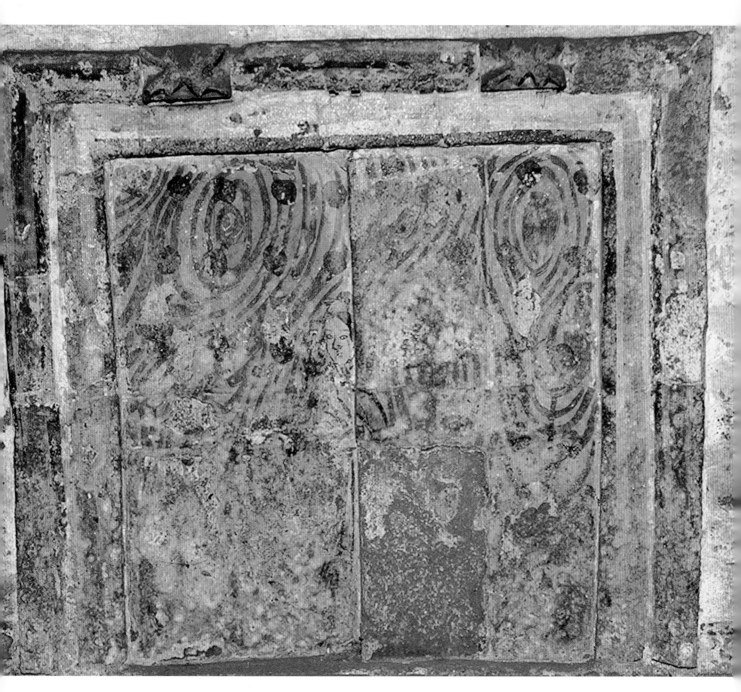

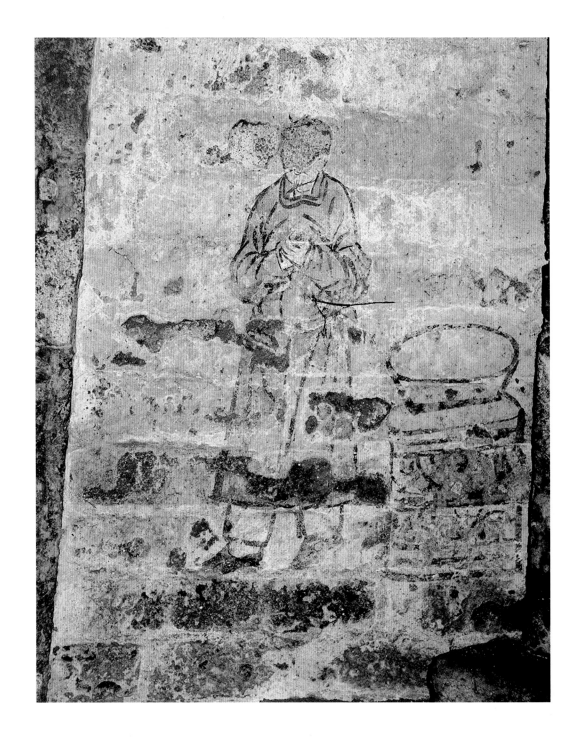

112. 男侍图

金大安二年（1210年）

高68、宽39厘米

1990年山东省淄博市博山区神头金墓出土。现存于博山区文物管理所。

墓向180°。位于墓室北壁东部。以墨线勾绘一男仆面左而立，着方领窄袖长袍，腰束带，持叉手礼，其身后地面上有一方形盆架，上有一盆。人物面部剥落不清。

（撰文、摄影：郑同修）

Servant

2nd Year of Da'an Era, Jin (1210 CE)

Height 68 cm; Width 39 cm

Unearthed from the Shentou Jin tomb at Boshan District in Zibo, Shandong, in 1990. Preserved in the Committee for Preservation of Ancient Monuments in Boshan District.

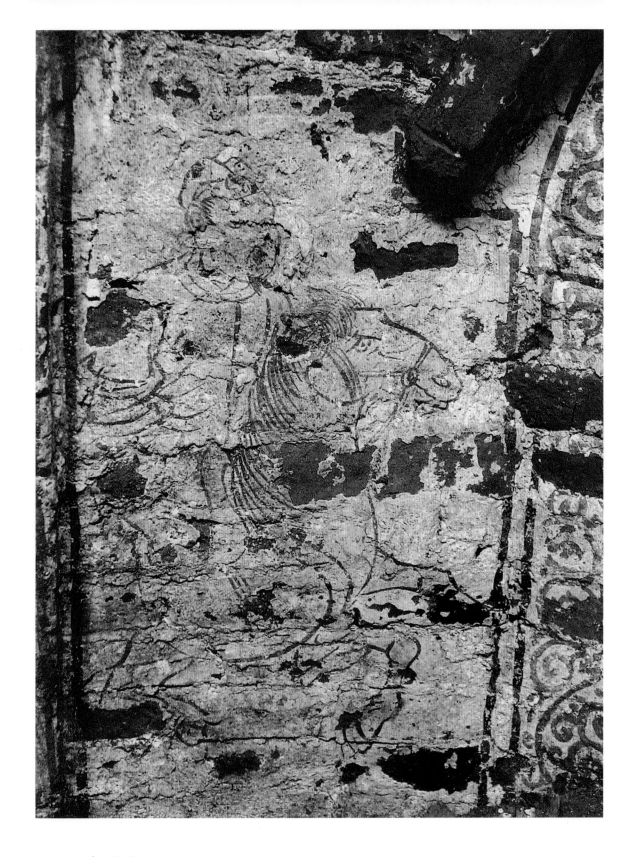

113.骑马图

金（1115～1234年）

高60、宽90厘米

2002年山东省章丘市宝岛街金墓出土。已残毁。

墓向189°。位于前墓室南壁，画中一男子软巾浑裹，着圆领袍，骑在奔驰的马上。画面部分剥落。

（撰文、摄影：李铭）

Horse Riding

Jin (1115-1234 CE)

Height 60 cm; Width 90 cm

Unearthed from the Jin tomb at Baodao Street in Zhangqiu, Shandong, in 2002. Not preserved.

114.侍女图（一）

金（1115～1234年）

高60、宽90厘米

2002年山东省章丘市宝岛街金墓出土。已残毁。

墓向189°。位于前墓室西壁，墨线勾勒为主，填以单色染彩，图左一身着对襟绰子，手持火镰的年长侍女，前方有灯檠，似在点灯。身后站一年青女子，垂双髻，着对襟绰子，袖手而立。画面部分剥落。

（撰文、摄影：李铭）

Maids (1)

Jin (1115-1234 CE)

Height 60 cm; Width 90 cm

Unearthed from the Jin tomb at Baodao Street in Zhangqiu, Shandong, in 2002. Not preserved.

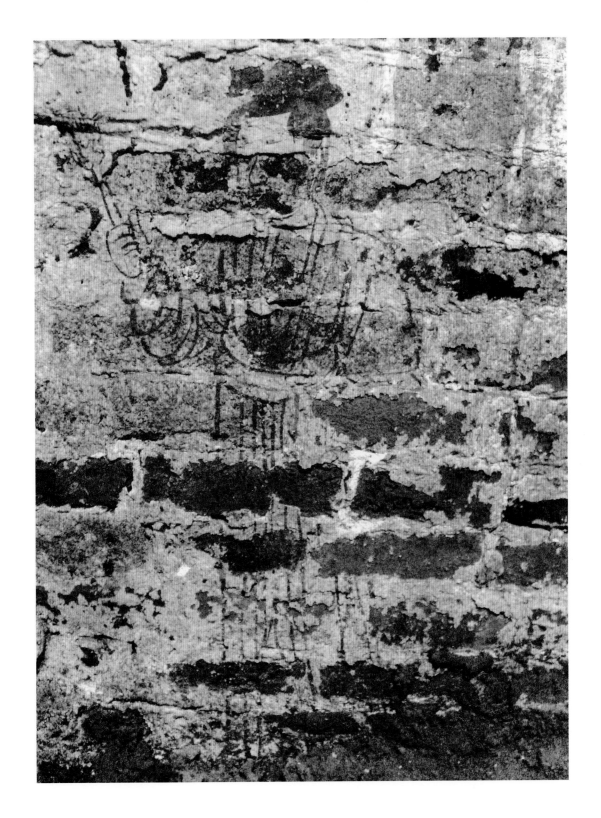

115.持火燫侍女图

金（1115～1234年）

高30、宽70厘米

2002年山东省章丘市宝岛街金墓出土。已残毁。

墓向189°。位于前墓室西壁，墨线勾绘侍女，身着长
襦，腰束带，右手持火燫，似在点灯。画面部分剥落。

（撰文、摄影：李铭）

Maid Holding Torch(1)

Jin (1115-1234 CE)

Height 30 cm; Width 70 cm

Unearthed from the Jin tomb at Baodao
Street in Zhangqiu, Shandong, in 2002. Not
preserved.

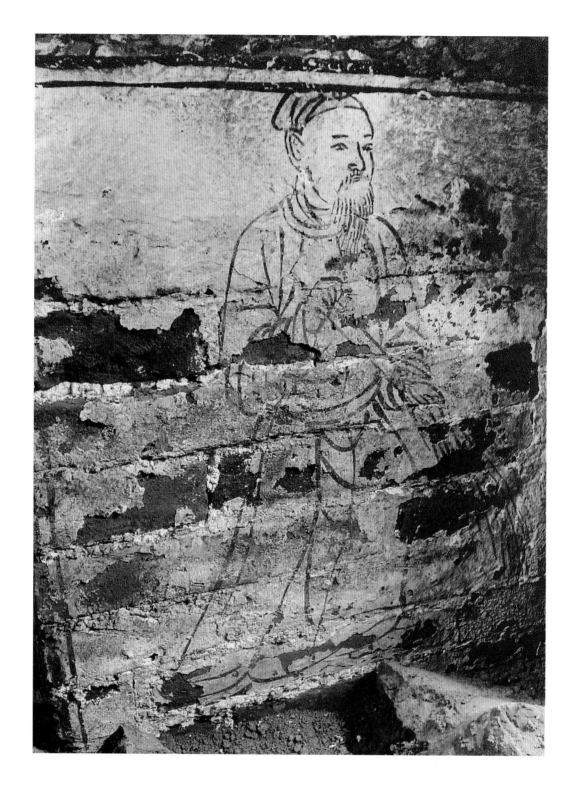

116. 男侍图（一）

金（1115～1234年）

高60、宽40厘米

2002年山东省章丘市宝岛街金墓出土。已残毁。

墓向189°。位于后墓室南壁，长须老者，头戴巾子，身着盘领长袍，腰束带，手持扫帚，似为管仓之人。画面部分剥落。

（撰文、摄影：李铭）

Servant (1)

Jin (1115-1234 CE)

Height 60 cm; Width 40 cm

Unearthed from the Jin tomb at Baodao Street in Zhangqiu, Shandong, in 2002. Not preserved.

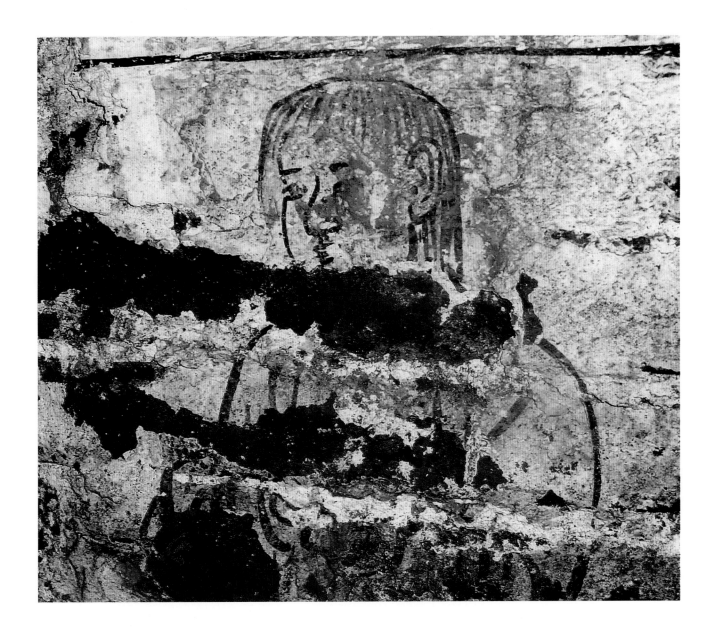

117. 男侍图（二）（局部）

金（1115～1234年）

高20、宽40厘米

2002年山东省章丘市宝岛街金墓出土。已残毁。

墓向189°。位于前墓室西壁，男子顶部髡发，边侧垂长发。双手放于胸前，似持叉手礼。画面部分剥落。

（撰文、摄影：李铭）

Servant (2) (Detail)

Jin (1115-1234 CE)

Height 20cm; Width 40cm

Unearthed from the Jin tomb at Baodao Street in Zhangqiu, Shandong, in 2002. Not preserved.

118. 男侍图（三）

金（1115～1234年）

高60、宽40厘米

2002年山东省章丘市宝岛街金墓出土。已残毁。

墓向189°。位于前墓室穹隆顶东壁，画中一男子头顶髻发，身穿盘领长袍，双手捧盆、内盛珊瑚宝器。画面部分剥落。

（撰文、摄影：李铭）

Servant (3)

Jin (1115-1234 CE)

Height 60 cm; Width 40 cm

Unearthed from the Jin tomb at Baodao Street in Zhangqiu, Shandong, in 2002. Not preserved.

119. 丁兰牌位

金（1115～1234年）

高40、宽20厘米

2002年山东省章丘市宝岛街金墓出土。已残毁。

墓向189°。位于前墓室穹隆顶东壁，丁兰牌顶部为荷叶，下部画荷花托座，丁兰是二十四孝之一的孝子。

（撰文、摄影：李铭）

Tablet Shrine of Ding Lan

Jin (1115-1234 CE)

Height 40 cm; Width 20 cm

Unearthed from the Jin tomb at Baodao Street in Zhangqiu, Shandong, in 2002. Not preserved.

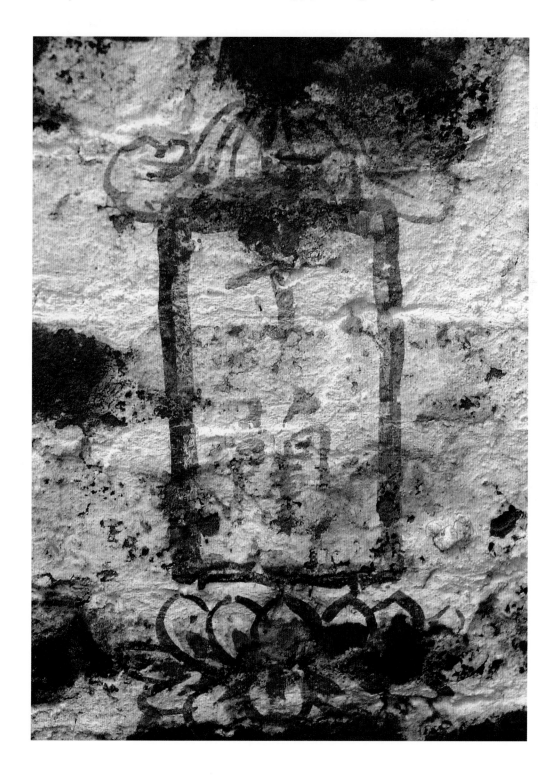

金（1115～1234年）
高40、宽20厘米

120.侍女图（二）

金（1115～1234年）

高70、宽40厘米

2002年山东省章丘市宝岛街金墓出土。已残毁。

墓向189°。位于后墓室西壁，画中一身着长绰子的侍女。除面部外，其他地方漫漶不清。

（撰文、摄影：李铭）

Maid (2)

Jin (1115-1234 CE)

Height 70 cm; Width 40 cm

Unearthed from the Jin tomb at Baodao Street in Zhangqiu, Shandong, in 2002. Not preserved.

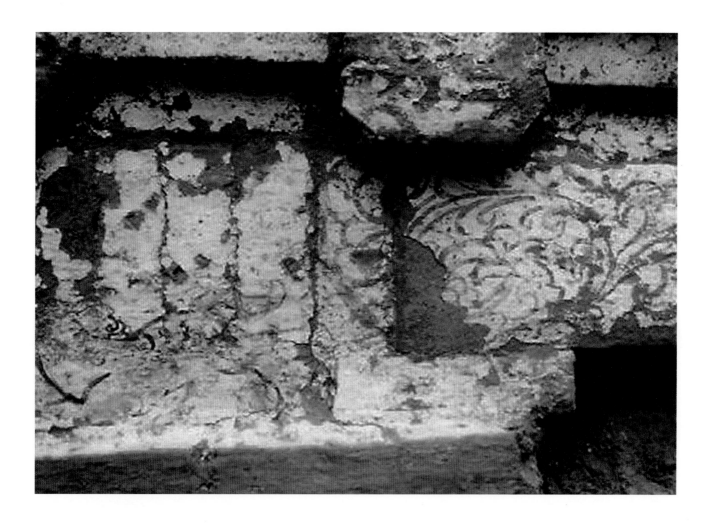

121.花卉猛虎图

金（1115～1234年）

高约27、宽约40厘米

1990年山东省章丘市绣惠镇女郎山65号墓出土。已残毁。

墓向90°。位于墓室西北角砖雕斗拱的下面。画面右侧以墨线勾勒一只回首观望的猛虎，左侧为花卉。部分脱落，画面不甚清晰。

（撰文、摄影：李日训）

Flowers and Tiger

Jin (1115-1234 CE)

Height ca. 27 cm; Width ca. 40 cm

Unearthed from tomb M65 at Nülangshan in Xiuhuizhen of Zhangqiu, Shandong, in 1990. Not preserved.

122. 猛虎图

金（1115～1234年）

高约10、宽约20厘米

1990年山东省章丘市绣惠镇女郎山65号墓出土。已残毁。

墓向90°。位于墓室西北角砖雕两斗拱之间。画面右侧以墨线勾勒一只回首翘尾的猛虎。

（撰文、摄影：李日训）

Tiger

Jin (1115-1234 CE)

Height ca. 10 cm; Width ca. 20 cm

Unearthed from tomb M65 at Nülangshan in Xiuhuizhen of Zhangqiu, Shandong, in 1990. Not preserved.

123. 衣架图

元至元年间（1264～1294年）

高100、宽110厘米

2004年山东省章丘市双山镇三涧村元墓出土。已残毁。

墓向185°。位于墓室西壁西柱间，绘红色帷幕，下方绘出衣架，两端翘起，衣架上方有墨书"至元"题记，此墓中两处出视"至元"年号，根据墓葬和绘画风格推测为至元年间。

（撰文：李铭　摄影：孙涛）

Clothes Stand

Zhiyuan Era, Yuan (1264-1294 CE)

Height 100 cm; Width 110 cm

Unearthed from the Yuan tomb at Sanjiancun in Shuangshanzhen of Zhangqiu, Shandong, in 2004. Not preserved.

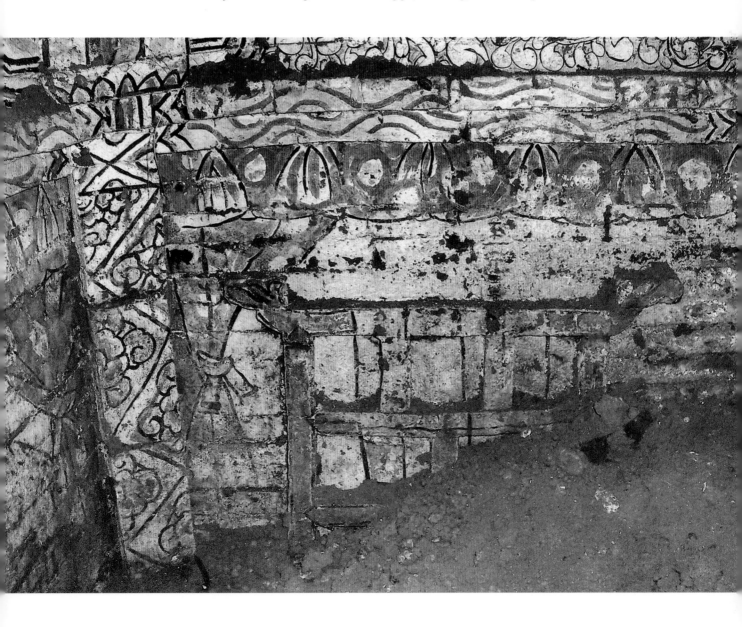

124.门楼图

元至元年间（1264～1294年）

高120、宽140厘米

2004年山东省章丘市双山镇三涧村元墓出土。已残毁。

墓向185°。位于墓室北壁，北壁共有四根倚柱，中间两柱间绘老者启门图，板门两侧各有一钱纹槟花窗。柱端有阑额，上有四朵四铺作斗拱，拱眼壁绘莲花。

（撰文：王兴华　摄影：孙涛）

Gatehouse

Zhiyuan Era, Yuan (1264-1294 CE)

Height 120 cm; Width 140 cm

Unearthed from the Yuan tomb at Sanjiancun in Shuangshanzhen of Zhangqiu, Shandong, in 2004. Not preserved.

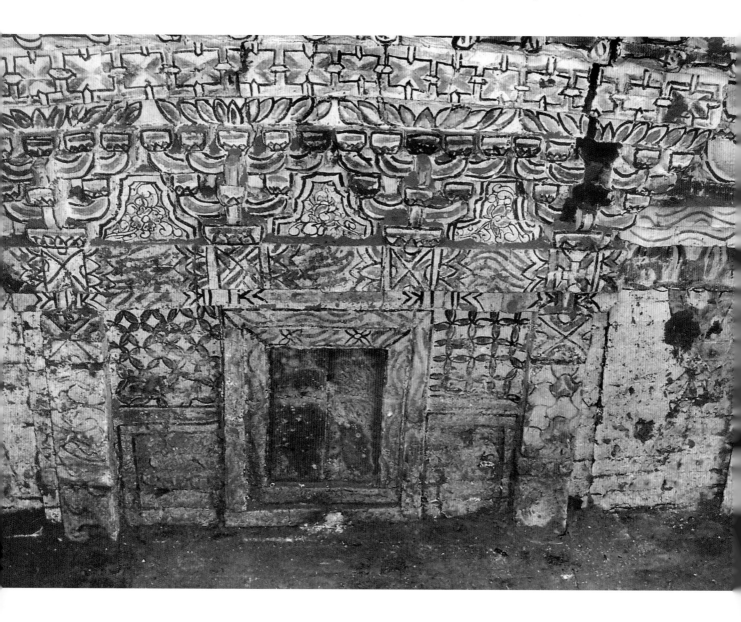

125. 启门图

元至元年间（1264～1294年）

高60、宽42厘米

2004年山东省章丘市双山镇三涧村元墓出土。已残毁。
墓向185°。位于墓室北壁中央，两扇红色板门，门上五排
门钉，门半开，一长髯男子戴东坡巾，着窄袖长袍，半身
探出门外。

（撰文：李铭　摄影：孙涛）

Opening the Door Ajar

Zhiyuan Era, Yuan (1264-1294 CE)
Height 60 cm; Width 42 cm
Unearthed from the Yuan tomb at Sanjiancun
in Shuangshanzhen of Zhangqiu, Shandong, in
2004. Not preserved.

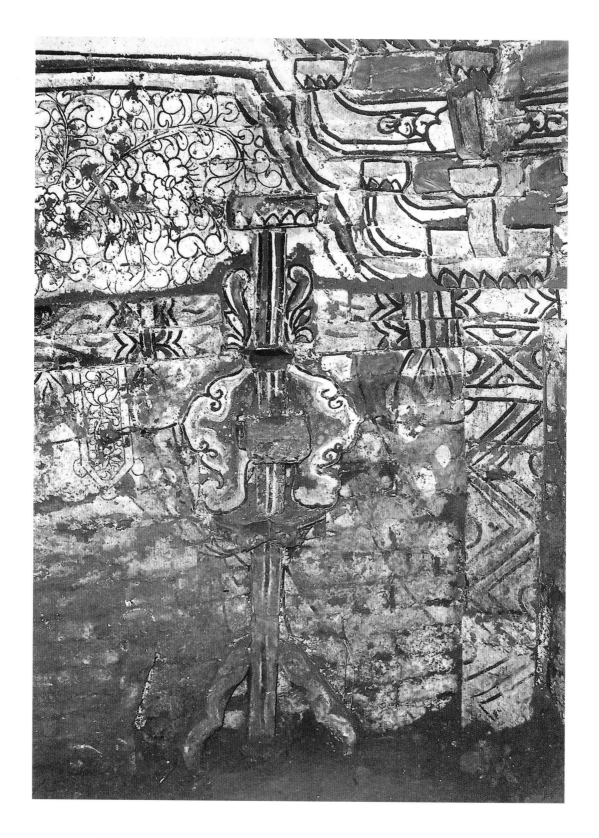

126.灯檠图

元至元年间（1264～1294年）

高120、宽80厘米

2004年山东省章丘市双山镇三涧村元墓出土。现已毁。

墓向185°。位于墓室东壁，彩绘灯檠，下部有三叉支架，中部有如意头形云板，均为元代的典型风格。

（撰文：李铭　摄影：孙涛）

Lamp Stand

Zhiyuan Era, Yuan (1264-1294 CE)

Height 120 cm; Width 80 cm

Unearthed from the Yuan tomb at Sanjiancun in Shuangshanzhen of Zhangqiu, Shandong, in 2004. Not preserved.

127.粮仓图

元至元年间（1264～1294年）

高80、宽80厘米

2004年山东省章丘市双山镇三涧村元墓出土。已残毁。

墓向185°。位于墓室南壁，图中绘两圆形尖顶的库房，顶用草铺盖，仓库各有一紧闭的库门。

（撰文：李铭　摄影：孙涛）

Granaries

Zhiyuan Era, Yuan (1264-1294 CE)

Height 80 cm; Width 80 cm

Unearthed from the Yuan tomb at Sanjiancun in Shuangshanzhen of Zhangqiu, Shandong, in 2004. Not preserved.

128.染缸图

元至元年间（1264～1294年）

高60、宽42厘米

2004年山东省章丘市双山镇三涧村元墓出土。已残毁。

墓向185°。位于墓室南壁券门东，上绘折枝荷花，下绘两圆形染缸，其中一缸上盖搭布巾。

（撰文：李铭　摄影：孙涛）

Dye Vats

Zhiyuan Era, Yuan (1264-1294 CE)

Height 60 cm; Width 42 cm

Unearthed from the Yuan tomb at Sanjiancun in Shuangshanzhen of Zhangqiu, Shandong, in 2004. Not preserved.

129.墓室一角

元至元年间（1264～1294年）

高190、宽122厘米

2004年山东省章丘市双山镇三涧村元墓出土。已残毁。

墓向185°。位于墓室西南壁，角柱绘"十"字形纹，两侧绘垂帐，倚柱和斗拱上满绘建筑彩画，拱眼壁绘荷花和牡丹，下部绘一人坐在椅子上。

（撰文：李铭　摄影：孙涛）

Corner of Tomb Chamber

Zhiyuan Era, Yuan (1264-1294 CE)

Height 190 cm; Width 122 cm

Unearthed from the Yuan tomb at Sanjian-cun in Shuangshanzhen of Zhangqiu, Shandong, in 2004. Not preserved.

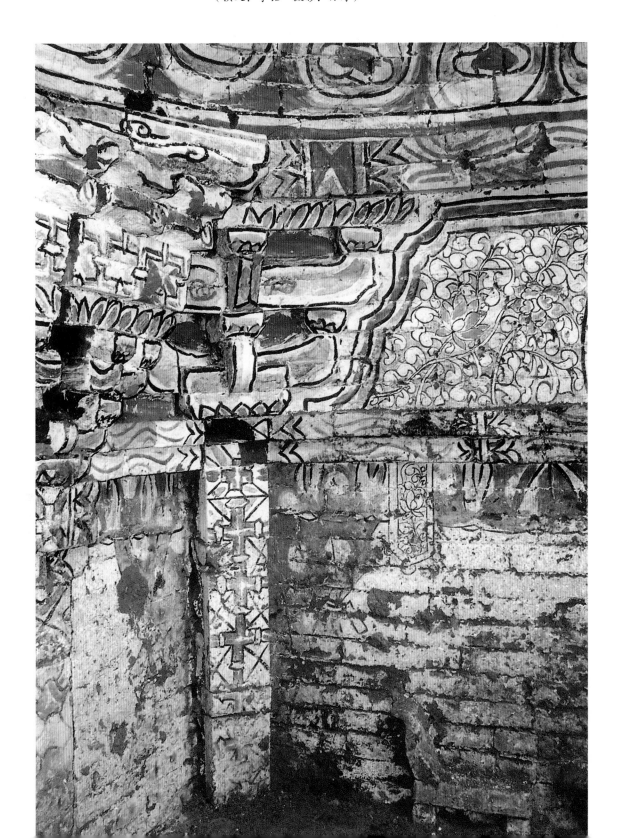

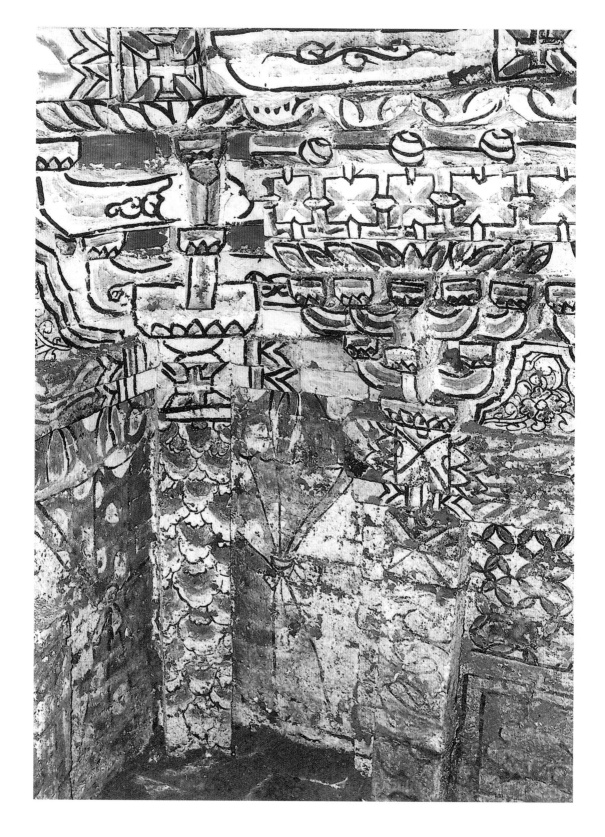

130.墓室西北角

元至元年间（1264~1294年）

高190、宽122厘米

2004年山东省章丘市双山镇三涧村元墓出土。已残毁。墓向185°。位于墓室西北角，角柱绘云形鱼鳞纹，两侧绘帷幔，斗拱上满绘建筑彩画，拱眼壁绘花卉，右边绘钱纹棂花窗。

（撰文：李铭　摄影：孙涛）

Northwestern Corner of the Tomb Chamber

Zhiyuan Era, Yuan (1264-1294 CE)

Height 190 cm; Width 122 cm

Unearthed from the Yuan tomb at Sanjiancun in Shuangshanzhen of Zhangqiu, Shandong, in 2004. Not preserved.

131.柜子图

元至元年间（1264～1294年）

高140、宽80厘米

2004年山东省章丘市双山镇三涧村元墓出土。已残毁。

墓向185°。位于墓室西壁，砖雕出一方形柜，柜子上放一长方形盖盒。

<div align="right">（撰文：李铭　摄影：孙涛）</div>

Cupboard

Zhiyuan Era, Yuan (1264-1294 CE)

Height 140 cm; Width 80 cm

Unearthed from the Yuan tomb at Sanjiancun in Shuangshanzhen of Zhangqiu, Shandong, in 2004. Not preserved.

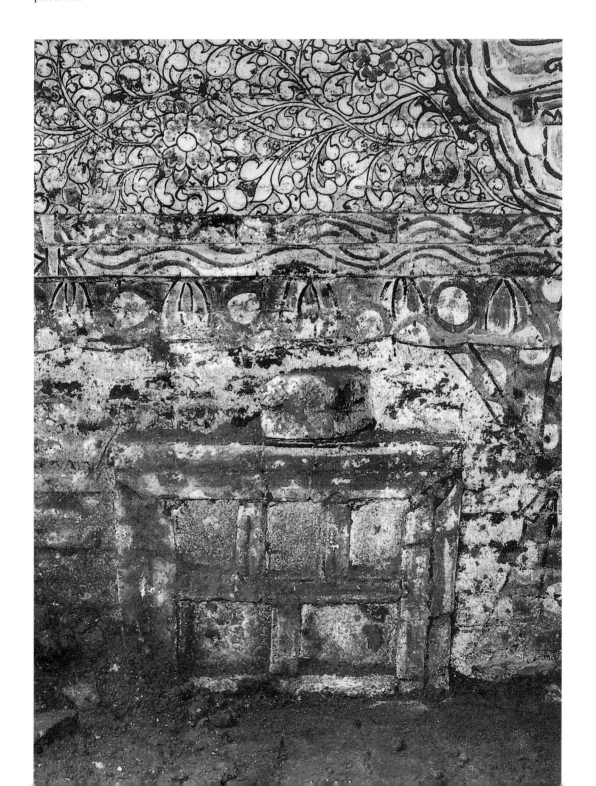

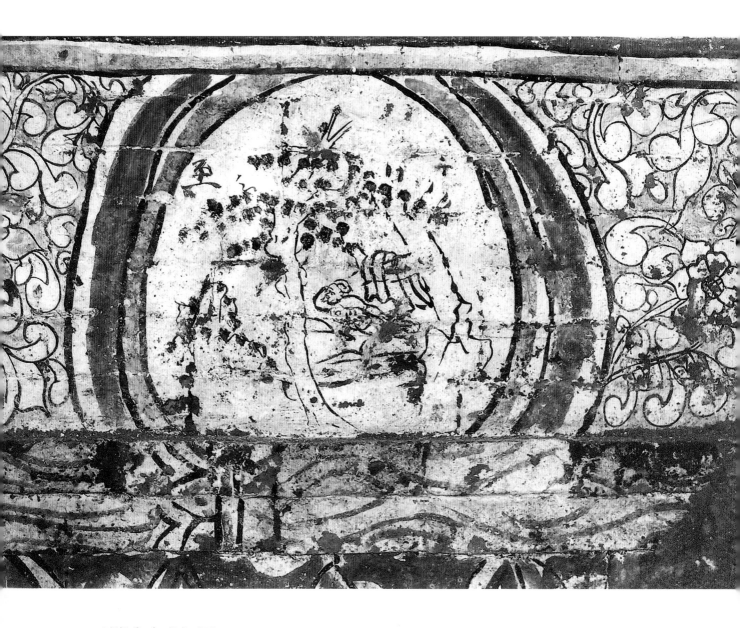

132.王祥卧冰求鲤图

元至元年间（1264～1294年）

高35、宽40厘米

2004年山东省章丘市双山镇三涧村元墓出土。已残毁。

墓向185°。位于墓室西壁中上部，圆图中绘小山和两树，在两树之间，有一人赤裸着身子躺卧在冰面上，衣服挂在树上，这是二十四孝中为母卧冰求鲤的王祥。在圆图的上方书写"至元"两字。

<div align="right">（撰文：李铭　摄影：孙涛）</div>

Wang Xiang,One of the "Twenty-Four Paragons Filial Piety"

Zhiyuan Era, Yuan (1264-1294 CE)

Height 35 cm; Width 40 cm

Unearthed from the Yuan tomb at Sanjiancun in Shuangshanzhen of Zhangqiu, Shandong, in 2004. Not preserved.

133.拱眼壁缠枝牡丹图

元至元年间（1264～1294年）

高40、宽160厘米

2004年山东省章丘市双山镇三涧村元墓出土。已残毁。

墓向185°。位于墓室西壁，两斗之间的拱眼壁部，绘缠枝牡丹和荷花。

<div align="right">（撰文：李铭　摄影：孙涛）</div>

Peonies on Board between Bracket Sets

Zhiyuan Era, Yuan (1264-1294 CE)

Height 40 cm; Width 160 cm

Unearthed from the Yuan tomb at Sanjiancun in Shuangshanzhen of Zhangqiu, Shandong, in 2004. Not preserved.

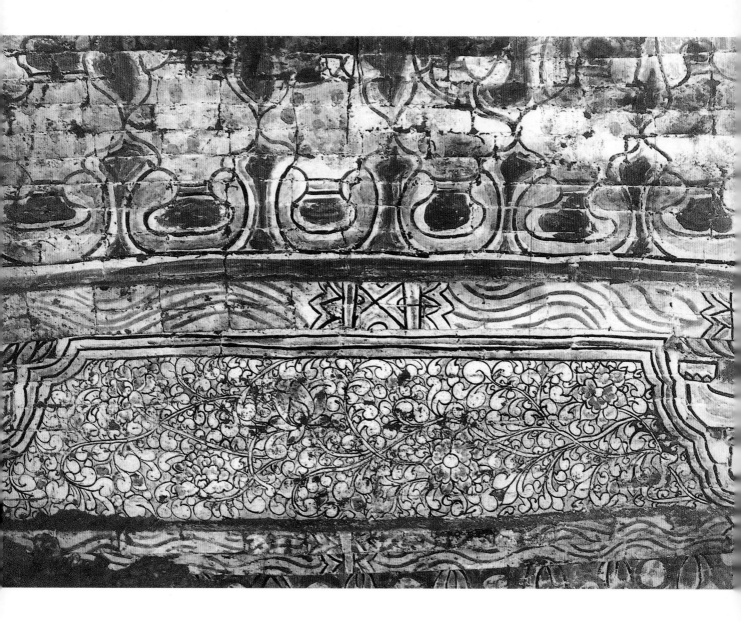

134.侍奉图

元至正十一年（1351年）

高91、宽97厘米

1991年山东省济南市历城区郭店镇省地质局第一地质大队院内元墓出土。原址保存。

墓向190°。位于墓室东壁，画面上方为帷帐，下方为一桌案，两侍女侍立于桌案两侧，桌上可辨有茶盏并托一套，似表现奉茶场面，画面右侧用红彩绘灯檠。

（撰文、摄影：刘善沂）

Serving Scene

11th Year of Zhizheng Era, Yuan (1351 CE)

Height 91 cm; Width 97 cm

Unearthed from the Yuan tomb at the courtyard of the First Geological Team of Provincial Geological Bureau in Guodian of Licheng District, Jinan, Shandong, in 1991. Preserved on the original site.

135.雄鸡牡丹图

元至正十一年（1351年）

高90、宽40厘米

1991年山东省济南市历城区郭店镇省地质局第一地质大队院内元墓出土。原址保存。

墓向190°。位于墓室南门洞西侧墓壁上。绘一昂首站立的公鸡，身后绘牡丹花卉。

<div align="right">（撰文、摄影：刘善沂）</div>

Rooster and Peony

11th Year of Zhizheng Era, Yuan (1351 CE)

Height 90 cm; Width 40 cm

Unearthed from the Yuan tomb at the courtyard of the First Geological Team of Provincial Geological Bureau in Guodian of Licheng District, Jinan, Shandong, in 1991. Preserved on the original site.

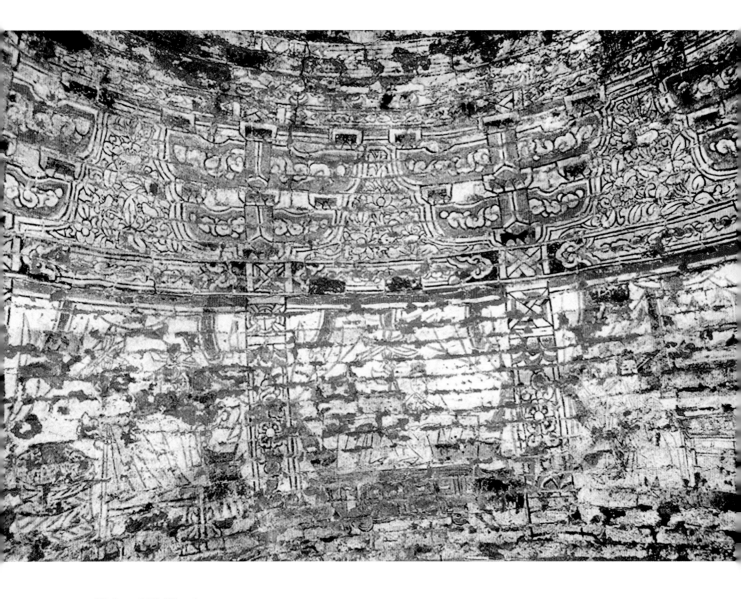

136. 墓室西壁壁画

元至正十一年（1351年）

高256、宽395厘米

1991年山东省济南市历城区郭店镇省地质局第一地质大队院内元墓出土。原址保存。

墓向190°。位于墓室西壁，可见到三个层次的壁画。第一层为家居生活的场景，第二层为斗拱建筑图案，第三层为卷云纹图案。

<div align="right">（撰文、摄影：刘善沂）</div>

Mural on the West Wall of the Tomb Chamber

11th Year of Zhizheng Era, Yuan (1351 CE)

Height 256 cm; Width 395 cm

Unearthed from the Yuan tomb at the courtyard of the First Geological Team of Provincial Geological Bureau in Guodian of Licheng District, Jinan, Shandong, in 1991. Preserved on the original site.

137. 仓库图

元至正十一年（1351年）

高90、宽120厘米

1991年山东省济南市历城区郭店镇省地质局第一地质大队院内元墓出土。原址保存。

墓向190°。位于墓室西壁。画面上为帷帐，左侧为一粮囤，右为一衣架，上挂搭衣帛。

（撰文、摄影：刘善沂）

Granary

11th Year of Zhizheng Era, Yuan (1351 CE)

Height 90 cm; Width 120 cm

Unearthed from the Yuan tomb at the courtyard of the First Geological Team of Provincial Geological Bureau in Guodian of Licheng District, Jinan, Shandong, in 1991. Preserved on the original site.

138.彩绘斗拱

元至正十一年（1351年）

高48、宽85厘米

1991年山东省济南市历城区郭店镇省地质局第一地质大队院内元墓出土。原址保存。

墓向190°。位于墓室转角处柱头斗拱，为四铺作重拱斗拱，上墨线勾绘卷云图案，地填红彩。

（撰文、摄影：刘善沂）

Colored Bracket Set

11th Year of Zhizheng Era, Yuan (1351 CE)

Height 48 cm; Width 85 cm

Unearthed from the Yuan tomb at the courtyard of the First Geological Team of Provincial Geological Bureau in Guodian of Licheng District, Jinan, Shandong, in 1991. Preserved on the original site.

139. 供奉龛

元至正十七年（1357年）

高约168、宽约140厘米

2004年山东省淄博市临淄区大武村元墓出土。已残毁。

墓向185°。位于东壁。图像表现一座山花向前的歇山顶式建筑。主体为砖雕，配以色彩鲜艳的建筑彩绘。其形制与西壁的一组大体相同。这组建筑的普柏枋出头明显比阑额长，另外在屋顶的山花部画了三只小鸟。在厅堂正中用砖雕出一个带座的长方形龛，龛内放置砖雕的顶部为梯形的碑。碑上墨书题记三行，中间一行为"至正贰四年二月初吉日"，右边为"长男于洹"，左边为"于贤泣立□□□□"。此处明显为一处供奉龛。

（撰文：秦大树、魏成敏　摄影：魏成敏）

Shrine

17th Year of Zhizheng Era, Yuan (1357 CE)

Height ca. 168 cm; Width ca. 140 cm

Unearthed from the Yuan tomb at Dawucun in Linzi district of Zibo, Shandong, in 2004. Not preserved.

140. 墓门内壁壁画

元至正十七年（1357年）

高约140、宽约148厘米

2004年山东省淄博市临淄区大武村元墓出土。已残毁。

墓向185°。墓门上方起券部饰红地黄彩的卷草纹，第二层立颊上也饰红地黄彩的卷草纹。门左右两侧上部各饰两组砖雕的上下相对的草叶纹和一组彩绘折枝草叶纹。

（撰文：秦大树、魏成敏　摄影：魏成敏）

Mural inside Tomb's Doorway

17th Year of Zhizheng Era, Yuan (1357 CE)

Height ca. 140 cm; Width ca. 148 cm

Unearthed from the Yuan tomb at Dawucun in Linzi District of Zibo, Shandong, in 2004. Not preserved.

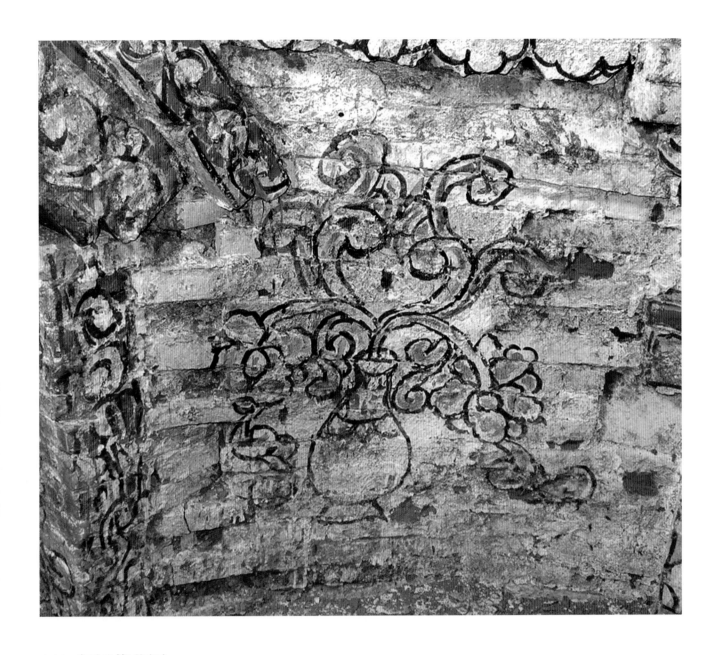

141.瓶插莲花图

元至正十七年（1357年）

高约84、宽约72厘米

2004年山东省淄博市临淄区大武村元墓出土。已残毁。

墓向185°。位于墓门西侧，为一组瓶插莲花图案，花头内填以红彩，花枝和花瓶颈部施淡蓝彩。取香花供养之意。

（撰文：秦大树、魏成敏　摄影：魏成敏）

Lotus in Vase

17th Year of Zhizheng Era, Yuan (1357 CE)

Height ca. 84 cm; Width ca. 72 cm

Unearthed from the Yuan tomb at Dawucun in Linzi District of Zibo, Shandong, in 2004. Not preserved.

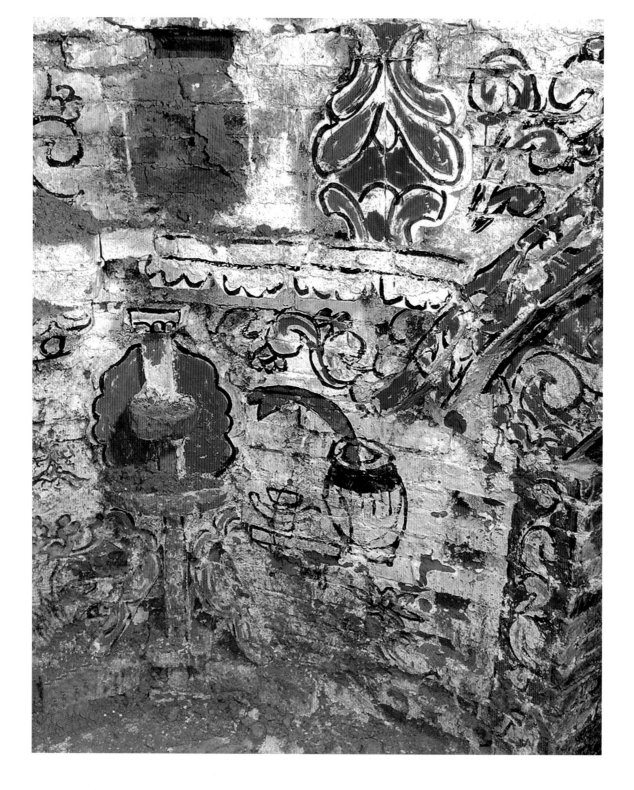

142. 灯檠器物图

元至正十七年（1357年）

高约100、宽约96厘米

2004年山东省淄博市临淄区大武村元墓出土。已残毁。

墓向185°。位于墓门右侧。主体为一个砖雕的灯檠，下部有底座，上部有两个砖砌的凸出的平面，用来放置灯盏。灯檠右侧中部画出一副劝盘并盏和一个罐子，从罐子口部伸出一个弯曲的酒勺柄，尾部分叉，施红彩。两组器物是宋元时期的典型酒器，取酒饮备荐之意。

（撰文：秦大树、魏成敏　摄影：魏成敏）

Lamp Stand and Utensils

17th Year of Zhizheng Era, Yuan (1357 CE)

Height ca. 100 cm; Width ca. 96 cm

Unearthed from the Yuan tomb at Dawucun in Linzi District of Zibo, Shandong, in 2004. Not preserved.

143.建筑图

元至正十七年（1357年）

高约172、宽约132厘米

2004年山东省淄博市临淄区大武村元墓出土。已残毁。

墓向185°。位于西壁中部。图像表现一座山花向前的歇山顶式建筑。主体为砖雕，配以色彩鲜艳的建筑彩绘。在两根立柱间置一长案，案上放置一个盒状物，用黑彩将正面画成网状，似表现放置衣物的箧笥。上部是阑额和普柏枋。阑额之下似有帷帐，两侧还画出龟背形的花结。普柏枋上有三朵斗拱，均为把头绞项造式，栌头和散斗的斗欹部均画出莲瓣，斗拱之上为两层砌出的砖带，其上画出圆形椽头和瓦。上面的一层为博脊，并画出一对方形和一对圆形的博脊端头，再上为三角形的屋顶山面。博风板上用黑彩画出帽钉，上接人字瓦坡、排山勾滴和垂脊，垂脊的端头用彩画示意性地表现戗脊。在山花板的正中为近似葫芦形的悬鱼。

（撰文：秦大树、魏成敏　摄影：魏成敏）

Brick Carving Architecture

17th Year of Zhizheng Era, Yuan (1357 CE)

Height ca. 172 cm; Width ca. 132 cm

Unearthed from the Yuan tomb at Dawucun in Linzi District of Zibo, Shandong, in 2004. Not preserved.

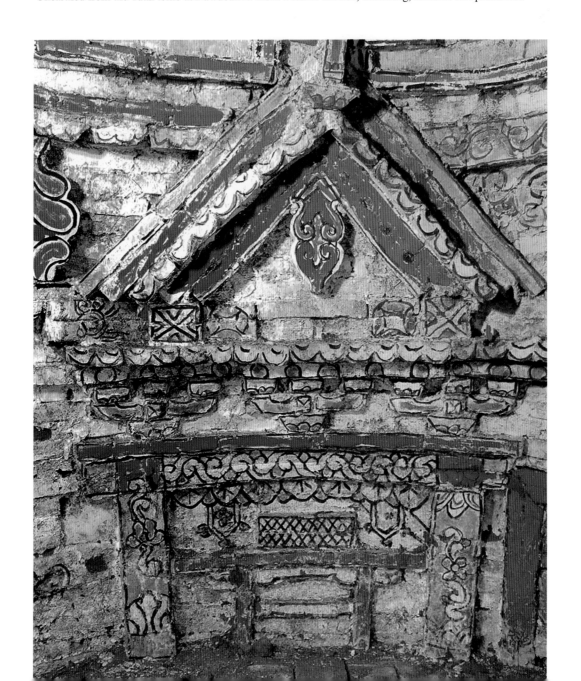

144.门楼假门图

元至正十七年（1357年）

高约240、宽约172厘米

2004年山东省淄博市临淄区大武村元墓出土。已残毁。

墓向185°。位于后壁正中。图像用砖雕表现一座重檐歇山顶的建筑。主体为砖雕，配以色彩鲜艳的建筑彩绘。下部正中为带门钉和门锁的两扇门板，门上部有两枚方形门簪。门钉和锁均施黑彩，门两侧的泥道板上绘画花卉。顶部为阑额、普柏枋，上承三朵把头绞项造式斗拱。斗拱之上承托用蓝绿彩涂画的撩檐枋，其上为画出的圆形椽头和瓦。再上又有三根蜀柱，上接阑额、普柏枋、三朵斗拱和撩檐枋、圆形椽头和瓦。上一层为博脊，最上部为歇山顶的山花部。

（撰文：秦大树、魏成敏　摄影：魏成敏）

Gatehouse and Phony Door

17th Year of Zhizheng Era, Yuan (1357 CE)

Height ca. 240 cm; Width ca. 172 cm

Unearthed from the Yuan tomb at Dawucun in Linzi District of Zibo, Shandong, in 2004. Not preserved.

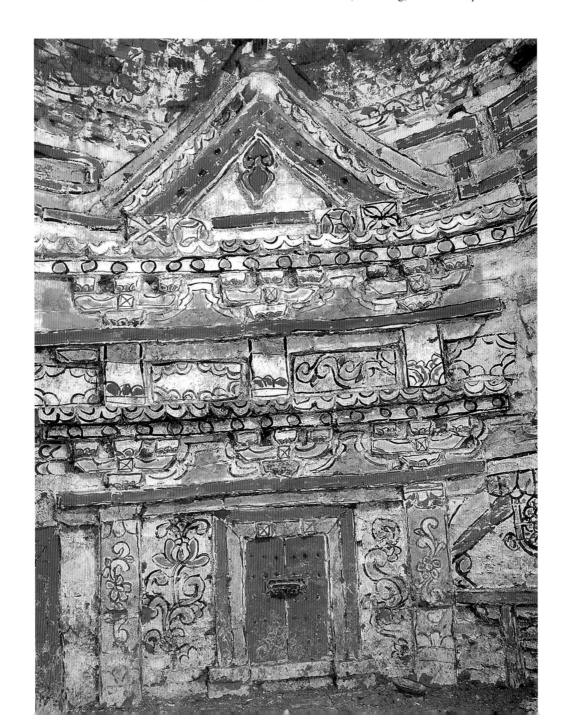

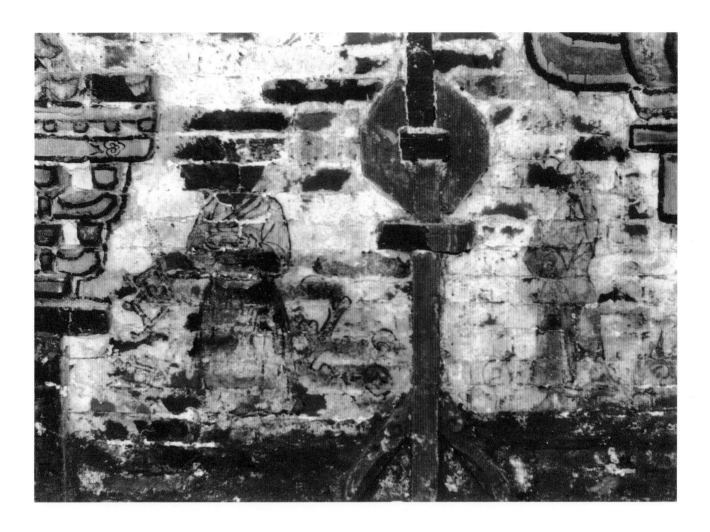

145.灯檠侍者图

元（1206～1368年）

高80、宽120厘米

1988年山东省济南市文化东路济南柴油机厂元墓出土。原址保存。

墓向正北。位于墓室东壁。中间用红彩绘一灯檠，两侧各站一侍者，左侧一人着交领长袍，双手捧持一付酒台子，身后绘各种杂宝；右侧一人怀抱玉壶春瓶，表现进酒题材。

（撰文、摄影：李铭）

Lamp Stand and Servants

Yuan (1206-1368 CE)

Height 80 cm; Width 120 cm

Unearthed from the Yuan tomb at Diesel Engine Plant in East Wenhua Road of Jinan, Shandong, in 1988. Preserved on the original site.

146.人物图

元（1206～1368年）

高70、宽50厘米。

1988年山东省济南市文化西路济南柴油机厂元墓出土。原址保存。墓向正北。位于墓室东壁南侧，一男子侍立，着长袍，腰围抱肚，怀抱玉壶春瓶。

（撰文、摄影：刘善沂）

Servant

Yuan (1206-1368 CE)

Height 70 cm; Width 50 cm

Unearthed from the Yuan tomb at Diesel Engine Plant in East Wenhua Road of Jinan, Shandong, in 1988. Preserved on the original site.

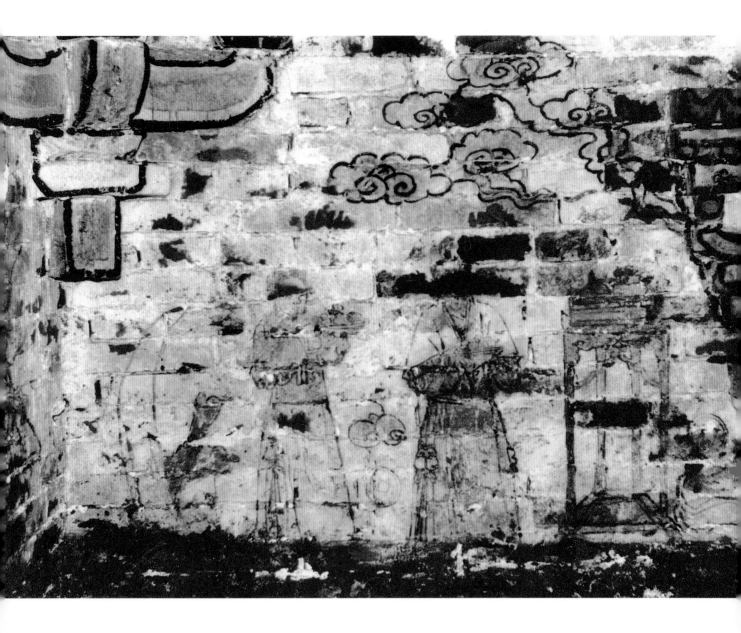

147.侍从图

元（1206～1368年）

高80、宽120厘米

1988年山东省济南市文化东路济南柴油机厂元墓出土。原址保存。

墓向正北。位于墓室西壁。画面左边画有犀角杂宝；右边画高脚方形栏杆供桌，桌上置罐、盒。画面中两个人物，右侧侍女上着半臂，袖手而立；左侧男侍头戴钹笠冠，上着短袄，下作裙式长袍，双手捧食盘。

<div align="right">（撰文、摄影：刘善沂）</div>

Servants

Yuan (1206-1368 CE)

Height 80 cm; Width 120 cm

Unearthed from the Yuan tomb at Diesel Engine Plant in East Wenhua Road of Jinan, Shandong, in 1988. Preserved on the original site.

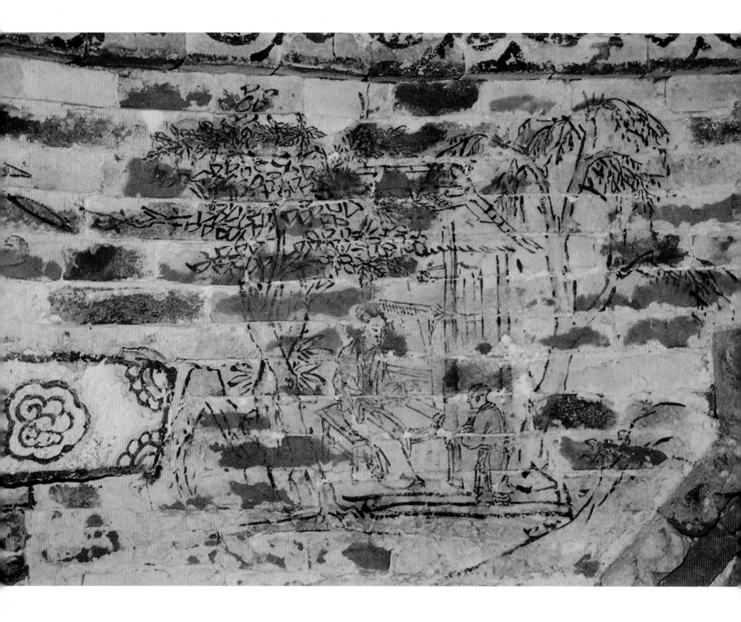

148.孟母断机图

元（1206～1368年）

高77、宽106厘米

1988年山东省济南市文化东路济南柴油机厂元墓出土。原址保存。

墓向正北。位于墓室东壁左上方。画面绘草庐一间，两侧有树，屋内孟母坐织机旁，左手指向孟子作训示状，孟子拱手聆听母亲教诲。

（撰文、摄影：刘善沂）

Mencius' Mother Breaking Loom

Yuan (1206-1368 CE)

Height 77 cm; Width 106 cm

Unearthed from the Yuan tomb at Diesel Engine Plant in East Wenhua Road of Jinan, Shandong, in 1988. Preserved on the original site.

149. 刘明达孝行故事图

元（1206～1368年）

高77、宽110厘米

1988年山东省济南市文化东路济南柴油机厂元墓出土。原址保存。

墓向正北。位于墓室穹隆顶东北壁。图左边一妇女身穿长裙目送骑马男子，坐于马上的男子身穿红袍头戴展脚幞头，手抱一幼童，回头顾望，马前站立一拿枪年青人。似表现刘明达孝行故事。

<div align="right">（撰文、摄影：刘善沂）</div>

Liu Mingda, One of the "Twenty-Four Paragons of Filial Piety"

Yuan (1206-1368 CE)

Height 77 cm; Width 110 cm

Unearthed from the Yuan tomb at Diesel Engine Plant in East Wenhua Road of Jinan, Shandong, in 1988. Preserved on the original site.

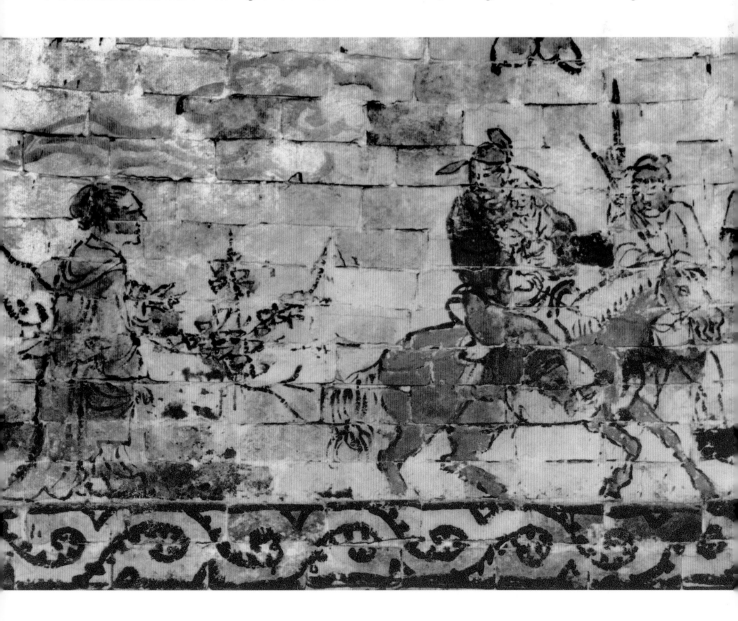

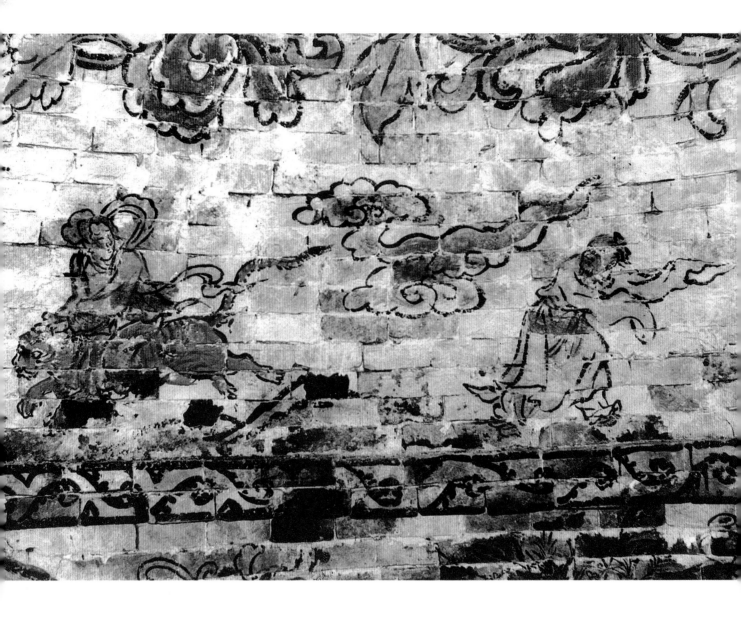

150.杨香打虎救父图

元（1206～1368年）

高77、宽130厘米

1988年山东省济南市文化东路济南柴油机厂元墓出土。原址保存。

墓向正北。位于墓室穹隆顶东北壁。左为一女子正在按着一老虎颈部，扭头往后看，一老者表情慌张奔跑逃命，回首后望。表现杨香打虎救父孝行故事。

<div align="right">（撰文、摄影：李铭）</div>

Yang Xiang, One of the "Twenty-Four Paragons of Filial Piety"

Yuan (1206-1368 CE)

Height 77 cm; Width 130 cm

Unearthed from the Yuan tomb at Diesel Engine Plant in East Wenhua Road of Jinan, Shandong, in 1988. Preserved on the original site.

151.鲁义姑舍子救侄图

元（1206～1368年）

高77、宽110厘米

1988年山东省济南市文化东路济南柴油机厂元墓出土。原址保存。

墓向正北。位于墓室穹隆顶西北壁。左为一武官身穿铠甲，手拿长枪坐于马上，表情严肃，马前站立一裨将，图右边为一妇女身穿长裙，怀抱一幼儿，一幼童躲于妇女右侧裙后。表现鲁义姑舍子救侄故事。

（撰文、摄影：刘善沂）

Lu Yigu, One of the "Twenty-Four Paragons of Filial Piety"

Yuan (1206-1368 CE)

Height 77 cm; Width 110 cm

Unearthed from the Yuan tomb at Diesel Engine Plant in East Wenhua Road of Jinan, Shandong, in 1988. Preserved on the original site.

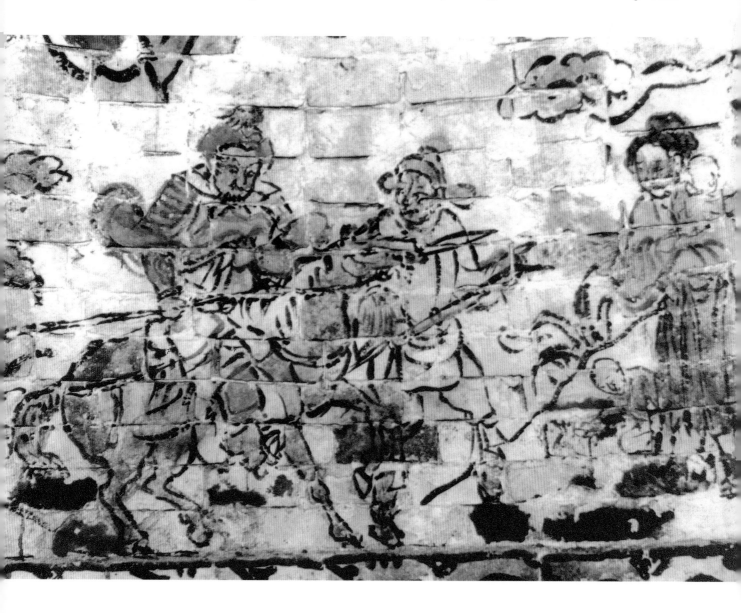

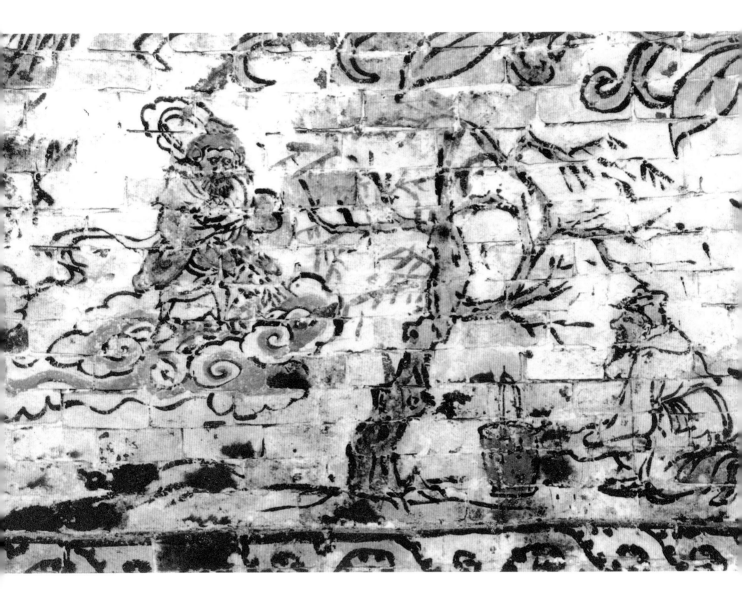

152.蔡顺拾葚奉母图

元（1206～1368年）

高77、宽120厘米

1988年山东省济南市文化东路济南柴油机厂元墓出土。原址保存。

墓向正北。位于墓室穹隆顶西北壁。图中画两人，一男子身穿长衫跪在地上，面前放一竹篮，左上方一仙人乘云而来。这是二十四孝中蔡顺拾葚的故事。

（撰文、摄影：刘善沂）

Cai Shun, One of the "Twenty-Four Paragons of Filial Piety"

Yuan (1206-1368 CE)

Height 77 cm; Width 120 cm

Unearthed from the Yuan tomb at Diesel Engine Plant in East Wenhua Road of Jinan, Shandong, in 1988. Preserved on the original site.

153.元觉谏父图

元（1206～1368年）

高77、宽130厘米

1988年山东省济南市文化东路济南柴油机厂元墓出土。原址保存。

墓向正北。位于墓室穹隆顶北壁。图中一少年右手拿担架，躬身朝着一长者，身后山石上坐一老人。表现元觉谏父的故事。

（撰文、摄影：刘善沂）

Yuan Jue, One of the "Twenty-Four Paragons of Filial Piety"

Yuan (1206-1368 CE)

Height 77 cm; Width 130 cm

Unearthed from the Yuan tomb at Diesel Engine Plant in East Wenhua Road of Jinan, Shandong, in 1988. Preserved on the original site.

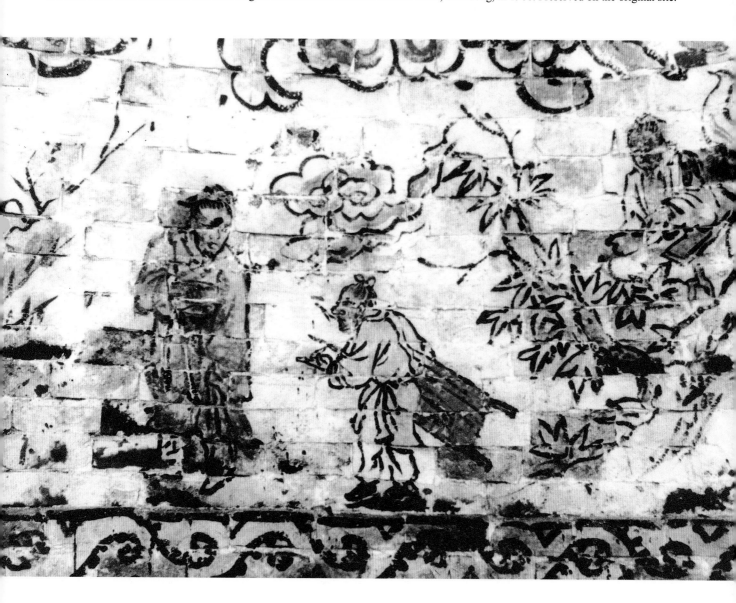

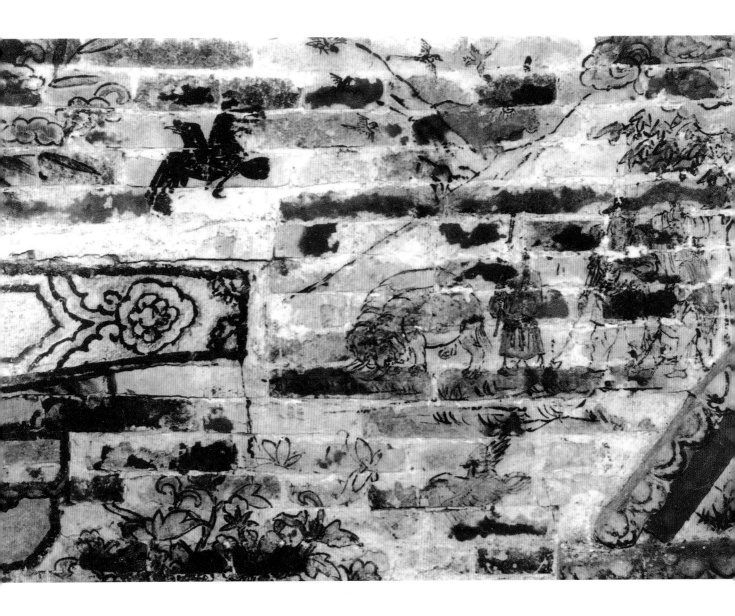

154. 虞舜孝感动天图

元（1206～1368年）

高77、宽110厘米

1988年山东省济南市文化东路济南柴油机厂元墓出土。原址保存。

墓向正北。位于墓室穹隆顶北壁。图中一年青人拿一棍子在赶着大象耕田，身后站着两人在观看，大象前飞着黄色的鸟和蝴蝶，天上有飞着黑色的大鸟和一些小鸟。虞舜早年丧母，继母虐待他，而他加倍对继母孝敬，对弟弟也非常好，使他们受到了感化，其孝行感动了上天，舜在历山时大象替他耕田，鸟儿替他除草，这就是虞舜孝感动天的故事。

<div style="text-align: right">（撰文、摄影：李铭）</div>

Emperor Shun, One of the "Twenty-Four Paragons of Filial Piety"

Yuan (1206-1368 CE)

Height 77 cm; Width 110 cm

Unearthed from the Yuan tomb at Diesel Engine Plant in East Wenhua Road of Jinan, Shandong, in 1988. Preserved on the original site.

155.郭巨埋儿奉母图

元（1206～1368年）

高83、宽100厘米

1988年山东省济南市文化东路济南柴油机厂元墓出土。原址保存。

墓向正北。位于墓室西壁右上方。内容似为郭巨埋儿的孝行故事。画面绘一庭院，屋内坐一老妇，院内有三株树，一妇人持杖立于院中左侧，前置香几，上有熏炉，右侧一男子持锹掘土。

<div align="right">（撰文、摄影：刘善沂）</div>

Guo Ju, One of the "Twenty-Four Paragons of Filial Piety"

Yuan (1206-1368 CE)

Height 83 cm; Width 100 cm

Unearthed from the Yuan tomb at Diesel Engine Plant in East Wenhua Road of Jinan, Shandong, in 1988. Preserved on the original site.

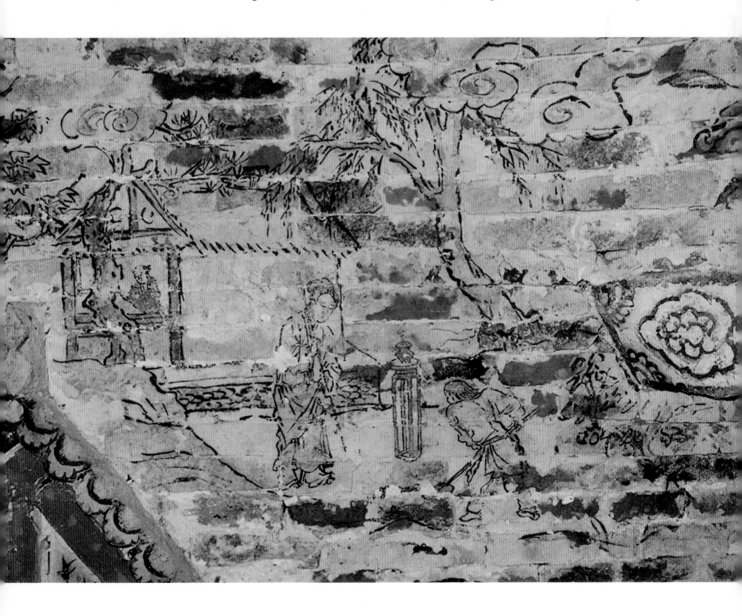

156. 王祥卧冰求鲤图

元（1206～1368年）

高83、宽100厘米

1988年山东省济南市文化东路济南柴油机厂元墓出土。原址保存。

墓向正北。位于墓室北壁右上方。内容为王祥卧冰求鲤的孝行故事。画面绘王祥裸身半卧冰上，背后有一小桥，桥上一人骑驴而行，两人凭栏俯视。

（撰文、摄影：刘善沂）

Wang Xiang, One of the "Twenty-Four Paragons of Filial Piety"

Yuan (1206-1368 CE)

Height 83 cm; Width 100 cm

Unearthed from the Yuan tomb at Diesel Engine Plant in East Wenhua Road of Jinan, Shandong, in 1988. Preserved on the original site.

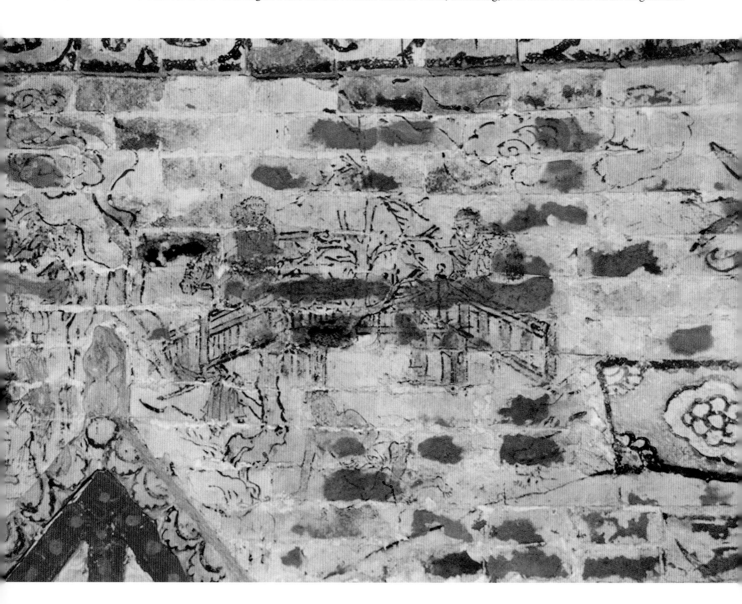

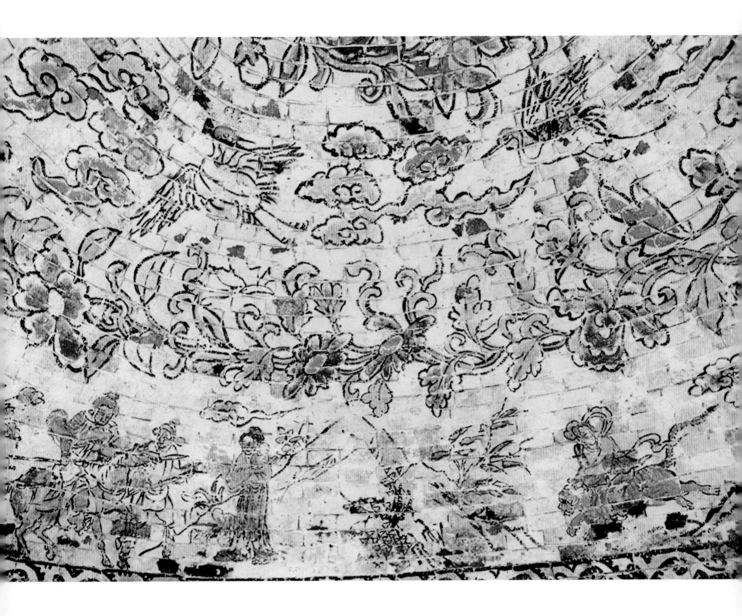

157.穹隆顶壁画

元（1206～1368年）

高231、宽360厘米

1988年山东省济南市文化东路济南柴油机厂元墓出土。原址保存。

墓向正北。位于墓室穹隆顶北壁。绘有仙鹤、祥云、缠枝牡丹花卉及鲁义姑舍子救侄、杨香打虎救父等孝行故事。

<div align="right">（撰文、摄影：刘善沂）</div>

Mural on Dome Ceiling

Yuan (1206-1368 CE)

Height 231 cm; Width 360 cm

Unearthed from the Yuan tomb at Diesel Engine Plant in East Wenhua Road of Jinan, Shandong, in 1988. Preserved on the original site.

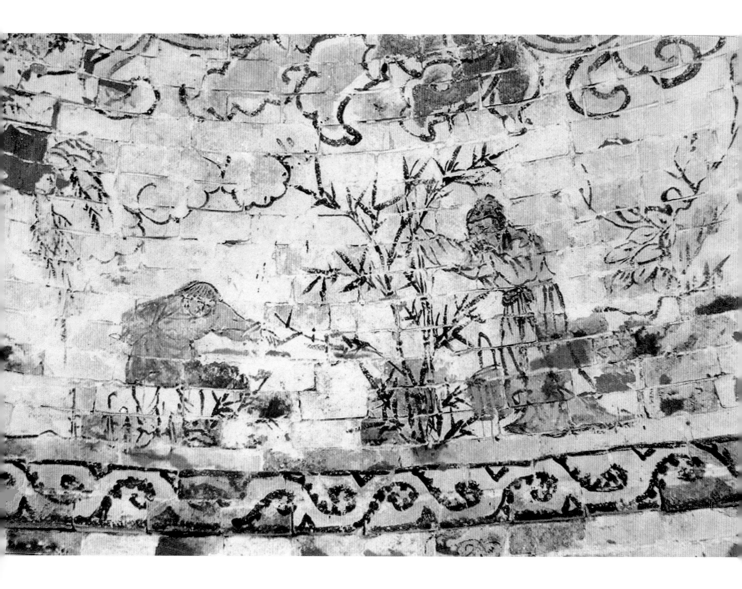

158.孟宗哭竹生笋图

元（1206～1368年）

高77、宽89厘米

1988年山东省济南市文化东路济南柴油机厂元墓出土。原址保存。

墓向正北。位于墓室穹隆顶北壁。孟宗右手扶竹，左手掩面哭泣，身边放一篮。左侧一童，双臂张开俯身下望，脚下竹笋丛生。

<div align="right">（撰文、摄影：刘善沂）</div>

Meng Zong, One of the "Twenty-Four Paragons of Filial Piety"

Yuan (1206-1368 CE)

Height 77 cm; Width 89 cm

Unearthed from the Yuan tomb at Diesel Engine Plant in East Wenhua Road of Jinan, Shandong, in 1988. Preserved on the original site.

159.朱寿昌弃官寻母图

元（1206～1368年）

高70、宽100厘米

1988年山东省济南市文化东路济南柴油机厂元墓出土。原址保存。

墓向正北。位于墓室顶西部。画面一人头戴展脚幞头，身穿官服，右手掩面。左侧有一仆从，肩挑两个箱笼。所画当系朱寿昌弃官寻母故事。

<div style="text-align:right">（撰文、摄影：刘善沂）</div>

Zhu Shouchang, One of the "Twenty-Four Paragons of Filial Piety"

Yuan (1206-1368 CE)

Height 70 cm; Width 100 cm

Unearthed from the Yuan tomb at Diesel Engine Plant in East Wenhua Road of Jinan, Shandong, in 1988. Preserved on the original site.

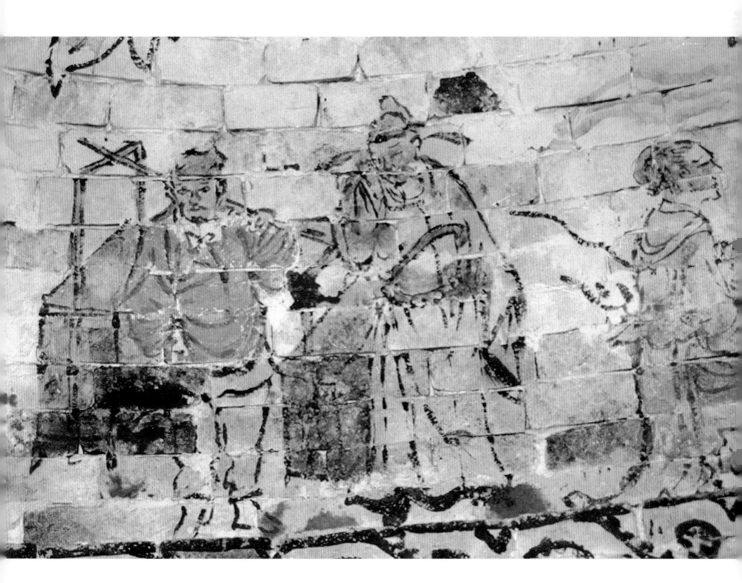

160.花卉图（一）

元（1206～1368年）

高40、宽63厘米。

1988年山东省济南市文化东路济南柴油机厂元墓出土。原址保存。

墓向正北。位于墓室东南隅的拱眼壁内，为折枝花卉。

<div align="right">（撰文、摄影：刘善沂）</div>

Flowers (1)

Yuan (1206-1368 CE)

Height 40 cm; Width 63 cm

Unearthed from the Yuan tomb at Diesel Engine Plant in East Wenhua Road of Jinan, Shandong, in 1988. Preserved on the original site.

161.花卉图（二）

元（1206～1368年）

高40、宽128厘米

1988年山东省济南市文化东路济南柴油机厂元墓出土。原址保存。

墓向正北。位于墓室南甬道西侧及西南隅斗拱之间的墓壁上。左侧为绿叶牡丹，右侧为瓶插花卉。

（撰文、摄影：刘善沂）

Flowers (2)

Yuan (1206-1368 CE)

Height 40 cm; Width 128 cm

Unearthed from the Yuan tomb at Diesel Engine Plant in East Wenhua Road of Jinan, Shandong, in 1988. Preserved on the original site.

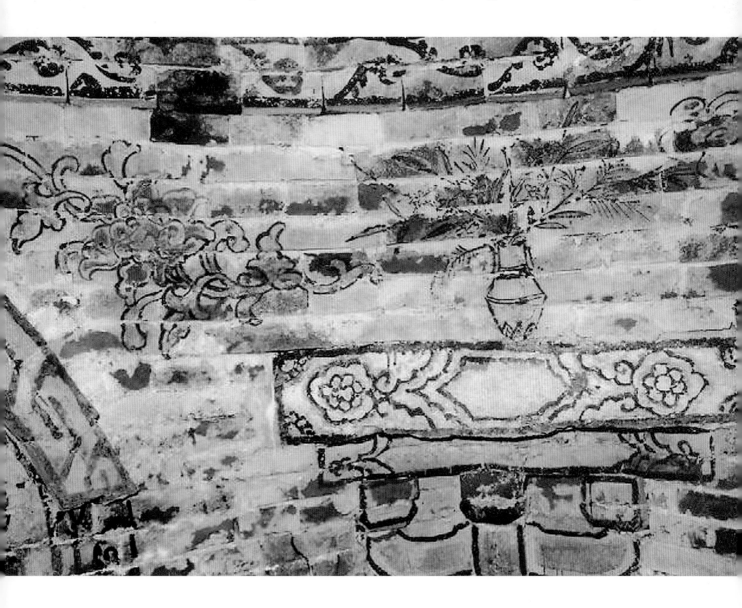

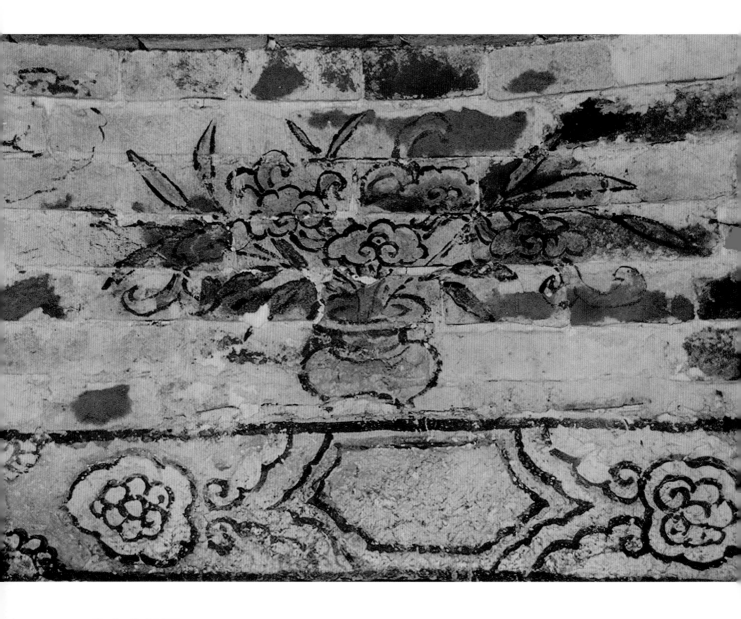

162. 花卉盆景图

元（1206～1368年）

高40、宽104厘米

1988年山东省济南市文化东路济南柴油机厂元墓出土。原址保存。

墓向正北。位于墓室东北隅斗拱之上。图中为一黄色鬲式炉，内插花卉。

<div align="right">（撰文、摄影：刘善沂）</div>

Bonsai Flower

Yuan (1206-1368 CE)

Height 40 cm; Width 104 cm

Unearthed from the Yuan tomb at Diesel Engine Plant in East Wenhua Road of Jinan, Shandong, in 1988. Preserved on the original site.

163.云鹤图

元（1206～1368年）

高70、宽90厘米

1988年山东省济南市文化东路济南柴油机厂元墓出土。原址保存。

墓向正北。位于墓室穹隆顶北壁。一仙鹤展翅高飞，背景为花卉云朵。

（撰文、摄影：李铭）

Clouds and Crane

Yuan (1206-1368 CE)

Height 70 cm; Width 90 cm

Unearthed from the Yuan tomb at Diesel Engine Plant in East Wenhua Road of Jinan, Shandong, in 1988. Preserved on the original site.

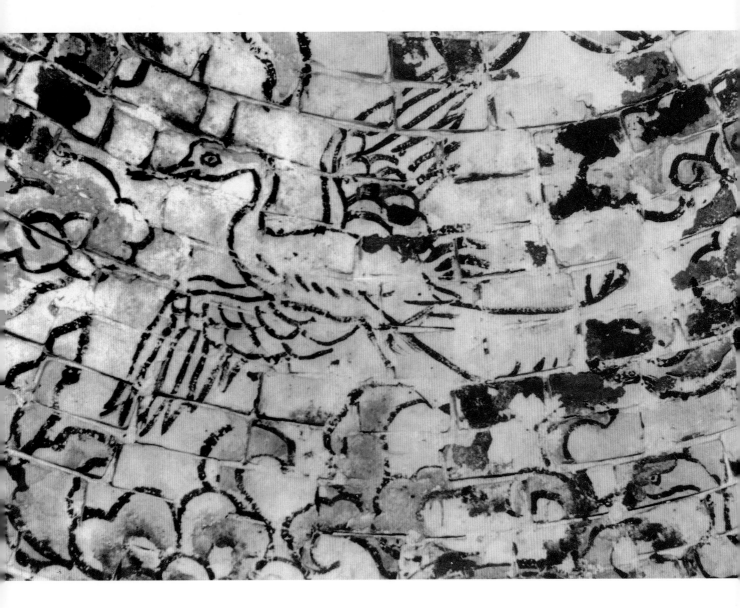

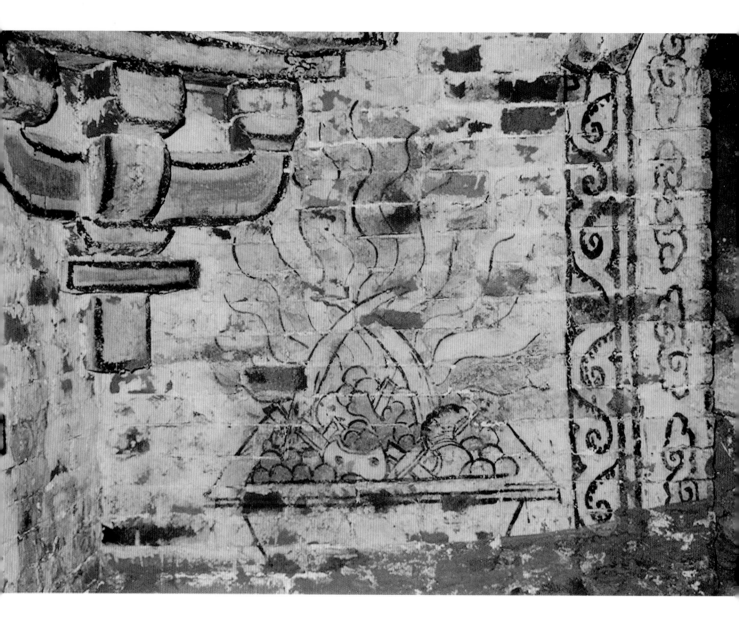

164.杂宝盆图

元（1206～1368年）

高120、宽103厘米

1988年山东省济南市文化东路济南柴油机厂元墓出土。原址保存。

墓向正北。位于墓室南壁墓门东侧。盆为方形，内置象牙、银铤、珠宝等物。

<div align="right">（撰文、摄影：刘善沂）</div>

Treasure Bowl

Yuan (1206-1368 CE)

Height 120 cm; Width 103 cm

Unearthed from the Yuan tomb at Diesel Engine Plant in East Wenhua Road of Jinan, Shandong, in 1988. Preserved on the original site.

165.牡丹花卉图

元（1206～1368年）

高108、宽102厘米

1988年山东省济南市文化东路济南柴油机厂元墓出土。原址保存。

墓向正北。位于墓室北壁西侧。牡丹花插在一双耳长颈瓶中，上有数只蝴蝶，瓶下有座，花卉两侧绘散置的象牙、金银珠宝等物。

（撰文、摄影：刘善沂）

Peonies

Yuan (1206-1368 CE)

Height 108 cm; Width 102 cm

Unearthed from the Yuan tomb at Diesel Engine Plant in East Wenhua Road of Jinan, Shandong, in 1988. Preserved on the original site.

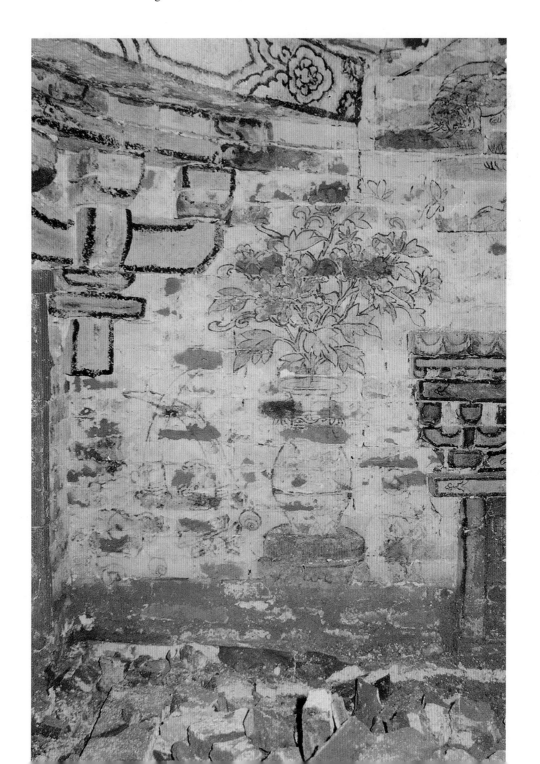

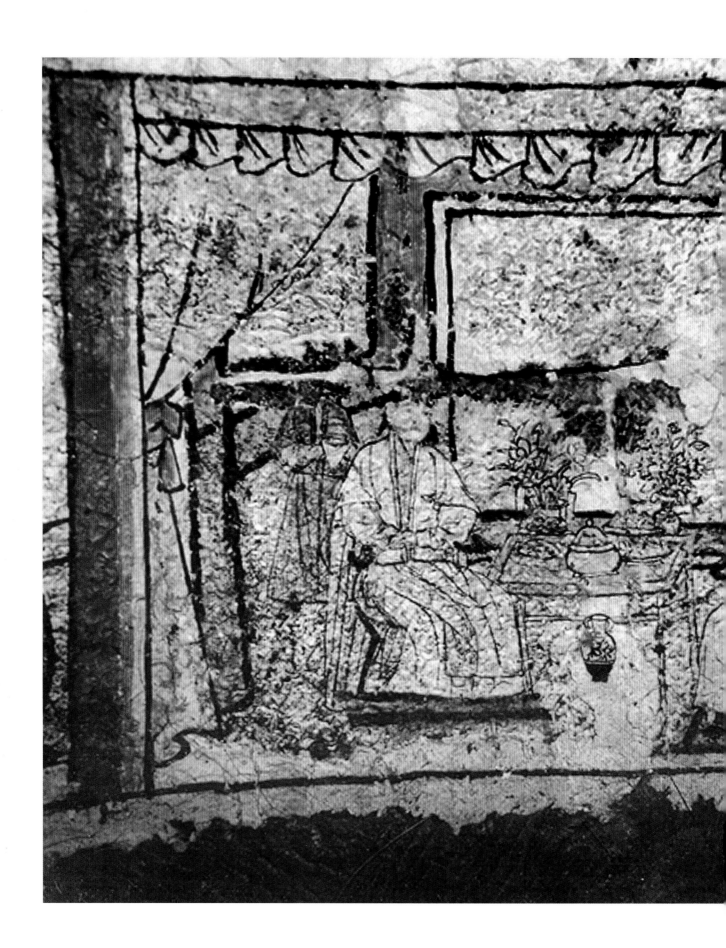

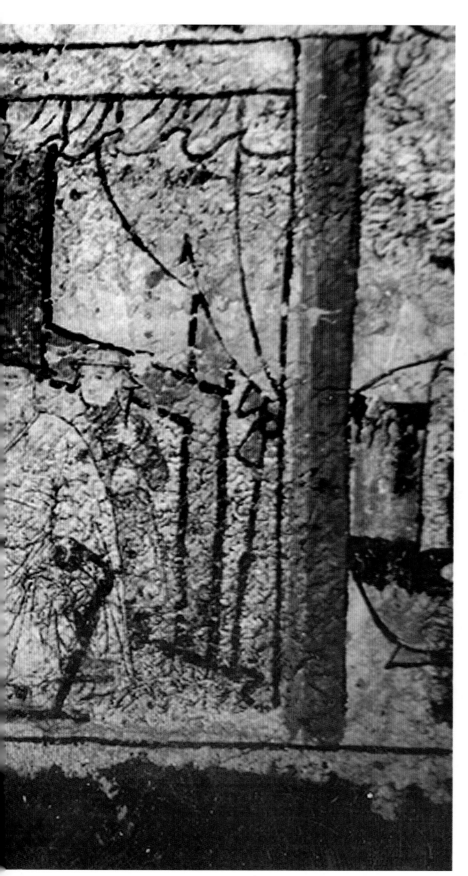

166. 夫妇对坐图

元（1206～1368年）

高76、宽100厘米

2001年山东省济南市历城区大正小区埠东村元石雕墓出土。原址保存。

墓向170°。位于墓室北壁，画面正中为屏风，上方有帷幕，男女墓主人并坐于方桌两侧，脚踏足承，男主人头戴笠帽，身着交领长袍，身后站立持骨朵男侍。女主人梳髻，上身对襟半臂，下着裙，身后立捧物侍女，中间方桌上放置一盖罐、食盘二碟和一丛瓶花，一丛盆花。桌下放置一白地黑花双耳瓶。

（撰文、摄影：刘善沂）

Tomb Occupant Couple Seated Beside the Table

Yuan (1206-1368 CE)

Height 76 cm; Width 100 cm

Unearthed from the Carved Stone Yuan tomb at Budongcun in Dazhengxiaoqu of Licheng District, Jinan, Shandong, in 2001. Preserved on the original site.

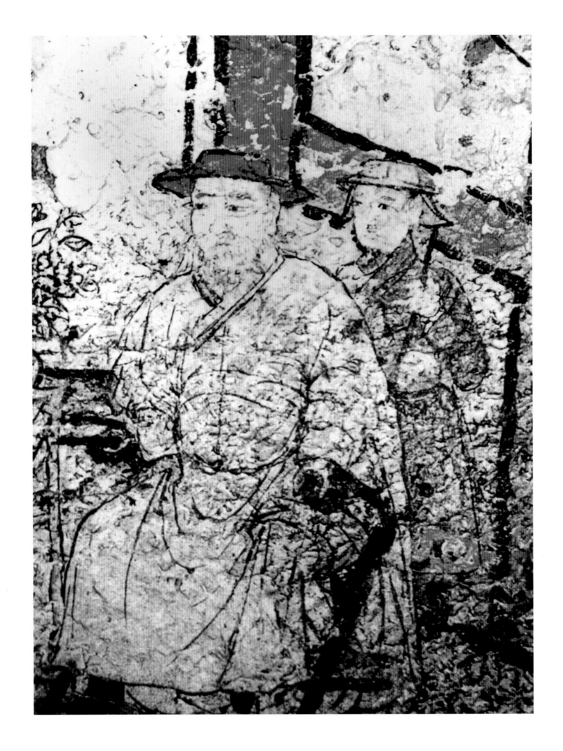

167. 男主人图

元（1206～1368年）

高约31、宽约20厘米

2001年山东省济南市历城区大正小区埠东村元石雕墓出土。原址保存。

墓向170°。位于墓室北壁，屏风前，男主人头戴红色圆形毡帽，身着交领长袍，端坐于桌右侧椅子上。其身后立一男仆，头戴白色后檐帽，身穿束腰长袍，脚穿皂靴，右手持骨朵。

（撰文、摄影：刘善沂）

Male Tomb Occupant

Yuan (1206-1368 CE)

Height ca. 31 cm; Width ca. 20 cm

Unearthed from the Carved Stone Yuan tomb at Budongcun in Dazhengxiaoqu of Licheng District, Jinan, Shandong, in 2001. Preserved on the original site.

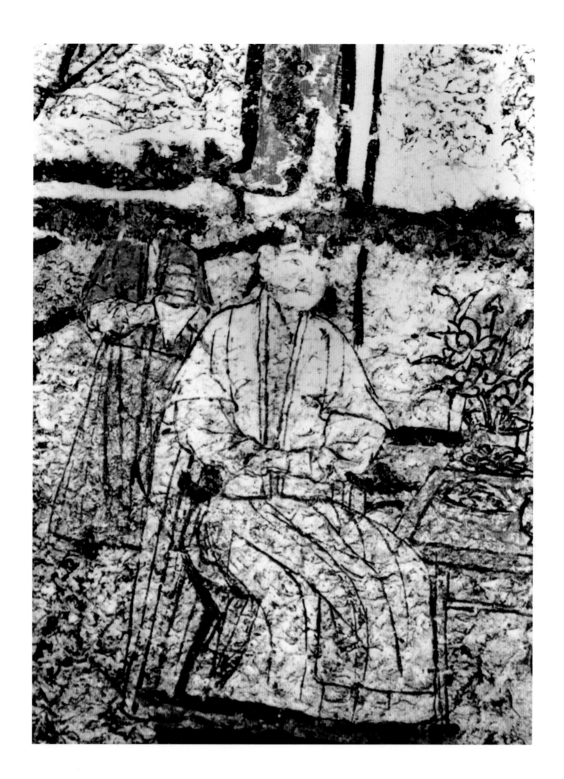

168.女主人图

元（1206～1368年）

高约31、宽约20厘米

2001年山东省济南市历城区大正小区埠东村元石雕墓出土。原址保存。墓向170°。位于墓室北壁，屏风前，女主人面相端庄，头上部画面残缺，梳双垂髻，内穿长袍，外套半臂，抄手端坐于左侧椅子上。其身后立一侍女，头部画面残缺，上身内穿长袖白衫，外套绿色半臂，双手捧巾盒。

（撰文、摄影：刘善沂）

Female Tomb Occupant

Yuan (1206-1368 CE)

Height ca. 31 cm; Width ca. 20 cm

Unearthed from the Carved Stone Yuan tomb at Budongcun in Dazhengxiaoqu of Licheng District, Jinan, Shandong, in 2001. Preserved on the original site.

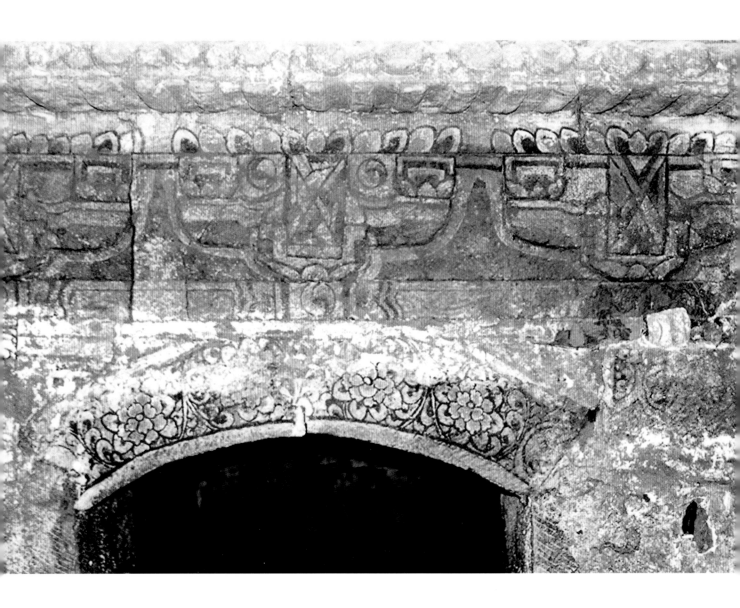

▲ 169.门楼图（局部）

元（1206～1368年）

高70、宽190厘米

2001年山东省济南市历城区大正小区埠东村元石雕墓出土。原址保存。

墓向170°。位于墓门门楣及第一层檐下，门楣上绘缠枝牡丹，第一层檐下绘三组把头绞项造斗拱，用红、绿、蓝等色绘建筑彩画。

（撰文、摄影：刘善沂）

Patterns on Gatehouse (Detail)

Yuan (1206-1368 CE)

Height 70 cm; Width 190 cm

Unearthed from the Carved Stone Yuan tomb at Budongcun in Dazhengxiaoqu of Licheng District, Jinan, Shandong, in 2001. Preserved on the original site.

170.启门图 ▶

元（1206～1368年）

高170、宽82厘米

2001年山东省济南市历城区大正小区埠东村元石雕墓出土。原址保存。

墓向170°。位于墓室东壁，顶部为山花向前式歇山屋顶石雕，屋顶两侧绘牡丹。下面为男仆半启门图像。板门两扇，圆形门簪，各有五排门钉，圆形门簪，一男侍头戴铱笠冠，着圆领窄袖长袍，半身探出门外。

（撰文、摄影：刘善沂）

Opening the Door Ajar

Yuan (1206-1368 CE)

Height 170 cm; Width 82 cm

Unearthed from the Carved Stone Yuan tomb at Budongcun in Dazhengxiaoqu of Licheng District, Jinan, Shandong, in 2001. Preserved on the original site.

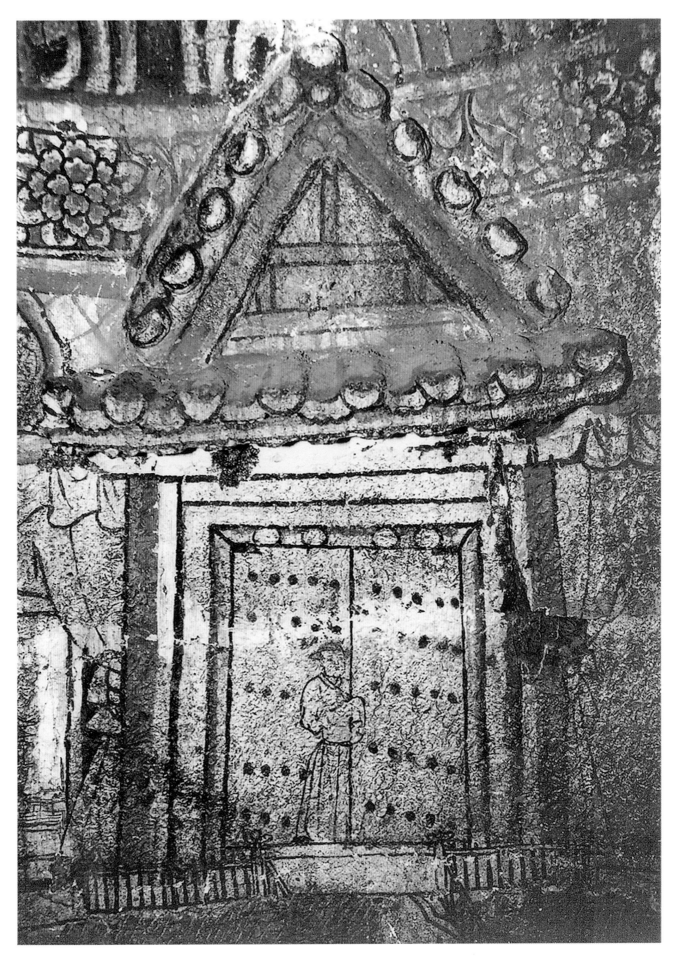

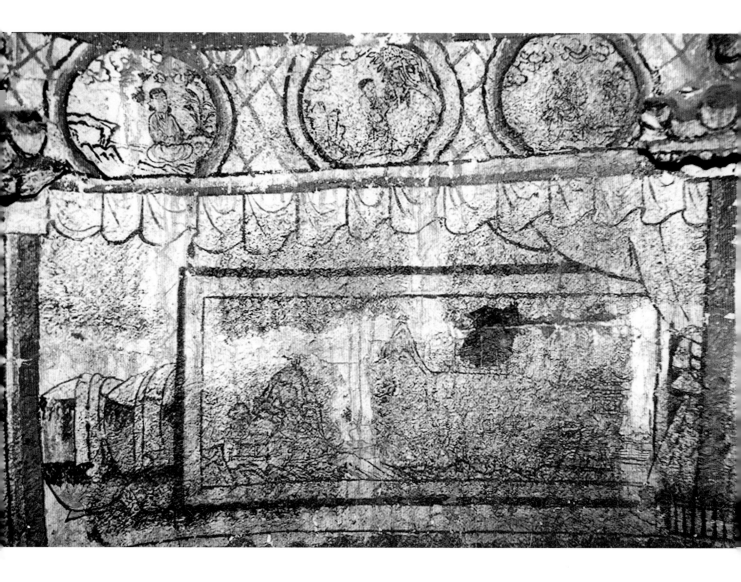

171.山水屏风图 （一）

元（1206 ~ 1368年）

屏风高76、宽149厘米

2001年山东省济南市历城区大正小区埠东村元石雕墓出土。原址保存。

墓向170°。位于墓室东北壁，画面上为帷帐，下为山水屏风，右侧两个大染缸，上搭布帛。

（撰文、摄影：刘善沂）

Landscape Screen (1)

Yuan (1206-1368 CE)

Height 76 cm; Width 149 cm

Unearthed from the Carved Stone Yuan tomb at Budongcun in Dazhengxiaoqu of Licheng District, Jinan, Shandong, in 2001. Preserved on the original site.

172.山水屏风图（二）

元（1206～1368年）

高约45、宽约90厘米

2001年山东省济南市历城区大正小区埠东村元石雕墓出土。原址保护。

墓向170°。位于墓室西北壁建筑之间。屏风画面为一组高低错落的山峦，山峦间依山势排列若干座建筑。屏风北侧置粮仓若干。

（撰文、摄影：刘善沂）

Landscape Screen (2)

Yuan (1206-1368 CE)

Height ca. 45 cm; Width ca. 90 cm

Unearthed from the Carved Stone Yuan tomb at Budongcun in Dazhengxiaoqu of Licheng District, Jinan, Shandong, in 2001. Preserved on the original site.

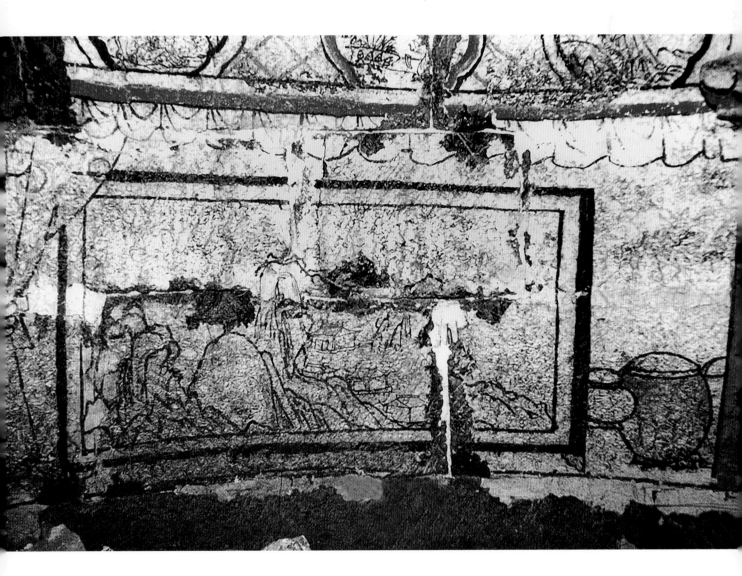

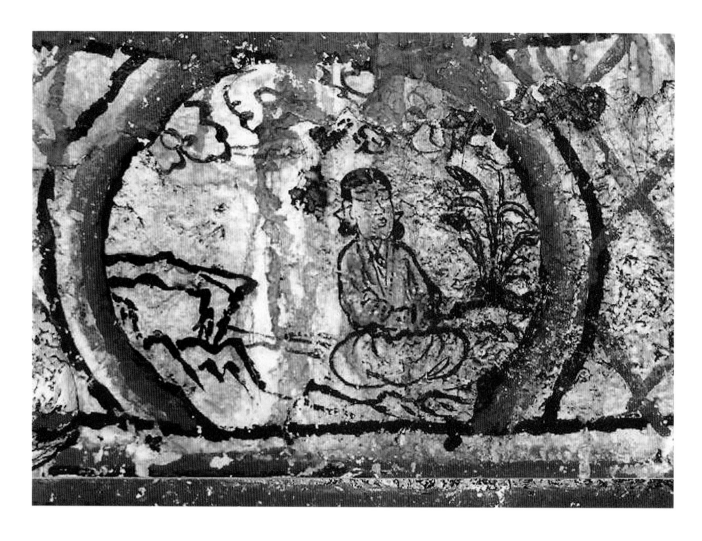

173. 焦花女哭麦图

元（1206～1368年）

高26、宽36厘米

2001年山东省济南市历城区大正小区埠东村元石雕墓出土。原址保存。

墓向170°。位于墓室东壁第二层拱眼壁上。画面为椭圆形，边缘绘朱彩，墨线勾框，内绘一女子盘腿坐于地上，面对一丛麦穗作悲伤状。

<div align="right">（撰文、摄影：刘善沂）</div>

Lady Jiaohua Weeping Wheats

Yuan (1206-1368 CE)

Height: 26 cm; Width 36 cm

Unearthed from the Carved Stone Yuan tomb at Budongcun in Dazhengxiaoqu of Licheng District, Jinan, Shandong, in 2001. Preserved on the original site.

174.郭巨埋儿奉母图

元（1206～1368年）

高26、宽36厘米

2001年山东省济南市历城区大正小区埠东村元石雕墓出土。原址保存。

墓向170°。位于墓室东壁第二层拱眼壁上。画面为椭圆形，边缘绘朱彩，墨线勾框内绘郭巨右手持锹，左手持钱串观看，右侧妻子怀抱婴儿立于院中。

（撰文、摄影：刘善沂）

Guo Ju, One of the "Twenty-Four Paragons of Filial Piety"

Yuan (1206-1368 CE)

Height 26 cm; Width 36 cm

Unearthed from the Carved Stone Yuan tomb at Budongcun in Dazhengxiaoqu of Licheng District, Jinan, Shandong, in 2001. Preserved on the original site.

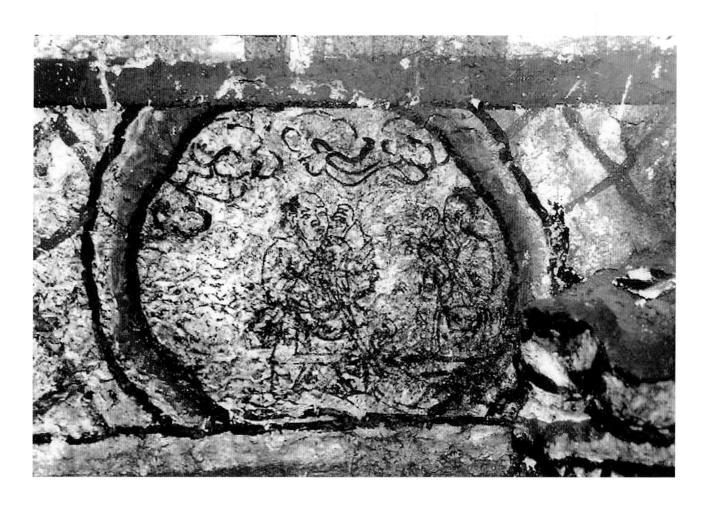

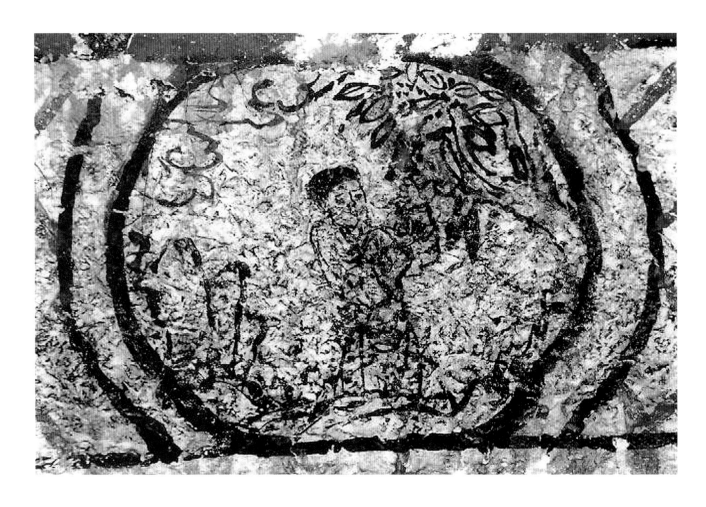

175. 蔡顺拾葚奉母图

元（1206～1368年）

高26、宽36厘米

2001年山东省济南市历城区大正小区埠东村元石雕墓出土。原址保存。

墓向170°。位于墓室东壁第二层拱眼壁上。画面为椭圆形，边缘绘朱彩，墨线勾框，内绘一男子在树下拾桑葚。

（撰文、摄影：刘善沂）

Cai Shun, One of the "Twenty-Four Paragons of Filial Piety"

Yuan (1206-1368 CE)

Height 26 cm; Width 36 cm

Unearthed from the Carved Stone Yuan tomb at Budongcun in Dazhengxiaoqu of Licheng District, Jinan, Shandong, in 2001. Preserved on the original site.

176.夫妇对坐图

元（1206～1368年）

高76、宽100厘米

1995年山东省济南市历城区港沟镇邢村元墓出土。原址保存。

墓向182°。位于墓室东壁，男女墓主人端坐于桌两侧高背椅上，主人身后立有侍女。男主人头戴毡帽，身着红色长袍。女主人上身对襟半臂，下着裙，中间桌上放置一酒罐和长柄勺，食盘三，小瓶两只等物。桌下居中放置一酒瓮，左右为玉壶春瓶。

（撰文、摄影：王惠民）

Tomb Occupant Couple Seated Beside the Table

Yuan (1206-1368 CE)

Height 76 cm; Width 100 cm

Unearthed from the Yuan tomb at Xingcun in Ganggouzhen of Licheng District of Jinan, Shandong, in 1995. Preserved on the original site.

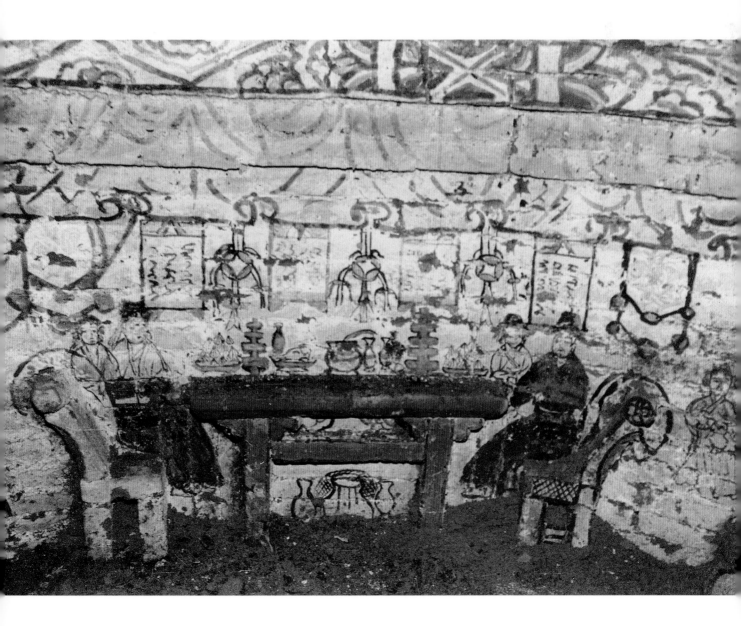

177.家居生活图

元（1206～1368年）

高85、宽144厘米

1995年山东省济南市历城区港沟镇邢村元墓出土。原址保存。

墓向182°。位于墓室西壁，主体为一衣架，上挂搭衣帛，架后站一侍女。

<div align="right">（撰文、摄影：王惠民）</div>

Home Living Scene

Yuan (1206-1368 CE)

Height 85 cm; Width 144 cm

Unearthed from the Yuan tomb at Xingcun in Ganggouzhen of Licheng District of Jinan, Shandong, in 1995. Preserved on the original site.

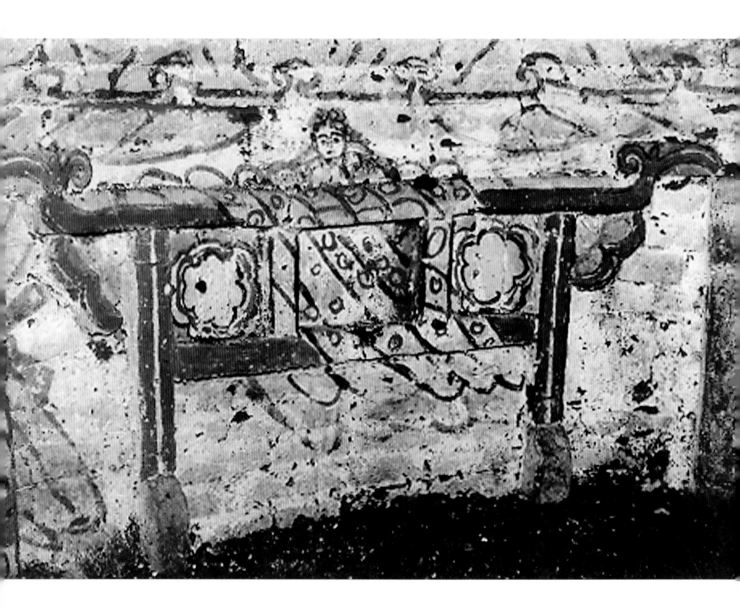

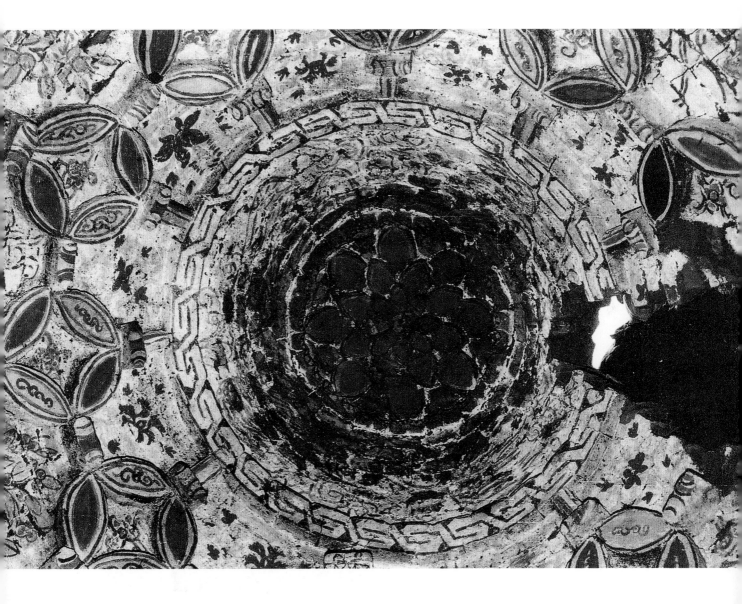

178. 仙鹤莲花藻井

元（1206～1368年）

直径141厘米

1995年山东省济南市历城区港沟镇邢村元墓出土。原址保存。

墓向182°。位于墓室顶部，用连续曲带纹勾边，内由彩绘莲花藻井及仙鹤祥云组成。

（撰文、摄影：王惠民）

Cranes and Lotus in the Cassion Ceiling

Yuan (1206-1368 CE)

Diameter 141 cm

Unearthed from the Yuan tomb at Xingcun in Ganggouzhen of Licheng District of Jinan, Shandong, in 1995. Preserved on the original site.

179. 王祥卧冰求鲤图

元（1206~1368年）

高43、宽41厘米

1995年山东省济南市历城区港沟镇邢村元墓出土。原址保存。

墓向182°。位于墓室东南穹隆顶灯笼状流苏砖雕之间。王祥侧卧于冰上，身前有二鲤鱼跃出水面，画工稚拙。

（撰文：刘善沂　摄影：王惠民）

Wang Xiang, One of the "Twenty-Four Paragons of Filial Piety"

Yuan (1206-1368 CE)

Height 43 cm; Width 41 cm

Unearthed from the Yuan tomb at Xingcun in Ganggouzhen of Licheng District of Jinan, Shandong, in 1995. Preserved on the original site.

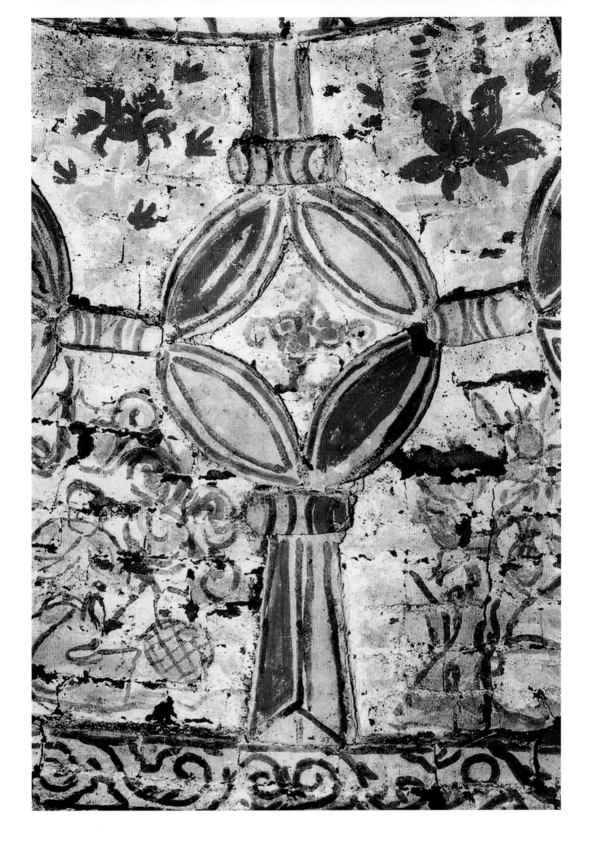

180. 流苏图案

元（1206～1368年）

高43、宽41厘米

1995年山东省济南市历城区港沟镇邢村元墓出土。原址保存。
墓向182°。位于墓室东南穹隆顶，用砖雕出灯笼状流苏，其
上绘出彩画，其间绘出人物、花卉图案。

（撰文：刘善沂 摄影：王惠民）

Tassel Pattern

Yuan (1206-1368 CE)

Height 43 cm; Width 41 cm

Unearthed from the Yuan tomb at
Xingcun in Ganggouzhen of Licheng
District of Jinan, Shandong, in 1995.
Preserved on the original site.

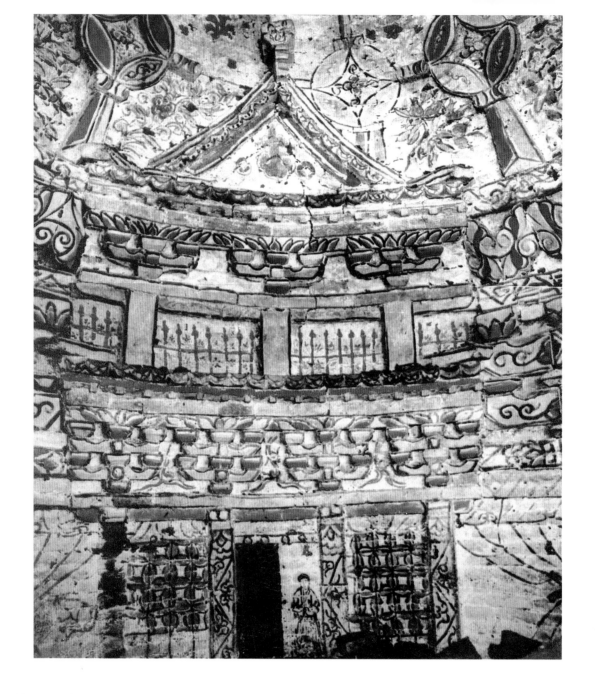

181. 仿木楼阁图

元（1206～1368年）

高300、宽178厘米

1995年山东省济南市历城区港沟镇邢村元墓出土。原址保存。

墓向182°。位于墓室北壁，正中砌一山花向前的歇山顶式仿木结构二层楼阁。下为基台，基台上立四柱，柱上承阑额、普柏枋及柱头铺作，为四铺作重拱斗拱。铺作上承撩檐枋、檐椽及瓦垄。其上为二层，结构与第一层大体相同，柱头铺作为把头绞项造。再上为歇山式屋顶，周围为流苏装饰。流苏之间绘孝行故事和写意花卉，最上方中心为莲花藻井。北壁楼阁最下方基台无彩绘，柱上下两端各绘仰莲、覆莲及半柿蒂纹箍头图案，莲瓣涂红彩，柱身绘三个三角纹，内绘花卉图案。明间绘一方门，门额上绘四个圆形门簪，门内左侧一黑门板绘红乳钉，另一板门开启，立一女子；门两侧各有一槏花窗。

（撰文：刘善沂　摄影：王惠民）

Imitation Wooden Pavilion

Yuan (1206-1368 CE)

Height 300 cm; Width 178 cm

Unearthed from the Yuan tomb at Xingcun in Ganggouzhen of Licheng District of Jinan, Shandong, in 1995. Preserved on the original site.

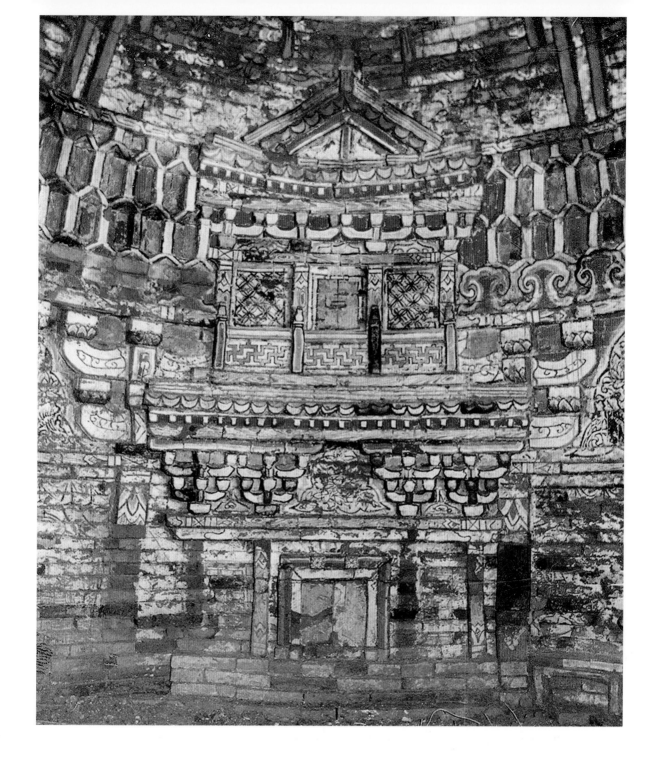

182. 楼阁式歇山顶仿木建筑图

元（1206～1368年）

高241、宽140厘米

1997年山东省济南市历下区司里街元墓出土。原址保存。

墓向182°。位于墓室北壁。为二层仿木建筑的楼阁，上绘建筑彩画。图像表现一座山花向前的歇山顶式建筑。主体为砖雕，配以色彩鲜艳的建筑彩绘。下部中为两扇门板，门上部有两枚方形门簪，顶部为阑额、普柏坊，上承四朵四铺作重拱斗拱。斗拱之上承托撩檐枋，其上为画出的圆形椽头和瓦。再上又有四根柱子，正中为带门钉和门锁的两扇门板，门钉和锁均施黑彩，门两侧为钱纹楞花窗。柱子上接栏额、普柏坊、四朵斗拱和撩檐枋、圆形椽头和瓦。最上部为歇山顶的山花部。

（撰文、摄影：刘善沂）

Imitation Wooden Pavilion with Gable-and-Hip Roof

Yuan (1206-1368 CE)
Height 241 cm; Width 140 cm
Unearthed from the Yuan tomb at Silijie Street in Lixia District of Jinan, Shandong, in 1997. Preserved on the original site.

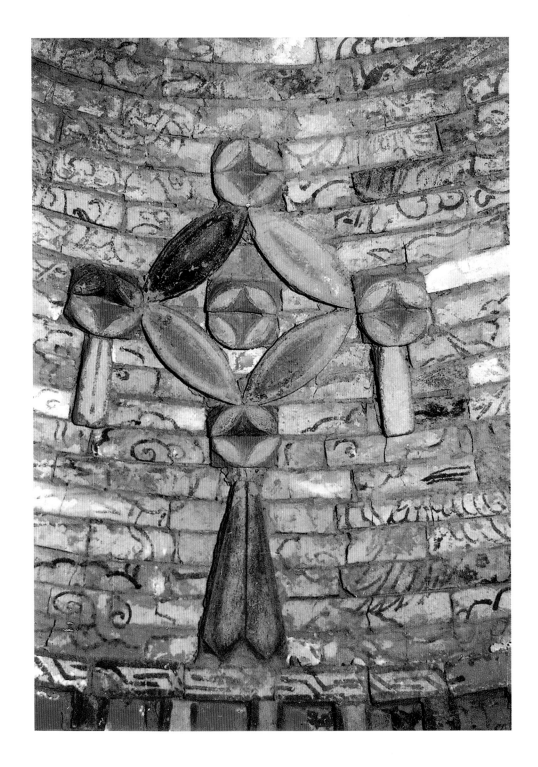

183.流苏砖雕彩绘图

元（1206～1368年）

高84、宽51厘米

1997年山东省济南市历下区司里街元墓出土。原址保存。

墓向182°。位于墓室仿木倚柱之间，穹隆顶部用砖雕灯笼状流苏，其上绘彩画。

<div align="right">（撰文、摄影：刘善沂）</div>

Colored Brick Carving Lantern Shape Tassel

Yuan (1206-1368 CE)

Height 84 cm; Width 51 cm

Unearthed from the Yuan tomb at Silijie street in Lixia District of Jinan, Shandong, in 1997. Preserved on the original site.

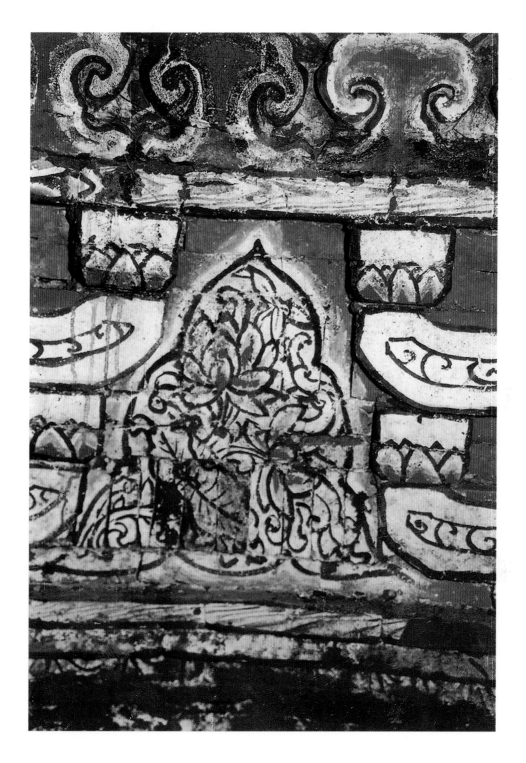

184.拱眼壁莲花图

元（1206～1368年）

高50、宽55厘米

1997年山东省济南市历下区司里街元墓出土。原址保存。

墓向182°。位于墓室柱头斗拱之间，墨线勾绘莲花花卉图案。

（撰文、摄影：刘善沂）

Lotus on Board Between Bracket Sets

Yuan (1206-1368 CE)

Height 50 cm; Width 55 cm

Unearthed from the Yuan tomb at Silijie street in Lixia District of Jinan, Shandong, in 1997. Preserved on the original site.

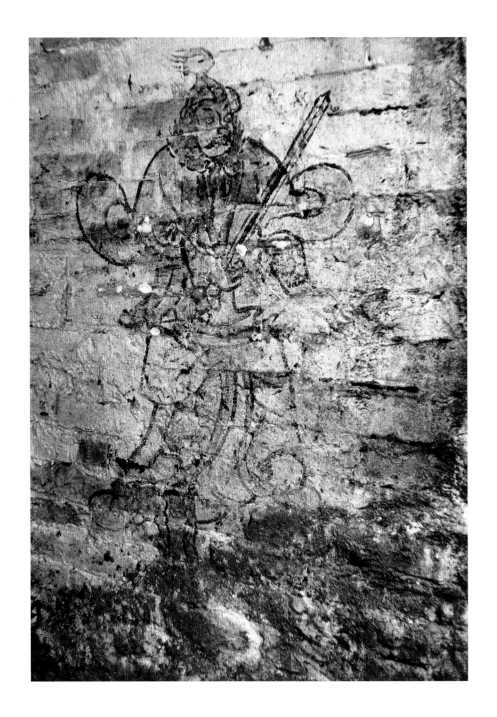

185.门吏图（一）

元（1206～1368年）

高约100、宽85厘米

1985年山东省济南市千佛山北麓齐鲁宾馆元墓出土。现存于济南市博物馆。

墓向170°。位于墓门甬道东壁。绘一武士门吏，门吏头着盔，身穿铠甲，上臂隐于衣中，双手持剑，下着裤。足穿长筒靴。

<div align="right">（撰文、摄影：李铭）</div>

Door Guard (1)

Yuan (1206-1368 CE)

Height ca. 100 cm; Width 85 cm

Unearthed from the Qilu Hotel Yuan tomb at the Northern foot of Qianfoshan Mountain in Jinan, Shandong, in 1985. Preserved in the Jinan Museum.

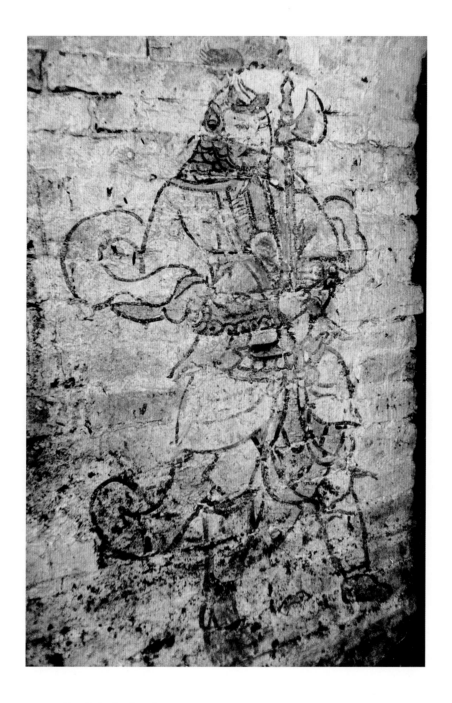

186.门吏图（二）

元（1206～1368年）

高约100、宽85厘米

1985年山东省济南市千佛山北麓齐鲁宾馆元墓出土。现存于济南市博物馆。

墓向170°。位于墓门甬道西壁。门吏头着盔，身穿铠甲，腰围抱肚，下着裤，双手持斧，护于胸前。

（撰文、摄影：李铭）

Door Guard (2)

Yuan (1206-1368 CE)

Height ca. 100 cm; Width 85 cm

Unearthed from the Qilu Hotel Yuan tomb at the Northern foot of Qianfoshan Mountain in Jinan, Shandong, in 1985. Preserved in the Jinan Museum.

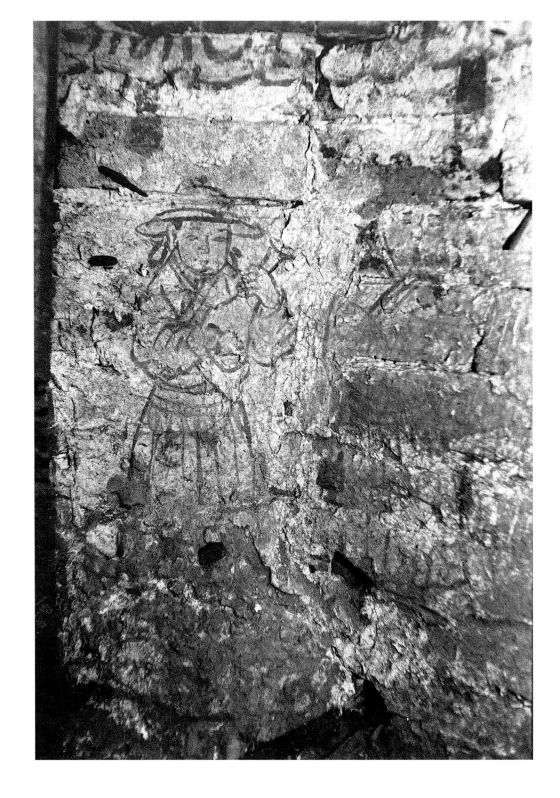

187. 奉酒图

元（1206～1368年）

高60、宽40厘米

1985年山东省济南市千佛山北麓齐鲁宾馆元墓出土。现存于济南市博物馆。

墓向170°。位于墓前室东北角。画面为两男仆，左侧一人头戴宽沿笠帽，身穿交领长袍，双手持玉壶春瓶站立。右侧一人头戴红色圆帽，着交领窄袖长袍，手捧台盏。画面下部脱落较严重。

（撰文、摄影：李铭）

Wine Serving Scene

Yuan (1206-1368 CE)

Height 60 cm; Width 40 cm

Unearthed from the Qilu Hotel Yuan tomb at the Northern foot of Qianfoshan Mountain in Jinan, Shandong, in 1985. Preserved in the Jinan Museum.

188.奉茶图

元（1206～1368年）

高约60、宽40厘米

1985年山东省济南市千佛山北麓齐鲁宾馆元墓出土。现存于济南市博物馆。

墓向170°。位于墓前室西北角。左侧一人上身穿红衣，下着裙，双手端茶盏站立；其后一人着长裙，手捧温碗汤瓶。画面漫漶较严重。

（撰文、摄影：李铭）

Tea Serving Scene

Yuan (1206-1368 CE)

Height ca. 60 cm; Width 40 cm

Unearthed from the Qilu Hotel Yuan tomb at the Northern foot of Qianfoshan Mountain in Jinan, Shandong, in 1985. Preserved in the Jinan Museum.

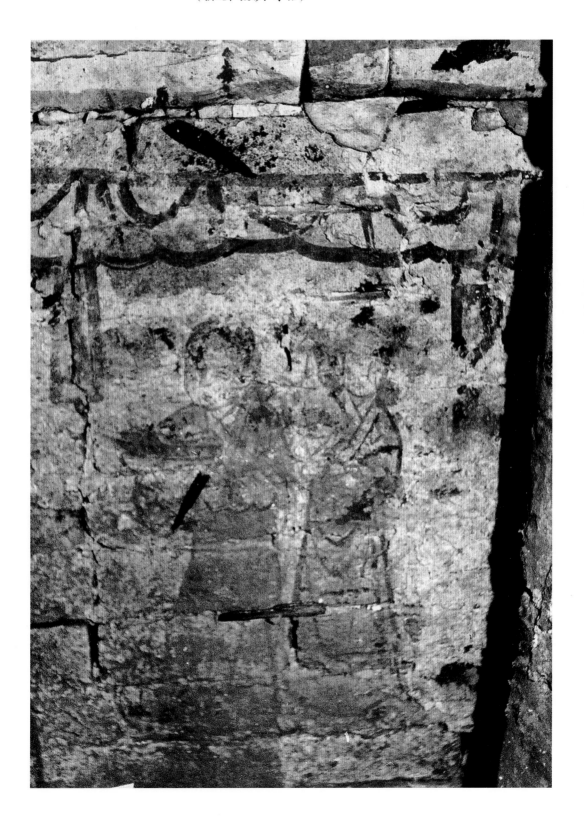

189. 伎乐图（一）

元（1206～1368年）

高48、宽120厘米

1985年山东省济南市千佛山北麓齐鲁宾馆元墓出土。现存于济南市博物馆。

墓向170°。位于前室墓壁过道东壁，画面为有六女子组成的乐伎队，六人身穿长裙分别手持不同乐器，最南端女子双手弹�"筝"，北邻一女子手抱马头弯柄琵琶，需用弓来演奏，另一女子双手持拍板，当中两人看不出拿何乐器，北端一人双手抱琵琶形乐器。

<div align="right">（撰文、摄影：李铭）</div>

Music Band Playing (1)

Yuan (1206-1368 CE)

Height 48 cm; Width 120 cm

Unearthed from the Qilu Hotel Yuan tomb at the Northern foot of Qianfoshan Mountain in Jinan, Shandong, in 1985. Preserved in the Jinan Museum.

190. 伎乐图（二）

元（1206～1368年）

高48、宽120厘米

1985年山东省济南市千佛山北麓齐鲁宾馆元墓出土。现存于济南市博物馆。

墓向170°。位于前室墓壁过道西壁。有五男子组成的打击乐伎队，五人均着交领窄袖长袍，分别持不同乐器，最南端男子面前为一面大鼓，北邻男子身挎中间细两端粗的腰鼓，中间两人所拿乐器不明，北端一人双手拿觱篥正在演奏。

（撰文、摄影：李铭）

Music Bank Playing (2)

Yuan (1206-1368 CE)

Height 48 cm; Width 120 cm

Unearthed from the Qilu Hotel Yuan tomb at the Northern foot of Qianfoshan Mountain in Jinan, Shandong, in 1985. Preserved in the Jinan Museum.

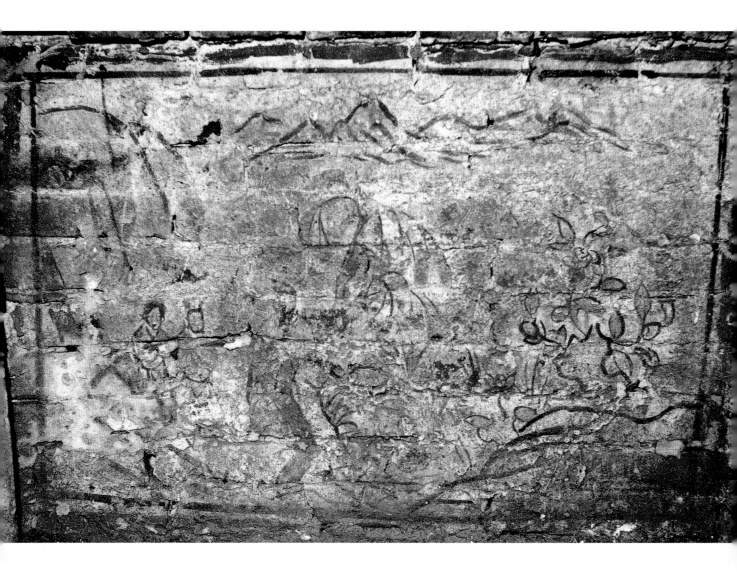

191.山水人物图（一）

元（1206～1368年）

高66、宽96厘米

1985年山东省济南市千佛山北麓齐鲁宾馆元墓出土。现存于济南市博物馆。

墓向170°。位于墓前室东壁南侧。画面为远山，近景左侧为山林树木，画面中心有一树，一人扶树而立，左侧立二侍者，右侧为水塘，水面长有荷花及水草。

（撰文：刘善沂　摄影：济南市博物馆）

Landscape and Portraits (1)

Yuan (1206-1368 CE)

Height 66 cm; Width 96 cm

Unearthed from the Qilu Hotel Yuan tomb at the Northern foot of Qianfoshan Mountain in Jinan, Shandong, in 1985. Preserved in the Jinan Museum.

192.山水人物图（二）

元（1206～1368年）

高66、宽96厘米

1985年济南市千佛山北麓齐鲁宾馆元墓出土。现存于济南市博物馆。

墓向170°。位于墓前室东壁南侧。画面右上方为远山，右下方一小桥，桥上一人向左方行走，右侧岸边一人肩负梅枝跟随上桥。桥左岸有二树，梅开朵朵，二树间放置一案一交椅，椅旁立一小童。

<div style="text-align: right">（撰文：刘善沂　摄影：济南市博物馆）</div>

Landscape and Portraits (2)

Yuan (1206-1368 CE)

Height 66 cm; Width 96 cm

Unearthed from the Qilu Hotel Yuan tomb at the Northern foot of Qianfoshan Mountain in Jinan, Shandong, in 1985. Preserved in the Jinan Museum.

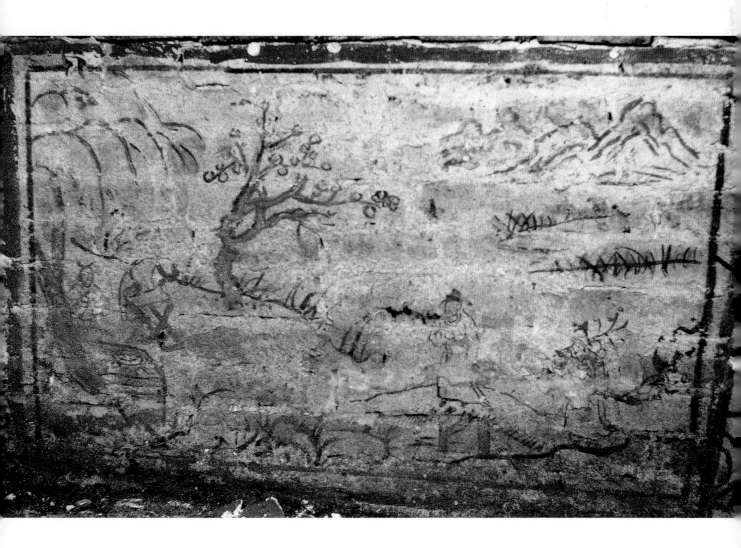

193.山水人物图（三）

元（1206～1368年）

高66、宽96厘米

1985年山东省济南市千佛山北麓齐鲁宾馆元墓出土。现存于济南市博物馆。

墓向170°。位于墓前室西壁南侧，画面为远山浮云，左侧秋树下遍开菊花，近景三人均由左向右行进。

（撰文：刘善沂　摄影：济南市博物馆）

Landscape and Portraits (3)

Yuan (1206-1368 CE)

Height 66 cm; Width 96 cm

Unearthed from the Qilu Hotel Yuan tomb at the Northern foot of Qianfoshan Mountain in Jinan, Shandong, in 1985. Preserved in the Jinan Museum.

194.山水人物图（四）

元（1206～1368年）

高66、宽94厘米

1985年山东省济南市千佛山北麓齐鲁宾馆元墓出土。现存于济南市博物馆。

墓向170°。位于墓前室西壁北侧，画面为远山，左侧一树，树右侧立三人临塘而立，一人前行，中一人着红色大袍，似为主人，手持麈尾，后一侍童身背行囊，整个画面似表现行旅。

（撰文：刘善沂　摄影：济南市博物馆）

Landscape and Portraits (4)

Yuan (1206-1368 CE)

Height 66 cm; Width 94 cm

Unearthed from the Qilu Hotel Yuan tomb at the Northern foot of Qianfoshan Mountain in Jinan, Shandong, in 1985. Preserved in the Jinan Museum.

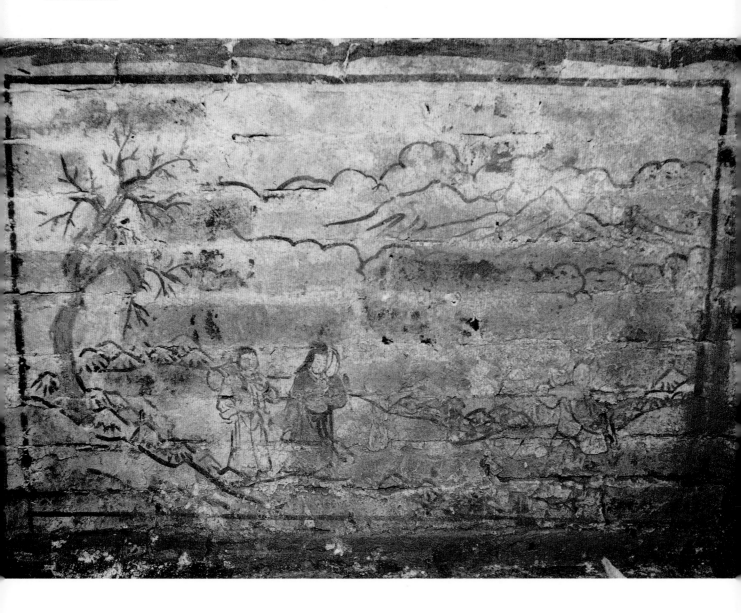

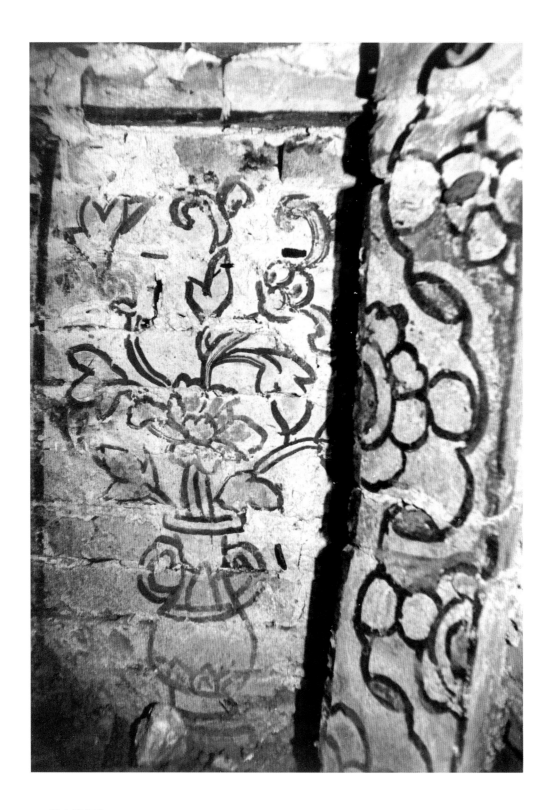

195.瓶花图

元（1206～1368年）

高60、宽40厘米

1985年山东省济南市千佛山北麓齐鲁宾馆元墓出土。现存于济南市博物馆。

墓向170°。位于墓前室西南壁，画面为双耳花瓶中插一支盛开的牡丹花。

（撰文、摄影：李铭）

Flowers in Vase

Yuan (1206-1368 CE)

Height 60 cm; Width 40 cm

Unearthed from the Qilu Hotel Yuan tomb at the Northern foot of Qianfoshan Mountain in Jinan, Shandong, in 1985. Preserved in the Jinan Museum.

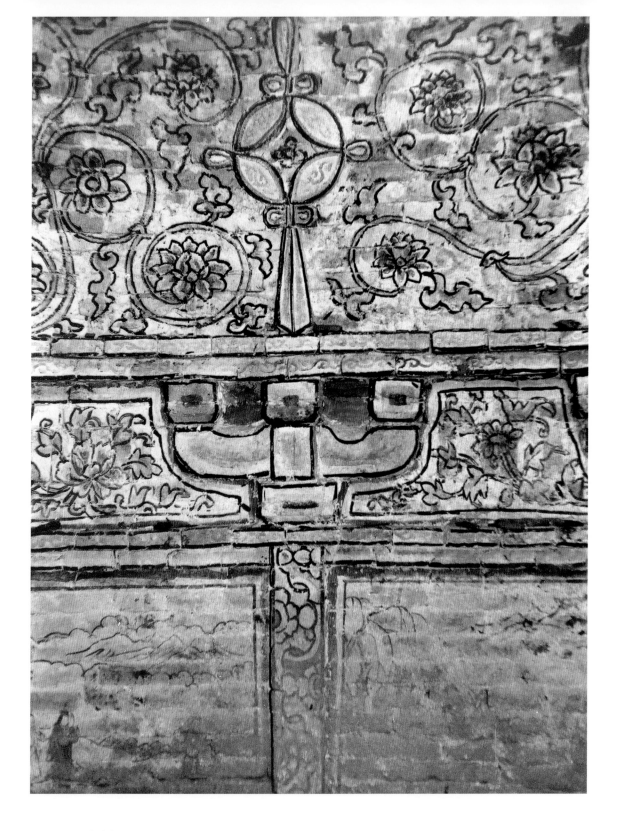

196. 斗拱图

元（1206～1368年）

高约120、宽60厘米

1985年山东省济南市千佛山北麓齐鲁宾馆元墓出土。现存于济南市博物馆。

墓向170°。位于墓前室西壁，画面中部为一朵三升式斗拱，拱眼壁绘牡丹花，檐椽以上绘流苏和缠枝花卉纹。

（撰文、摄影：李铭）

Bracket Set

Yuan (1206-1368 CE)

Height ca. 120 cm; Width 60 cm

Unearthed from the Qilu Hotel Yuan tomb at the Northern foot of Qianfoshan Mountain in Jinan, Shandong, in 1985. Preserved in the Jinan Museum.

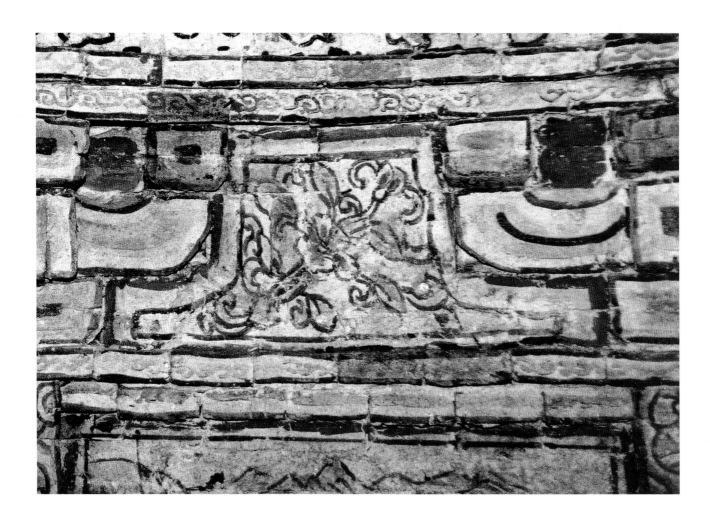

197.拱眼壁花卉图

元（1206～1368年）

高30、宽40厘米

1985年山东省济南市千佛山北麓齐鲁宾馆元墓出土。现存于济南市博物馆。

墓向170°。位于墓前室西壁中部。两斗拱之间绘折枝花卉。

<div align="right">（撰文、摄影：李铭）</div>

Flowers on Board Between Bracket Sets

Yuan (1206-1368 CE)

Height 30 cm; Width 40 cm

Unearthed from the Qilu Hotel Yuan tomb at the Northern foot of Qianfoshan Mountain in Jinan, Shandong, in 1985. Preserved in the Jinan Museum.

198.墓顶花卉图

元（1206~1368年）

高约300、宽280厘米

1985年山东省济南市千佛山北麓齐鲁宾馆元墓出土。现存于济南市博物馆。

墓向170°。位于墓葬前室北部。整座墓葬的四壁和墓顶均绘满壁画，共分六层，由下而上依次是山水人物图、斗拱彩绘、缠枝荷花、云鹤、花卉、莲花藻井。此图主要表现檐椽以上的缠枝西番莲和流苏。

（撰文、摄影：李铭）

Flowers on Ceiling

Yuan (1206-1368 CE)

Height ca. 300 cm; Width 280 cm

Unearthed from the Qilu Hotel Yuan tomb at the Northern foot of Qianfoshan Mountain in Jinan Shandong, in 1985. Preserved in the Jinan Museum.

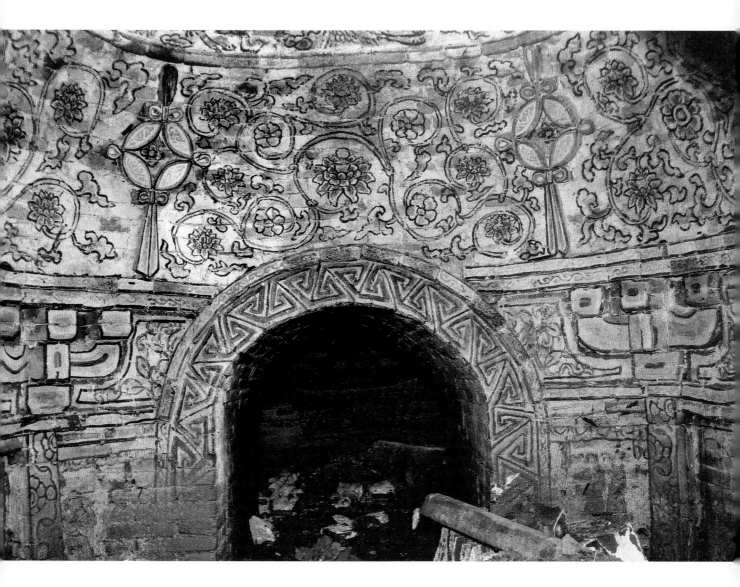

199.翔鹤图（局部）

元（1206～1368年）

高约60、宽40厘米

1985年山东省济南市千佛山北麓齐鲁宾馆元墓出土。现存于济南市博物馆。

墓向170°。位于墓葬前室顶部。绘制一鹤飞翔。

<div align="right">（撰文、摄影：李铭）</div>

Flying Crane (Detail)

Yuan (1206-1368 CE)

Height ca. 60 cm; Width 40 cm

Unearthed from the Qilu Hotel Yuan tomb at the Northern foot of Qianfoshan Mountain in Jinan, Shandong, in 1985. Preserved in the Jinan Museum.

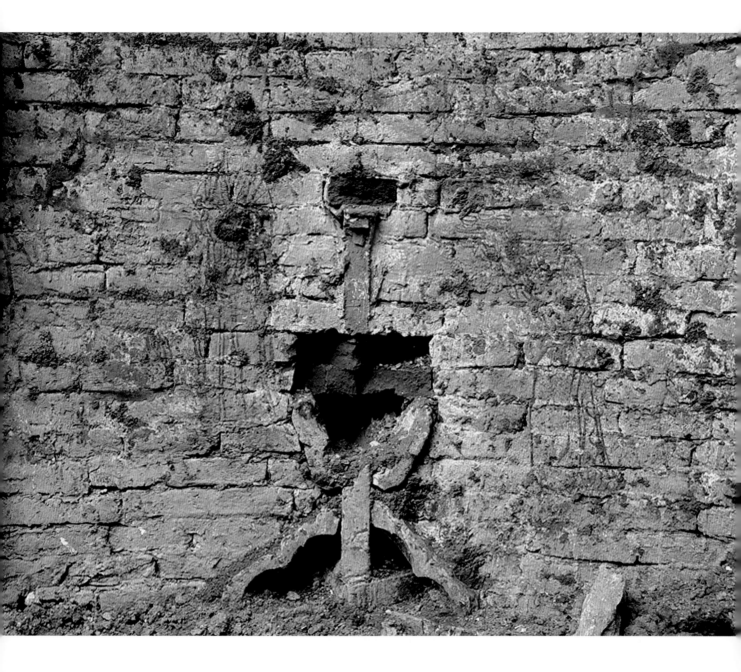

200. 侍女图（局部）

元（1206～1368年）

高约100、宽约250厘米

2004年山东省济南市华龙路元墓出土。已残毁。

墓向170°。位于墓室东壁，中间为一砖雕灯檠，两侍女身穿绿色长衫分立两侧，左侧一人拱手侍立，右侧侍女捧一盘，盘中有三只酒盏。

<div align="right">（撰文、摄影：李 铭）</div>

Maids (Detail)

Yuan (1206-1368 CE)

Height ca. 100 cm; Width ca. 250 cm

Unearthed from the Yuan tomb at Hualonglu Road in Jinan, Shandong, in 2004. Not preserved.

201. 仙人控鹤图

元（1206～1368年）

高约80、宽约120厘米

2004年山东省济南市华龙路元墓出土。已残毁。

墓向170°。位于墓室穹顶西南壁中部，一飞行仙鹤背部端坐一仙童，披帛飘飞，手捧供盘端果，意思似为驾鹤西游，死后升入天堂。

（撰文、摄影：李铭）

Immortal Riding Crane

Yuan (1206-1368 CE)

Height ca. 80 cm Width ca. 120 cm

Unearthed from the Yuan tomb at Hualonglu Road in Jinan, Shandong, in 2004. Not perserved.

202. 夫妇对坐图

元（1206～1368年）

高约120、宽约190厘米

2004年山东省章丘市龙山镇元墓出土。已残毁。

墓向190°。位于墓室西北壁，画面上部悬挂帷帐，下部中间为一方桌，桌上置有食物，桌子两侧各有一椅，墓主人夫妇分别坐在方桌两侧，男女主人背后各有一佣人，方桌后面也有一穿红衣的佣人，手持玉壶春瓶正在添酒。画面下部泥土覆盖，画面不清晰。

（撰文：王兴华　摄影：孙涛）

Tomb Occupant Couple Seated Beside the Table

Yuan (1206-1368 CE)

Height ca. 120 cm Width ca. 190 cm

Unearthed from the Yuan tomb at Longshanzhen in Zhangqiu, Shandong, in 2004. Not preserved.

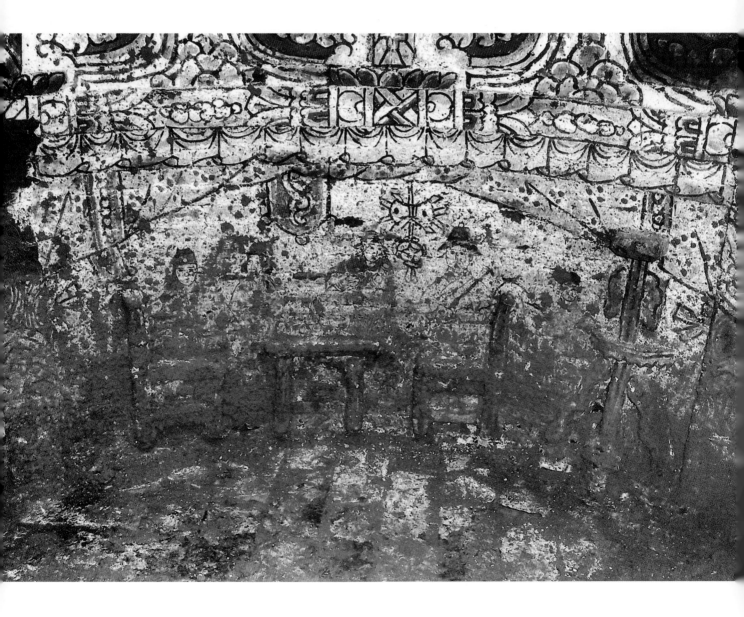

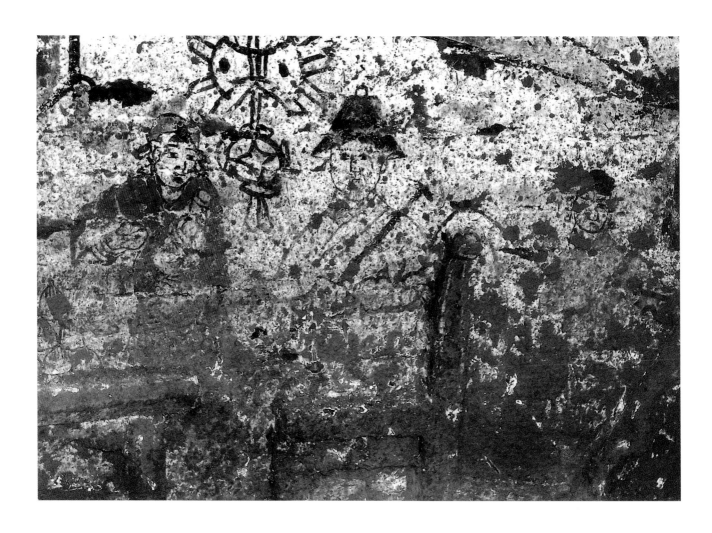

203. 夫妇对坐图（局部）

元（1206～1368年）

高约80、宽约100厘米

2004年山东省章丘市龙山镇元墓出土。已残毁。

墓向190°。位于墓室西北壁。墓主人坐在方桌右侧，桌上置一盘，盘内有包子状食物，墓主人头戴笠帽，着交领袍，正襟危坐，执手杖，身后站立一佣人，主人左侧、桌子后面也有一穿红衣的男仆，梳三搭头，两手各持玉壶春瓶和酒盏，似正在荐酒。

<div style="text-align:right">（撰文：李铭　摄影：孙涛）</div>

Tomb Occupant Couple Seated Beside the Table (Detail)

Yuan (1206-1368 CE)

Height ca. 80 cm; Width ca. 100 cm

Unearthed from the Yuan tomb at Longshanzhen in Zhangqiu, Shandong, in 2004. Not preserved.

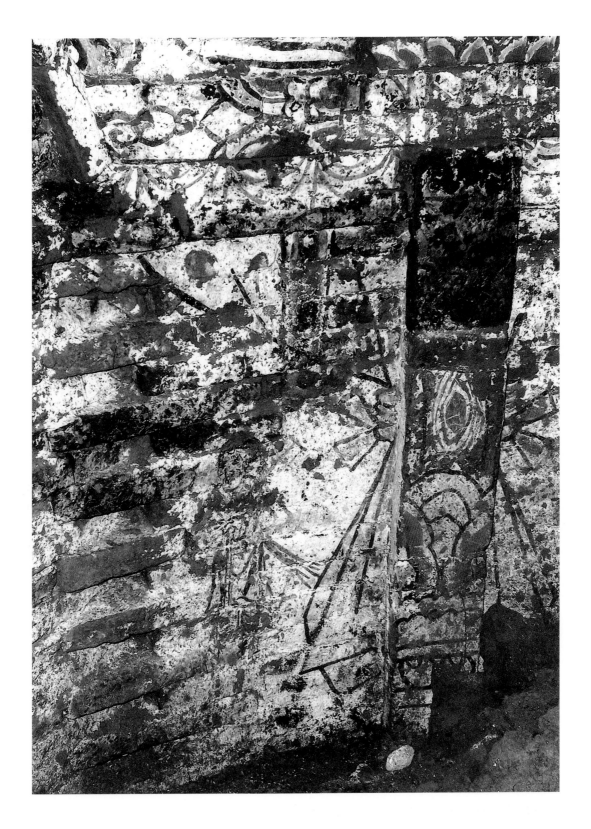

204.人物图

元（1206～1368年）

高约100、宽约50厘米

2004年山东省章丘市龙山镇元墓出土。已残毁。

墓向190°。位于墓室南壁。画面绘一人物面左而立，手持一器具。整个画面漫漶，不甚清晰。

（撰文：李铭　摄影：孙涛）

Figure

Yuan (1206-1368 CE)

Height ca. 100 cm; Width ca. 50 cm

Unearthed from the Yuan tomb at Longshanzhen in Zhangqiu, Shandong, in 2004. Not preserved.

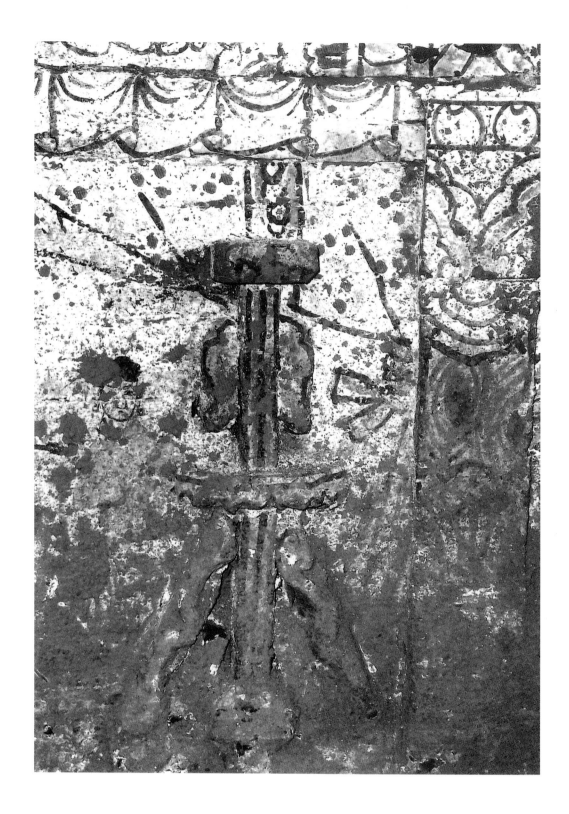

205.灯檠图

元（1206～1368年）

高约90、宽约40厘米

2004年山东省章丘市龙山镇元墓出土。已残毁。

墓向190°。位于墓室西壁。画面以红黑彩绘一灯檠，灯架左侧有一女侍面向灯架而立。画面以下为泥土覆盖，不甚清晰。

（撰文：李铭　摄影：孙涛）

Lamp Stand

Yuan (1206-1368 CE)

Height ca. 90 cm; Width ca. 40 cm

Unearthed from the Yuan tomb at Longshanzhen in Zhangqiu, Shandong, in 2004. Not preserved.

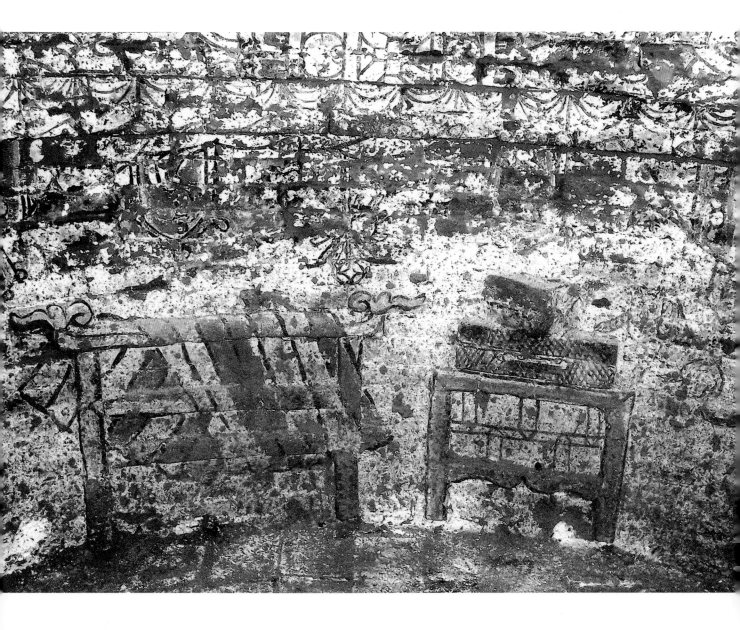

206.家具图

元（1206～1368年）

高约144、宽约180厘米

2004年山东省章丘市龙山镇元墓出土。已残毁。

墓向190°。位于墓室西壁，图左绘一衣架，两端翘起如意头，架子上搭白、红两色衣帛；架子右边有一长方形立柜，柜子上置放一竹编箧笥和一漆木盒，右侧边上卧一犬。

（撰文：李铭　摄影：孙涛）

Furniture

Yuan (1206-1368 CE)

Height ca. 144 cm; Width ca. 180 cm

Unearthed from the Yuan tomb at Longshanzhen in Zhangqiu, Shandong, in 2004. Not preserved.

207.门楼图（局部）

元（1206～1368年）

高约120米、宽约170厘米

2004年山东省章丘市龙山镇元墓出土。已残毁。

墓向190°。位于墓室北壁。画面下层两柱之间绘两扇红门，门上以黑彩绘门钉，两侧绘直棂窗，门楣上有柿蒂形门簪，其上部填龟背纹。画面上部为建筑彩绘，拱眼壁绘花卉，三组斗拱均施彩绘。

（撰文：李铭　摄影：孙涛）

Gatehouse (Detail)

Yuan (1206-1368 CE)

Height ca. 120 cm; Width ca. 170 cm

Unearthed from the Yuan tomb at Longshanzhen in Zhangqiu, Shandong, in 2004. Not preserved.

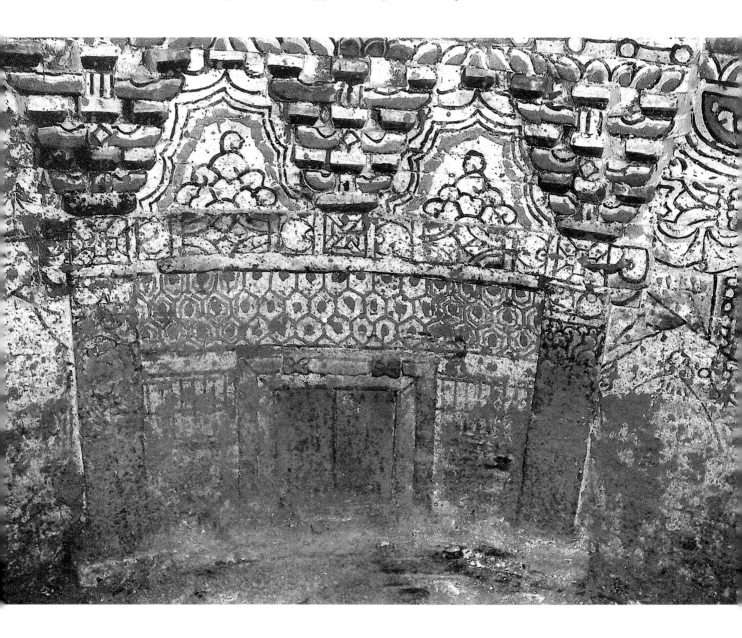

208.粮仓图

元（1206～1368年）

高约120、宽约50厘米

2004年山东省章丘市龙山镇元墓出土。已残毁。

墓向190°。位于墓室北壁。画面以黑彩勾绘一圆形粮仓。画面下部为泥土覆盖不清。

（撰文：李铭　摄影：孙涛）

Granary

Yuan (1206-1368 CE)

Height ca. 120 cm; Width ca. 50 cm

Unearthed from the Yuan tomb at Longshanzhen in Zhangqiu, Shandong, in 2004. Not preserved.

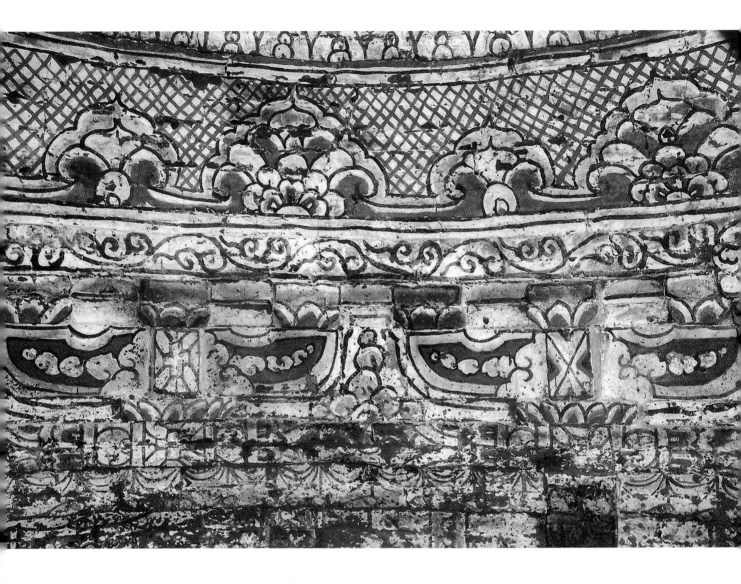

209.彩绘斗拱

元（1206～1368年）

高约210、宽约110厘米

2004年山东省章丘市龙山镇元墓出土。已残毁。

墓向190°。位于墓室西北壁。画面为墓室一角，以红黑彩绘柱子和斗拱，柱顶和斗拱空隙均满绘花卉，两侧的帐子系在柱子的中间。

（撰文：李铭　摄影：孙涛）

Colored Bracket Sets

Yuan (1206-1368 CE)

Height ca. 210 cm; Width ca. 110 cm

Unearthed from the Yuan tomb at Longshanzhen in Zhangqiu, Shandong, in 2004. Not preserved.

210.花卉图（局部）

元（1206～1368年）

高约100、宽约170厘米

2004年山东省章丘市龙山镇元墓出土。已残毁。

墓向190°。位于墓室穹隆顶北壁，图下层绘如意形花朵，当中部为建筑的山花空白处填菱形几何纹，中部绘仰莲，上部为大朵的缠枝牡丹花。

（撰文：李铭　摄影：孙涛）

Flowers Patterns (Detail)

Yuan (1206-1368 CE)

Height ca. 100 cm; Width ca. 170 cm

Unearthed from the Yuan tomb at Longshanzhen in Zhangqiu, Shandong, in 2004. Not preserved.

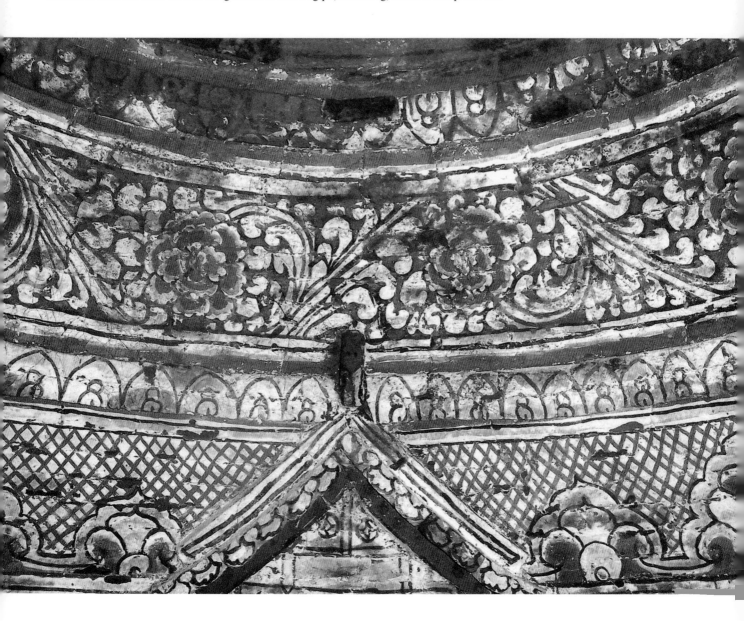

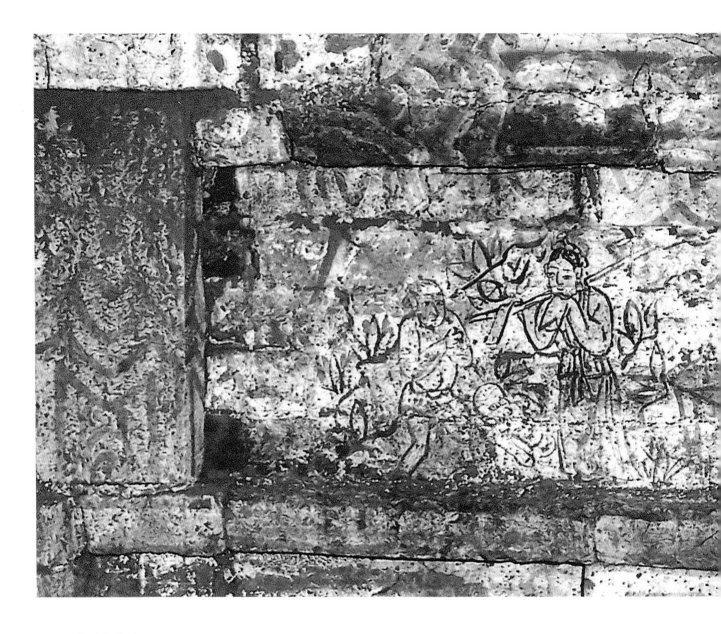

211.孝行故事

元（1206～1368年）

高约40、宽约100厘米

2004年山东省章丘市西沟头中基集团工地元墓出土。已残毁。

墓向195°。位于墓室西壁中上部。画面是两副孝子故事，左边一副图绘一身穿长裙的妇人肩扛锹，表情痛苦，对面站一壮年男子，两人中间有一幼童，应是二十四孝中郭巨埋儿的故事。右边一副画面绘一老妇坐在椅子上，前设供桌，一男子叉手躬身而拜，身后一人跪地而揖，为丁兰刻木事亲。

（撰文：李铭　摄影：何利）

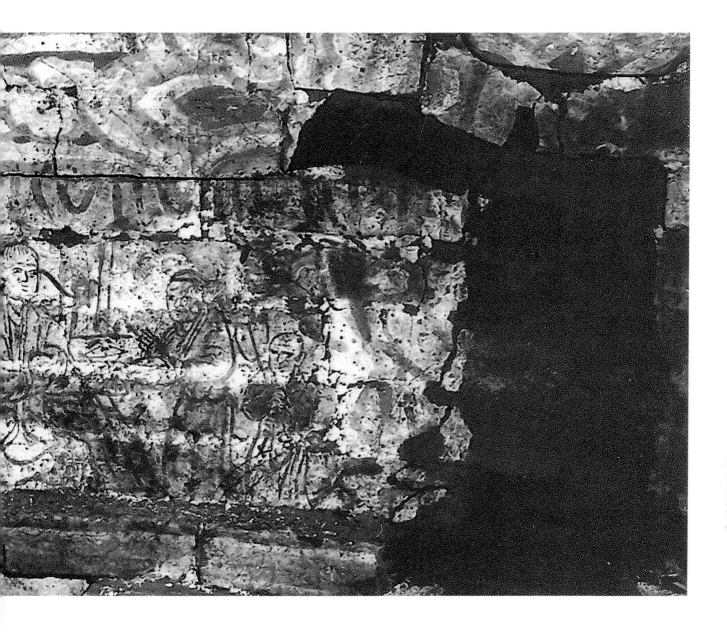

Filial Piety Story

Yuan (1206-1368 CE)

Height ca. 40 cm; Width ca. 100 cm

Unearthed from the Xigoutou Yuan tomb at the construction site of Zhongji Group in Zhangqiu, Shandong, in 2004. Not preserved.

212.王祥卧冰求鲤图

元（1206～1368年）

高约40、宽约100厘米

2004年山东省章丘市西沟头中基集团工地元墓出土。已残毁。

墓向195°。位于墓室西壁中上部。画面绘一男子赤身躺卧在冰面上。应是二十四孝中为母卧冰求鲤的王祥。

（撰文：李铭　摄影：何利）

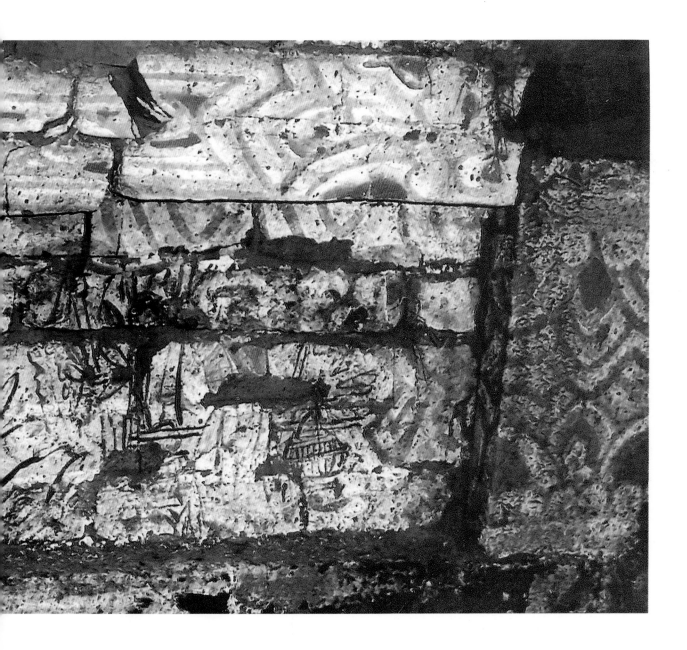

Wang Xiang, One of the "Twenty-Four Paragons of Filial Piety"

Yuan (1206-1368 CE)

Height ca. 40 cm; Width ca. 100 cm

Unearthed from the Xigoutou Yuan tomb at the construction site of Zhongji Group in Zhangqiu, Shandong, in 2004. Not preserved.

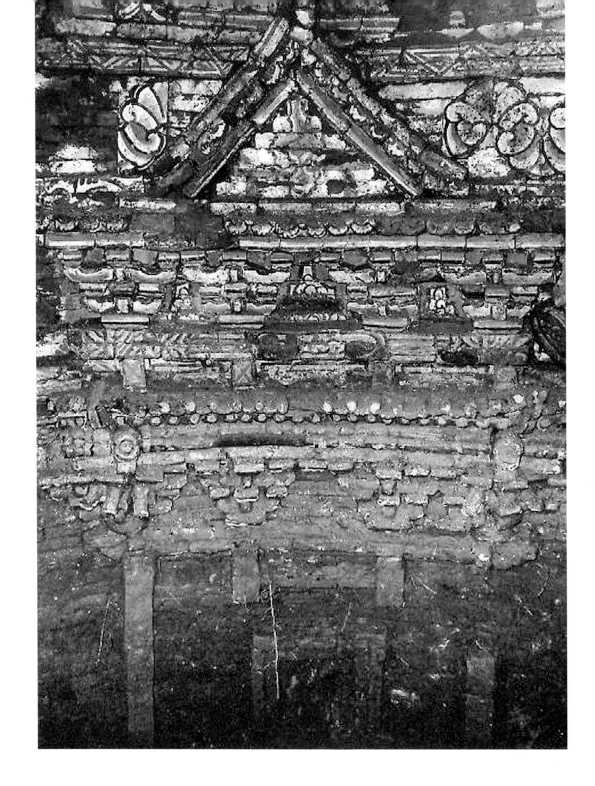

213.门楼图

元（1206～1368年）

高约360、宽约240厘米

2004年山东省章丘市西沟头中基集团工地元墓出土。已残毁。

墓向195°。位于墓室北壁。画面用砖雕表现一座山花向前式的歇山顶的建筑。主体为砖雕，配以色彩鲜艳的建筑彩绘。下部正中为两扇门板，因有泥土附着不甚清晰。顶部为阑额、普柏坊，上承四朵把头绞项造式斗拱。斗拱之上承托用蓝绿彩涂画的撩檐枋，其上为画出的圆形椽头和瓦。再上又有四根柱子，上接阑额、普柏坊、四朵斗拱和撩檐枋、圆形椽头和瓦。最上部为歇山顶的山花部。

（撰文：李铭　摄影：何利）

Gatehouse

Yuan (1206-1368 CE)

Height ca. 360 cm; Width ca. 240 cm

Unearthed from the Xigoutou Yuan tomb at the construction site of Zhongji Group in Zhangqiu, Shandong, in 2004. Not preserved.

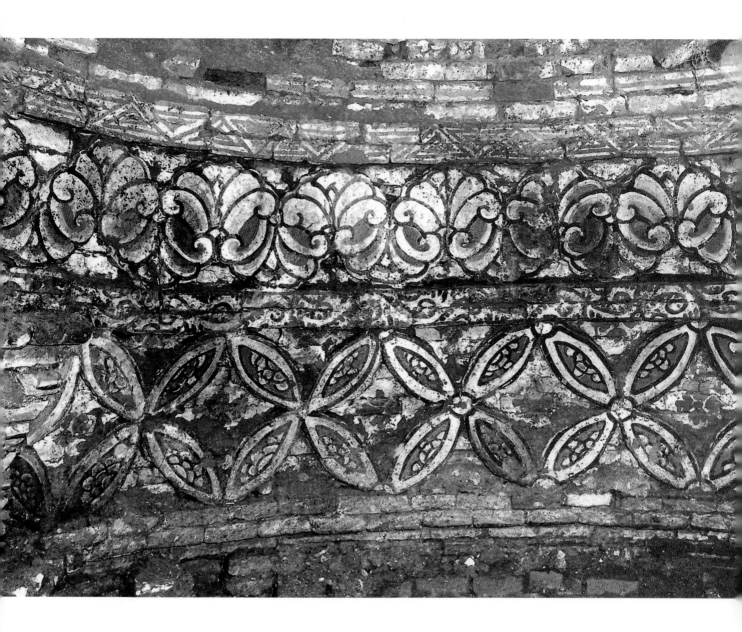

214.花卉和钱纹图

元（1206～1368年）

高约60、宽约120厘米

2004年山东省章丘市西沟头中基集团工地元墓出土。已残毁。

墓向195°。位于墓室西北壁上部。多层彩绘有钱纹、花卉和三角几何图形纹饰。

（撰文：李铭　摄影：何利）

Flowers and Coins Patterns

Yuan (1206-1368 CE)

Height ca. 60 cm; Width ca. 120 cm

Unearthed from the Xigoutou Yuan tomb at the construction site of Zhongji Group in Zhangqiu, Shandong, in 2004. Not preserved.

215. 双层门楼图

元（1206～1368年）

高约200、宽约120厘米

2004年山东省章丘市相公庄镇小康村元墓出土。已残毁。

墓向185°。位于墓室东壁。画面用砖雕表现一座山花向前式的重檐歇山顶的双层门楼建筑。主体为砖雕，配以建筑彩绘，彩绘斑驳不甚清晰。下部正中为一门框，门框内有一龛，门框上部三朵斗拱，斗拱之上承托撩檐枋，其上画出的圆形椽头和瓦。再上又有两根柱子，上接阑额、普柏枋、两朵斗拱，最上部为歇山顶的山花部。

（撰文：李铭　摄影：孙涛）

Double Storey Gatehouse

Yuan (1206-1368 CE)

Height ca. 200 cm; Width ca. 120 cm

Unearthed from the Yuan tomb at Xiaokangcun in Gongzhuangzhen of Zhangqiu, Shandong, in 2004. Not preserved.

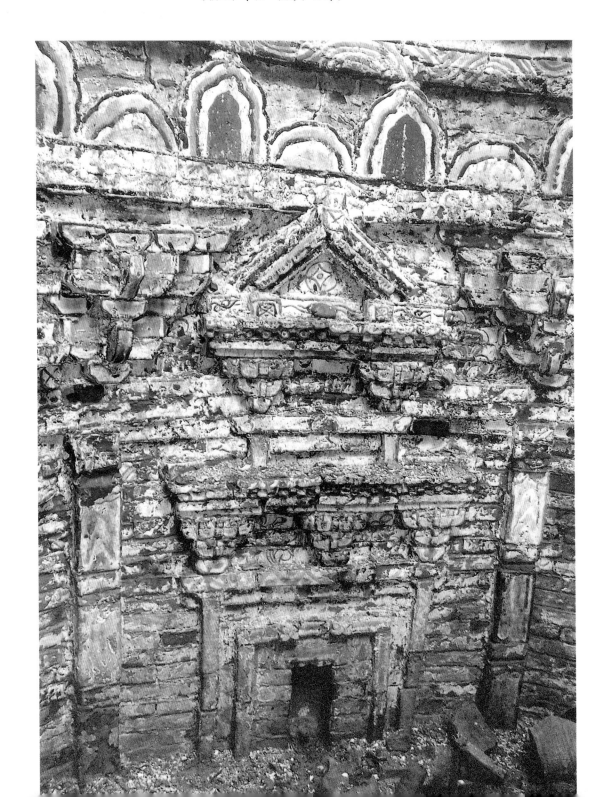

216. 单层门楼图

元（1206～1368年）

高约200、宽约120厘米

2004年山东省章丘市相公庄镇小康村元墓出土。已残毁。

墓向185°。位于墓室北壁。画面用砖雕表现一座单层门楼建筑。主体为砖雕，配以建筑彩绘，彩绘斑驳不甚清晰。下部正中为一砖砌的龛，龛内置一供案，上放置罐、盘等物，门框上部两朵斗拱，顶部为歇山顶。

（撰文：李铭　摄影：孙涛）

Single Storey Gatehouse

Yuan (1206-1368 CE)

Height ca. 200 cm; Width ca. 120 cm

Unearthed from the Yuan tomb at Xiaokangcun in Gongzhuangzhen of Zhangqiu Shandong, in 2004. Not preserved.

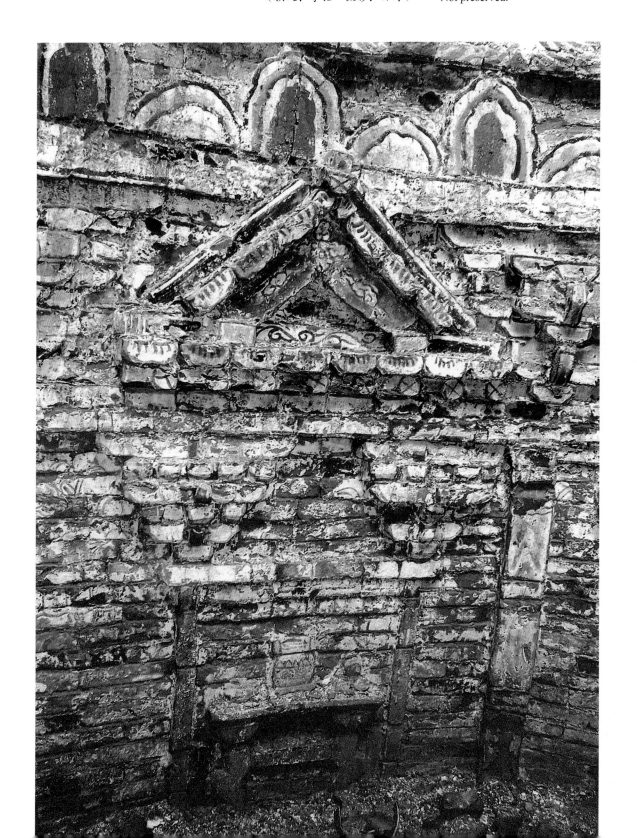

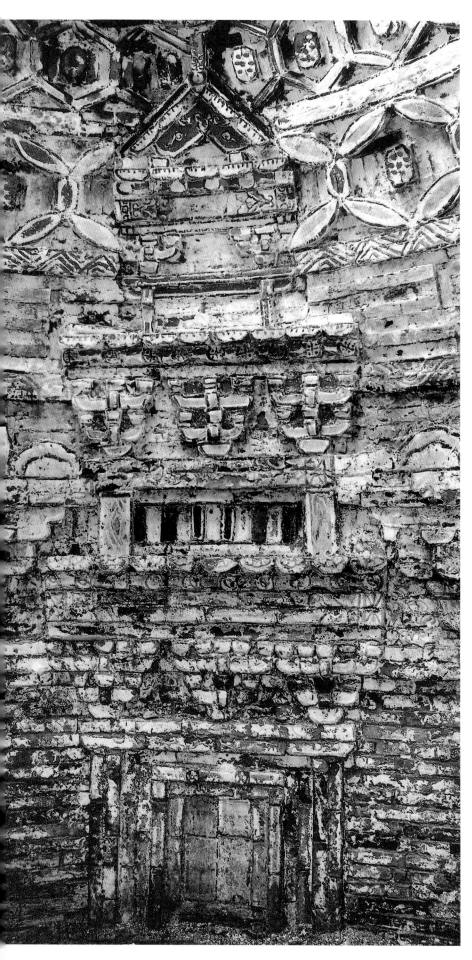

217. 多层门楼图

元（1206～1368年）

高约440、宽约220厘米

2004年山东省章丘市相公庄镇小康村元墓
出土。已残毁。

墓向185°。位于墓室北壁。画面用砖雕表
现一座多层门楼建筑。主题为砖雕，配以
色彩艳丽的建筑彩绘。下部正中绘两扇红
色板门，门上以黑彩绘制门钉，其上三朵
斗拱。中层为长方形直棂窗，上部有斗拱
三朵，上接阑额、普柏枋、两朵斗拱，最
上部为歇山顶的山花部。

（撰文：李铭　摄影：孙涛）

Multiple Storey Gatehouse

Yuan (1206-1368 CE)

Height ca. 440 cm; Width ca. 220 cm

Unearthed from the Yuan tomb at
Xiaokangcun in Gongzhuangzhen of
Zhangqiu, Shandong, in 2004. Not preserved.

218. 灯檠图

元（1206～1368年）

高约120、宽约160厘米

2004年山东省章丘市相公庄镇小康村元墓出土。已残毁。墓向185°。位于墓室南壁。画面两侧为立柱，中间一彩绘砖雕灯檠，砖雕两朵斗拱，拱眼壁绘花卉。

（撰文：李铭　摄影：孙涛）

Lamp Stand

Yuan (1206-1368 CE)

Height ca. 120 cm; Width ca. 160 cm

Unearthed from the Yuan tomb at Xiaokangcun in Gongzhuangzhen of Zhangqiu, Shandong, in 2004. Not preserved.

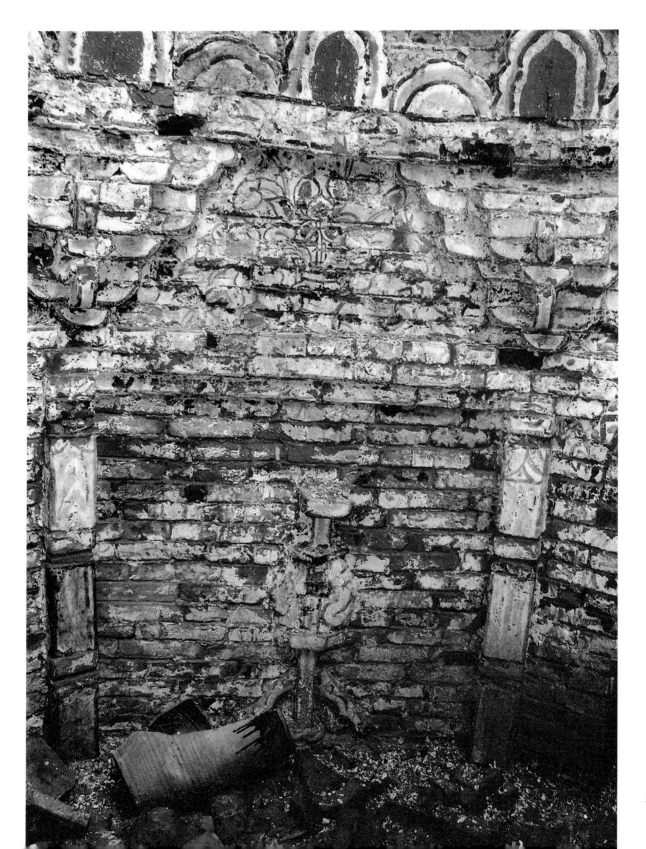

219.人物图

元（1206～1368年）

残高29、宽13厘米

1990年山东省章丘市绣惠镇女郎山71号元代壁画墓出土。已残毁。

墓向190°。位于墓门内侧砖壁上。画面为一男侍形象，头梳小辫，身穿绿色方领窄袖长袍，围系腰，手捧水盆，下部漫漶不太清晰。

（撰文、摄影：李日训）

Figure

Yuan (1206-1368 CE)

Remain Height 29 cm; Width 13 cm

Unearthed from the Yuan tomb M71 at Nülangshan in Xiuhuizhen of Zhangqiu, Shandong, in 1990. Not preserved.

220. 添油图

明（1368～1644年）

高约207、宽约125厘米

1990年山东省章丘市绣惠镇女郎山14号墓出土。已残毁。
墓向190°。位于墓室东壁。画面分上下两层：上层以墨
线、赭色勾勒卷云及花卉图案；下层画面以白色帷帐、帐饰
及赭色幔带作为前景装饰，周匝以赭色勾框，顶部绘帷幔，
一侍女身着绿色短袄，曳地长裙，右手提油罐，左手向灯盏
内添灯油，北侧还绘以花卉。

（撰稿、摄影：邱玉鼎）

Adding Lamp-oil

Ming (1368-1644 CE)
Height ca. 207 cm; Width ca. 125 cm
Unearthed from tomb M14 at Nülang-
shan in Xiuhuizhen of Zhangqiu,
Shandong, in 1990. Not preserved.

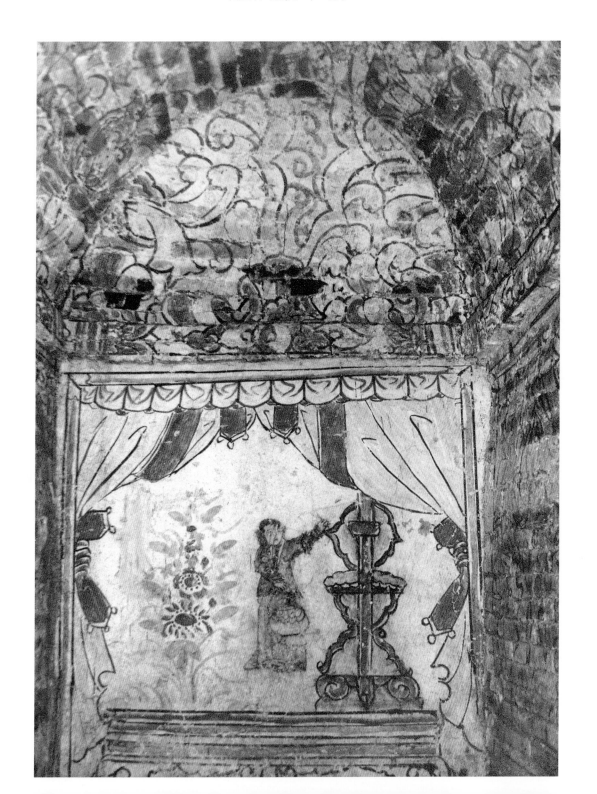

221.帐幔门扉图

明（1368～1644年）

高约220厘米

1990年山东省章丘市绣惠镇女郎山16号墓出土。已残毁。墓向190°。位于墓室北壁西侧。画面分上下两层：上层以墨线、赭色勾勒花卉图案；下层画面以白色帷帐、帐饰及赭色幔带作为前景装饰。以墨线、赭色绘双扇格子门，底部漫漶不清。

（撰文、摄影：邱玉鼎）

Draperied Door

Ming (1368-1644 CE)

Height ca. 220 cm

Unearthed from tomb M16 at Nülangshan in Xiuhuizhen of Zhangqiu, Shandong, in 1990. Not preserved.

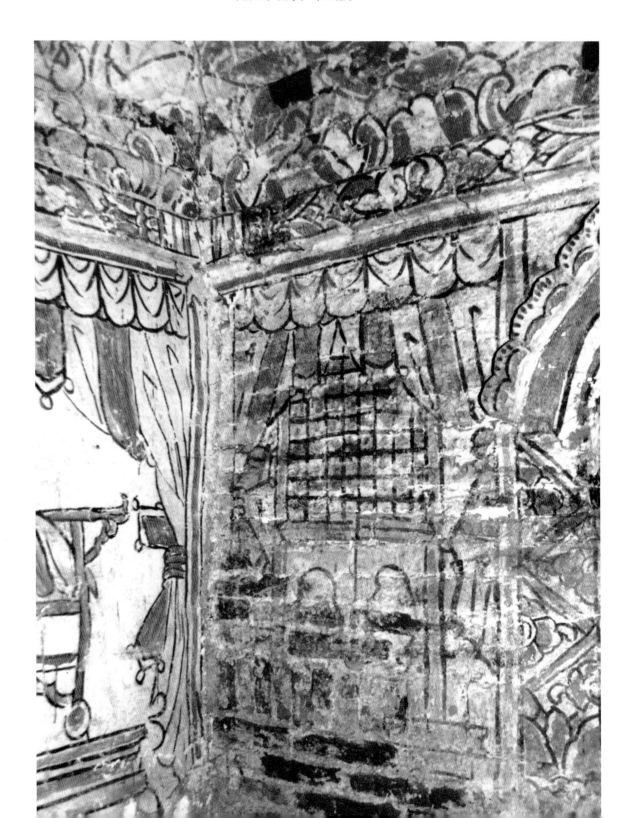

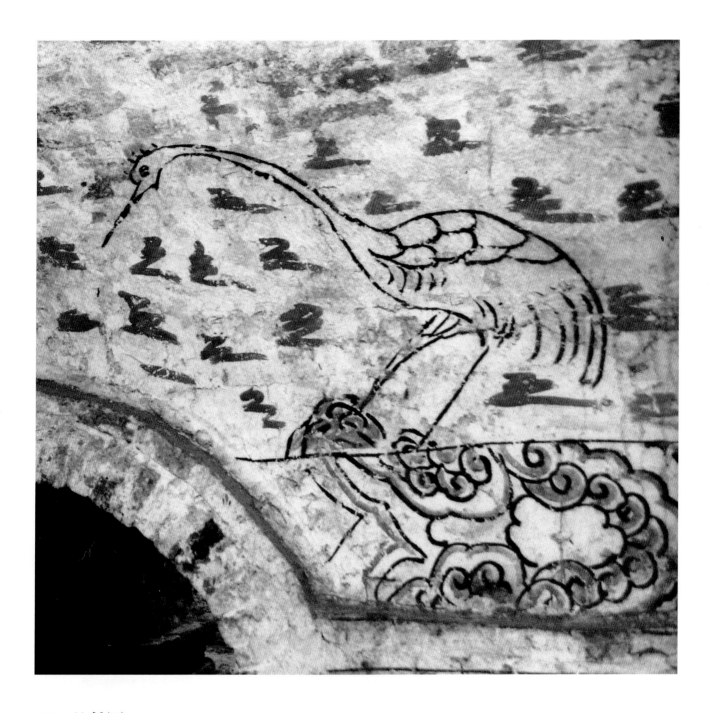

222. 仙鹤图

明（1368～1644年）

高约86、宽约100厘米

1990年山东省章丘市绣惠镇女郎山16号墓出土。已残毁。

墓向190°。位于后室券门左上侧。画面以墨线勾绘一丹顶鹤，立于祥云之上，周围为赭色流云。

<div align="right">（撰文、摄影：邱玉鼎）</div>

Red-crested Crane

Ming (1368-1644 CE)

Height ca. 86 cm; Width ca. 100 cm

Unearthed from tomb M16 at Nülangshan in Xiuhuizhen of Zhangqiu, Shandong, in 1990. Not preserved.

223. 后室东壁壁画

明（1368～1644年）

高约240、宽约250厘米

1990年山东省章丘市绣惠镇女郎山16号墓出土。已残毁。

墓向190°。位于后室券门左上侧东壁。画面分上中下三层，上层以墨线、赭色勾绘杂宝图案；中层即起券分位线绘卷云、花卉图案；下层以帷幔、绶带作为装饰，被帐幔和柱分隔成两间，白壁未作画。

（撰文、摄影：邱玉鼎）

Mural on the East Wall in the Rear Chamber

Ming (1368-1644 CE)

Height ca. 240 cm; Width ca. 250 cm

Unearthed from tomb M16 at Nülangshan in Xiuhuizhen of Zhangqiu, Shandong, in 1990. Not preserved.

224.杂宝图

明（1368～1644年）

高约60、宽约130厘米

1990年山东省章丘市绣惠镇女郎山16号墓出土。已残毁。

墓向190°。位于后室西壁。画面以黑色绘一三云头形足的承盘，其内放置犀角、银铤、宝珠等杂宝，宝光四射。

<div align="right">（撰文、摄影：邱玉鼎）</div>

Various Treasures

Ming (1368-1644 CE)

Height ca. 60 cm; Width ca. 130 cm

Unearthed from tomb M16 at Nülangshan in Xiuhuizhen of Zhangqiu, Shandong, in 1990. Not preserved.

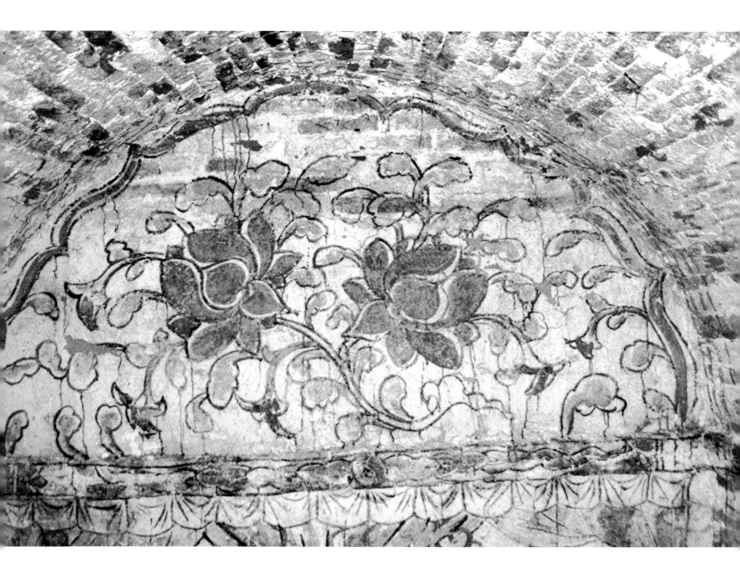

225.花卉图

明（1368～1644年）

高约100、宽约100厘米

1990年山东省章丘市绣惠镇女郎山60号墓出土。已残毁。

墓向192°。位于墓葬后室西壁上部。绘两大朵并蒂牡丹，花赭红色，叶青绿色。

（撰文、摄影：邱玉鼎）

Flowers

Ming (1368-1644 CE)

Height ca. 100 cm; Width ca. 100 cm

Unearthed from tomb M60 at Nülangshan in Xiuhuizhen of Zhangqiu, Shandong, in 1990. Not preserved.

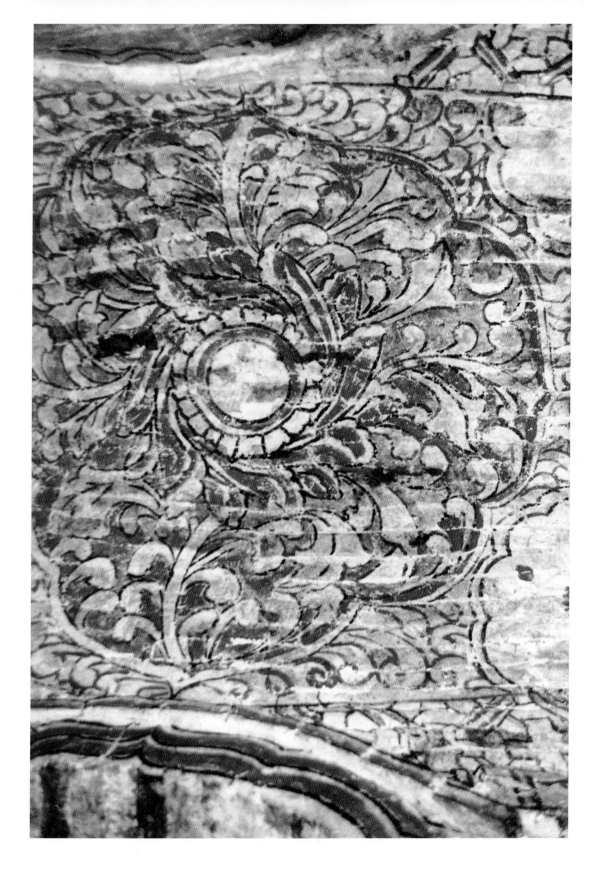

226.前室墓顶壁画

明（1368～1644年）

1990年山东省章丘市绣惠镇女郎山60号墓出土。已残毁。
墓向192°。位于前室顶部。画面以墨线、赭色勾绘大朵
赭色团花。

（撰文、摄影：邱玉鼎）

Mural on the Ceiling of the Front Chamber

Ming (1368-1644 CE)

Unearthed from tomb M60 at Nülangshan
in Xiuhuizhen of Zhangqiu, Shandong, in
1990. Not preserved.

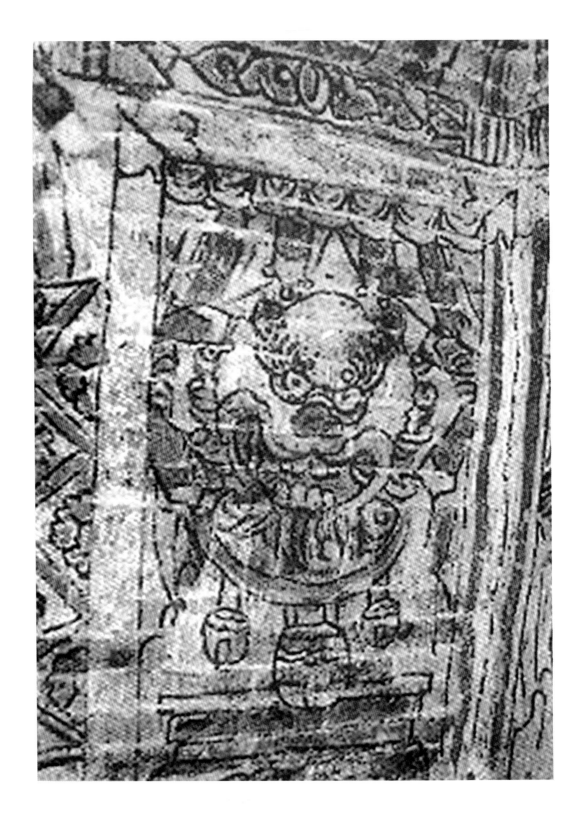

227.怪兽图

明（1368～1644年）

高约135、宽约85厘米

1990年山东省章丘市绣惠镇女郎山60号墓出土。已残毁。

墓向192°。位于墓葬前、后室间甬道的东侧。画面以白粉为地，用黑、赭色绘一面目狰狞的怪兽，周匝以墨线勾框，似为魁头。

（撰文、摄影：邱玉鼎）

Monster

Ming (1368-1644 CE)

Height ca. 135 cm; Width ca. 85 cm

Unearthed from tomb M60 at Nülang-shan in Xiuhuizhen of Zhangqiu, Shandong, in 1990. Not preserved.